Modern Art Museum of Fort Worth **110**

Michael Auping, General Editor

With commentaries by Michael Auping,
Andrea Karnes,
and Mark Thistlethwaite

 III THIRD MILLENNIUM
PUBLISHING, LONDON

Contents

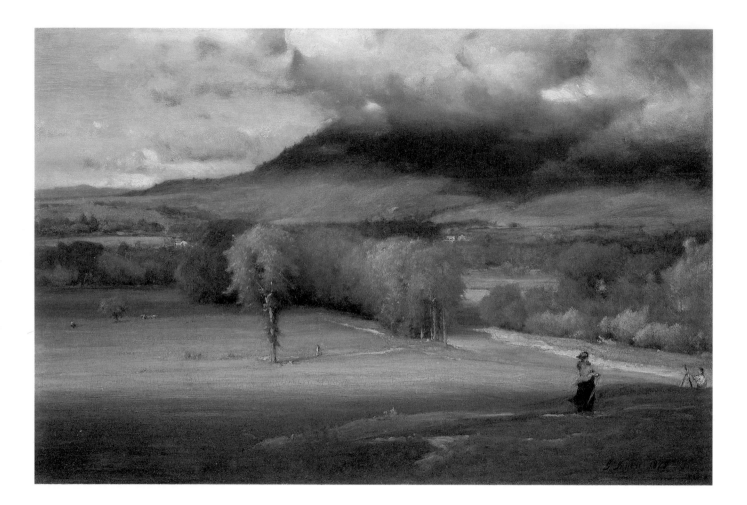

George Inness
Approaching Storm, 1875
Oil on canvas
19 1/2 × 29 1/2 inches (49.5 × 74.9 cm)
Purchased by public subscription
1904.1.P.P

6

Introduction

I never read, I just look at pictures.[1]
ANDY WARHOL

Andy Warhol liked to visit the collection of the Metropolitan Museum of Art, occasionally pausing in front of a 200-year-old painting to exclaim "How contemporary."[2] By that, we can assume he meant "How relevant." Warhol, who operated on the cutting edge of style and culture throughout his life, was a sly student of art history, and like so many artists before him, he saw the value of a museum's permanent collection. As Warhol often pointed out, those who understand the breakthroughs of their predecessors are capable of making breakthroughs of their own; those who do not simply copy. It was the difference between stealing and borrowing, the former being the preferred method.

Since their invention more than two centuries ago, art museums and their permanent collections have been vital sites of learning and inspiration for artists, a kind of second studio. Pierre-Auguste Renoir's declaration that one learns to paint in a museum was meant conceptually and literally. When the Louvre opened in 1793— one of the first "public" art museums—the first five days of every ten were reserved exclusively for artists. Easels were not an uncommon sight in the galleries.

This is not to say that museums and their collections have not been controversial, even at odds with the artists whose work they house, particularly in the complex realm of contemporary art, where the present clashes with even the immediate past. As one artist put it, a finished painting is only a reminder of what needs to be done tomorrow. When all is said and done, however, artists have often been the first to acknowledge the importance of the material culture they inherit. The same Gustave Courbet who dismissed his esteemed elders Raphael and Michelangelo worked day and night in the Louvre to protect treasures by them from destruction during Paris's political unrest of 1848. Claude Monet later paid several visits to the same institution—not to look at the works of art, but rather to look out of the window. From the east balcony of the Louvre, he painted three controversial, impressionistic cityscapes of modern Paris. Turning his back on the collection, as it were, Monet made a gesture that has been described as symbolic of his rejection of the museum.[3] Of course, it could also be thought of as a synthetic moment, a threading together of the old and the new. The museum's collection of masterpieces provided the now-famous Impressionist with a platform from which to jump into a new arena. There were, after all, other buildings from which to paint the new landscape of the city.

The Futurists were adamant about denouncing the past in favor of a hyper-future —F. T. Marinetti referred to museum collections simply as "cemeteries"—but were quietly hopeful that their works would be interred with the likes of those by Titian, Leonardo, and Michelangelo.[4] More recently, Robert Smithson echoed Marinetti's description, referring to museums in general as "tombs." Smithson, a pioneer of the Earth art movement in the late 1960s, advocated that artists free themselves of both commercial and institutional culture by working outside the walls of galleries and museums. Speaking of his monumental *Spiral Jetty*, 1970, however, a fifteen-

hundred-foot spiral of rocks and earth that stretches a quarter-mile out into the Great Salt Lake, he said simply, "I thought of Jackson Pollock's *Eyes in the Heat*."[5] Smithson would have seen Pollock's 1946 painting hanging in the collection of the Guggenheim Museum. His contemporary Robert Mangold worked as a guard at The Museum of Modern Art, some thirty-seven blocks away, where he routinely stared at the greatest collection of Pollocks in the world, along with world-class collections of Piet Mondrian and Kazimir Malevich, which still trigger memories for the artist: "Working at MoMA was a great job.... You were paid to look at great art. But then you had to go back to the studio and figure out how to take a run at Malevich. It was intimidating. But ignoring one of the great pioneers of abstraction was not an option."[6]

It stands to reason, then, that if a lay public wanted to learn about art, they would go where artists go. Indeed, what has been the fate of Smithson's "tombs" in recent years? As *Newsweek* magazine recently reported, museum visits in the United States in 2000 were over one billion for the first time, "more than double the attendance at sports events."[7] Certainly a substantial aspect of this growth can be directly attributed to the infamous "blockbuster" exhibition—temporary exhibitions with international loans of iconic and well-publicized work that attract lines and waiting lists so long they make the five o'clock news. They are a fact of our time and a reflection of the museum's increasing role as "entertainer" as well as educator. It is difficult to argue against the fact that high-profile exhibitions increase a museum's attendance while they educate an ever-widening public audience.

While a curator's responsibility has traditionally been linked to acquisition, preservation, interpretation, and installation of the collection, over the past three decades curatorial practice has emphasized the organization of high-profile exhibitions that follow the blockbuster model. Indeed, a curator's standing in the field is now primarily defined by his or her ability to produce such exhibitions. Whether this is a good thing or a bad thing remains to be seen.

The role of permanent collections in this new environment is also still being decided. With limited exhibition space, greater demands for high-profile temporary exhibitions, and curators whose reputations are increasingly gauged by the number of traveling exhibitions they produce, it is tempting for some museums to show their permanent collection sparingly, and then only as the benign backdrop for the temporary lead performer. On the other hand, museum collections can be highly charged entities in which a variety of issues and ideas intersect. These range from which works of art are appropriate to acquire at what time to the best way to display and interpret them. Interwoven into these issues are larger questions about the "space" of the museum and the way in which the intellectual and curatorial framework of the institution shapes and structures the experience of looking at art and art history. The Museum of Modern Art's series of collection exhibitions *Modernstarts* and the Tate Modern's recent reinstallation of its collection, presented for the first time in a newly renovated power station, were lightening rods for debate and controversy. Rather than presenting a traditional chronological sequence of movements and stylistic developments, these presentations grouped works across generations, according to

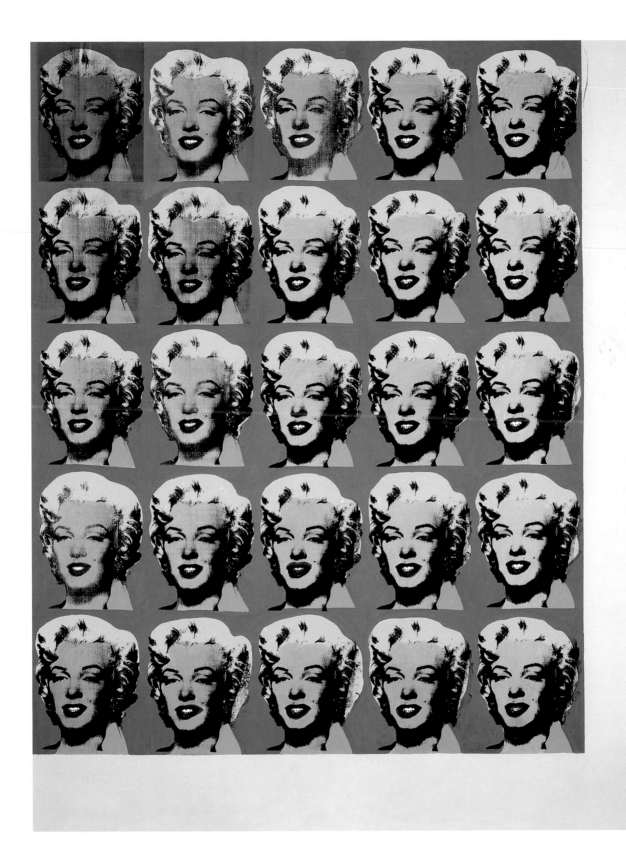

Andy Warhol
Twenty-Five Colored Marilyns, 1962
Acrylic on canvas
82 × 66¼ inches (208.3 × 168.3 cm)

genre and theme. In both cases, casual museum visitors registered pleasure at the speculative connections between artists of distant time periods, while artists and critics were less enthusiastic. The artist Frank Stella lambasted *Modernstarts* as "spastic and senseless."[8] In response to the Tate's hanging, *New York Times* art critic Michael Kimmelman wrote that the sequencing of works was "occasionally eccentric to the point of distraction." The critic went on to argue that "museums should make it easier for people to stand in front of a work [of art] unencumbered."[9]

Indeed, it has been argued by many that individual art objects should be presented on their own terms, without contextualization. Along with the early concept of the "cabinet of curiosities" and the subsequent ideal of the museum as an instrument of broad public education through the systematic organization of objects, we now engage the concept of looking at art objects as unique sensory experiences. Today museums are often compared to religious sites, where a visitor can spend quiet moments contemplating a given work of art, more as a sacred presence than as an artifact.

That these different philosophies regarding permanent collection displays have elicited passionate responses testifies to the engaging role collections play in the ongoing debate regarding a museum's ultimate mission and service to its audience. The challenge and multiple implications of presenting art and art history through a museum's holdings become obvious given the number of permutations possible. As one critic recently pointed out, for even a small group of ten art objects, there are 3,628,800 possible arrangements.[10]

It would be hard to imagine a more interesting time to build a museum and celebrate a collection. This book accompanies the inaugural exhibition at the new Modern Art Museum of Fort Worth, designed by the architect Tadao Ando. The central subject of and impetus for this building from the beginning has been art, with particular emphasis on the display of the permanent collection. Of the 153,000 square feet of space, 53,000 is gallery space, a proportion of art space to support space that emphasizes art like few museums in the world. That the first exhibition in these pristine galleries is devoted to the collection is a testament of pride and priority. Works by approximately 150 artists are currently displayed over the Museum's three two-story gallery pavilions. In honor of the Museum's 110th anniversary, 110 of these artists have been chosen for inclusion in this publication. The installation and the publication both represent works acquired primarily over fifty years of the Museum's history, reflecting the organization's long and varied evolution.

As the oldest museum in the state of Texas, it must be said that the Modern Art Museum of Fort Worth was both an early starter and a late bloomer. Following a charter granted in 1892 to the Fort Worth Public Library and Art Gallery, the Museum's early course was set by volunteers, specifically by a group of ambitious women whose daily preoccupations were for the most part taken up by being on the leading edge of Western migration, or the "opening up of the West" and all that it entailed. One can only imagine what a Board of Trustees meeting would have been like in the Fort Worth of the 1890s, when whiskey was the common anesthetic and oil was being exploited in a boom town of "cattlemen, horse traders, bone haulers, gamblers, and fakers of

every conceivable nature."[11] A child's prayer of the time recited in Eastern states went, "Goodbye, God. This will be the last chance I get to talk to you. We're moving to Texas."[12]

Like most early American museums at the turn of the twentieth century, Fort Worth's museum was guided by what might best be regarded as enlightened conservatism. The first work to enter the collection was George Inness's *Approaching Storm*, 1875. The choice of this painting may have unconsciously reflected a city whose identity was poised between a kind of avant-garde domesticity and the frontier. While Inness's gentle expressionism seems conservative by twenty-first-century standards of contemporary art, his paintings were sought after by collectors interested in pushing the boundaries of American painting from literal forms of realism to more challenging impressionistic depictions. However, unlike many of his contemporaries, who chose to portray untamed wilderness, Inness—like the French Barbizon painters—preferred an intimate, domesticated, or in his words, a "civilized" landscape. The locale depicted has not been conclusively identified, but is likely somewhere in New England. With a little imagination, however, the scene could resemble areas of North Texas, with gentle grassy expanses punctuated by rougher terrain of bushes and trees.

In 1925 The Friends of Art was formed with art patrons who agreed to contribute $50 or more annually toward the purchase of art. This eventually developed into the nucleus of a small purchase fund, which resulted in the Museum acquiring Thomas Eakins's *Swimming*, 1885, a painting that reflected America's preference for well-crafted realism, combined with a controversial scene of male nudes.[13] It is noteworthy that both Inness's and Eakins's works were purchased within relatively close proximity of the artists' lifetimes. To put things in context, it is helpful to remember that the concept of a truly contemporary museum—a museum that collects and exhibits the work of living artists—is a relatively recent phenomenon. Fort Worth was clearly part of a growing wave of American museums willing to take the art of their time seriously.

The Museum's collection grew slowly over the next decade, but although the collection was growing, it remained nomadic, moving from building to building around the city. In 1944 a $500,000 bond issue was approved for a permanent museum building, and a decade later, in the fall of 1954, Fort Worth's first permanent museum facility was completed. Designed by ex-Bauhaus architect Herbert Bayer, it consisted of approximately 5,000 square feet of exhibition space. To oversee the project, the Museum appointed Daniel S. Defenbacher as its first director; he held that position until 1955.

Defenbacher and those directors who followed over the next thirteen years (Henry B. Caldwell, 1955–1960; Raymond Entenmann, 1960–1966; and Donald Burrows, 1966–1968) established the Museum as a professional organization. Their primary responsibilities involved assembling a trained staff who would operate the Museum on a day-to-day basis, researching the collection, educating docents and the public, developing ongoing exhibition programs, and forming a reference library. In regard to acquisitions, they relied primarily on gifts, with the vast majority of artworks acquired being works on paper. A significant exception was the purchase of Pablo Picasso's

Femme couchée lisant (Reclining Woman Reading), 1960. On a cold night in 1967, Fort Worthians, along with millions of viewers around the world, watched the first internationally televised art auction as Fort Worth museum director Burrows outbid interested buyers in Los Angeles and New York for *Femme couchée lisant*, a masterpiece in black, white, and gray that remains one of the most important works in the Museum's collection.

In 1968 the Museum hired Henry Hopkins, formerly curator of education at the Los Angeles County Museum of Art. During his five-year tenure, Hopkins made acquisitions a priority, with purchases significantly outweighing gifts. Hopkins purchased key works by artists who had been influential in the 1940s, 1950s, and 1960s, such as Joseph Cornell, Jim Dine, Donald Judd, Ellsworth Kelly, Mark Rothko, Ben Shahn, and Clyfford Still. He also purchased key works by artists just beginning to make their mark, such as Larry Bell, Lynda Benglis, Robert Irwin, Brice Marden, and Lucas Samaras.

The decade leading up to 1972 was critical to the Museum's current collection goals and responsibilities. In 1961 the Amon Carter Museum of Western Art opened in Fort Worth, eventually establishing a collection of American art dated through the beginning of the twentieth century. Businessman Kay Kimbell, upon his death in 1964, left his art collection and personal fortune to the Kimbell Art Foundation for the purpose of establishing a major public art museum. Kimbell's collection represented European developments through the late Renaissance and Baroque periods, along with French and American paintings of the nineteenth century. Richard Fargo Brown was hired to direct the museum and work with the architect Louis I. Kahn to build the Kimbell Art Museum, which opened to the public in 1972. Thus, a third major museum became a part of what would later be designated the Cultural District of Fort Worth. A collaborative agreement among the three museums was established for the future, with each institution building on the strengths of their respective collections. The Kimbell Art Museum would henceforth collect European, ancient, and non-Western art dated up to approximately 1940, while the Amon Carter Museum would collect only American art, with a specialization in art of the western states dated to approximately 1940. Ironically, the oldest museum in Fort Worth, now legally the Fort Worth Art Association, would focus on the most recent developments internationally, collecting European, American, and non-Western art dated from 1940 onward.

Following Hopkins, a series of directors (Richard Koshalek, 1974–1976; Jay Belloli, 1976–1978; Marge Goldwater, interim director, 1978–1979; and David Ryan, 1979–1984) further initiated the Museum's new role as a museum of contemporary art, adding significant works by Josef Albers, John Chamberlain, Vernon Fisher, Adolph Gottlieb, Red Grooms, Roy Lichtenstein, Claes Oldenburg, Robert Rauschenberg, Ed Ruscha, Michael Singer, Nicolas de Staël, and Andy Warhol.

Although often emphasized in the Museum's past acquisitions, American art became a distinct priority with the appointment of E. A. Carmean, Jr. in 1984. A scholar of Abstract Expressionism, Carmean acquired groups of work by Robert Motherwell, including two major canvases; Jackson Pollock, including three paintings done between 1938 and 1952, along with four drawings and fourteen prints; and Morris

Louis, including four works from his acclaimed *Veil* series. During this time, the Museum also collected works by a number of emerging and mid-career artists, including David Bates, Chuck Close, Nancy Graves, Melissa Miller, Frank Stella, Donald Sultan, and Mark Tansey. Perhaps the most important accomplishment of Carmean's era was the establishment of two substantial acquisitions endowments, made possible by generous gifts from The Burnett Foundation and the Sid W. Richardson Foundation.

Under the directorship of Marla Price since 1991, the Museum's collection has continued to expand. Indeed, the past decade constitutes one of the most aggressive eras of collecting for the Modern Art Museum of Fort Worth. Rare works by Robert Motherwell and Ad Reinhardt have further enhanced the Museum's collection of Abstract Expressionism. Working closely with the Dedalus Foundation over a seven-year period, the Museum has acquired thirty-three works by Motherwell, resulting in one of the largest and most sophisticated collections of the artist's work in the world. Along with the Motherwell collection, the Museum has begun collecting a number of artists in depth over the past ten years, with developing bodies of work by Philip Guston, Anselm Kiefer, Agnes Martin, Susan Rothenberg, and Sean Scully.

Recognizing that the collection should be international in scope, the Museum has made a number of significant acquisitions in the area of European Pop art. These include Raymond Hains's *SEITA*, 1966–67; Alain Jacquet's *Camouflage Botticelli (Birth of Venus)*, 1963–64; and Gerhard Richter's *Ferrari*, 1964. The Museum has acquired works by other Europeans, including Stephan Balkenhol, Georg Baselitz, Sophie Calle, Howard Hodgkin, Ron Mueck, and Michelangelo Pistoletto. The Pop collection has been broadened and diversified by the addition of works by two Californians: Jess's *Montana Xibalba: Translation #2*, 1963 and Vija Celmins's *German Plane*, 1966. Minimalism has been significantly addressed with the recent acquisition of Carl Andre's *Tau and Threshold (Element Series)*, 1971 and *Slit*, 1981; Dan Flavin's seminal *Diagonal of May 25, 1963*, 1963; Sol LeWitt's *Wall Drawing #302*, 1976; Richard Long's *Cornwall Summer Circle*, 1995; Agnes Martin's *Untitled*, 1977 and *Untitled XVI*, 1996; Richard Serra's *Right Angle Corner Prop with Pole*, 1969; and Jackie Winsor's *Green Piece*, 1976–77. In almost every case, these were the first works by the artists to enter the collection.

Over the past five years the Museum has begun to address the critical issue of photography, particularly as it has affected contemporary art after 1960, when that medium became an integral part of the fabric of the avant-garde. Previously, the Museum had been able to define photography as a specialized field with an aesthetic agenda, separate from contemporary art in general. However, photographic practice, along with video and digital imagery, has come to dominate the vocabulary of many of our artists. The Museum has recently acquired works by Bernd and Hilla Becher, Thomas Joshua Cooper, Barbara Ess, Hamish Fulton, Gilbert & George, Sally Mann, Richard Misrach, Yasumasa Morimura, Bruce Nauman, Richard Prince, Gerhard Richter, Thomas Ruff, Cindy Sherman, Thomas Struth, Hiroshi Sugimoto, and Bill Viola.

Like our predecessors, we see these acquisitions of the past decade as key elements in a large puzzle that is the art of our time, and of course we hope they will

resonate meaning beyond this moment, understanding full well George Eliot's admonition that "Among all forms of mistake, prophecy is the most gratuitous."[14] We flatter ourselves if we believe that we are better talent scouts than those who came before us, when we know that museum collections are complex, organic entities that attempt to represent the history of art while reflecting the tastes and ideas of each generation of board, director, and curator. Under the leadership of Alfred H. Barr, Jr., The Museum of Modern Art in New York amassed what is arguably one of the most important collections of twentieth-century art in the world. Yet Barr was the first to admit that his basement was full of missed opportunities. Barr thought that if a museum's "failure" rate was ninety percent, the museum should consider itself satisfied. To what extent we have succeeded or failed, it is too early to judge. This will be the job of another generation.

This publication is designed to supplement a visitor's experience of the Modern Art Museum's collection, as both a reference guide—that in many cases offers the artist's own voice—and a curatorial interpretation in the form of prose commentaries that discuss such issues as subject matter, the relationship of a given work to others by the artist, important aspects of the work's history or physical condition, and any other significant information uncovered. In undertaking work on this project several years ago, we set for ourselves the difficult, dualistic goal of producing a book that serves the needs of artists, art historians, and other specialists, and is useful and interesting for non-specialists. While it is our hope that these essays will offer a doorway for the specialist and the layperson into each work and its role in the field of contemporary art, the best advice we can offer is to reiterate Warhol's simple declaration: "Look at the pictures."

Michael Auping, Chief Curator

1 Quoted in Andy Warhol, Kasper König, Pontus Hultén, and Olle Granath, eds., *Andy Warhol* (Stockholm: Moderna Museet, 1968).

2 James Elliott, whom I worked with at the University Art Museum, Berkeley, and Henry Geldzahler, whom I came to know through Francesco Clemente, both used to mimic Warhol's response to art not of his time.

3 Linda Nochlin, "Museums and Radicals: A History of Emergencies," *Art in America* 59 (July–August 1971): 32–33.

4 F. T. Marinetti in "The Foundation and Manifesto of Futurism," 1908, in H. B. Chipp, ed., *Theories of Modern Art: A Source Book by Artists and Critics* (Berkeley and Los Angeles: University of California Press, 1969): 287.

5 Robert Smithson, "The Spiral Jetty," in Nancy Holt, ed., *The Writings of Robert Smithson* (New York: New York University Press, 1979): 112.

6 Robert Mangold in conversation with the author, 18 August 1988.

7 Cathleen McGuigan and Peter Plagens, "State of the Art," *Newsweek* (26 March 2001): 56.

8 Frank Stella, "Mindless play and thoughtless speculation," *The Art Newspaper* 114 (May 2001): 62.

9 Michael Kimmelman quoted in "Tate Modern: An astonishing achievement—but," *The Art Newspaper* 104 (June 2000): 15.

10 Arthur C. Danto, "American Realities," *Artforum* 37 (January 1998): 92.

11 Jerry Flemmons, *More Texas Siftings* (Fort Worth: Texas Christian University Press, 1997): 7.

12 Jerry Flemmons, *Texas Siftings* (Fort Worth: Texas Christian University Press, 1995): 97.

13 In 1990 *Swimming* (also commonly known as *The Swimming Hole*) was deaccessioned by the Modern Art Museum and acquired by the Amon Carter Museum. For a superb study of the subject matter of *Swimming* and the controversy that has surrounded it, see Doreen Bolger and Sarah Cash, eds., *Thomas Eakins and the Swimming Picture* (Fort Worth: Amon Carter Museum, 1996).

14 *Middlemarch*, 1871–72, bk. 1, ch. 10.

JOSEF ALBERS	ADOLPH GOTTLIEB	PABLO PICASSO	CY TWOMBLY
CARL ANDRE	NANCY GRAVES	MICHELANGELO PISTOLETTO	JACQUES VILLEGLÉ
MILTON AVERY	RED GROOMS	SYLVIA PLIMACK MANGOLD	BILL VIOLA
STEPHAN BALKENHOL	PHILIP GUSTON	JACKSON POLLOCK	ANDY WARHOL
GEORG BASELITZ	RAYMOND HAINS	RICHARD PRINCE	CARRIE MAE WEEMS
DAVID BATES	JOSEPH HAVEL	MARTIN PURYEAR	WILLIAM WEGMAN
WILLIAM BAZIOTES	HOWARD HODGKIN	ROBERT RAUSCHENBERG	WILLIAM T. WILEY
BERND & HILLA BECHER	HANS HOFMANN	AD REINHARDT	JACKIE WINSOR
ROBERT BECHTLE	ROBERT IRWIN	GERHARD RICHTER	
LARRY BELL	ALAIN JACQUET	LINDA RIDGWAY	
LYNDA BENGLIS	JESS	SUSAN ROTHENBERG	
ED BLACKBURN	DONALD JUDD	MARK ROTHKO	
DENNIS BLAGG	CRAIG KAUFFMAN	THOMAS RUFF	
JONATHAN BOROFSKY	ELLSWORTH KELLY	EDWARD RUSCHA	
JULIE BOZZI	ANSELM KIEFER	LUCAS SAMARAS	
SOPHIE CALLE	SOL LEWITT	KURT SCHWITTERS	
ANTHONY CARO	ROY LICHTENSTEIN	SEAN SCULLY	
VIJA CELMINS	RICHARD LONG	GEORGE SEGAL	
JOHN CHAMBERLAIN	MORRIS LOUIS	RICHARD SERRA	
CHUCK CLOSE	SALLY MANN	ANDRES SERRANO	
CLYDE CONNELL	BRICE MARDEN	BEN SHAHN	
THOMAS JOSHUA COOPER	AGNES MARTIN	CINDY SHERMAN	
JOSEPH CORNELL	MELISSA MILLER	MICHAEL SINGER	
TONY CRAGG	RICHARD MISRACH	LEON POLK SMITH	
RICHARD DIEBENKORN	TATSUO MIYAJIMA	NICOLAS DE STAËL	
JIM DINE	HENRY MOORE	ANN STAUTBERG	
BARBARA ESS	YASUMASA MORIMURA	FRANK STELLA	
LYONEL FEININGER	ROBERT MOTHERWELL	CLYFFORD STILL	
VERNON FISHER	RON MUECK	THOMAS STRUTH	
DAN FLAVIN	VIK MUNIZ	HIROSHI SUGIMOTO	
FORT WORTH CIRCLE	BRUCE NAUMAN	DONALD SULTAN	
SAM FRANCIS	NIC NICOSIA	JAMES SURLS	
HAMISH FULTON	CLAES OLDENBURG	ERICK SWENSON	
GILBERT & GEORGE	TONY OURSLER	MARK TANSEY	

A
B
C
D
E
F
G
H
I
J
K
L
M
N
O
P
Q
R
S
T
U
V
W
X
Y
Z

artists whose names appear in gray have an extended commentary in the plate section

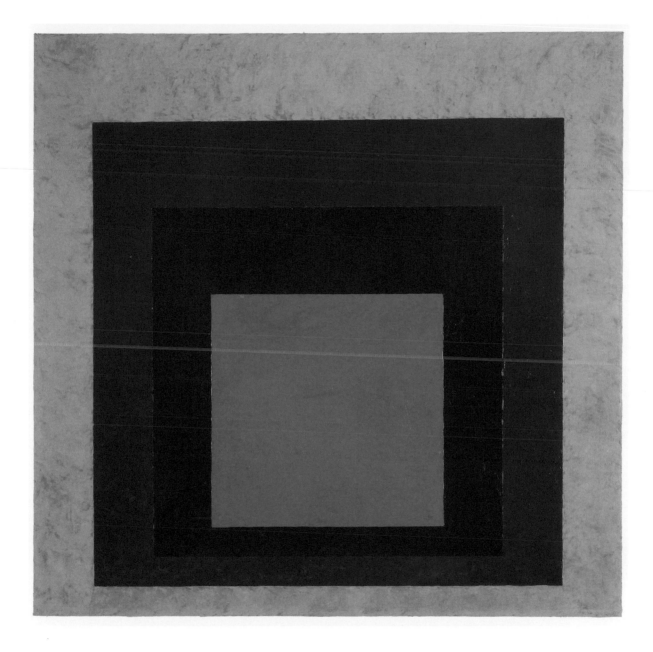

Josef Albers
Homage to the Square (La Tehuana), 1951
Oil on fiberboard
30³/₄ × 30³/₄ inches (78.1 × 78.1 cm)
Commentary on page 205

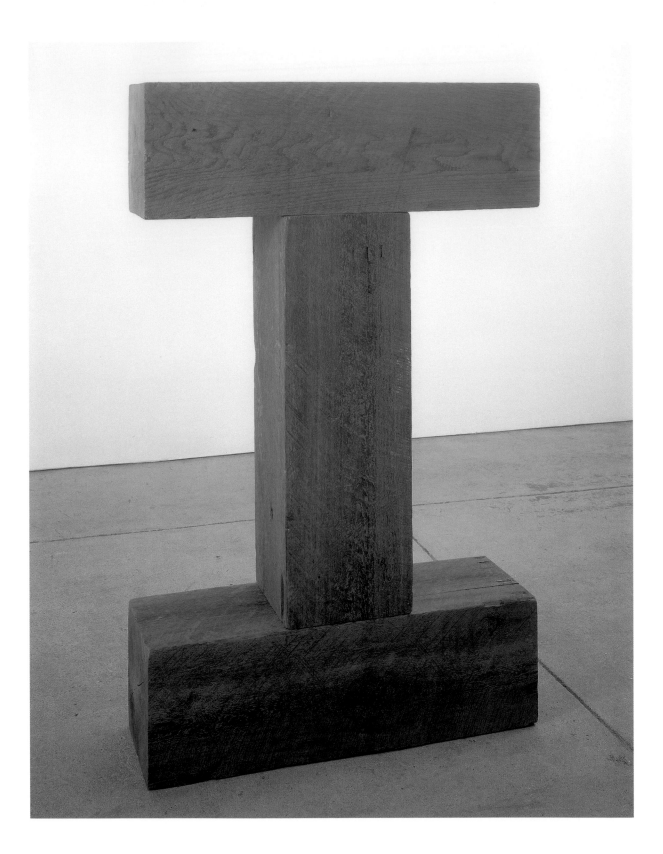

Carl Andre
Tau and Threshold (Element Series), 1971
Western red cedar
60 × 36 × 12 inches (152.4 × 91.4 × 30.5 cm)
Commentary on page 206

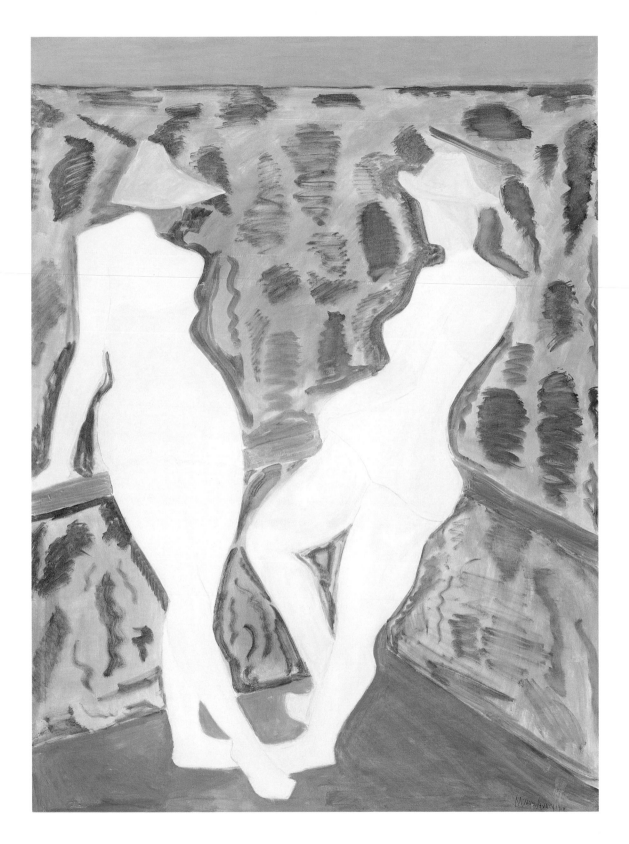

Milton Avery
Two Figures, 1960
Oil on canvas
72 × 52 inches (182.9 × 132.1 cm)
Commentary on page 207

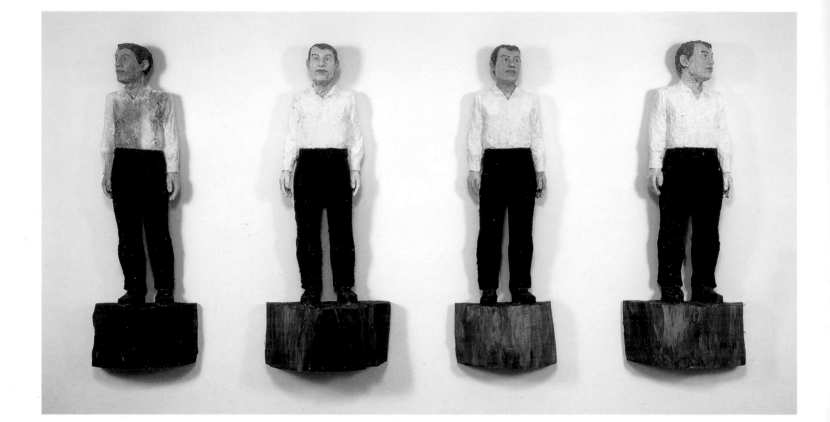

Stephan Balkenhol
4 Figures, 2000
Painted wood
Four figures, each 65 × 19 × 14 inches
(165.1 × 48.3 × 35.6 cm)
Commentary on page 208

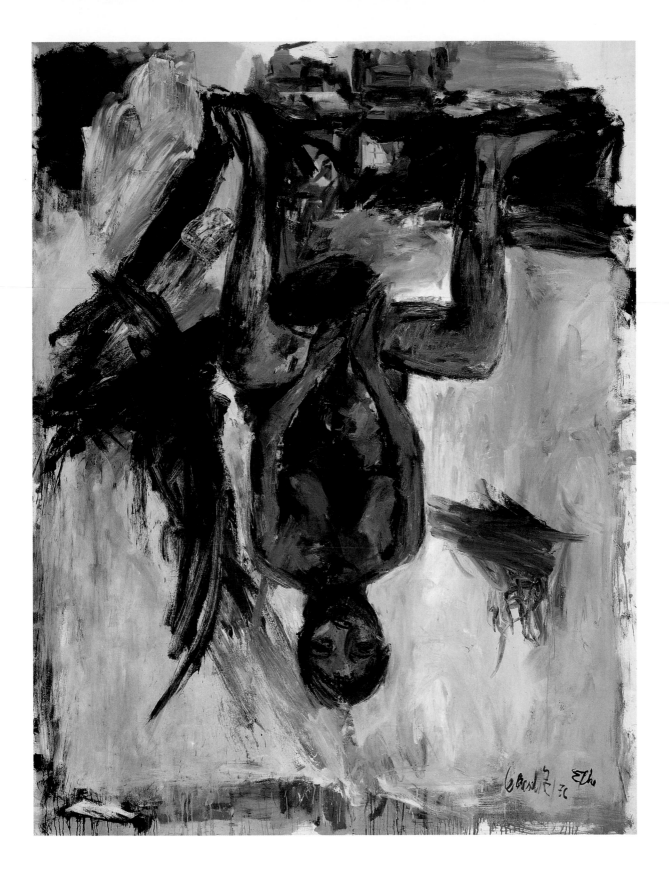

Georg Baselitz
Elke, 1976
Oil on canvas
98 1/2 × 75 inches (250.2 × 190.5 cm)
Commentary on page 209

David Bates
Night Heron, 1986–87
Oil on canvas
96 × 78 inches (243.8 × 198.1 cm)
Commentary on page 211

B

William Baziotes
Sea Phantoms, 1952
Oil on canvas
40¹/₄ × 60 inches (102.2 × 152.4 cm)
Commentary on page 211

25

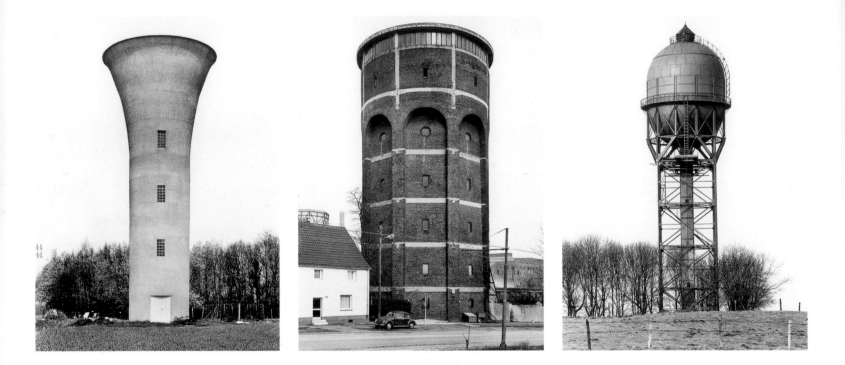

Bernd & Hilla Becher

Maisoncelles, Seine-Marne, France, 1972
Gelatin silver print, edition 4/5
24 × 20 inches (61 × 50.8 cm)

Bochum, Germany, 1980, 1992
Gelatin silver print
24 × 20 inches (61 × 50.8 cm)

*Water Tower, Dortmund-Grevel,
Germany,* 1965/printed 1993
Gelatin silver print, edition 1/5
24 × 20 inches (61 × 50.8 cm)

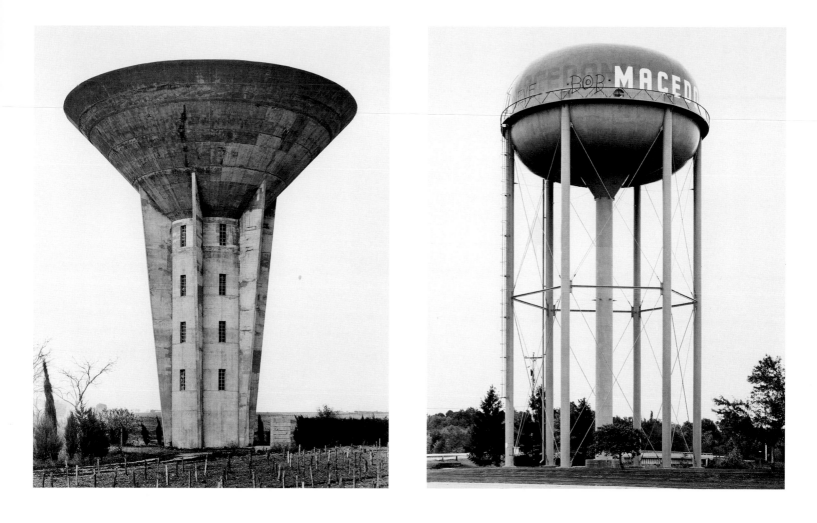

Béziers, Hérault, France, 1984
Gelatin silver print
24 × 20 inches (61 × 50.8 cm)

Water Tower, Macedonia, Ohio, USA, 1982
Gelatin silver print
24 × 20 inches (61 × 50.8 cm)

Commentary on page 212

27

Robert Bechtle
'63 Bel Air, 1973
Oil on canvas
48 × 69 inches (121.9 × 175.3 cm)
Commentary on page 214

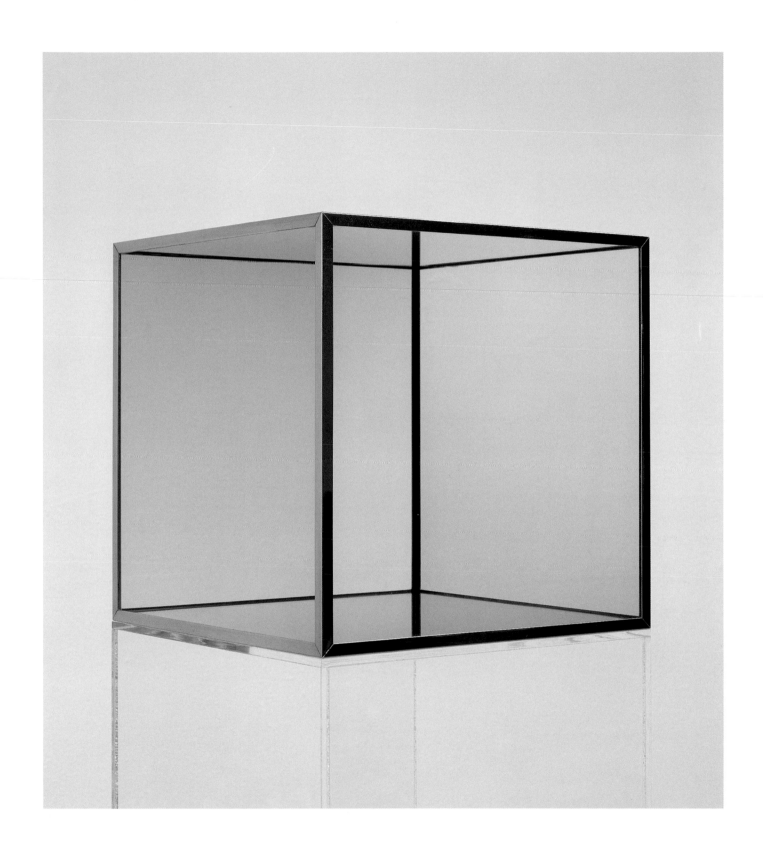

Larry Bell
Untitled from *Terminal Series*, 1968
Glass and chrome
$12\,^1/_8 \times 12\,^1/_8 \times 12\,^1/_4$ inches
$(30.8 \times 30.8 \times 31.1$ cm$)$
Commentary on page 215

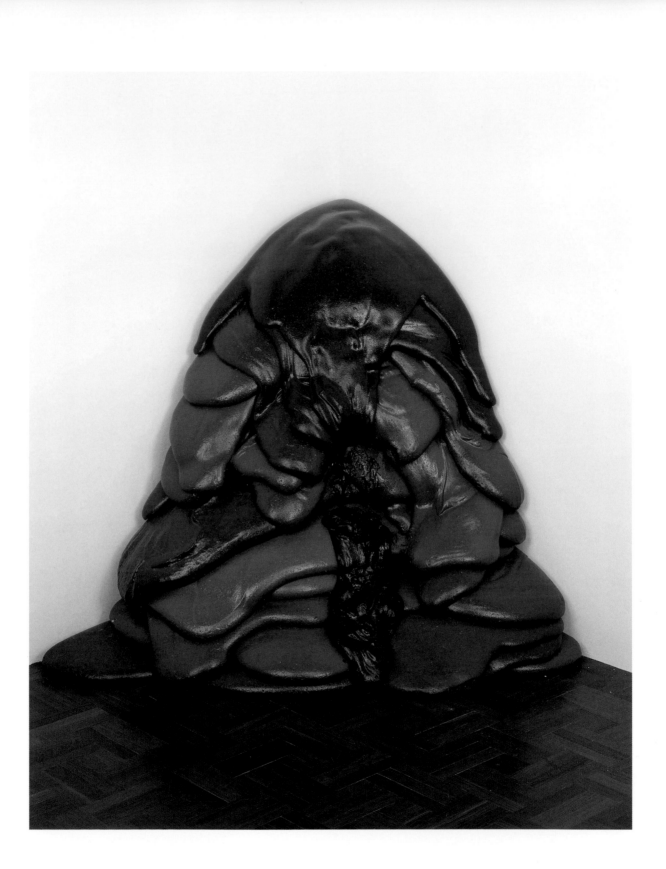

Lynda Benglis
For Carl Andre, 1970
Acrylic foam
56 1/4 × 53 1/2 × 46 3/16 inches
(142.9 × 135.9 × 117.3 cm)
Commentary on page 216

Ed Blackburn
Hoppy Serves a Writ, 1982
Acrylic on canvas
61⁷/₈ × 83³/₄ inches (157.2 × 212.7 cm)
Commentary on page 217

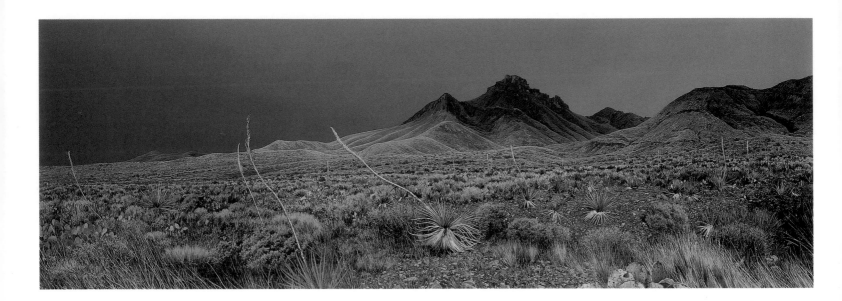

Dennis Blagg
Passover, 1997
Oil on canvas
44 × 121⁷/₈ inches
(111.8 × 309.6 cm)
Commentary on page 218

facing page:
Jonathan Borofsky
*Self-Portrait with Big Ears
(Learning to be Free)*, 1980/1994
Latex on wall, dimensions variable
Commentary on page 219

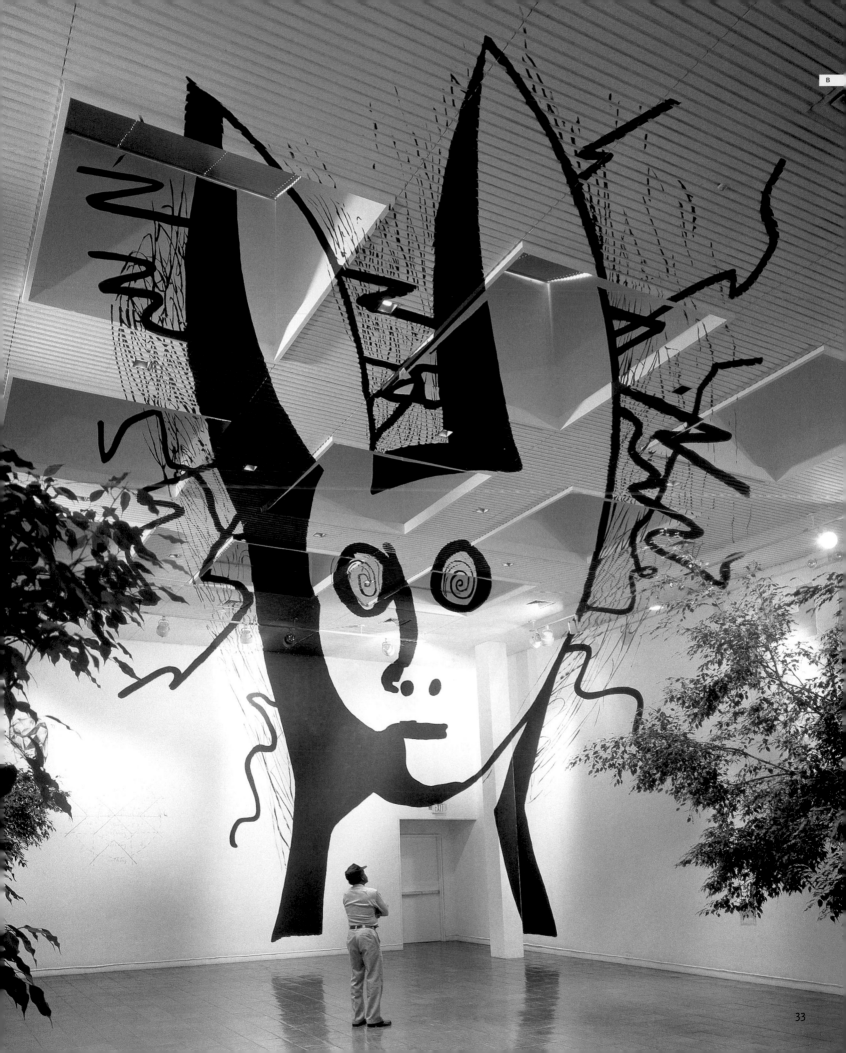

Julie Bozzi
Embankment—Air Base, 2000
Oil on linen
4 × 10 inches (10.2 × 25.4 cm)
Commentary on page 220

34

«The man I live with is the most beautiful thing I know. Even though he could be a few inches taller. I've never come across absolute perfection. I prefer well-built men. It's a question of size and shape. Facial features don't mean much to me. What pleases me aesthetically is a man's body, slim and muscular.»

Sophie Calle
The Blind #19, 1986
Color photograph, black-and-white
photograph, text, and wooden shelf
Overall 47 1/4 × 51 3/4 inches
(120 × 131.4 cm)
Commentary on page 221

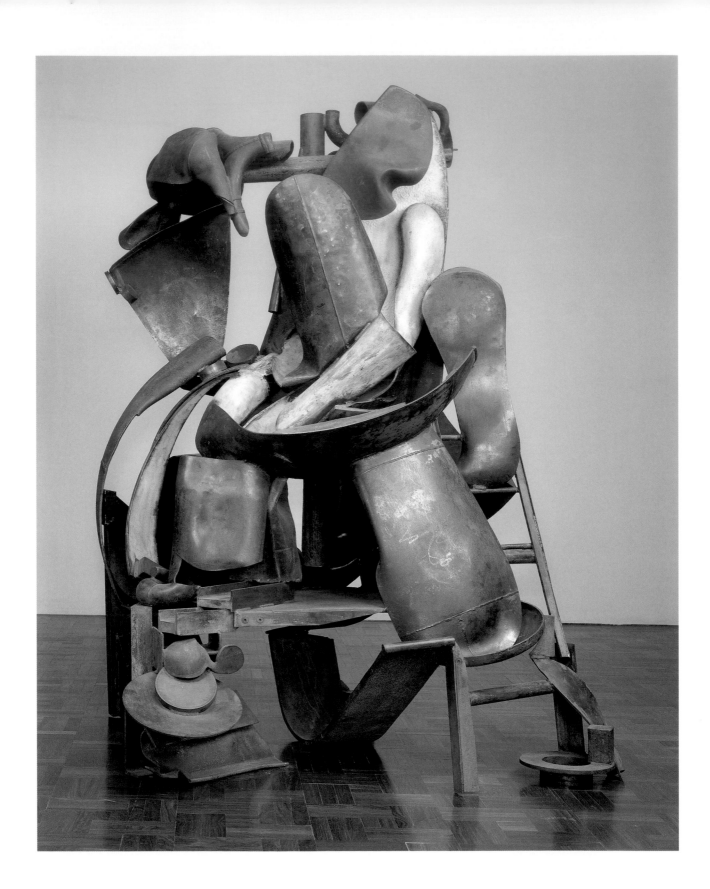

Anthony Caro
The Descent from the Cross
(after Rubens), 1987–88
Steel, rusted and waxed
96 × 73 × 63 inches (243.8 × 185.4 × 160 cm)
Commentary on page 222

36

Vija Celmins

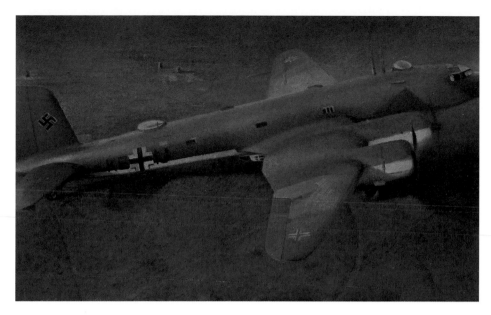

The Modern Art Museum's collection includes three key works by Vija Celmins, each of which reflects her acute sensitivity to adjustments in space, scale, and color. In the early 1960s Celmins focused on creating imagery of common domestic items, including pencils, erasers, combs, heaters, and lamps, approaching them with a style reminiscent of Edward Hopper's approach to people. As the decade progressed, Celmins broadened her range of subject matter to incorporate other objects, such as cars and airplanes, and elements from the landscape, which, like her early work, she rendered with deadpan realism.

Whether depicting objects or landscape, Celmins works from photographs and photographic reproductions. Her artistic process involves masking out a desired area within a photograph and then replicating what she has framed using a restricted gray-scale palette similar to that of actual black-and-white photographs. By isolating part of an image for reproduction, Celmins displaces her subject from its context, severing the source from its original meaning.

In an interview conducted by her longtime friend Chuck Close, whom Celmins met in 1961 at Yale Summer Art School and who also creates photo-based paintings, Celmins discusses why she works from photographs:

> The photo is an alternate subject, another layer that creates distance. And distance creates the opportunity to view the work more slowly and to explore your relationship to it. I treat the photograph as an object, an object to scan…. In a way, the photograph helps unite the object with the two-dimensional [canvas] plane. Although I think that with the airplanes there is this kind of wonderful place [in the pictorial space] where they really float, and then they become dimensional, and they take off as well as stay flat….the subject matter has a kind of internal tension.[1]

German Plane, 1966 contains the internal tension that Celmins describes. The painting was created at a time when she was making small grisaille works with imagery culled from magazines, many of which included warplanes and photojournalistic events such as car accidents. The World War II bomber seen in *German Plane* is taken from a photograph Celmins found at a second-hand store in Los Angeles. She shows the menacing warplane, capturing its powerful presence and physicality just as a camera would do—in a close-cropped, scaled-down format. This image, like much of the artist's work, involves a number of subtle ambiguities.

Despite the fearsome bomber that takes up most of the picture plane, the work possesses an eerily calm atmosphere. Celmins shows the top of the plane from a bird's-eye view, and the landing gear is down, as if it is descending, or has just taken off. The engine propellers, however, appear to be slowly whirring, rather than blurred to indicate maximum speed, and the plane's shadow is visible on the ground below. These signs indicate that the plane is on or near the ground, but the landscape in the background is diminished, even generalized to the point of abstraction.

In her interview with Close, Celmins explains that she strives for neutrality in images like *German Plane*. In fact, her desire for neutrality is one reason she uses photographs and magazine reproductions, attempting to mimic their perceived intrinsic objective quality. The limited gray-scale palette is yet another effort to strip down the painting to its essentials, and make a dispassionate image. Celmins's approach to this particular subject is perhaps an attempt not only to create neutrality, but to actually neutralize it. During World War II, her family fled their home in Riga, Latvia, for Germany and then the United States, settling in Indiana in 1949. Of her upbringing, Celmins has said, "I think of my childhood as being full of excitement and magic, and terror too—bombs, fires, fear, escape—very eventful. It wasn't until I was ten years old and living in the United States that I realized living in fear wasn't normal."[2] In light of this, the objective quality of *German Plane* could be her attempt to distance herself from, or even engage with, the warplane. In either case, Celmins uses a straightforward approach.

Painted in the mid-1960s, *German Plane*, like much of Celmins's work, shares affinities with aspects of the Pop art movement, which flourished during that decade. Like many of the Pop artists, she often singled out everyday objects, generally taken from photographic reproductions and advertisements. However, her style and treatment of the subject matter distinguishes her work from theirs. Unlike the Pop artists' colorful tongue-in-cheek images and objects, Celmins's work is sober, evoking a darker side of the movement.

In terms of American Pop, Celmins's work is highly graphic, like that of one of her contemporaries also working on the West Coast, Ed Ruscha. Her imagery perhaps also correlates with a specific body of work by Andy Warhol: his early 1960s death and disaster pictures, which comprise serial silk-screened images on canvas with subjects such as electric chairs, car crashes, and First Lady Jacqueline Kennedy at President Kennedy's funeral. Through repetition, Warhol created detached images of adversity that comment on the way the media changes our perception of real events. Many of Celmins's images, such as *German Plane*, impart a similar bleak sensibility.

Shortly after creating *German Plane*, Celmins took a nearly ten-year reprieve from painting, and it was during these years that she created *Untitled*, 1970. With her landscapes, she moved away from objects with cultural attachments to depict universal subject matter. Using pencil and paper, Celmins began depicting the oceans, deserts, lunar floors, and skies. As in her painting of the ominous German bomber, with *Untitled*, Celmins conveys a vast subject within the small, controlled space of a flat sheet of paper.

Untitled, like most of her works of this time, has to do with Celmins's interest in making individual graphite marks on paper that eventually form a whole picture, which she refers to as "broken-surface" images. Using single, organized lines, Celmins methodically and gradually commands the white space, resulting in a unified and highly representational depiction of the ocean. The graphite marks, however, can be read separately, or in small series, so that they look like abstract patterns. Thus, on one hand, the ocean's waves and crests are identifiable; but on the other, the series of graphite lines and marks can look entirely nonrepresentational. This drift between realism and abstraction extends to other dichotomies. The isolated view, with no horizon line or central focus, tests the boundaries of part/whole, static/motion, figure/ground, painting/photography, and reality/representation.

Her work *Night Sky #17*, 2000–01 has a similar impact. It is a generic clip from yet another infinite subject, the sky, in an intimate format. Celmins smoothed out the raw canvas tooth by using a thick layer of gesso and then sanding it to make

Untitled, 1970
Pencil and acrylic on paper
12³/₄ × 17¹/₂ inches (32.4 × 44.5 cm)

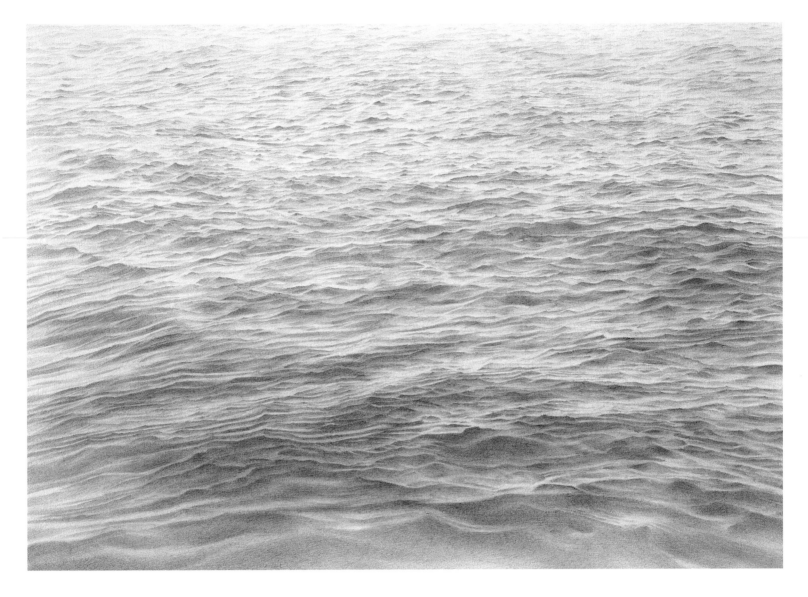

the surface even. Next she applied a matte gray pigment, dabbing it sporadically with white to indicate the stars. The picture takes on the quality of a distant satellite view, but the subtle bursts of white scattered throughout the canvas have the distinct quality of actual light. This artistic process helps Celmins create an image that is at once dull and luminous. In this sense, for the artist, painting the night sky is an exploration of the relationship between her material, how to treat its surface, and her content.

Night Sky #17 and *Untitled* especially connect to another of Celmins's contemporaries, the American artist Agnes Martin. Both artists work

obsessively to convey nature with abstract marks and gestures and a minimal color palette. While Celmins's work is representational, but potentially verges on abstraction, Martin's pictures are completely nonrepresentational, reduced to penciled-in irregular lines on canvas and faintly colored squares and rectangles. Although they represent nature differently, Martin's and Celmins's landscapes present viewers with a similar contemplative image.

Celmins's style and subjects also draw on a number of past artists and movements. Like her work, seventeenth-century Dutch still-life paintings have an illusionary, lucid quality, yet

Night Sky #17, 2000–01
Oil on linen, mounted on wood
31 × 38 inches (78.7 × 96.5 cm)

Celmins's pictures are otherworldly, linking to Surrealist artists, such as René Magritte. Magritte and the Surrealists often juxtaposed incongruent objects to make them enigmatic and fantastic. Like Magritte, Celmins often focuses on the issue of reality (or unreality) and distorts space and scale. Perhaps key in shaping her artistic style,

however, is Celmins's childhood exposure to diverse cultures and locales, which affected her outlook, especially in relation to history, memory, and sight.

ANDREA KARNES

1 For an insightful dialogue between Celmins and Close, with descriptions of Celmins's artistic concerns in her own words, see Chuck Close, *Vija Celmins*, ed. William S. Bartman (New York: A.R.T. Press, 1992). The quote appears on page 12.
2 Ibid., 20.

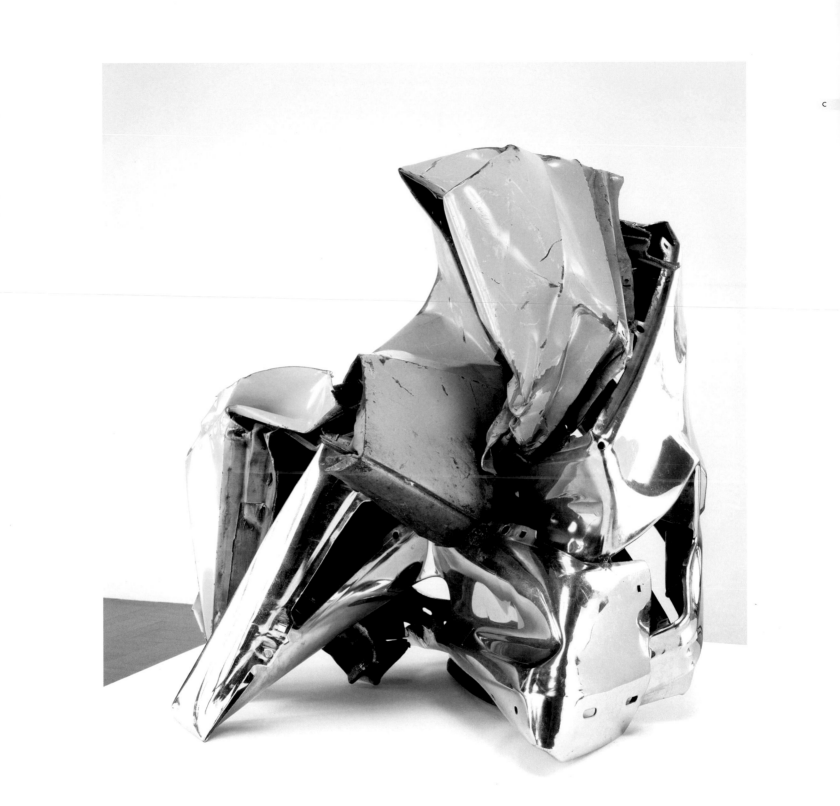

John Chamberlain
Scull's Angel, 1974
Welded painted steel
29 × 45 × 38 inches (73.7 × 114.3 × 96.5 cm)
Commentary on page 224

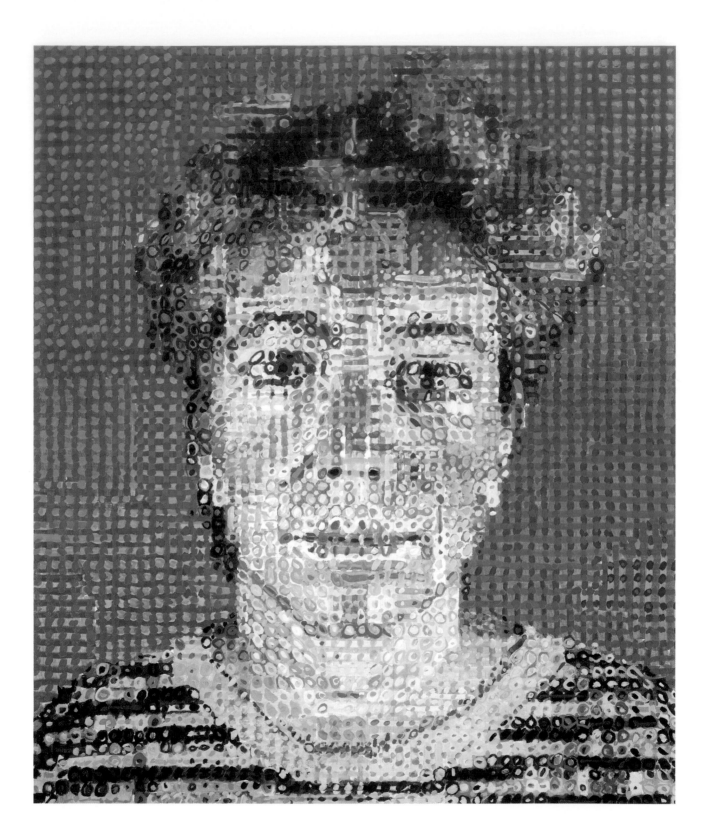

Chuck Close
Judy, 1989–90
Oil on canvas
72 × 60 inches (182.9 × 152.4 cm)
Commentary on page 225

42

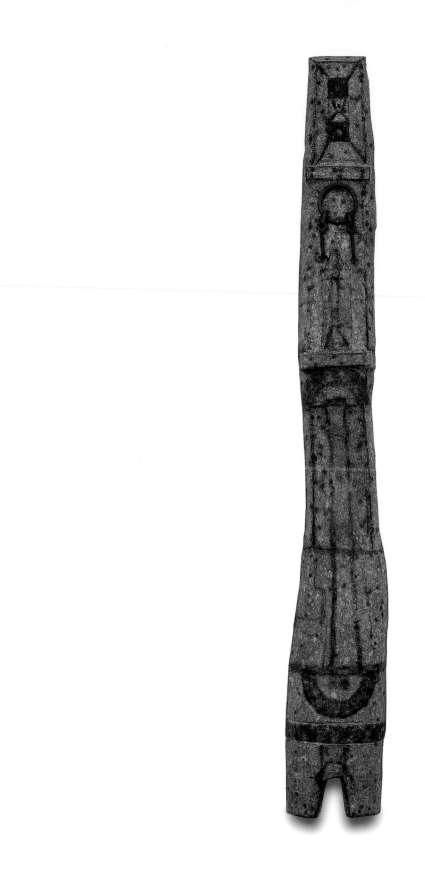

Clyde Connell
Guardian No. 4, 1988
Redwood, paper, glue, and metal
91 × 12 $^1/_4$ × 3 $^1/_2$ inches (231.1 × 31.1 × 8.9 cm)
Commentary on page 226

Thomas Joshua Cooper

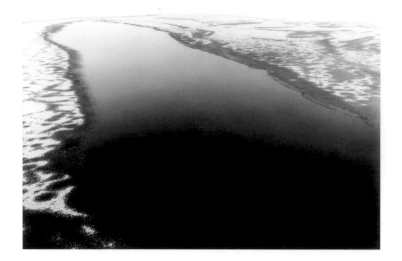

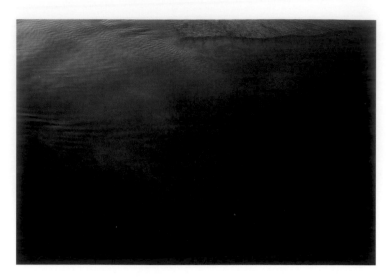

For more than ten years, Thomas Joshua Cooper has considered and studied Ferdinand Magellan and his great voyage of global circumnavigation. "I try," Cooper has said, "not to take the meaning, consequences, and possibilities of his global quest for granted."[1] Carrying a heavy, 100-year-old camera, Cooper has circumnavigated the globe more than once, devoting himself to a series of extended photographic projects. For Cooper, Magellan's accomplishments offer a starting point of creative rediscovery.

A significant part of Cooper's quest throughout the past decade has involved exploring the great rivers of the world, from their source to the sea. Of these, the most ambitious has been his *Rio Grande River Crossings*. For seven years, the artist has traveled thousands of miles up and down its 2,000-mile course, from its headwaters in Colorado to its mouth in the Gulf of Mexico. The result has been a modest sixty-four photographs that distill Cooper's experiences as he attempts "to find the pulse and deep history of the great river." The Modern Art Museum's collection contains all sixty-four images, a testament to the alluring presence of this natural force in the state of Texas, as well as Cooper's unique way of revealing it.

The relationship between Cooper's work and that of the great pioneers of American landscape photography is both obvious and subtle. The artist's admiration for the photographs of Timothy O'Sullivan is acknowledged in a number of his titles. He is a perpetual student of the history of photography and admires those who first documented their travels through the American West. His appreciation of O'Sullivan's work, however, is coupled with an even stronger passion for the abstract paintings of Mark Rothko, Ad Reinhardt, and Agnes Martin. Although such influences may seem incongruous, they are critical to a full understanding of Cooper's vision, whose ambition is not so much one of documentation as it is one of spiritual encounter.

Born in California, a member of the Cherokee Nation, Cooper lived on various western reservations as a young man, eventually graduating with a degree in photographic arts from the University of New Mexico. Since 1973 he has been Professor of Photography at the Glasgow School of Art, University of Glasgow in Scotland. Cooper's experience as part Native American plays a central role in his approach to what he calls "the imagination of place": "As a young man I suppose I was as irreverent and cynical as most, but I had some experiences with sacred sites that scared the hell out of me."

Cooper describes his photographs as "recognitions," the result of sensing the

Snow Storm Life Line I, Rio Grande River Crossing at the Source of the Rio Grande, Mineral County, Colorado, 1995, 1995
Framed silver gelatin print, selenium and gold chloride toned, edition 1/3
30¹/₄ × 38¹/₂ inches (76.8 × 97.8 cm)

Snow Storm Life Line II, The Rio Grande— Looking North, Bridge Street, Albuquerque, New Mexico, 1995, 1995
Framed silver gelatin print, selenium and gold chloride toned, edition 1/3
30¹/₄ × 38¹/₂ inches (76.8 × 97.8 cm)

Boca Chica (Little Mouth), The Mouth of the Rio Grande at the Gulf of Mexico, Texas, Mexico Border, 1996–97, 1996–97

Framed silver gelatin print, selenium and gold chloride toned, edition 2/3
31 × 39 inches (78.7 × 99 cm)

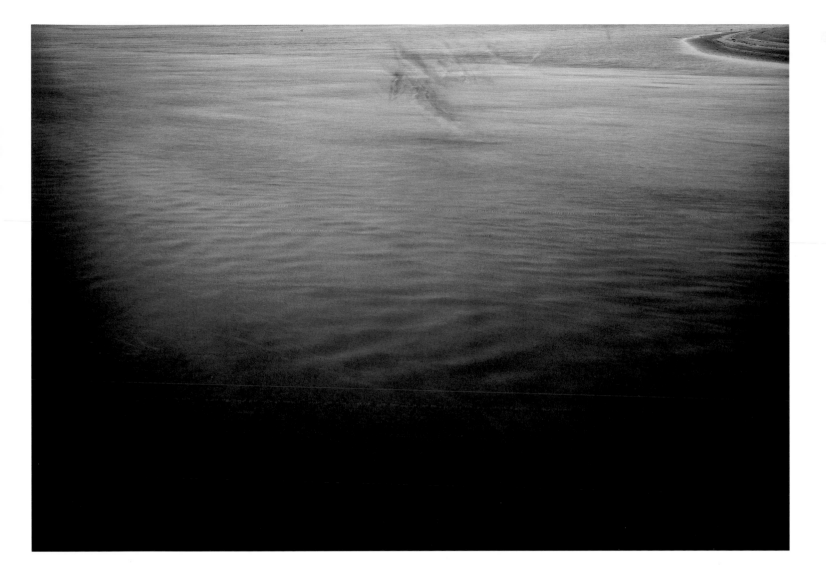

underlying, possibly even sentient, qualities of place: "I spend a lot of time just looking and walking and waiting for the land and its knowledge to reveal itself." Cooper's ruminative approach is reflected in his sensitivity to minimal details and abstract qualities of landscape. The resulting images are a cross between reverie and eccentric realism. Three of the earliest works in the series establish the psychological and formal variations the artist balances throughout much of his work. *Snow Storm Life Line I*, 1995 captures the artist's first encounter with the river's source in Mineral County, Colorado. The artist describes the context for the encounter:

As I went north toward the source, I ran into a massive snowstorm. So it took me a while to get there. I was very charged up. Of course, the source of many rivers is undramatic in the picturesque sense—a hole in the ground with varying amounts of water coming out. It is more about being at the actual source that is powerful, a feeling or an energy. It was cold and there was snow on the ground. It seemed desolate and lonely in a powerful kind of way. I just tried to capture that.

The image Cooper chose to represent that moment is a view from downstream looking north just thirty yards to the source, where the

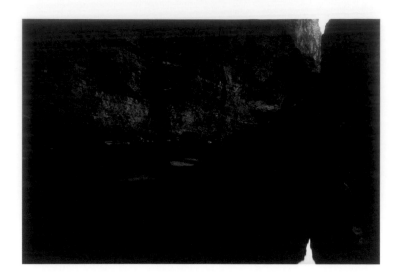 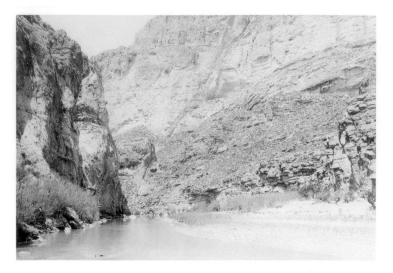

river shrinks to a point high in the photograph. Spreading out from its modest source toward the lens of the camera, the river suggests a tranquil building of power. Surrounded by snow-covered banks, the predominant tone of the image is white, a suggestion of the water opening out and beginning its journey.

The companion image to the work is almost black. Taken further downriver in New Mexico, *Snow Storm Life Line II*, 1995 is a nearly abstract study in a deep charcoal tone, beginning in the lower right-hand section of the photograph and moving north to the upper register of the image to a slightly lighter dark gray, where subtle ripples on the water's surface are apparent. As with many of Cooper's images, no horizon is presented, a strategy adopted by the artist so that the viewer cannot objectify the scene, but is directly confronted by the richness of the water and the earth itself.

More than a year later, Cooper photographed the mouth of the river in soft tones of gray. *Boca Chica (Little Mouth)*, 1996–97, taken at the Gulf of Mexico on the Texas-Mexico border, depicts a hazy gray surface of gently undulating water. In the upper section of the photograph, this gentle gray space is disturbed by a blurred gesture, which captures the movement of birds across the viewfinder. The resulting image resembles a

graphite drawing as much as it does a photograph. "I like to work with a very basic technology so that I can create a sense of touch in my images," Cooper has said. He carries with him a bulky 1869 camera that makes five-by-seven-inch negatives. He searches an area, sometimes for hours, for a point from which to shoot. Then he exposes one negative, usually very slowly, from thirty seconds to as much as one and a half hours. Prior to printing, each image is subtly underpainted with tones of selenium and gold, a painterly process that creates rich and deeply resonate surfaces.

In the diptych *Last Light—Brightest Light*, 1996 the artist depicts the river running through a canyon at two different times of day. In *Brightest Light*, the water and canyon walls have a translucent clarity that is the result of a white-gold light that seems to be emanating from inside the water and rock. In its opposite, *Last Light*, Cooper's chemical painterliness evokes a dreamlike blackness in which the canyon walls suggest strange, facelike apparitions.

The artist's attraction to creating dark and light oppositional forces is also evident in the powerful diptych *A Premonitional Work*, which depicts two views of the south rim of Canyon del Muerto, in Navajo Tribal Territory, Arizona. Many miles from the river itself, this Navajo site was the furthest point "the river still remained in my thoughts as

Last Light—Brightest Light (Message to Robert Adams) The Rio Grande Entering St. Elena Canyon, The Big Bend, Texas, 1996–97, 1996–97
Framed silver gelatin print, selenium and gold chloride toned, edition of 3, AP2
30¹/₄ × 38¹/₂ inches (76.8 × 97.8 cm)

Last Light—Brightest Light (Message to Robert Adams) The Rio Grande Leaving Boquillas Canyon, The Big Bend, Texas, 1996–97, 1996–97
Framed silver gelatin print, selenium and gold chloride toned, edition of 3, AP2
30¹/₄ × 38¹/₂ inches (76.8 × 97.8 cm)

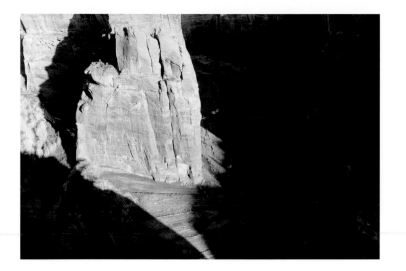 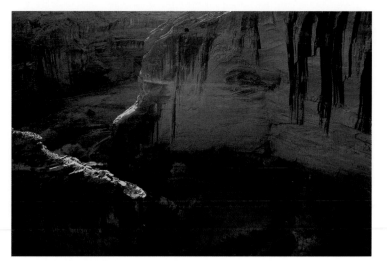

I traveled," and was a point of contact between the ancient Anasazi, who developed around the Rio Grande, and a later, expanding Navajo nation. Here darkness, bright light, and subtle grays create areas of dramatic tension that bring the vast space, both psychological and perceptual, of this ancient canyon dwelling to life. The artist has employed the term "premonitional" in a number of his photographs as a means of giving the viewer license, as it were, to open the image up to interpretation, as a mysterious moving force. "When I take a photograph," Cooper has said, "it's because I feel something is about to happen or that there is something happening around me that has a tangible, spiritual presence…I'm very patient, but I only make one take. If what I'm feeling at the moment reveals itself within the exposure time, it's great. If it doesn't, I move on. It's not about capturing something static. It's about finding the energy and movement in the place."

Approaching the Rio Grande as "the Nile of the Southwest," Cooper envisions the great river as both a living place and a powerful symbol of time and creative forces. Since antiquity, rivers have been portrayed as "bodies" of water, their flow analogous to blood circulating through a body; to understand this circulation was to be closer to an understanding of the circular nature of life and

time.[2] For Cooper, the river is a means of being swept into a current of living forces and deep memories. An international boundary and a source of vital irrigation, the Rio Grande is now a modern event, siphoned by farmers and enjoyed by boaters, fishermen, and campers. It is a place of modern recreation. For Cooper, however, the water runs deeper. "It is still possible," he says, "to find the river our ancestors knew. You just need to know where to go and wait, and it will make itself felt."

MICHAEL AUPING

from *The Great River, Rio Grande River Crossings, The Source to the Sea: A Premonitional Work, (Message to Timothy H. O'Sullivan), Antelope Ruins, Canyon del Muerto, (Navajo Tribal Territory), Arizona, U.S.A.*, 1994–95
Framed silver gelatin prints, selenium and gold chloride toned, edition 1/3
Diptych, each 30 1/2 × 38 5/8 inches
(77.5 × 97.1 cm)

1 Quotes from the artist are from a conversation with the author, 20 October 2001.
2 Heinrich Zimmer, *Myths and Symbols in Indian Art and Civilization* (New York: Pantheon Books, 1946): 60.

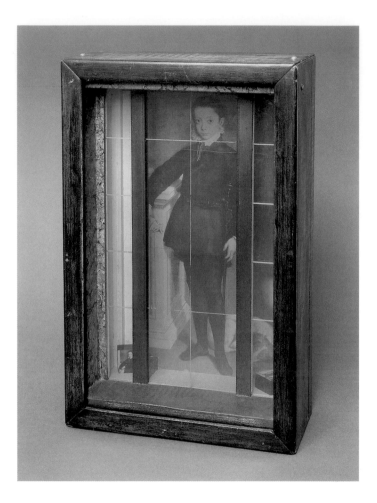

Joseph Cornell
Untitled (Medici Boy), 1953
Wood, glass, oil, and paper
18 1/4 × 11 3/8 × 5 1/2 inches (46.4 × 28.9 × 14 cm)
Commentary on page 228

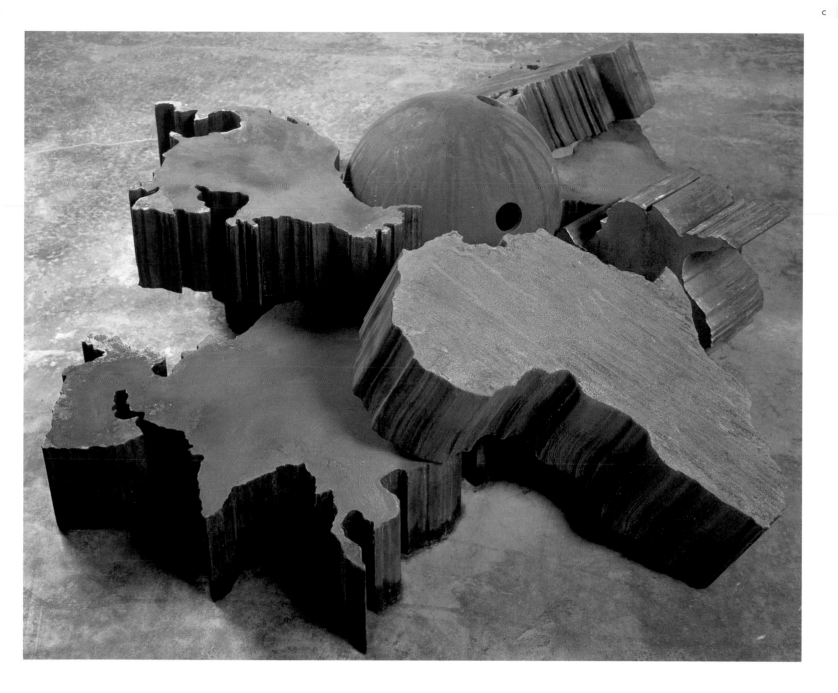

Tony Cragg
Ball Contact, 1990
Eight pieces of steel
36 × 85 × 72 inches (91.4 × 216 × 182.9 cm)
installed (variable)
Commentary on page 229

Richard Diebenkorn

Although Richard Diebenkorn is best known for his *Ocean Park* paintings, such as the Museum's *Ocean Park #105*, 1978, some of the artist's finest and most interesting works predate that series. One could argue that a full understanding of his achievements is only possible through a broader knowledge of his development.

Born in Portland, Oregon, Diebenkorn was raised in the San Francisco Bay Area. After attending Stanford University, he enlisted in the Marine Corps in 1943 and was transferred to the University of California, Berkeley, where he received his BA in 1944. Eventually he was stationed at the Officer Candidate School at Quantico, Virginia, where he had the opportunity to visit the Phillips Collection in Washington, D.C. There he saw the works of Pablo Picasso, Georges Braque, and Pierre Bonnard, and was particularly struck by the paintings of Henri Matisse, which had an enduring influence on his artistic development.

Discharged from the Marine Corps in 1945, he returned to California and in 1946 attended the California School of Fine Arts in San Francisco, where he eventually became a junior member of the faculty, which also included the Abstract Expressionist Clyfford Still and visiting faculty members Ad Reinhardt and Mark Rothko. Diebenkorn had been introduced to Abstract Expressionism in 1944 when he purchased a copy of *DYN* magazine in which surrealistically based paintings by Robert Motherwell and William Baziotes were reproduced. Diebenkorn was jarred and intrigued by the immediacy and seeming improvisation of the new painting, with its "blots and scratches."[1]

A critical point in the artist's career came when he accepted a teaching position at the University of Illinois. Here he developed, over a period of nine months, his distinct approach to Abstract Expressionism, which involved a procedure that intertwined drawing and painting, landscape and abstraction, and that brought together his appreciation of Matisse and the more spontaneous qualities of Abstract Expressionism. *Urbana #6*, 1953 evokes the issues Diebenkorn was dealing with at the time. Employing an overall field (some would say semi-aerial) composition of abstract parcels that would later be used to varying degrees in the *Ocean Park* series, the artist has painted meandering areas of charcoal black surrounded by passages of sky blue, green, yellow, and purple. As always, landscape and atmosphere affected Diebenkorn's palette, and it is possible that the industrial character of parts of Midwestern cities, as seen by a Californian used to long light, inspired the darker areas of paint. The gestural fluidity that begins to emerge in *Urbana #6* is coincident with Willem de Kooning's paintings of the 1950s, and predates de Kooning's great abstract landscapes of the late 1950s and early 1960s, while the meandering grid-like structure of the composition creates a poetic echoing of horizontal and vertical lines so often a hallmark of Matisse's greatest paintings. As it was for Matisse and de Kooning, drawing was an important means of articulating compositional structure. In the case of *Urbana #6*, it is drawing that suggests form; specifically, a landscape that is being rendered without giving full details. The effect is that of a form of abstraction that appears to have latent representational yearnings.

In the mid-1950s, a time when his abstract paintings were at their most lush and spontaneous, Diebenkorn returned to representational painting. Troubled that abstraction was becoming too facile, more style than substance, he set himself the challenge of reinventing figuration. Diebenkorn's paintings of friends and family— mostly figures of women in austere settings (such as *Girl with Flowered Background*, 1962)—were part of a bold figurative revival later known as the Bay Area Figurative School, which also included the works of David Park and Elmer Bischoff.

The presence of Park in the Bay Area was particularly important to many artists of

Urbana #6, 1953
Oil on canvas
68 5/16 × 57 15/16 inches (173.5 × 147.2 cm)

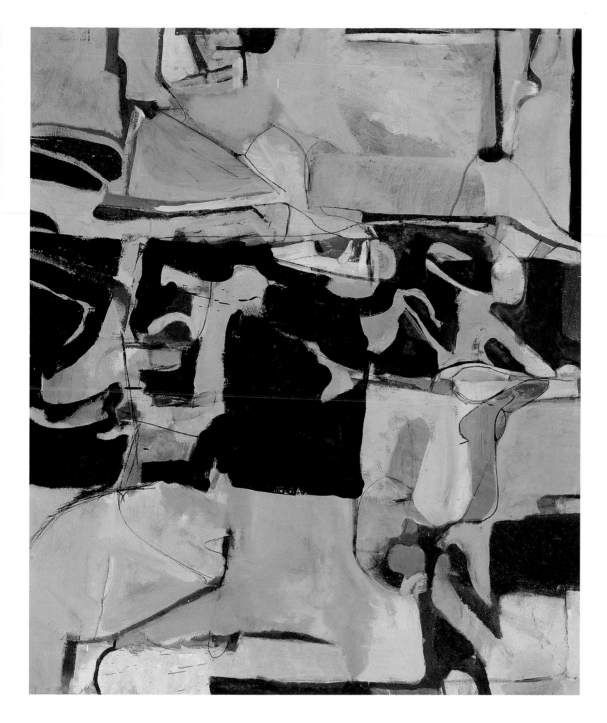

Diebenkorn's generation, especially those associated with the California School of Fine Arts. Park was central to the development of Bay Area painting in the 1950s. Through the influence of Clyfford Still, Park took up abstraction in the late 1940s, but by 1950 he was creating radically generalized figure painting using thick impasto, awkwardly direct drawing, and an emotive approach to color. Park made his move from abstraction to figuration dramatically, some would say even melodramatically. At the age of thirty-eight, after diligently pursuing abstraction for four years, Park took all of his abstract paintings to a dump in Berkeley and burned them. Many artists in the Bay Area applauded Park's move as a protest against what was often referred to in the

Girl with Flowered Background, 1962
Oil on canvas
40 × 34 inches (101.6 × 86.4 cm)

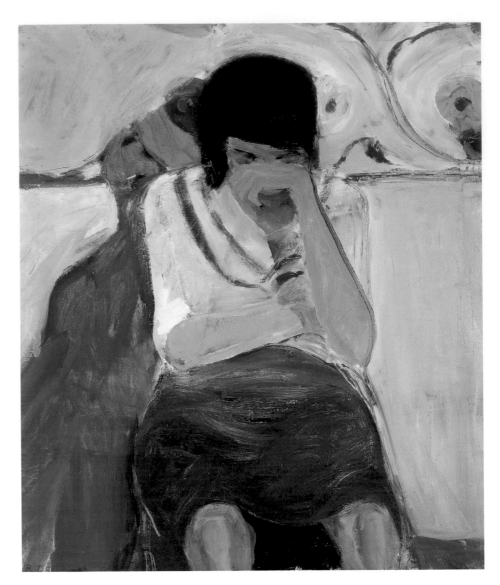

Bay Area as "New Yorkery" abstraction.[2] While Diebenkorn appreciated and learned from Park's example, he began to employ still life and figuration as a means of renegotiating the act of artmaking: specifically, to both slow down his method of painting—in essence to reevaluate the role of drawing in his method—and to reengage something outside of the self-reflexive act of painting. As Diebenkorn remembered it:

> As soon as I started using the figure my whole idea of my painting changed. Maybe not in the most obvious structural sense, but these figures distorted my sense of interior or environment, or the painting itself—in a way that I welcomed. Because you don't have this in abstract painting.... In abstract painting one can't deal with...an object or person, a concentration of psychology which a person is as opposed to where the figure isn't in the painting.... And that's the one thing that's always missing for me in abstract painting, that I don't have this kind of dialogue between elements that can be ...wildly different and can be at war, or in extreme conflict.[3]

Girl with Flowered Background, like many of Diebenkorn's images of women seated in lonely interiors, evokes a moody, internalized quality. The figure stares down into her lap, covering her face. The underlying subject of the image is the private space of a personal moment, and the artist has made us a part of the "conflict" he speaks about, in the sense of being detached and empathetic. The figure and background are simplified into areas of surface and color that verge on the abstract. As his early abstractions would reach out to elements of representation, his figurative works now incorporated the reductive dynamics of abstraction's emphasis on expressive color and gestural line.

In 1967 Diebenkorn moved from northern California to southern California. No longer in

contact with a group of staunch representational painters, and struck by the change in light and color in the south, the artist returned to abstraction, creating his most heralded body of work, the *Ocean Park* series. Named after the beachfront section of Santa Monica where he lived, these paintings reflect the moody sunlight and languid colors found there. The Museum's *Ocean Park #105*, like most in the series, is organized in a vertical format. The bottom two-thirds is painted in broad blocks of green, blue-green, and gray, suggesting an expansive, atmospheric space. Other than the lines that divide the colors, there is little or no drawing

Ocean Park #105, 1978
Oil and charcoal on canvas
99⁷/₈ × 93 inches (253.7 × 236.2 cm)

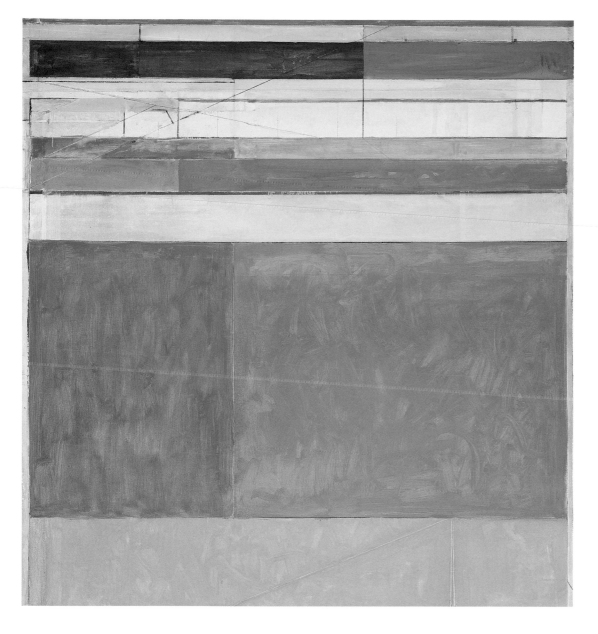

1 Quoted in Maurice Tuchman, "Diebenkorn's Early Years," in *Richard Diebenkorn: Paintings and Drawings, 1943–1980*, rev. ed. (New York: Rizzoli in association with Albright-Knox Art Gallery, 1980): 7.
2 The artist Jess, quoted in Michael Auping, "Jess: A Grand Collage," in Michael Auping, Robert J. Bertholf, and Michael Palmer, *Jess: A Grand Collage 1951–1993* (Buffalo: Albright-Knox Art Gallery, 1993): 35.
3 Quoted in Jane Livingston, "The Art of Richard Diebenkorn," in Jane Livingston, Ruth E. Fine, and John Elderfield, *The Art of Richard Diebenkorn* (New York and Berkeley: Whitney Museum of American Art in association with University of California Press, 1997): 50.
4 Quoted in John Russell, *Richard Diebenkorn* (Uxbridge, England and London: Hillingdon Press in association with Marlborough Fine Art, 1973): 7.

activity in this lower section. Rather, gentle brushstrokes suggest a liquid translucence. The upper third of the canvas, however, is more densely packed with color zones of red, black, yellow, white, green, and blue, connected by or marked with diagonal, vertical, and horizontal lines. The compacted nature of the upper area of the canvas balanced by the broad openness of the lower area is compositionally dynamic, as well as reflective of his new environment. Anyone who has visited Santa Monica's beachfront will recognize the essence of a place in which city buildings give way to expanses of grass, sand, water, and sky, and a moist, light-filled ethereality. As he did in his *Urbana* series, Diebenkorn's *Ocean Park* works are not only about making a painting, but imbuing painting with a sense of place. Diebenkorn once remarked, "Temperamentally, I have always been a landscape painter."[4]

MICHAEL AUPING

Jim Dine
The Art of Painting, 1972
Mixed media on canvas with objects
Five panels, each 72 × 30 inches
(182.9 × 76.2 cm)
Commentary on page 230

Vernon Fisher

Lunga Point, 1974
Acrylic and thread on vinyl
58 1/8 × 63 1/2 inches (147.6 × 161.3 cm)

I would go into the studio and tell myself to make "serious" paintings, and at the end of the day I would have a few hours left, so I would start making books. But then the next day I wouldn't work on the painting; I would still be involved with the book, and I would work on it throughout the week, all the while feeling guilty that I wasn't making "art." I made about twenty books, not realizing that they meant a whole lot more to me than my paintings. The big breakthrough was when I started inserting text into my images. My first narrative painting, *Smoke*, dates from 1975. I think the story is pretty good, but a bit overworked. It should have been called *Vernon Fisher Learns from Faulkner*. I couldn't stop myself from writing.[1]

The presence of language within the realm of painting and sculpture has always been strongly, if often unconsciously, felt. At its most basic level, the title of a work points to a definition and a network of allegorical and narrative cues that substantially form the viewer's reading of the image. This simple bond between language and image has been preserved from antiquity, at times generating profound debates over whether "the word" does or should predominate over visual perception or image. This phenomenon has become increasingly complex in the art of our time. As early as 1908 the Cubists incorporated fragments of language into their paintings, both as compositional elements and to convey content. Subsequently, the Dada collagists similarly used portions of images and texts in their compositions, as did the Futurists in their typographical collages. Such text fragments were meant to be ambiguous, functioning to create a dynamic tension between the graphic and the grammatical.

Vernon Fisher, who has been juxtaposing images and text for almost three decades, has helped bring this perceptual tension into the postmodern era. Mixing a broad range of media (painting, sculpture, photography, and language)

and images or "signs" (from Romantic landscapes to the Dairy Queen marquee), Fisher explores what he calls "the edges of understanding."[2] For Fisher, the postmodern world is an oscillating field of symbolic analogues in which disparate image and text fragments compete for attention at the same time they find a common, if transient, meaning.

Born in Fort Worth, Texas, the son of a Baptist preacher, the artist graduated from college with degrees in English literature (BA, Hardin Simmons University, Abilene, Texas, 1967) and fine arts (MFA, University of Illinois, Champaign-Urbana, 1969). The result is what the artist calls "a storyteller without a plot."[3] Fisher's earliest work in the Modern Art Museum's collection, *Lunga Point*, 1974, reflects the artist's transition from "pure" abstract painting to works that incorporate groups of tongue-in-cheek representations. Utilizing the language of late twentieth-

84 Sparrows, 1979
Acrylic and graphite on laminated paper
69 × 176 inches (175.3 × 447 cm)
Dimensions variable

century abstraction—a background grid over which floats geometric and gestural shapes—Fisher creates a mock field painting that suggests an ironic battlefield of competing references. What at first appears to be a non-illusionist (i.e., flat) abstract painting is a collaged space that contains areas of the literal and the illusionistic. Geometric drawing springs out from the grid, cutting through expressionistic paint gestures, pitting the logic of geometry with the emotional reference of spontaneous painthandling. Undercutting both systems of image-making, the artist creates a collaged field in which the spontaneous gesture is in fact a carefully selected and cut out spill of paint, a representation of the spontaneous. In the lower left-hand corner of the painting, a geometric shape is also cut out and attached to the surface, its precision undermined by its slightly wrinkled state and the fact that it is covered with gestural painting. From the right-hand point of this pyramidal shape, another attached blob of paint literally hangs from a thread. The point of such a seemingly disjunctive image—a point that the artist would pound home throughout the rest of his career—is that all systems of representation are just that: invented systems, one no more "truthful" or necessarily meaningful than the other.

During the mid-1970s, when he was experimenting with making artist's books at the same time he was making abstract paintings, Fisher began to incorporate text into his images as yet another system of reference. The Modern Art Museum's *84 Sparrows*, 1979 is one of the artist's early "narrative" works, made up of three seemingly sequential parts. The center panel is an unstretched canvas tacked to the wall with the image of a parked camper pointed toward a horizon of cumulus clouds in the sky. Over the image, the artist has laid a story. In a few previous narrative works Fisher used a short story he had written about an event or fantasy, the most important quality of the story being that it evoked a

strong visual image, which would be positioned near a painted or photographic image. It was important that an image and a text compete equally for the viewer's attention, without relating too directly to each other. The result is a story without resolution or closure; a story with an uncertain path or boundary. In *84 Sparrows* the artist makes an even more syntactically unstable narrative. Instead of a single story, Fisher has collaged together several seemingly disconnected sentence fragments. The text begins with "I am crouched behind the camper holding my arm down between my legs. Blood streams from under my shirt sleeve and down my wrist and off the tips of my fingers...." This text/image panel is flanked on the left by cut-out, hand-painted birds tacked to the wall in a configuration generally mimicking the camper and text canvas, but breaking away on the edges from the square format into what appears from a distance to be a loose field of red gestures. The final panel to the viewer's right consists of a blown-up Nancy cartoon that shows Nancy and her aunt mixing cake batter when a brick or stick of butter unexpectedly flies into the picture, splattering cake mix over their faces.

Private Africa, 1995
Oil on blackboard slating on wood
92 7/8 × 93 9/16 inches (235.9 × 237.6 cm)

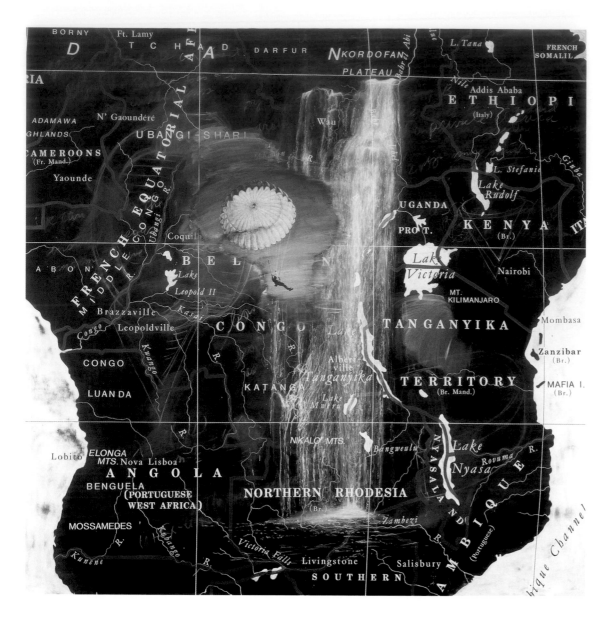

The three panels of *84 Sparrows* present us with a fluid, uncertain narrative space that nonetheless creates ironic, often humorous connections between art and life: the bright red flecks of blood in the story relate to the red birds, which might be red smears, and which are echoed in the violent dark splatters on the faces of Nancy and her aunt. The final sentence of the narrative provides what could be considered the conceptual leitmotif of all of Fisher's narratives: "Is this how it ends or what?"

Another common element in Fisher's imagery is the use of a faux blackboard background for his images and texts. The blackboard, a symbol of teaching and factual transmission, is for Fisher a platform for overlapping metaphors. The hazy erasures that occur on a blackboard's surface, and which he faithfully replicates in his paintings, allow the artist to cross-reference abstract gestural painting. Like a Franz Kline abstraction in reverse, these lyrical translucent gestures again compete with the texts and images he paints over and into them. Fisher acknowledges these references, and elaborates, "Blackboards present interesting pedagogical associations and the blackboard 'erasures' have affinities with the processes of thought and memory. I was also intrigued with the

Tunis, 1999
Acrylic on canvas, cast epoxy
Painting: 84 × 84 inches (213.4 × 213.4 cm)
Overall dimensions variable

F

notion of the blackboard as a place where things appear to exist in perpetual jeopardy, where things are susceptible to being 'rubbed out.'"[4]

The blackboard image is poignantly exploited in the Modern Art Museum's *Private Africa*, 1995. The title refers to the artist's memory of Africa as the "Dark Continent" ("probably formed from stories I heard in church from Baptist missionaries"[5]). Painted over the blackboard background is a white, chalklike map of colonial, rather than contemporary, Africa. A cascading waterfall spills over the map, as a parachuting figure also glides over its surface. Like a waterfall that finds its own path over the land's surface, Fisher depicts himself free-floating over a world of blacks and whites.

In 1999 Fisher atypically abandoned text altogether, creating a group of paintings that rely strictly on image to establish a symbolic conversation. The Modern Art Museum's *Tunis*, 1999 is from the artist's *Zombie* series, which once again references Africa, as well as the artist's early abstract paintings. Thickly textured paint, infused with subtle, pale colors, suggests that the artist has returned to his formalist beginnings. A closer inspection, however, reveals that the paint is cracking, like a relic from a museum of the antique. Moreover, discreetly placed over the surface of the painting and on the wall around it are remarkably real-looking houseflies cast from epoxy and hand-painted. A simplistic interpretation would be that the artist is attempting to render the end of abstraction in the form of a kind of rotting sublime. Fisher's reference may seem surprisingly oblique: "I began the zombies thinking of a scene from *The Passenger* (set in North Africa) where the protagonist watches a fly crawl along the wall. I had this image of weak, maybe fragile colors placed one over the other, suggesting both desert landscapes and the surfaces of buildings in that part of the world, where painted surfaces are bleached and oxidized by the sun. The flies light on the paintings and wall indiscriminately and could be seen as illustrating Auden's *Musée des Beaux Arts*, 'where the dogs go on with their doggy life and the torturer's horse scratches its innocent behind on a tree.'"[6]

Tunis is not about the death of abstraction any more than it is about the superiority of "realism." Rather, it carries a message about the instability of interpretation when disparate forms and meanings—realism vs. abstraction, the inert vs. the living, the symbolic surface of a painting vs. the neutral surface of the wall it hangs on—exist in a single image. For Fisher, that image is the surface of our reality. As the artist likes to put it, "I don't mind making an art that is polymorphic, impure, and eccentrically inclusive. If less is more, then more is more too."[7]

MICHAEL AUPING

1 The artist quoted in Hugh M. Davies and Madeleine Grynsztejn, "Interview with Vernon Fisher," in *Vernon Fisher* (La Jolla: La Jolla Museum of Contemporary Art, 1988): 78.
2 The artist in a letter to the author, 12 September 2001.
3 The artist in conversation with the author, 3 October 2001.
4 Fisher letter, 12 September 2001.
5 Ibid.
6 Ibid.
7 Undated statement, Registrar's Files, Modern Art Museum of Fort Worth.

Dan Flavin
Diagonal of May 25, 1963, 1963
Warm white fluorescent light
Edition 2/3
96 inches (243.8 cm)
Commentary on page 234

Fort Worth Circle

Bill Bomar
The Web and Roses, c. 1948
Oil on canvas
24 1/4 × 28 1/8 inches (61.6 × 71.4 cm)

The people involved in the Fort Worth Circle were interested in visual art, theater, dance, music and literature. We gathered at the Reeders' house almost every Saturday night for great soirées—sometimes musicians and dancers would come along. Classical music was always going on the phonograph and inevitably we would burst into dance, creating our own ballets. Never was there a party without dance. The Reeders had their school, of course [Children's School of Theater and Design, 1945–1958], so we often raided their costume box to complement our improvised ballets. I think of my days in Fort Worth as really decadent and romantic.[1] KELLY FEARING

Artist Kelly Fearing currently resides in Austin and is Professor Emeritus at the University of Texas. Now eighty-three years old, Fearing still paints nearly every day in his studio. Cynthia Brants of Granbury, considered a second-generation Fort Worth Circle member, is the only other living artist associated with the group's most active years, which spanned 1943 to 1958. The year the group began to disband, 1958, also marked the closing of the Children's School of Theater and Design, an initial meeting point for these artists, who often created stage sets and costumes for the children's plays. Fearing and Brants's reminiscences vivify the atmosphere of Fort Worth in the 1940s and 1950s.

The Fort Worth Circle was critical in the development of the city's growing arts community. By 1939 the Fort Worth Art Association (now the Modern Art Museum of Fort Worth) had moved from the Carnegie Public Library to the new Fort Worth Public Library. There the Association began annual juried local art shows with purchase prizes that were often awarded to members of the Fort Worth Circle. In addition to Fearing, Brants, and Dickson and Flora Reeder, the group included Bill Bomar, Veronica Helfensteller, Bror Utter, Lia Cuilty, Marjorie

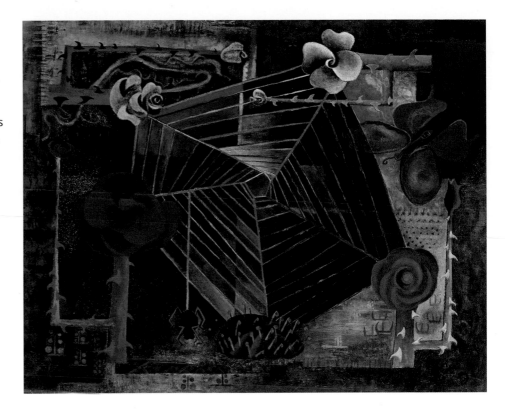

F

Johnson Lee, George Grammer, Emily Guthrie Smith, McKie Trotter, James Boynton, and many others. Their meetings at Helfensteller's studio and print shop around 1939 are often cited to indicate the group's formation. Utter, Bomar, Fearing, and occasionally Dickson Reeder used Helfensteller's printing press to experiment with printmaking techniques such as intaglio, and they would also explore the city together. Although they differed stylistically, the artists shared a love of sketching outdoors and of Fort Worth's landscape and architecture.

World War II played a major role in the expansion of the Fort Worth Circle when an influx of people moved to the city, or came back to it, for various war-related reasons. In 1942 Marjorie Johnson Lee relocated to Fort Worth to serve in the US Navy's WAVES (Women Accepted for Volunteer Emergency Service), where she taught radio communication and celestial navigation. In 1943 Fearing moved from Louisiana to work for Consolidated Vultee Aircraft as a production illustrator, where Dickson Reeder was already on

Cynthia Brants
The Celebrity, 1950
Oil on canvas
38 × 24 inches (96.5 × 61 cm)

the team. As these people met and exchanged ideas, they gradually began to shift the focus of the art produced and collected in Fort Worth from nineteenth-century Impressionism and American art, which were still favored by the city's art patrons, to modernism.

The Fort Worth Circle is sometimes referred to as "The Fort Worth School," yet the former is the preferred name, according to those associated with the group, either as artists or scholars. "Circle" is more fitting, in that the individuals involved did not subscribe to any one artistic philosophy or style. Thus, rather than being a "school" with similar artistic goals, the group was largely a social one. Their common thread can be broadly described as their interest in modernism, their desire to share ideas, and their eagerness to explore new techniques in printmaking.

Instrumental to the group were Sam Cantey and his wife Betsy. The Canteys shared an enthusiasm for local art, and it was partially through their involvement—including parties and connections with dealers and collectors in Fort Worth, Dallas, and New York—that the Fort Worth Circle gained national exposure and was recognized outside of the realm of Regionalism. Along with the Canteys, Betty McLean (now Betty Blake), who owned the Betty McLean Gallery in Dallas, was behind much of the group's success and exposure. The gallery was managed by Donald Vogel, an artist and dealer originally from Fort Worth who was involved with the Fort Worth Circle and later opened Valley House Galleries in Dallas.

Of the group's national recognition, Cynthia Brants has said, "The Fort Worth Circle had an amazing connection with New York critics and curators. Staff from The Museum of Modern Art and the Metropolitan Museum of Art came to Fort Worth and had good things to say about the caliber of work coming out of here."[2] As a result, several members of the Circle were included in two New York shows: one entitled *Texas Wildcat* at M. Knoedler & Company in 1951,

and another at Edith Halpert's Downtown Gallery.

The artists in the Fort Worth Circle can be said to have an international outlook, in part because many of them had studied art outside of Fort Worth. Bill Bomar, Dickson and Flora Reeder, and Cynthia Brants studied in New York City; Dickson and Flora Reeder had also studied in Paris in the late 1920s and early 1930s at William Stanley Hayter's Atelier 17 (which relocated to New York City during World War II).

The Fort Worth Circle clearly made a local and national impression during the 1940s and 1950s. Fort Worth art patrons were beginning to build collections that included members of the group along with important national and international

Bror Utter
Trio, undated
Oil on canvas
30 × 40 inches (76.2 × 101.6 cm)

artists. The group now had access to key modernist works in their own hometown. Fearing describes some of the most prominent private collections:

Bill Bomar had several important things. He was one of the first in Fort Worth to buy modern art. He bought a Lyonel Feininger and a Ben Shahn painting [now in the Museum's collection], several Paul Klee works, and a Modigliani. Anne Burnett Windfohr also had a great eye and I even advised her somewhat. She bought fifteen Paul Klees and then told me, "I bought Klee because you said you liked him." But she definitely assembled her own incredible collection.

The work of Henri Matisse and the Fauves, and the Cubism of Pablo Picasso and Georges Braque, which had been widely published in books and magazines, were influential to the Fort Worth Circle as well. Subsequent movements—Surrealism, especially the work of Joan Miró; abstraction, such as that of Piet Mondrian; and the works of Paul Klee and Wassily Kandinsky—also had a strong impact on their work. The American artists of interest to the group were those who also explored modernism and incorporated aspects of Fauvism, Cubism, German Expressionism, and geometric abstraction into their own paintings, such as John Marin, Arthur Dove, Stuart Davis, Charles Sheeler, and Marsden Hartley.

F

The Fort Worth Circle paintings in the Museum's collection clearly reflect the group's wide-ranging approaches and subjects. Bror Utter's undated painting *Trio* illustrates his attraction to Cubism. Utter depicts the same figure three times using a cubistic multiple perspective, but counter to the Cubists' use of geometry, his forms are gestural and fluid. Bill Bomar's *The Web and Roses, c.* 1948 is a densely painted garden scene in blacks, browns, blues, and reds that, like Surrealism, evokes Freudian symbolism with its thorny roses and a spider spinning down from its web. Fearing's *The Kite Flyers*, 1945 is an early work in the Regionalist genre, but its subject is not exactly straightforward and friendly. There is an element of his artistic transition from Regionalism to a Surrealist approach, especially in the potential danger seen in the ominous skies he added to this springtime activity. Brants's *The Celebrity*, 1950 suggests a high-society setting consisting of a vertiginous

field of transparent bodies and glancing eyes. The half-nude figure that floats in the center is portrayed as both alluring and vulnerable, her moment of celebrity a twisting flame of light radiating out into the room. *The Celebrity* is an apt symbol of the Fort Worth Circle's effects on Texas culture in the pioneering days of the 1940s and 1950s.

ANDREA KARNES

1 Quotes by Fearing are from a conversation with the author, 20 November 2001.
2 The artist in conversation with the author, 20 November 2001.

Gilbert & George
Mental No. 3, 1976
Photo piece, twenty-five panels
Overall 121 × 102 inches (307.3 × 259 cm)
Commentary on page 238

Adolph Gottlieb
Apaquogue, 1961
Oil on canvas
72 1/4 × 90 1/4 inches (183.5 × 229.2 cm)
Commentary on page 239

71

Philip Guston

Philip Guston's fifty-year career stands as a unique allegory of the changing conditions of American art in the latter half of the twentieth century. Evolving an imagery that moved from "Symbolic Realism" to abstraction and back to a searching form of autobiographical figuration in the last decade of his life, Guston engaged each decade as if it needed to be seen anew and the meaning of the moment renegotiated.

Guston's work came to full maturity in the 1950s, and the works in the collection of the Modern Art Museum of Fort Worth represent key phases in the development of Guston's style—both abstract and figurative—during that decade and through the 1960s and 1970s, when his bold change from abstraction to figuration inspired succeeding generations of American painters. However, the artist's early, formative years offer important insights to understanding his later work.

The youngest of seven children, Philip Goldstein was born in Montreal, Canada to Louis Goldstein and Rachel Ehrenlieb Goldstein, Russian émigrés from Odessa. When he was six years old, the family left "the ghetto" of Montreal for the promise of southern California, settling in the sprawling greater Los Angeles area.[1] The adjustment was difficult, particularly for Guston's

father, who had trouble finding a job, reluctantly working as a junkman collecting refuse in a horse-drawn wagon. He committed suicide by hanging himself a few years after their arrival. It was the young Guston who found his father hanging from a rope thrown over the rafter of a shed.

As his friend Ross Feld would later comment, Guston "literally drew a distance for himself away from the family's shock and grief,"[2] demonstrating a talent for drawing at an early age and exploiting this talent as a form of internal dialogue. Later, inspired by the irreverent antics of George Herriman's Krazy Kat and Budd Fisher's Mutt and Jeff comic strips, he enrolled in a correspondence course with the Cleveland School of Cartooning. Guston's favorite drawing sanctuary was a large closet illuminated by a single hanging light bulb, an image—along with that of a rope—that appears frequently in the artist's later work.

A high school dropout—initially attending Manual Arts High School with his friend Jackson Pollock—Guston supported himself working odd jobs, in an atmosphere when unionist and anti-unionist sentiments struggled for power. Art and politics were close bedfellows in 1930s America, and Guston's political awareness developed as quickly as did his artistic interests. Anti-Semitism

Drawing, 1965
Ink on paper
16 ¹/₂ × 23 ¹/₂ inches (41.9 × 59.7 cm)

Full Brush, 1966
Ink on paper
77 ¹/₂ × 22 ³/₄ inches (44.5 × 57.8 cm)

G

(he later changed his name from Goldstein to Guston) and racism were also a part of the southern California political landscape. The Ku Klux Klan had a significant membership in southern California in the 1930s and 1940s, a situation that clearly impressed itself on the young artist. One of Guston's earliest paintings, from 1930, shows a huddle of hooded Klan members with whips and ropes. The hooded figure would become part of a cast of characters that would play various roles in Guston's paintings of the 1940s, as well as his later autobiographical paintings.

Studying on his own, Guston was an ardent and eclectic student of art history, and his most significant paintings of the 1940s transform references to Venetian painting, commedia dell'arte, Giorgio de Chirico, and Max Beckmann into an eerie postwar metaphysics in which masked and hooded children share a proscenium space with light bulbs, ropes, and newspapers, referring variously to private symbols and public events. Toward the end of the decade Guston began to deconstruct his subject matter, burying his subjects metaphorically and literally under the surface of his paintings, leaving only vague traces of limbs and clothing to indicate the history of his symbolic imagery.

Having moved to New York in 1935, Guston reconnected with his high school friend Pollock and eventually became part of a group that would later be known as the Abstract Expressionists, whose explorations into the realm of "pure" abstraction would represent the most radical innovations in the history of American art.

Throughout much of the 1950s Guston addressed qualities of color, light, and physicality in his art, distinguishing himself with a signature style within Abstract Expressionism. The rich facture and subtle tonalities of his early abstractions led many to point to Claude Monet's late paintings of water lilies as the artist's primary source of inspiration, and to characterize his most seductive works of the period as "Abstract Impressionism." In fact, Guston's procedure of applying discrete strokes of paint in a cross-hatched manner owes more to Piet Mondrian's so-called *Pier and Ocean* series, completed between 1914 and 1915, in which a Cubist grid is opened and simplified to form a cluster of "plus" and "minus" signs.

Guston's reference to Mondrian's transitional abstractions is most clearly seen in his drawings of the early 1950s. As Mondrian had done, Guston began with the idea of activating pictorial space with strategically placed vertical and horizontal

Painter's Forms II, 1978
Oil on canvas
75 × 108 inches (190.5 × 274.3 cm)

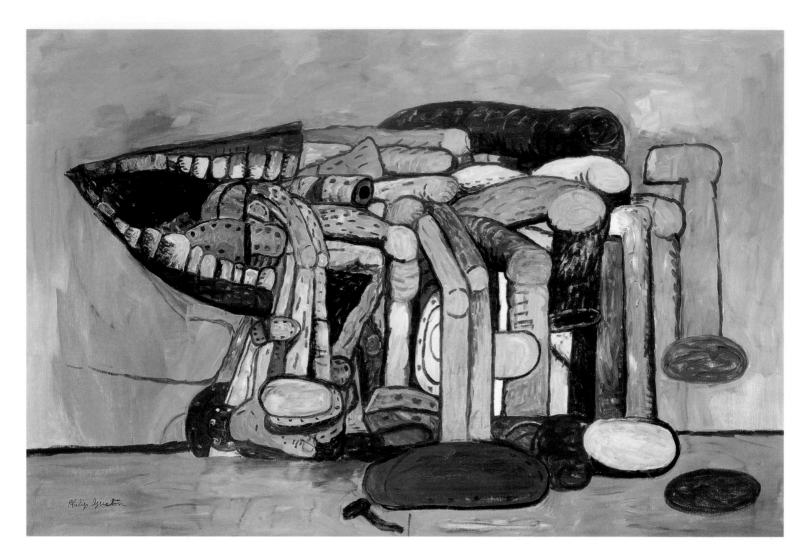

picture, dividing it into a lyrical, slightly turbulent sky reminiscent in passages of a Willem de Kooning landscape of the late 1950s, and a dark ocean whose surface is a field of shimmering greens, reds, and oranges. It is tempting to think of *Wharf* as Guston's *Monk by the Sea*, the famous Caspar David Friedrich painting from 1809–10 (Schloss Charlottenburg, Berlin) that depicts a lonely monk at the edge of the ocean staring beyond the horizon toward the vastness of space and the infinite world of the imagination. In contrast to the solitary presence of the monk in Friedrich's painting, however, Guston populates his image with the people, memories, and symbols that filled many of his late paintings. Guston is accompanied in the water by his

devoted wife, Musa, whose large eyes are directed upward in an accepting expression that seems to say "Here we go again." The artist's daughter has written a particularly moving account of her mother's patience and steadfast devotion to her husband, a devotion that Guston increasingly acknowledged later in life, and that undoubtedly elicited feelings of guilt as well as gratitude.[8]

The wharf referred to in the title is made up of a tangle of jostling legs and soles of floating shoes. A lover of language and poetry, Guston was a master of the visual pun. Carrie Rickey has pointed out, "And then there are those flamingo-like human legs which, however amputated, have lost none of their locomotive powers even though they have nowhere to run, and can only fold back on

1 Morton Feldman in conversation with the author, 20 May 1986.
2 Ross Feld, "Philip Guston: An Essay by Ross Feld," in *Philip Guston* (New York and San Francisco: George Braziller, Inc. in association with the San Francisco Museum of Modern Art, 1980): 12.
3 Guston's interest in Asian philosophy and art is discussed in Dore Ashton, *A Critical Study of Philip Guston* (Berkeley, Los Angeles, and Oxford: University of California Press, 1976): 92.
4 Ibid., 148.
5 Quoted in William Berkson, "Dialogue with Philip Guston, November 1, 1964," *Art and Literature: An International Review* 7 (Winter 1965): 66.

Wharf, 1976
Oil on canvas
80 × 116 inches (203.2 × 294.6 cm)

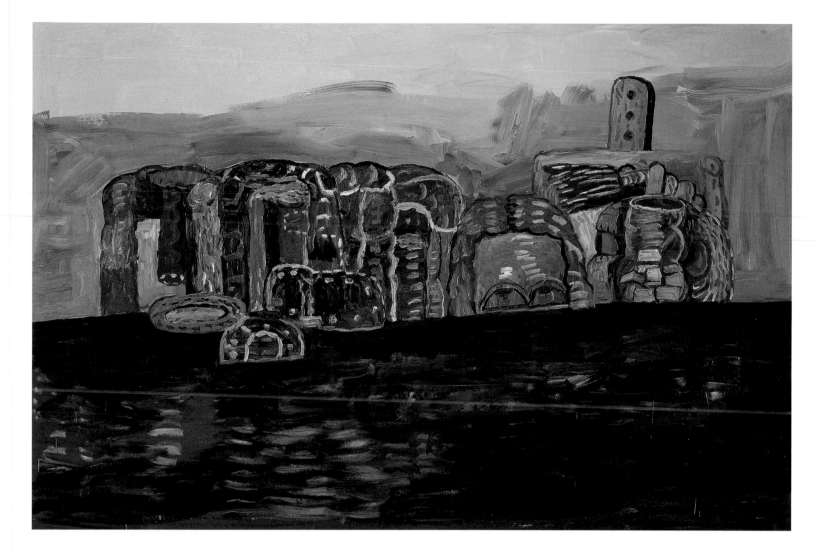

themselves, like intestines or surrealist plumbing. And then there are those limbs that don't have a leg to stand on…."[9] Sadly, there were also those legs of his favorite brother that were crushed by a runaway car (he later died). Like so much of the poetry he read, Guston's art is often sublimely tragic, fueled by a need to connect symbolically the difficulties faced in childhood with the problems related to a successful but always fragile career as an artist. Indeed, the shoe bottoms or soles, as Mark Rosenthal has aptly pointed out, are a punning reference to the "soul" that inhabits the shoes,[10] which must stay afloat in order to guide the artist's painting as well as his life.

Almost ten feet across and layered with painterly gesture, *Wharf* is also a brilliant demonstration of abstract markmaking reconciled with symbolic subject matter. Although he was now painting representationally, Guston never lost the delicate painterly touch that characterized his Abstract Expressionist works. *Wharf* integrates both ends of Guston's career. It is not difficult to see why so many painters in the 1970s, from Willem de Kooning to Susan Rothenberg, saw Guston's move to figuration as an act of "freedom," invigorating painting with a new sense of mission.

MICHAEL AUPING

6 Musa Mayer, *Night Studio: A Memoir of Philip Guston* (New York: Alfred A. Knopf, Inc., 1988): 141.
7 Carrie Rickey, "Twilight's Last Dreaming," in *Philip Guston* (Madrid: Centro de Arte Reina Sophía, 1989): 165.
8 Note 6 contains the full publication details for Musa Mayer's book about her father.
9 Rickey, 166.
10 Mark Rosenthal, "Guston's Metamorphosis: A Matter of Conscience," in *Philip Guston* (Madrid: Centro de Arte Reina Sophía, 1989): 162.

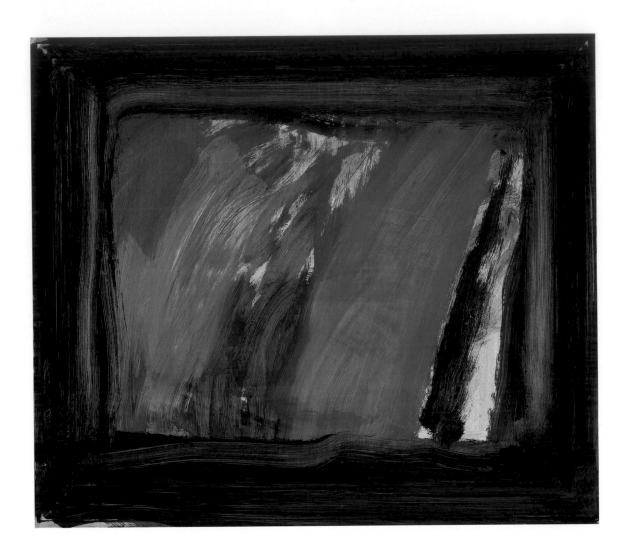

Howard Hodgkin
After Matisse, 1995–99
Oil on wood
43 3/8 × 49 5/8 inches (110.2 × 126 cm)
Commentary on page 245

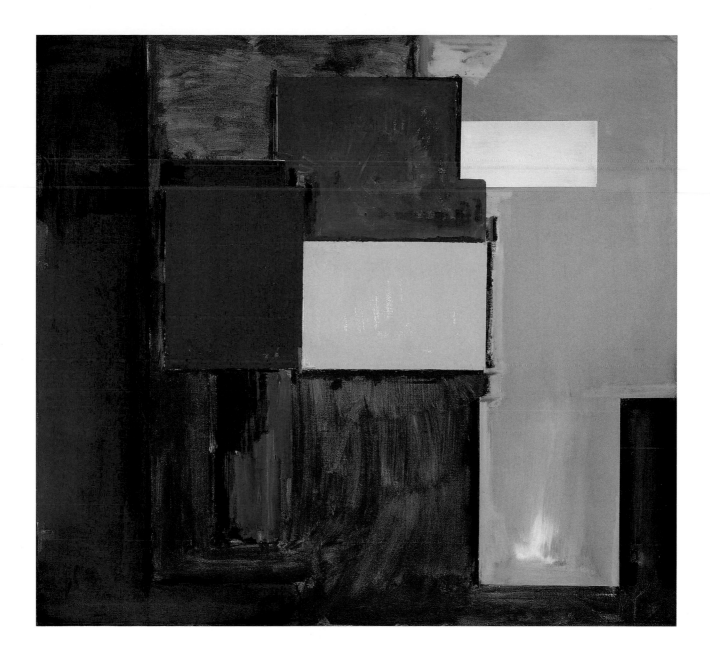

Hans Hofmann
To Miz—Pax Vobiscum, 1964
Oil on canvas
77 3/8 × 83 5/8 inches (196.5 × 212.4 cm)
Commentary on page 246

Jess
Montana Xibalba: Translation #2, 1963
Oil on canvas mounted on wood
29 3/4 × 33 inches (75.6 × 83.8 cm)
Commentary on page 249

86

Donald Judd
Untitled, 1967
Stainless steel and Plexiglas
Ten units, each 9 1/8 × 40 × 31 inches
(23.2 × 101.6 × 78.7 cm)
Overall 190 1/8 × 40 × 31 inches
(482.9 × 101.6 × 78.7 cm)
Commentary on page 251

Anselm Kiefer

Anselm Kiefer's unsettling cross-references between the Third Reich, Richard Wagner, the Fascist architecture of Albert Speer, and Teutonic mythology have been variously interpreted as an unwanted reminder of a very dark moment of German nationalism, or as a statement of redemption and cleansing. Born in Donaueschingen, Germany in 1945, Kiefer creates art that engages the sensitive issue of what it means to be German today, and the role German history plays in a larger historical cosmology. In his grandly scaled paintings and sculpture, his broad-ranging imagery alludes to alchemical treatises; Nordic, Greek, Egyptian, and early Christian mythology; and the mystical Jewish kabbala, often relating such images to historical developments in modern, particularly German, history.

Central to many of Kiefer's images is an exploration of the nature and role of evil. The artist's so-called "attic" paintings of the early 1970s are particularly fascinating in this regard. Among this series, one of the most intriguing works is the epic *Quaternity*, 1973. In the private collection of the German artist Georg Baselitz for more than twenty-five years, the painting is now in the collection of the Modern Art Museum of Fort Worth. *Quaternity* presents a grand philosophical drama that pivots between religious and historical themes in an effort to place the dilemmas of the present into a larger context.

The painting was completed when the artist was living in a remote village in the Odenwald district, a region of wooded uplands between Frankfurt and Stuttgart. It is a landscape of legend, a region near the Black Forest and the Nibelungenstrasse, or road of the Nibelungs, the ancient mythological German peoples. Living in a large wooden building that was formerly a schoolhouse, Kiefer used the attic of the building as his studio. This attic became the stage-like backdrop in the painting. Vaguely episodic, *Quaternity* is the second work in the series. The first, *Father, Son,*

Holy Ghost, also of 1973, depicts the Christian Trinity as three flames occupying three chairs situated in the center of the attic, above which the artist has handwritten in his now-familiar cursive German script their various designations. *Quaternity*, a vast canvas measuring 117 1/2 by 170 1/4 inches, also depicts the Holy Trinity as three flames, but situated directly on the wooden attic floor.

The grain of the attic interior is rendered in a detailed charcoal drawing that covers the entire surface of this nearly fifteen-foot-wide canvas. This grainy wood dominates the image, symbolically referring to the archetypal German forest, the source of so many German myths, where tales of good and evil are played out. Kiefer's dramatically tilted perspective of the room prompts an imagined fusion of the painted world with that of the viewer. We are invited into this burning matrix.

Quaternity also introduces the image of a serpent—which he labels Satan—that enters from a dark shadow on the right side of the canvas to establish a dialogue with the flames. An attic is an obviously symbolic space in which we store our past; it is a dark and secret realm we visit infrequently and often with mixed feelings, if not trepidation. We hide things in the attic. It does not take a great leap of imagination to transpose the serpent's designation of Satan to that of Hitler or more generally a swastika. Is there some contaminatory secret about Teutonic heritage that allowed Nazism to mature to such an extent, and is Kiefer suggesting that all Germans hide this unspoken fear? Perhaps, but this kind of specificity is too limited for an artist who insists on larger conflicts.

The title *Quaternity* refers to a theological debate within the early Christian church. If the Trinity represents invincible, all-consuming purity and power, what, then, is the origin and role of the devil? How and why was the devil allowed to come about? The fourth-century debate concluded that the devil was not a part of God, but left the issue

Quaternity, 1973
Oil and charcoal on burlap
117 1/2 × 170 1/4 inches (298.4 × 432.4 cm)

of the role of the devil in society largely unresolved. In *Quaternity* Kiefer presents evil, or Satan, as a fundamental element in the spiritual matrix, joining the Father, Son, and Holy Ghost with connecting lines that represent an exchange of energy between them. Although he does not give ultimate power to Satan—if the serpent enters too close to the Trinity, it could be consumed by the flames—he does not dismiss Satan as an ineffectual aberration. On the contrary, he is a major player on Kiefer's dramatic stage set.

 Quaternity is constructed on paradox. The flaming Trinity, which suggests an atmosphere of spiritual transcendence, also threatens to consume the building that houses it in an

apocalyptic blaze. The serpent/Satan is half in light, half in darkness. This symbiotic relationship between redemption and destruction, good and evil would be a central theme in Kiefer's subsequent art. The burning branches and fiery paintbrushes that would appear in later paintings are capable of shedding light, but can also be used to symbolically burn down forests. His recent images of ancient Mexican pyramids represent the site of a fusion of spiritual transcendence and bloody sacrifice, and his lilting sunflower paintings are covered with regenerative seeds that appear as black stars, or, from a distance, like flies populating a degenerating universe. There is no moral here. There is only impurity.

Aschenblume, 1983–97
Oil, emulsion, acrylic paint, clay, ash, earth,
and dried sunflower on canvas
149 $^{5}/_{8}$ × 299 $^{1}/_{4}$ inches (380 × 760 cm)

Sol LeWitt
Wall Drawing #302, 1976
Grid and arcs from the midpoints of three
sides in black pencil, dimensions variable
Commentary on page 254

Roy Lichtenstein
Mr. Bellamy, 1961
Oil on canvas
56 1/4 × 42 1/8 inches (142.9 × 107 cm)
Commentary on page 255

Richard Long
Cornwall Summer Circle, 1995
Cornish slate from Delabole
189 inches (480.1 cm) diameter
Commentary on page 257

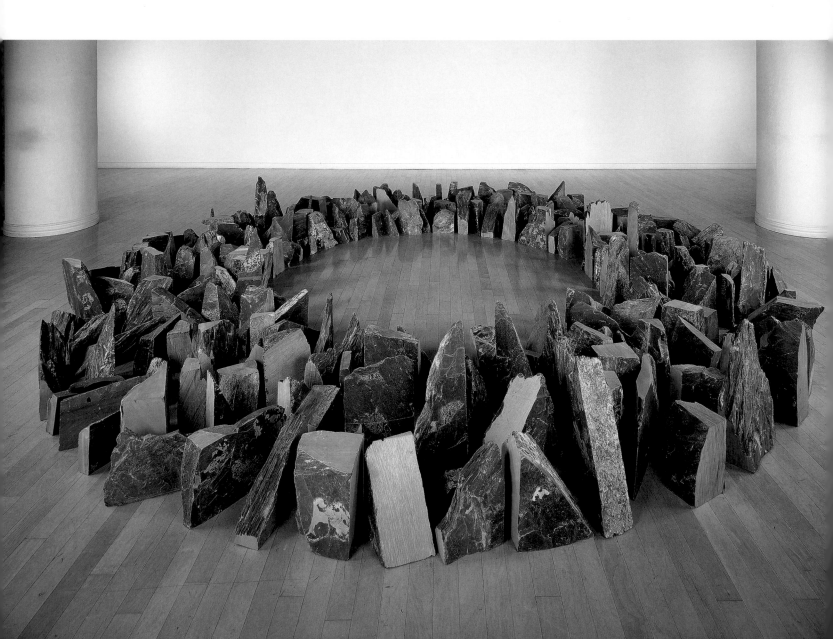

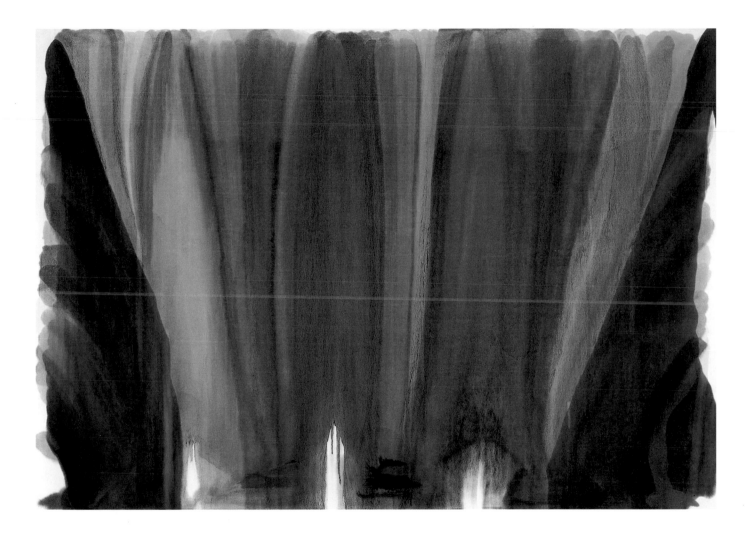

Morris Louis
Dalet Kaf, 1959
Acrylic resin (Magna) on canvas
100 5/8 × 143 inches (255.6 × 363.2 cm)
Commentary on page 258

Sally Mann
The New Mothers, 1989
Gelatin silver print, edition 8/25
20 × 24 inches (50.8 × 61 cm)
Commentary on page 259

M

Brice Marden
Urdan, 1970–71
Oil and wax on canvas
70 × 60 5/8 inches (177.8 × 154 cm)
Commentary on page 260

On a Clear Day (detail), 1973
Portfolio of thirty screenprints
Each 12 × 12 inches (30.5 × 30.5 cm)

arts courses, often gravitating to art. In a move to continue her formal study and simultaneously expose herself to the work of an emerging American avant-garde that would later be known as Abstract Expressionism, she moved to New York and enrolled at Teachers College, Columbia University, from which she received a degree in fine arts and art education in 1952. After teaching art to children in New York, she returned to New Mexico to teach at the University of New Mexico, during which time she abandoned conventional still life and portraiture and began to experiment with different modes of representing her response to nature, adopting a semiabstract style involving biomorphic forms related to the work of Adolph Gottlieb and William Baziotes. Martin also admired the work of other Abstract Expressionists, particularly that of Barnett Newman, Mark Rothko, and Ad Reinhardt. Like them, she moved increasingly toward creating abstract imagery in order to evoke pure, meditative states of mind.

Eventually line rather than form came to dominate Martin's images, as her gestures evolved into an attenuated handwriting that vaguely resembled horizons. During the late 1950s and early 1960s the artist's palette also suggested a landscape reference, incorporating the loamy browns, deep siennas, clay yellows, and near-blacks of tundras, mesas, and prairies. She titled her paintings *Wheat, Tideline, Earth*, and *Desert Rain*. Inspired by her memory of the vast plains of northern Saskatchewan and the high desert spaces of New Mexico, Martin engaged in a search for the perfect landscape, one that was as metaphysical as it was real. As she later noted, "I used to paint mountains here in New Mexico and I thought my mountains looked like ant hills. I saw the plain driving out of New Mexico and I thought that the plain had it, just the plane When I draw horizontals you see this big plane and you have certain feelings like you're expanding over the plane. Anything can be painted without representation."[6] Martin's interest in landscape and planar form developed increasingly away from representation into what the artist called "an awareness of perfection," and an acute appreciation of the metaphysical qualities of space and proportion.

Martin's breakthrough came in the mid-1960s with a series of simple pencil grids ruled directly onto gessoed canvases, of which the Modern Art Museum's *Leaf*, 1965 is a classic example. *Leaf* consists of a six-by-six-foot primed canvas, the surface of which is divided with 255 horizontal and 71 vertical pencil lines, creating a geometric web of small rectangular spaces. Related to two other works of the same year entitled *Tree*,[7] *Leaf* is a metaphoric expression of the factual "innocence" of a natural phenomenon. Her engagement with the grid form came with her thought of a tree. "When I first made a grid I happened to be thinking of the innocence of trees and then this grid came into my mind and I thought it represented innocence, and I still do, and so I painted it and then I was satisfied. I thought, this is my vision."[8]

Possessing what might seem to be a rigid and detached symbolism, Martin's grids are acutely sensitive to their source, forming a natural irregularity that is the visual substance of nature. Although Martin uses a ruler to apply delicate

Untitled XVI, 1996
Pencil and acrylic on canvas
60 × 60 inches (152.4 × 152.4 cm)

M

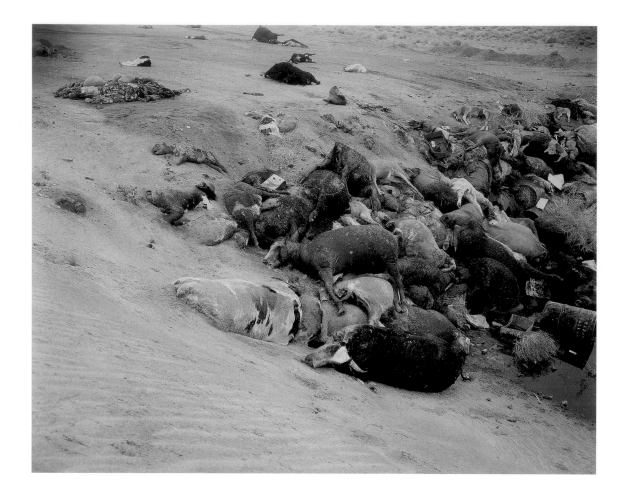

Richard Misrach
Dead Animals #1, 1987/1998
Chromogenic color print
40 × 50 inches (101.6 × 127 cm)
Commentary on page 262

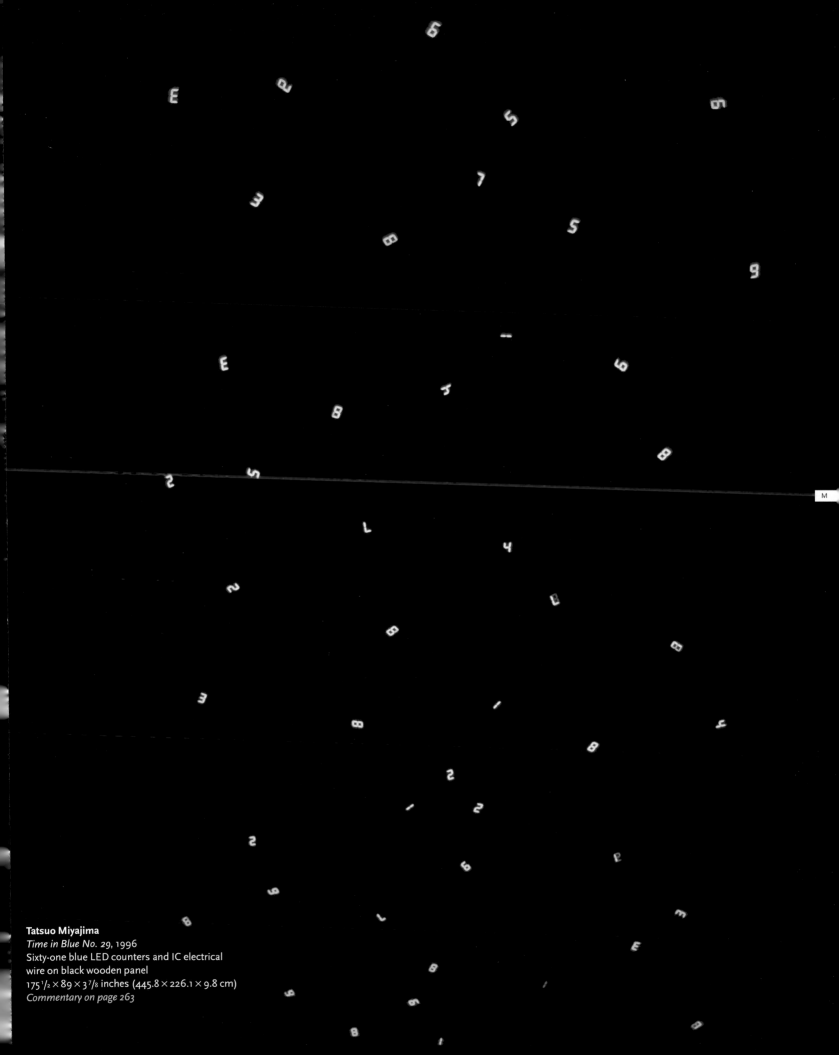

Tatsuo Miyajima
Time in Blue No. 29, 1996
Sixty-one blue LED counters and IC electrical
wire on black wooden panel
175 1/2 × 89 × 3 7/8 inches (445.8 × 226.1 × 9.8 cm)
Commentary on page 263

Yasumasa Morimura
Self-Portrait (Actress)/After Elizabeth Taylor 2, 1996
Ilfachrome photograph mounted on Plexiglas, edition 3/10
47 1/4 × 37 3/8 inches (120 × 94.9 cm)
Commentary on page 265

Robert Motherwell

One of the Museum's most significant holdings is its comprehensive collection of works by Robert Motherwell. Numbering fifty objects—paintings, collages, prints, and sketches—that date from 1941 (the year his career began) to 1990 (the year before his death), this body of work offers a unique opportunity to examine and appreciate the creative range of this major modernist artist. Motherwell, who coined the term "The New York School," is closely identified with Abstract Expressionism, a movement further represented in the Museum's collection by works of Jackson Pollock, Mark Rothko, Clyfford Still, William Baziotes, Franz Kline, and Adolph Gottlieb. Like these artists, Motherwell in the late 1940s embraced the tenets associated with Abstract Expressionism: the canvas as an arena in which the artist engages spontaneously and passionately in the physical and mental action of painting; the composition, often monumental in size, charged with feeling; the abstract forms suggesting deep, open-ended meanings. For Motherwell, "art is a form of action, a drama, a process. It is the dramatic gesture itself in modern times, not a religious content, that accounts for art's hold on the minds of men. One enters the studio as one would an arena. One's entire character is revealed in the action, one's style, as we say, which differs from individual to individual, and from tradition to tradition."[1] The rhetoric is typical of Motherwell and exemplifies his role not only as an artist, but also as an important writer who helped shape the reception of Abstract Expressionism. More than any other artist of the group, Motherwell passionately and intelligently articulated the basis for and possibilities of modernist abstract art.

Motherwell, the youngest of the Abstract Expressionists, differed from most of the other painters by not having been engaged in any of the federal WPA projects in the 1930s. Instead, he had studied philosophy at Stanford (1932–37) and Harvard (1937–38). After spending fifteen months in France (where, in Paris, his work was exhibited

in 1939), he returned to enter the doctoral program in art history at Columbia University. Under the influence of art historian Meyer Schapiro, Motherwell devoted himself to painting and met several of the Surrealists then residing in New York City. In 1941, his first year as a full-time painter, he traveled to Mexico with Roberto Matta Echaurren. A member of the Surrealists, Matta introduced Motherwell to their process of psychic automatism. Automatism, or automatic writing, was essentially a form of doodling that the Surrealists employed to tap into the unconscious. For Motherwell, automatism (what he came to call "artful scribbling") became his lifelong "creative principle" and the generative means by which "*one's own being is revealed*, willingly or not, which is precisely originality, that burden of modernist

M

Elegy to the Spanish Republic No. 171, 1988–90
Acrylic on canvas
84 × 168 1/8 inches (213.4 × 427 cm)

conflicts, and unrelieved anxiety."[15] The monumental darkness of *Open #150 in Black and Cream (Rothko Elegy)* which is simultaneously reinforced and relieved by the lightness of the cream-colored rectangle at top, powerfully evokes the sublimity and poignancy of Rothko's art. The painting's compositional and symbolic use of black and the inclusion of "elegy" in its title intriguingly links the work to Motherwell's best-known works, his *Elegies to the Spanish Republic*.

From 1948 until his death in 1991, Robert Motherwell explored the expressive contrast of black and white and vertical bars and ovoid shapes in close to two hundred paintings, and in hundreds more drawings and prints. The Museum's collection includes three small studies of 1968, 1975, and 1976, and three paintings: *Andáyar (España)*, 1951; *Elegy to the Spanish Republic*, 1960; and the magisterial *Elegy to the Spanish Republic No. 171*, 1988–90. The *Elegies* refer to the Spanish Civil War (1936–39) and what the artist saw as the tragic defeat of Spanish republicanism. For Motherwell, they are less history paintings and more memorials: "I take an elegy to be a funeral lamentation or funeral song for something one cared about. The Spanish Elegies are not 'political,' but my private insistence that a terrible death happened that should not be forgot. They are as eloquent as I could make them. But the pictures are general metaphors of the contrast between life and death, and their interrelation."[16]

Like the *Opens*, the *Elegies* began by "studio chance": In 1949 the artist came across an ink drawing he had made the previous year for a poem by Harold Rosenberg to be reproduced in a never-published issue of the journal *Possibilities*. He enlarged the drawing, reworked it in casein on board, and titled it *At Five in the Afternoon* after the refrain in Federico García Lorca's poem "Lament for Ignacio Sánchez Mejías." The economical composition of ovals and vertical bars of these initial sketches is recalled in *Andáyar (España)*,

Stephen's Iron Crown, 1981
Acrylic on oil-sized canvas
88 × 120 1/8 inches (223.5 × 305.1 cm)

The recurrence of the phrase "je t'aime" in his paintings, prints, and collages qualifies it as the credo of Motherwell's deep love for artmaking.

Throughout his career, the artist worked in series, and often the compositions from one series affected those in another. *Stephen's Iron Crown*, 1981 is part of a group of paintings—all bearing titles that refer to James Joyce—that the artist produced in 1981, and that were shown the following February and March at M. Knoedler & Company, New York. These pictures were based on a 1979 series of oil-on-paper paintings, *Drunk with Turpentine*, which Motherwell had generated by the process of automatism. In these works, including the Museum's *Drunk with Turpentine No. 2 (Stephen's Gate)*, 1979 the artist thinned oil paint with turpentine to the consistency of ink and spontaneously let the work, in his words, "pour out."[31] The oil bled into the paper, producing a halo effect that appealed to Motherwell, so in *Stephen's Iron Crown*, he used passages of ochre paint along the edges of the black to simulate that look. The uppermost portion of *Stephen's Iron Crown* reveals the influence of another Motherwell series: *Beside the Sea* of 1982. Again demonstrating his adherence to the automatist

approach, works from this oil-on-paper series featured the energetic splattering of paint that is later manifested in *Stephen's Iron Crown*.

Motherwell's title for his 1981 work derives from Joyce's *Ulysses*, 1922. In his modernist literary epic, Joyce refers to the iron crown of King Stephen of Hungary, who Christianized his country and received from the Pope the crown used at his coronation on Christmas Day, 1000. Like other Abstract Expressionists, Motherwell perceived Joyce's stream-of-consciousness writing as being akin to automatism.[32] His admiration for the Irish writer's works is evidenced not only by the 1981 series of which *Stephen's Iron Crown* is part, but also by earlier compositions with Joycean titles, including the Museum's studies for *Shem the Penman*, 1972 and *Finnegan's Wake VII with Green*, 1974. But these works, like other Motherwell compositions that reference writers—such as Stéphane Mallarmé, Rafael Alberti, and Octavio Paz—present something much more than textual illustrations. More accurately, they can be described as offering visual correspondences to human feelings.

Stephen's Iron Crown, Je t'aime with Gauloise Blue, the *Elegies, Open #150 in Black and Cream (Rothko Elegy), Spanish Picture with Window*, and all of his many other works in the Museum's collection emphatically support Motherwell's belief that an artist is "someone who has an abnormal sensitivity to a medium."[33] The works also express his adherence to the Symbolist Mallarmé's dictum that one must strive to render not the thing itself, but the effect it produces. As Motherwell himself said, "to express the felt nature of reality is the artist's principal concern."[34]

MARK THISTLETHWAITE

1 Robert Motherwell, "A Personal Expression" (19 March 1949), in Stephanie Terenzio, ed., *The Collected Writings of Robert Motherwell* (New York and Oxford: Oxford University Press, 1992): 61.
2 Barbaralee Diamonstein, *Inside New York's Art World* (New York: Rizzoli Publications, Inc., 1979): 242.
3 "Interview with Bryan Robertson, Addenda" (1965), in Terenzio, 146.
4 *Motherwell* (Barcelona: Fundación Antoni Tàpies, 1996) states that it was painted in Mexico, but Terenzio, *The Collected Writings* and Robert Saltonstall Mattison, *Robert Motherwell: The Formative Years* (Ann Arbor: UMI Press, 1987) indicate that the work was executed in New York.
5 Mattison, 57.
6 Ibid., 58.
7 *Robert Motherwell: The Open Door Exhibition Guide* (Fort Worth: Modern Art Museum of Fort Worth, 1992): 7; see also Terenzio, 146.
8 Mattison sees the whiteness and sketchy linearity as relating to Pablo Picasso's *The Studio*, 1928, which Motherwell knew from Peggy Guggenheim's collection (Mattison, 58).
9 Quoted in Mattison, 42.
10 Ibid.
11 Diamonstein, 246.
12 H. H. Arnason, *Robert Motherwell*, 2nd rev. ed. (New York: Harry N. Abrams, Inc., 1982): 163.
13 Unpublished recollection, 10 March 1967, in Terenzio, 196.
14 Eulogy read at National Institute of Arts and Letters, 28 January 1971, ibid., 198.
15 Ibid.
16 Quoted in David Rosand, ed., *Robert Motherwell on Paper: Drawings, Prints, Collages* (New York: Harry N. Abrams, Inc., in association with the Miriam and Ira D. Wallach Art Gallery, Columbia University, 1997): 21. Motherwell made the statement in 1963.
17 E. A. Carmean, Jr. and Eliza R. Rathbone, with Thomas B. Hess, *American Art at Mid-Century: The Subjects of the Artist* (Washington, D.C.: National Gallery of Art, 1978): 102.
18 For a discussion of the problem of numbering, see Carmean et al., 95. Before its acquisition by the Museum in 1993, *Elegy to the Spanish Republic* had never been exhibited.
19 E. C. Goosen, "Robert Motherwell and the Seriousness of Subject," *Art International* 3 (11 January 1959): 34. Goosen also did warn that any sexual implication was secondary to "the inner secret the artist wishes to share but does not make explicit." For a discussion of the impact of Goosen's reading, see Carmean et al., 106.
20 Carmean et al., 107.
21 Terenzio, 179. The quotation is from a lecture, "On the Humanism of Abstraction," given by the artist at St. Paul's School in Concord, New Hampshire on 6 February 1979.
22 Carmean et al., 104. The quotation is from a 1951 article by Motherwell entitled "The Public and the Modern Painter."
23 Ibid.
24 Terenzio, 135. The quotation is taken from a 1962 conversation at Smith College.
25 Rosand, 33. The remark was made in the conversation cited in note 24.
26 Quoted in Jack Flam, *Motherwell* (New York: Rizzoli, 1991): 18.
27 Jonathan Fineberg, "Death and Maternal Love: Psychological Speculations of Robert Motherwell's Art," *Artforum* 17 (September 1978): 55.
28 Terenzio, 111. The letter is to John [last name not identified], 10 November 1956.
29 Arnason, 130.
30 Terenzio, 139. The artist's remarks were part of a talk presented to a group of psychotherapists in 1963.
31 *Robert Motherwell: "Stephen's Iron Crown" and Related Works* (Fort Worth: Fort Worth Art Museum, 1985): 16. *Drunk with Turpentine No. 2* led directly to the acrylic-and-oil painting *Stephen's Gate* (1981), while another in the series, and also in the Museum's collection, was the source for the painting *Stephen's Iron Crown*.
32 Evan R. Firestone, "James Joyce and the First Generation New York School," *Arts* 56 (June 1982): 116.
33 Terenzio, 136.
34 Terenzio, 179, 31.

M

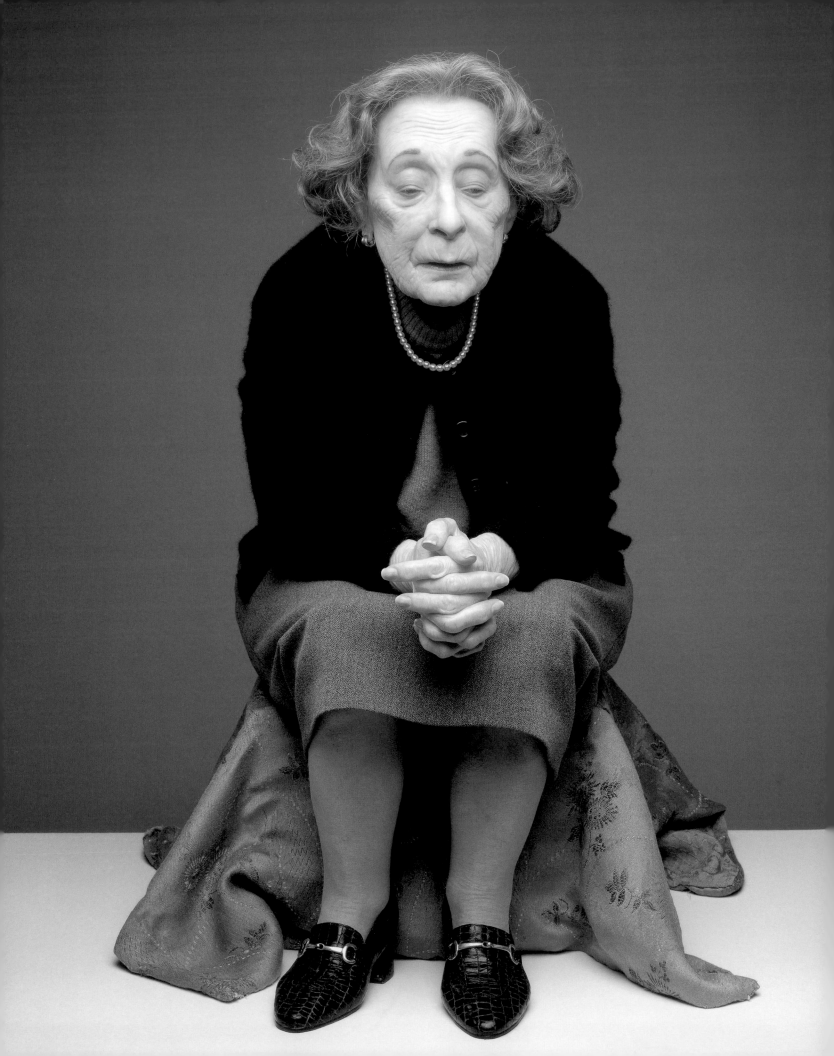

facing page:
Ron Mueck
Untitled (Seated Woman), 1999
Silicone, acrylic, polyurethane foam,
and fabric, 25 1/4 × 17 × 16 1/2 inches
(64.1 × 43.2 × 41.9 cm)
Commentary on page 267

this page:
Vik Muniz
The Doubting of Thomas, 2000
Cibachrome, 45 × 60 inches
(114.3 × 152.4 cm)
Commentary on page 268

Bruce Nauman
Setting a Good Corner (Allegory &
Metaphor), 2000
DVD, edition of 40, dimensions variable
Commentary on page 269

Nic Nicosia
Untitled #9, 1992
Oil on black-and-white photograph
36 × 36 inches (91.4 × 91.4 cm)
Commentary on page 270

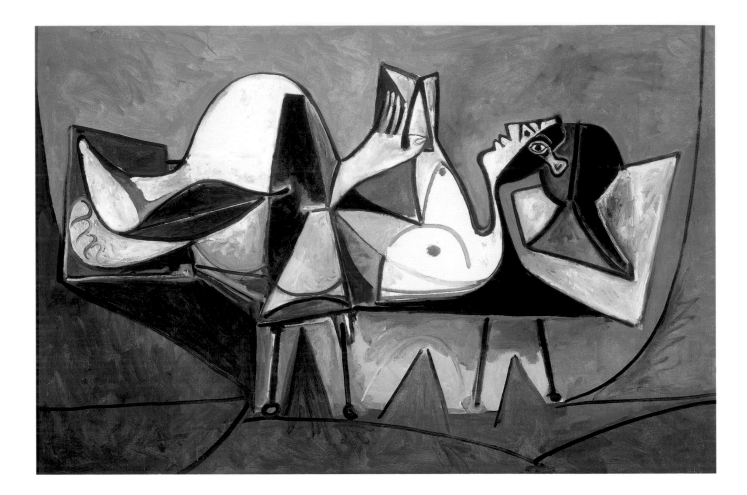

Pablo Picasso
Femme couchée lisant
(Reclining Woman Reading), 1960
Oil on canvas
51 ¹/₄ × 77 ¹/₄ inches (130.2 × 196.2 cm)
Commentary on page 274

Untitled (34 Bird), *c.* 1942
Pen and ink and gouache on
deep pink paper
10⅝ × 3¾ inches (27 × 9.5 cm)

of human/animal hybrids in meandering lines of
blue ink. In the center of the sheet, a four-legged
creature dominates the action. Part canine and
part human, the image predicts such
breakthrough paintings as *The She Wolf,* 1943
(The Museum of Modern Art, New York), inspired
partly by the wild animal of classical legend who
suckled Romulus and Remus, the twin founders
of Rome. Even if the artist had not undergone
Jungian analysis, he would very likely have been
aware of Jung's linkage between the modern
individual unconscious and the creation of
archetypes in myths and legends throughout
history, as Jung's ideas were a popular subject
of debate. In an interview conducted toward the
end of his life, however, Pollock stated explicitly,
"We're all of us influenced by Freud, I guess.
I've been a Jungian for a long time."[2]

Jung based a significant amount of his research
on the myths of "primitive," or non-Western,
cultures, and like the Cubists and Surrealists
before them, the Abstract Expressionists were also
inspired by the images produced by those
cultures. The Museum's small drawing *Untitled*
(34 Bird), *c.* 1942 on deep pink paper suggests
Pollock's interest in Native American cultures.
A standing figure with a cryptic, almost abstract
head sprouts four feathered wings rather than
arms, echoing feathered masks and totemic forms
Pollock had seen in periodicals, books, and
exhibitions. Pollock's interest in various types of
Native American masks is suggested by the fact
that these early figurative studies do not have
distinct or modeled faces, but appear cryptically
symbolic. Among the few papers the artist left
upon his death was a cut-out clipping from
The New York Times of a spread of ten masks from
The Museum of Modern Art's 1941 exhibition
Indian Art of the United States.[3]

The Modern Art Museum's important early
painting *Masqued Image,* 1938 evokes Pollock's
fascination with Picasso and Native American
shamanism. Loosely resembling the great Spanish

P

Number 5, 1952, 1952
Enamel on canvas
56 1/4 × 31 3/4 inches (142.9 × 80.6 cm)

Untitled (Collage I), c. 1951
Enamel, silver paint, and pebbles
on illustration board
21 3/4 × 30 inches (55.2 × 76.2 cm)

artist's famous painting *Girl Before a Mirror*, 1932
(The Museum of Modern Art, New York), *Masqued
Image* is a thickly painted mélange of disembodied
faces. Symbolically, the mask—like the mirror in
Picasso's painting—represents both reflection
and an inner search for the self. In her monograph
on Pollock, Ellen Landau notes, "Violet Staub de
Laszlo, who took over Pollock's psychiatric
treatment in 1941 after Joseph Henderson left
New York, has confirmed that during the period
she was seeing him, Jackson clearly exhibited a
'shamanistic primitive attitude' toward the
making of his images."[4] Masks are similar objects,
commonly used by shamans to communicate with
the supernatural and to induce personality
transformations.[5] Painted at a time when the artist
was attempting to address his alcoholism and to
locate an "identity" for himself and his art,

Masqued Image remains one of the artist's most
personal formative works.

By 1947 Pollock's self-reflective figuration had
given way to an expressive freedom that would be
the hallmark of Abstract Expressionism. The
floating masks literally unraveled to become a
lattice of free-floating drips and lines. Once again,
drawing became central to the artist's purposes.
By the time his paint hit the canvas, Pollock had
essentially reinvented painting by identifying it
with the spontaneity of drawing. "I approach
painting," the artist said, "in the same sense as
one approaches drawing; that is, it's direct."[6]
Pollock understood that drawing, freed from the
confines of a sheet of paper, could result in a new
type of space for painting. The viewer was no
longer looking into a window of illusion or at a
figure or object, but measuring himself against an
expansive field where linear gestures articulate
many focal points over a large canvas surface.
The drawing space that Pollock explored was
described by Harold Rosenberg as "an arena
in which to act—rather than as a space in which
to reproduce, re-design, analyze, or 'express'
an object."[7]

This is not to say that Pollock abandoned
working on paper during these so-called

"breakthrough" years. Although much of his efforts concentrated on large-scale paintings, the artist produced a number of rare drawings and paintings on paper, the Museum's *Untitled* (Collage I), *c.* 1951 being a superb example. *Untitled* (Collage I) represents Pollock's understanding and appreciation of the concept of scale; that is, the ability to make something small, even intimate, seem big. On a sheet of illustration board measuring twenty-one-and-three-quarters by thirty inches, the artist has created a pictorial galaxy using black enamel and silver paint infused with small pebbles. Discreetly dripping the paint near the corners and at times over the edges of the paper, the artist created lines of visual energy that suggest movement beyond the paper ground. Although flatness of the picture plane has often been a characteristic associated with Abstract Expressionism, Pollock's best works oscillate between surface and deep space, as in *Untitled* (Collage I). Here, the clusters of pebbles peek out of the pools of paint, enticing the eye to the surface, while also suggesting a telescopic view of a far-off planet or star clusters; a kind of Milky Way in enamel and rock.

It was also around 1951 that Pollock's abstractions began to mutate, the dark gestures of paint again suggesting a figurative presence. *Number 5*, 1952 was made during the artist's

controversial black-and-white period, in which he eliminated color and once again began drawing ambiguous figures into his abstract fields. Lee Krasner Pollock, the artist's widow, explained his technique: "…using sticks, and hardened or worn-out brushes…and basting syringes, he'd begin. His control was amazing. Using a stick was difficult enough, but the basting syringe was like a giant fountain pen. With it he had to control the flow of ink as well as his gesture."[8] *Number 5* demonstrates this control. A seated female figure, whose head, breasts, and legs seem spontaneously articulated, is embedded in a rush of lines and pools of black enamel. It is difficult to discern whether the figure has emerged from the overall field or the reverse, which creates a tight linkage between representation and abstraction. The same year, Pollock painted *Convergence*, 1952 (Albright-Knox Art Gallery), a monumental work in which similar figures float behind exuberant bursts of color. Throughout his career Pollock vacillated between a need to express himself figuratively and also in terms of abstraction, and the Modern Art Museum's small but poignant collection of Pollocks offers an insight into the creative wanderings of one of America's most acclaimed artists.

MICHAEL AUPING

1 Dorothy Sieberling, "The Wild Ones," *Time* 67 (20 February 1956): 73.
2 Selden Rodman, *Conversations with Artists* (New York: Devin-Adair, 1957): 87.
3 Ellen G. Landau, *Jackson Pollock* (New York: Harry N. Abrams, Inc., 1989): 60.
4 Ibid.
5 J. E. Cirlot, *A Dictionary of Symbols*, 2nd ed., trans. Jack Sage (New York: Philosophical Library, 1983): 205.
6 Quoted in Ellen H. Johnson, ed., *American Artists on Art from 1940 to 1980* (New York: Harper & Row, 1982): 8.
7 Harold Rosenberg, "The American Action Painters," *The Tradition of the New* (New York: Horizon Press, 1959): 25.
8 "An Interview with Lee Krasner Pollock by B. H. Friedman," in *Jackson Pollock: Black and White* (New York: Marlborough-Gerson Gallery, 1969): 10.

P

Richard Prince
Untitled (Cowboy), 1995
Ektacolor print, edition of 1
48 × 72 inches (121.9 × 182.9 cm)
Commentary on page 278

Martin Puryear
Red, Yellow, Blue, 1982
Painted pine
50 × 62 × 8 inches (127 × 157.5 × 20.3 cm)
Commentary on page 280

Commentary on page 280

Gerhard Richter

One of the most celebrated artists of the past two decades, Gerhard Richter is also one of the most perplexing. Since the early 1960s Richter has confounded our expectations that an artist must achieve an identifiable style in order to communicate effectively. At any given time, the artist's studio may contain thickly painted abstractions alongside meticulously rendered landscapes, still lifes, and portraits. In achieving the seemingly dubious status of "styleless" artist, Richter has, perhaps more than any other colleague of his generation, forced us to ask ourselves about the nature of representation and how we attach meaning to those representations.

If there is a continuity in Richter's art, it is to be found in a finely tuned dialectic that counterposes the seemingly irreconcilable opposites of subjective expression and objective analysis, and the mechanical versus the handmade. Richter seldom works directly from a subject, preferring the mediation of a photographic image. A majority of the artist's imagery (including many of his early abstractions) is derived from photographs, which he has kept in his "atlas," a vast private archive of photographic images taken by Richter or clipped from newspapers and magazines. Each of these images projects its own anomalous message peculiar to Richter's strangely oblique view of "reality."

Born in the former East German city of Dresden in 1932, Richter was encouraged to become a commercial artist at the age of sixteen, working as a scene painter for a theater company and as a sign painter in a factory, making political banners. After training in a Social Realist style, he began to take a serious interest in more avant-garde artistic forms from the United States and other parts of Europe, which were not condoned in East Germany. As a result of this, the young artist immigrated to West Germany in 1960 and enrolled in the Staatliche Kunstakademie Düsseldorf in 1961. He was immediately attracted to the experimental performances and installations of the Fluxus movement, led by George Maciunas and Joseph Beuys. Of equal if not greater importance, however, was his first exposure to American Pop art by Andy Warhol and Roy Lichtenstein. In 1963 Richter and a small group of art students—Sigmar Polke, Manfred Kuttner, and Konrad Lueg (who later became the art dealer Konrad Fischer)—organized what they called "the first exhibition of German Pop art" in a rented storefront in Düsseldorf. They dubbed their movement "Capitalist Realism," a term that satirized Social Realism in the East (and its restricted approach to artistic expression), as well as the highly capitalist nature of American Pop art. Richter's subsequent approach to "realist" painting would also be infused with irony.

Ferrari, 1964 encapsulates many of the issues that Richter would explore in his Capitalist Realism phase. The painting depicts a Ferrari automobile (what appears to be the 400 Superamerica model, initially developed in 1962) as it was photographically reproduced in a German car magazine. Richter's image questions the very definition of realism. The reality of Richter's Ferrari is not that he is depicting a car from "life," but a photographic image from a magazine; in effect, reproducing a reproduction, in this case by hand. Not only has Richter rendered the photograph of the car, but he has also meticulously painted the accompanying German text from the magazine page, which appears to be a critical assessment of the automobile's abilities under racing conditions:

…which would necessitate changing production methods. The pressure of a few sports-crazy engineers (like Zora Arkus Duntov, who had been sighted many times at Le Mans and also at the steering wheel of a Porsche) has for years, behind the scenes, been…
…, that while braking, power is released which hinders the car rising too high at the rear end and dipping too much at the front. The drive

Ferrari, 1964
Oil on canvas
57 × 78 ½ inches (144.8 × 199.4 cm)

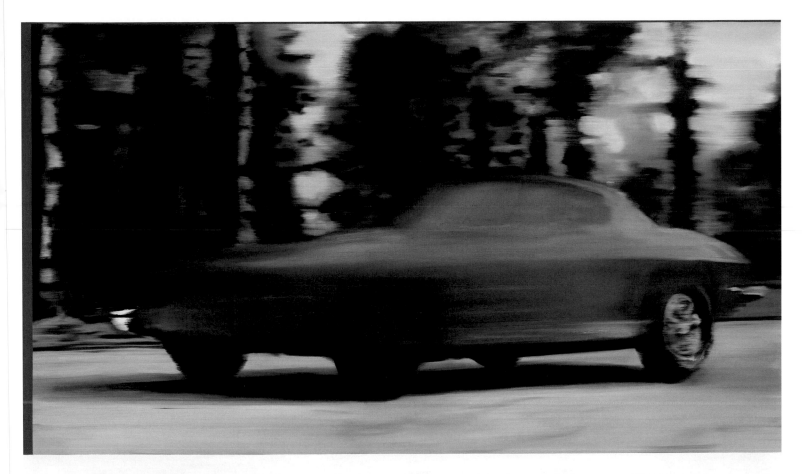

shaft has two holes on the exterior ends into
which the links of the rods can be screwed as
wished, so that the driver of an apparently direct
or less direct steering…
…with racing tires, which show little rod
resistance, undoubtedly in order that a
somewhat higher speed could have been
reached. The 3.36 reduction is exceptionally
comfortable for road use, considering that at
peak rotation the engine is vibration-free and
relatively quiet…

Images of automobiles are not uncommon in
art produced after World War II, and to some

extent Richter's laborious representation reflects
the widespread impact of mass-produced auto-
mobiles on society in the 1950s and early 1960s,
as well as visual artists' increasing interest not
only in popular subject matter, but in the use of
mass advertising. We can assume that the visual
stimulus of advertising must have made a fairly
significant impact on a young painter from a
Communist regime who had been exposed
primarily to propaganda and state-approved
images, and thus had little contact with free-
market advertising. Richter's choice of a Ferrari—
one of the most prestigious names in auto racing
at the time—is also significant. Richter painted

R

the Sea, 1809–10 (Schloss Charlottenburg, Berlin), which depicts a small figure staring out toward a vast and turbulent ocean, is often considered an icon of German Romanticism and of the philosophy of Edmund Burke and his concept of the sublime. The common denominator in all discussions of the sublime is the attempt to come to terms with limitlessness. This limitlessness is, in Burke's terms, invariably a function of space rather than form.[4] For Immanuel Kant, who acknowledges his indebtedness to Burke in *The Critique of Judgement*, the sublime evokes the idea of boundless and infinite space, whereas beauty is associated with form and limitation.[5] In the case of both Friedrich and Richter, space and infinity are implicit subjects, although the artists ultimately address them from very different viewpoints.

Richter has commented, "A painting by Caspar David Friedrich is not a thing of the past. What is past is only the set of circumstances that allowed it to be painted, specific ideologies, for example....it is therefore quite possible to paint like Caspar David Friedrich 'today.'"[6] However, he has also qualified such statements, suggesting that his paintings reveal elements of irony and loss that distinguish them from those of Friedrich's, stating, "If the Abstract Pictures show my reality, then the landscapes and still lifes show my yearning," further pointing out that he is motivated by "the anachronism in them" that "takes on a subversive and contemporary quality."[7] The artist has also said "my landscapes are...above all 'untruthful.'"[8] In fact, a work like *Sea Piece—Wave* recasts nature to embrace a more complex, contemporary truth.

On the one hand, it is possible that Richter's gaze suggests, as Friedrich's images did before him, a contemplative need to understand the "spiritual" essence of nature and the infinite, as if the moon and ocean in *Sea Piece—Wave* and the light they reflect represent an all-powerful, unknown God. There is something ambiguous in

Richter's Romanticism, however—an underlying doubt and remove that has to do with the artist's stubbornly clinical viewpoint. Richter has indeed been fascinated with the phenomenon of light, but from the standpoint of its sheer visual presence between photography and painting rather than its symbolism. In making *Sea Piece—Wave*, Richter projected a photograph onto canvas and then laboriously copied the image in oil paint. The result is two simultaneous illusions of reality. Richter is translating not only nature into paint, but also a photograph of that nature into paint;

that is, nature twice removed. Moreover, he incorporates essential characteristics of his amateur photography into the painting, such as the haziness and "bad" lighting associated with snapshots, as well as a slight dulling of colors that is typical of mass-produced commercial printing. In this way he is not simply copying a photograph but indeed "making a photograph" with paint. Despite the suggestion of a Romantic scene, then, *Sea Piece—Wave* projects a strange neutrality of emotion, a distant and disappearing symbol of the transcendent.

In *Sea Piece—Wave*, the dominant palette is primarily gray, with a remarkable range of tones. Out of this hazy grisaille field, smoky plumes of red and yellow emerge, suggesting an ethereal, indeterminate space. Regardless of the intervention of photography in Richter's image, the atmospheric blurring he embraces can be linked (ironically or otherwise) to Friedrich's own strategies. Friedrich stated that "when a landscape is covered by mist, it appears grander and more sublime. It strengthens the power of the imagination and arouses our expectation.... The eye and our fantasy are more readily attracted by nebulous distance than by what lies closer and more distinctly in front of us."[9]

Like other Richter landscapes, many of which depict unspectacular scenes of paths going nowhere, or fields of grass with no obvious subject or "event," *Sea Piece—Wave*'s blurry opacity leaves us wondering what we are looking at, and why. Richter demonstrates little interest in romanticizing nature, but rather represents it separate from the fantasies of human consciousness. It is for this reason that he understands his landscapes as being "'untruthful'... and by 'untruthful' I mean the glorifying way we look at Nature—Nature, which in all its forms is always

against us, because it knows no meaning, no pity, no sympathy, because it knows nothing and is absolutely mindless: the total antithesis of ourselves, absolutely inhuman."[10]

The portrait *Ema (Nude Descending a Staircase)*, 1992 is, in its own way, as mysterious and unlocatable as *Sea Piece—Wave*. *Ema* also began as a photograph, in this case a slightly blurry full-length nude portrait of the artist's first wife descending a staircase. The image was subsequently translated into a painting. Finally, Richter photographed the finished painting, creating a full-size photograph of a painting from an "original" photograph. In part, *Ema* refers to Marcel Duchamp's infamous *Nude Descending a Staircase*, 1912 (Philadelphia Museum of Art), which scandalized the 1913 Armory Show in New York. Duchamp's cubo-futuristic image was inspired by Étienne-Jules Marey's experiments in sequential photography. Referring to photography's ability to capture each seemingly mechanical move of the human body in movement, Duchamp boldly de-eroticized the female nude, transforming it into geometric planes that suggest a robotic figure analogous to modern machines. Richter acknowledges that Duchamp was an influence in his making of *Ema*, but negatively, "because his painting *Nude Descending a Staircase* rather irritated me."[11] In a very personal subject through three layers of reproduction (two of them mechanical), Richter ironically embraces the mechanical eye, while refuting Duchamp's mechanistic aesthetic. *Ema* emerges as a sensuous but ghostly apparition. As in the case of *Sea Piece—Wave*, there is a powerful fragility to *Ema*'s presence.

MICHAEL AUPING

1 Gerhard Richter, *The Daily Practice of Painting: Writings and Interviews 1962–1993*, ed. Hans-Ulrich Obrist, trans. David Britt (London: Thames & Hudson in association with Anthony d'Offay Gallery, 1995): 66.
2 Ibid., 73.
3 Ibid., 74.
4 Edmund Burke, *A Philosophical Inquiry Into the Origin of Our Ideas of the Sublime and Beautiful* (1757; reprint, ed. J. T. Boulton, New York: Columbia University Press, 1958): 61.
5 Immanuel Kant, *The Critique of Judgement* (1790; reprint, trans. J. C. Meredith, London: Oxford University Press, 1952).
6 Richter, 81.
7 Ibid., 98.
8 Quoted in O. Bätschmann, "Landscape at One Remove," in *Gerhard Richter: Landscapes*, ed. Dietmar Elger (Ostfildern-Ruit and New York: Hatje Cantz and D.A.P. in association with Sprengel Museum Hanover, 1998): 30.
9 Quoted in Jean-Philippe Antoine, "Photography, Painting, and the Real: The Question of Landscape in the Paintings of Gerhard Richter," in Gertrud Koch, Luc Lang, and Jean-Philippe Antoine, *Gerhard Richter* (Paris: Editions Dis Voir, 1995): 77.
10 Richter, 124.
11 Richter, 225.

R

Linda Ridgway
Three Squares, 2001
Bronze
108 × 26 × 26 inches (274.3 × 66 × 66 cm)
Dimensions variable
Commentary on page 284

148

Susan Rothenberg

Cabin Fever, 1976
Acrylic and tempera on canvas
67 × 84 1/8 inches (170.2 × 213.7 cm)

I didn't start out thinking of them [the horse images] as portraits...but gradually they did become a little less formal and more moody. There were times—though not all the time—that I definitely saw parts of myself in the horses.[1]

In 1973 Susan Rothenberg unconsciously doodled a crude horse image on a small sheet of paper. Intrigued—up to that point she had been making abstract Color Field paintings—she drew a similar image on a small piece of unstretched canvas. Thinking that she had done something wrong, the artist rolled up the small canvas and stuck it in a closet for a year.

From those early, seemingly offhand gestures, Rothenberg eventually developed a body of paintings that would be a defining moment not only for Rothenberg's career, but for the character of American painting as it would eventually develop in the last decades of the twentieth century. At a time when the austere imagery of Minimalist abstraction dominated the influential pages of the international art magazines, Rothenberg's horses were catalytic to a process in which figurative art in America would boldly reinvent and reassert itself.

The horse paintings constitute an image of profound synthesis, refiguring painting in a manner that acknowledged the impact of previous generations at the same time it drew new boundaries. These are works that maintain the inherent flatness and abstract tactility of the picture plane—a central concern of formalist painting in the 1940s, 1950s, and 1960s—while adding an unexpectedly potent image. The geometric lines and bars that cut through some of these images—in a number of cases the horse image is crossed out, drawn over, or quartered—create a unique melding of abstraction and figuration. As Rothenberg puts it, "In the early years, I had ambiguous feelings about the horse and what it meant to me. My formalist side was denying my content side. I wasn't sure if I wanted

the horse to disappear. Eventually, I began tearing it apart to find out what it meant. It obviously became a vehicle for certain kinds of emotions."[2] Rothenberg's formal manipulations notwithstanding, the horse did not elegantly disappear like Jasper Johns's *Flags*, to which they have often been compared. They are not simply a scaffolding for formal invention, but a vehicle of content.

Rothenberg is part of a loosely defined generation of artists that matured in the 1970s, a period of cross-fertilization and experimentation that witnessed the emergence of Conceptual art, Earth art, the women's movement, video art, performance art, and the so-called New Image Painting[3] with which she would eventually be linked. Her imagery reflects a particular moment when performance, painting, and sculpture of all types engaged in dialogue. Rothenberg studied dance with Deborah Hay and Joan Jonas before helping Nancy Graves construct her life-size camels.

For the performer-cum-painter, the horse was a personal signifier in a kind of pictorial

Orange Break, 1989–90
Oil on canvas
79 5/8 × 95 1/8 inches (202.2 × 241.6 cm)

performance. The fact that in 1974 the artist took
Polaroids of herself posed on all fours as studies
for paintings that never happened speaks for itself.
Rothenberg's horses are of human scale. In many
cases, they are close in size to the small, muscular
woman who painted them. Manifestations of a
covert expressionism, they illustrate the artist's
desire to reconnect to the body as an emotional
signifier. These horses fall down (*Axes*, 1976),
appear to weep as they stumble along together
(*Layering*, 1975), or in the case of the Modern Art
Museum's *Cabin Fever*, 1976, are literally and
symbolically stuck in place.

Rothenberg has described *Cabin Fever* simply
as "When you go nowhere."[4] The implication of
the image and the title is that of entrapment, or at
least stasis, a condition that could be both
psychological and pictorial. Rothenberg generally
titles her paintings after the fact, often when she is
in the process of contemplating her next creative
move. Although it would be logical to construe the
horse paintings as a series, they are, in fact, very
specific and individual undertakings. Asking
Rothenberg what she is working on during one of
these interludes often elicits the response, "I don't
know where I'm going yet," and in fact, she has

often thought that her most recent horse painting would be the last.[5] *Cabin Fever*, then, is symbolic of the unusual creative burst she experienced in 1976 (a number of her most memorable early works were done in that year), as well as the lingering doubts she often experienced about finding the next image to paint. The painting itself offers a formal parallel to this state, creating a strong tension between a sense of freedom—the horse image gallops in almost giddy exuberance—and entrapment, as the horse seems pinned in by the edges of the canvas, which are only a few inches from its nose and rear end.

Over the past two decades, Rothenberg has transformed the profile horse image into a diverse range of symbols, including hybrid human-animal figures, monumental heads and masks, fragmented dancers, landscapes, and strangely twisted bodies, each part of a larger narrative made up of the artist's observance of her current emotions and surroundings.

One of the most significant changes in the artist's life and career came in 1989, when she married the artist Bruce Nauman and subsequently moved with him to Galisteo, New Mexico. The move incited a provocative series of figures in various stages of deformation, which have come to be as critically acclaimed as the artist's early horse paintings. *Orange Break*, 1989–90 is from that important series. Constructed from a painterly field of deep reds and oranges, a single figure coils into a circle, its head tightly wedged between its legs. The tension of the form is so radical that it apparently breaks in half. As with her early horses, these figures form a kind of pictorial performance; the figure (whether a horse or human form) demonstrates an aspect of the mind that has no correlation in language. *Orange Break* is especially poignant in its mixed messages of sensuality and stress. The red-orange coloration of the painting evokes a heated, erotic quality, as if two figures are coupling in an amorous embrace. The image may also be a metaphor for Rothenberg's

complicated relationship to representation: a figure that is simultaneously pulling apart as it comes back together. The artist's straightforward comment on the painting suggests both possibilities: "It's sexual. Breaking to reconnect."[6]

Along with the tactile assertiveness of her brushstrokes, the diversity of Rothenberg's pictorial language is one of the qualities that sets her work apart from other figurative painters of her generation. She once said, "Maybe I paint like a man and think like a woman."[7] Rothenberg has never been a high-profile feminist, but she has clear views on the politics of equity, as well as the consequences of difference, and how those differences affect basic approaches to image-making:

MA: Do you think there is such a thing as "women's painting" or maybe, more accurately, a female sensibility as opposed to a male sensibility? Do you think such a thing exists?

SR: I never know what to do with these questions. I know men and women are different. I would imagine that a lot of the problem solving is dealt with differently. But I would hate to think that you could walk into a room and identify the sex of the painter. Because we all know that we have male and female in each one of us.... Most of the art that I saw as a young woman was made by a man, of course, and if there is one factor that I think women artists allow for better than men, it is rendering the world, truly I think, as more various. Men often try to impose coherence on that condition.

The issue of coherency is a key factor in understanding Rothenberg's approach to painting, an approach that keeps the figure in a constant state of flux, resulting in a body of work that has clearly enlivened the painted image in the late twentieth century.

MICHAEL AUPING

1 The artist in one of numerous conversations with the author, October 1990 to April 1992.
2 Ibid.
3 Richard Marshall, *New Image Painting* (New York: Whitney Museum of American Art, 1978).
4 Quoted in Michael Auping et al., *Susan Rothenberg Paintings* (Monterrey: Museo de Arte Contemporáneo de Monterrey, 1996): 120.
5 Conversations with the author, October 1990 to April 1992.
6 Auping et al., 172.
7 Quoted in Michael Auping, *Susan Rothenberg: Paintings and Drawings* (Buffalo: Albright-Knox Art Gallery, 1992): 55.
8 Ibid.

R

Edward Ruscha
Jar of Olives Falling, 1969
Oil on canvas
60 × 54 inches (152.4 × 137.2 cm)
Commentary on page 288

Lucas Samaras
Stiff Box #10, 1971
Cor-ten steel
21 3/4 × 22 × 15 7/8 inches (55.2 × 55.9 × 40.3 cm)
Commentary on page 289

Kurt Schwitters
Egg, Half Moon, Birchwood, Opening
Blossom, and *Flint Pebble,* 1937–47
Painted plaster, dimensions variable
Commentary on page 290

Sean Scully

Over the past decade the Modern Art Museum has acquired Sean Scully's work in depth. The total number of works in the Museum's collection includes thirty-four paintings and sixteen works on paper. A distinct body of works within this group is the artist's *Catherine* series, acquired in their entirety from the artist in October 2001. Between 1979 and 1996, the artist chose a particularly representative painting each year, which he titled after his then wife, artist Catherine Lee, retaining that painting for his personal collection. The result is a condensed, almost two-decade retrospective of the artist's work.

The first *Catherine* painting, completed in 1979, reflects the formative influence of Minimalism on the artist's early development. Speaking of *Catherine*, 1979, the artist remembers being "completely involved with very basic structures, as I understood them through [Carl] Andre, [Agnes] Martin, and [Sol] LeWitt. Also, the music of Philip Glass was in the air."[1] Indeed, the systemic and layered character of much Minimalist work can be seen in *Catherine*, 1979, in which two mixed colors are laid down using a predetermined formula. Having measured the canvas support precisely, and with the use of masking tape, the artist applied alternate bands of blue-black and brown-black paint so that each color covers exactly fifty percent of the surface, creating a subtle optical buzz that Scully has described as "a cushion of air in front of the painting." Although systemic in origin, there is a gentle sense of "touch" not only in surface character but in the subtle way the colors set each other off, as in the point where sky and horizon meet. This is clearly a nod to Martin rather than to Frank Stella, whose work is often brought up in discussions of Scully's early work.

By 1982 Scully exchanged precise measurements and sharp, masked edges for a more intuitive approach as in *Catherine*, 1982, involving alternate stripes of red and orange interrupted by a tightly fitted insert (literally a canvas within a canvas) covered with blue and black stripes. By now, all of

the stripes had become thicker, wider, and had rougher edges. From that point on, Scully's work became fundamentally architectural. Utilizing massive stretcher bars, the artist literally built up his paintings like reliefs. You aren't necessarily drawn into these pictures of the 1980s as much as asked to back up and give them room. It could be argued that Scully was making art that had the appearance of painting but the visual weight of sculpture. *Catherine*, 1983, for example, may be the closest painting comes to post-and-lintel architecture, with a panel of massive orange and brown horizontal stripes balanced on top of one with equally hefty vertical stripes of black and white. The artist refers to such works as "Druid Minimalism," evoking the stacked boulders at Stonehenge and the stoic balance they represent.

Scully's works are never framed, since a frame is

s

Catherine, 1982
Oil on canvas
114 × 97 3/4 inches (289.6 × 248.3 cm)

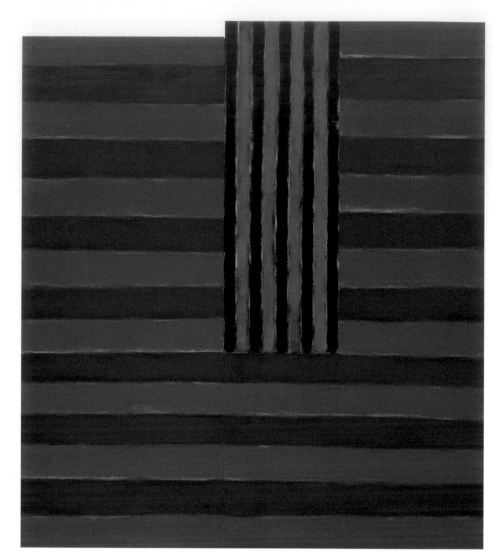

designed to isolate our experience from the wall, and Scully's paintings identify with the wall. The result is not so much a painting on a wall, but a wall on a wall. Over the course of the past twenty years, the meaning and presence of this wall has changed, moving from the realm of youthful physicality and assertiveness into the ethereal area of the emotional and metaphysical. An early indication of the emotional weight these stripes would carry is the dark, elegiac *Catherine*, 1986, painted shortly after the death of his son. Scully can't remember making a painting that did not in some way incorporate black, but in this case it is palpably tragic.

By the late 1980s the heaviness and darkness that characterized much of the first decade or so of his work began to take on various degrees of light. Both through its title and its color organization of alternating vertical bands of orange-red and ashy white, a painting like *Pale Fire*, 1988 suggests a softened geometry and more subtle approach to the evocation of light. The optical effect of these bands, and a small insert of gold and brown vertical lines, creates the abstract effect of a fire in its twilight moments.

The same year that Scully painted *Pale Fire*, he found himself experimenting with watercolor on a beach in Zijuatanejo, Mexico, where he created the first image that would inspire an extended meditation on architecture and light. In this ongoing series, which he entitled *Wall of Light*, simple but ultimately profound changes took place in Scully's art. What had been "stripes" of color became "bricks" of color, suggesting a new chapter in the context of his work. Regarding that trip the artist remarked, "I can't exactly explain it, but seeing the Mexican ruins, the stacking of the stones, and the way light hit those facades, had something to do with it, maybe everything to do with it."

The title *Wall of Light*, evocative in so many ways, is weighted with contradiction. A wall has density; it separates and divides. It contains space

and closes off light. Light, on the other hand, is ethereal; it opens and spreads. It radiates and fills space. These polarities are an intrinsic part of the process and content of Scully's recent paintings, in which he uses these apparent contradictions to create emotional content.

In that first Mexican watercolor, we can glimpse the change in process. Vaguely rectilinear blotches of color stain the small, thick sheet of paper. Like beams, or stones, these shapes imply a strength and support that is effectively countered by the diffusiveness of the watercolor medium. This was Scully's first use of watercolor (on a whim, he purchased a nineteenth-century-style watercolor travel kit just before leaving on his Mexican

Catherine, 1983
Oil on canvas, two panels
Overall 115 × 96 inches (292.1 × 243.8 cm)

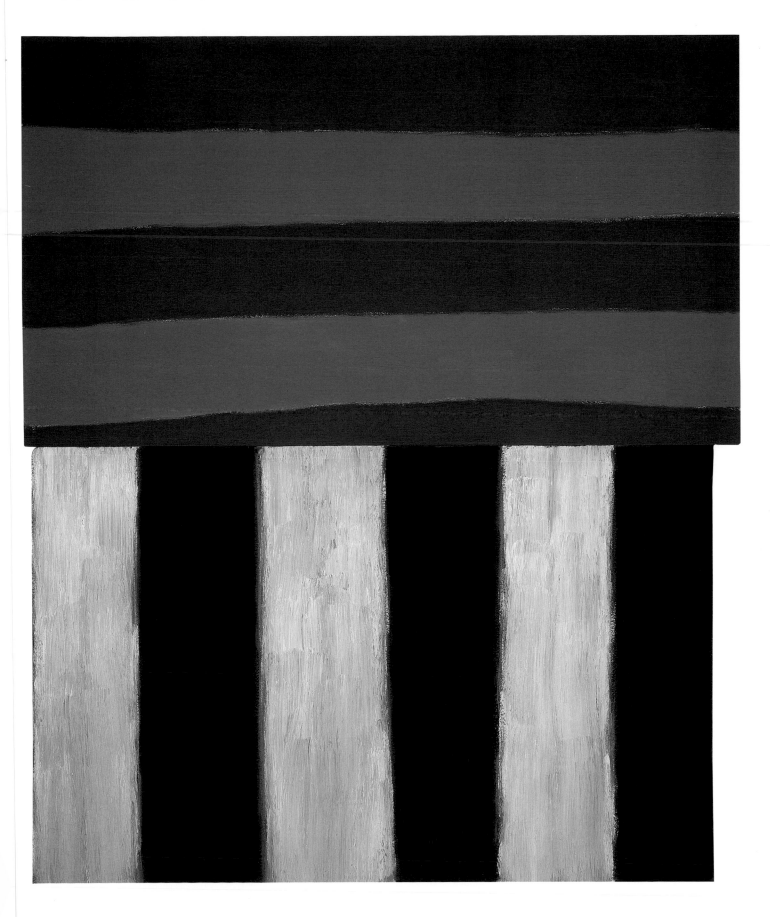

s

Wall of Light Desert Night, 1999
Oil on linen, two panels
Overall 108 × 132 inches
(274.3 × 335.3 cm)

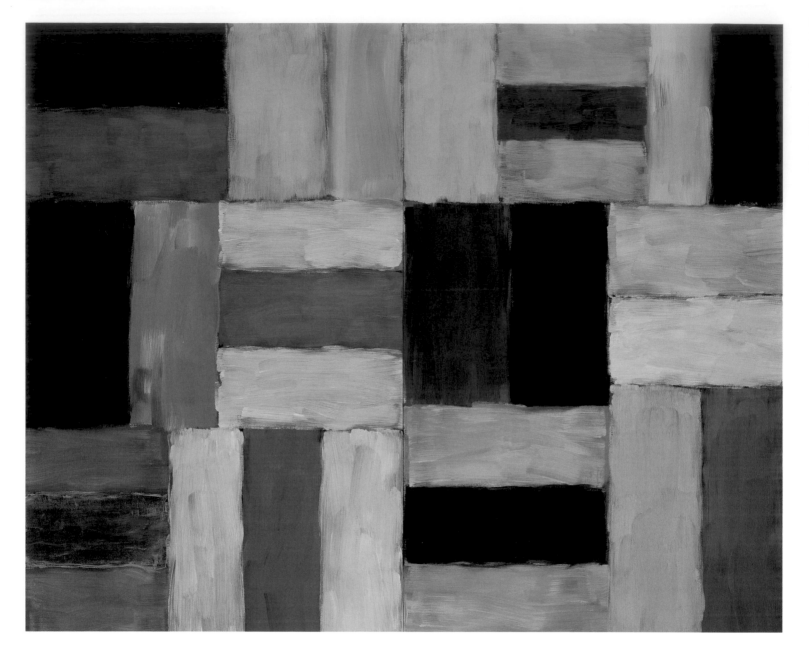

elegy to the Gaelic latent in him. Educated in England, Scully speaks longingly of an Ireland he never fully experienced. "London," he says, "is where I learned my craft. Ireland is where I look for myself." One could argue that Scully has used his different ports of call to help him define his Irishness, and that this Irishness is now emerging in a way that it could not have when he was a student and practicing artist in London.

Ireland's rural character leaves its imprint on anyone who has visited. An island of green and mist, the Irish landscape is like a national symbol. It is the atmosphere of this landscape that has impressed Scully—the way light peeks in and out of perception, and how this quality might relate to the people that live in it and the history they have lived. The Irish have reason to be sensitive to light. Given its relative scarcity over long winters, they can wax poetically on the different colors of darkness. Scully's *Wall of Light* images might just as easily represent landscapes and atmospheres of imagined memory. Irish light has a peculiar and melancholic quality, what the late poet Robert Duncan called "a light wet with doubt."[2] Indeed, Scully is not a painter of first light, when the dawn brings the optimism of new beginnings. Scully gravitates to dusk, to late light, when doubt fuels the imagination.

While many artists seek to bring light out of dark, Scully seems intent on bringing darkness to light, as if he were revealing a deeper inner secret.

He said recently, "I'm sure you know that the Irish have a darkness that is more powerful than light." In the office next to his studio, a cubbyhole contains a small drawing by the artist that shows a primitive-looking wall or structure supporting a poem by Scully, the words of which are a variation on *The Dire Fire of Ireland*. It does not take a great leap to see the wall the artist uses in his titles as a broad metaphor for a space where the light and dark, the material and the metaphysical, meet.

Scully's photographs of stone fences and walls on the Isle of Arran in Scotland offer a particularly apt clue to the artist's philosophy of painting. Each of the stones that make up these walls is lifted by hand and placed in response to a previous one, the action then repeated until a wall is deemed finished. Such architecture, created stone by stone, celebrates the beautiful honesty and awkwardness of human ingenuity. For Scully, this honesty is directly related to the act of painting, which is equally reflexive, with each brushstroke formed to and informing others. His *Wall of Light* paintings are not illustrative of a particular wall, but are virtually analogous to the building of one. Color is applied in various brick-like configurations that must fit together in order to create a compact, overall field—one that is not too perfect. Scully's blocks of color, at their best, have the naturalness of stones.

MICHAEL AUPING

1 Quotes by the artist are from conversations with the author in London, 3 November 2000.
2 Robert Duncan in conversation with the author, May 1983.

S

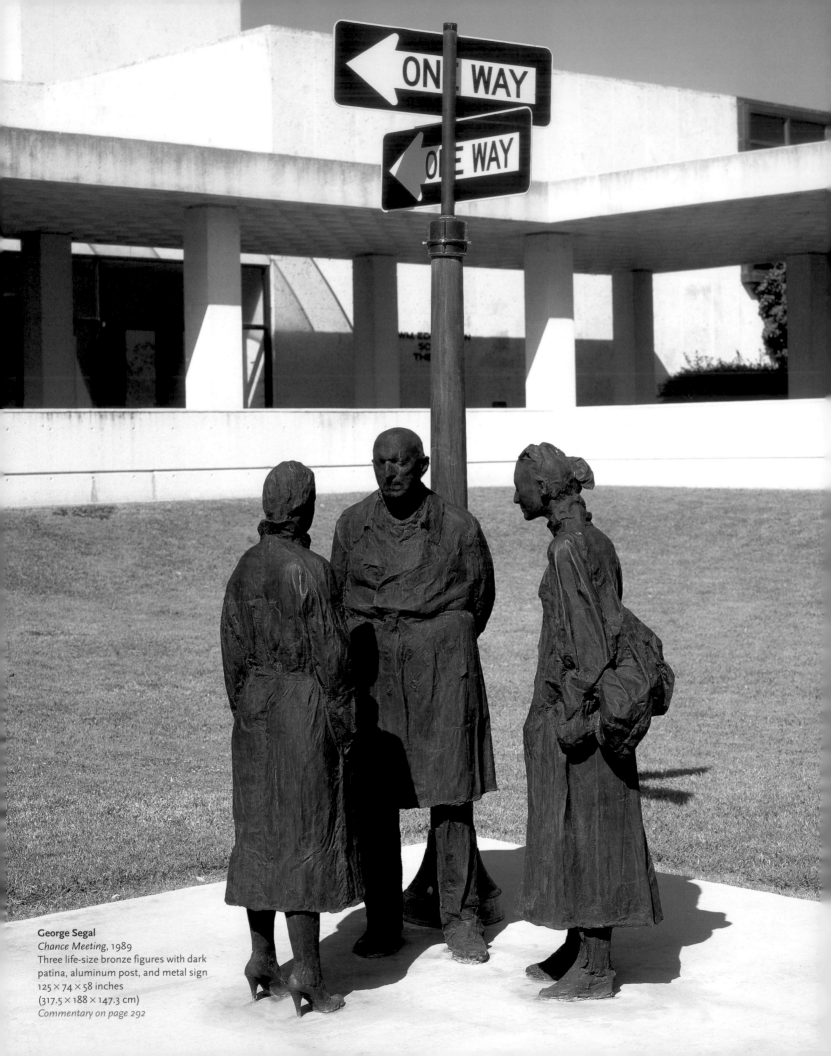

George Segal
Chance Meeting, 1989
Three life-size bronze figures with dark
patina, aluminum post, and metal sign
125 × 74 × 58 inches
(317.5 × 188 × 147.3 cm)
Commentary on page 292

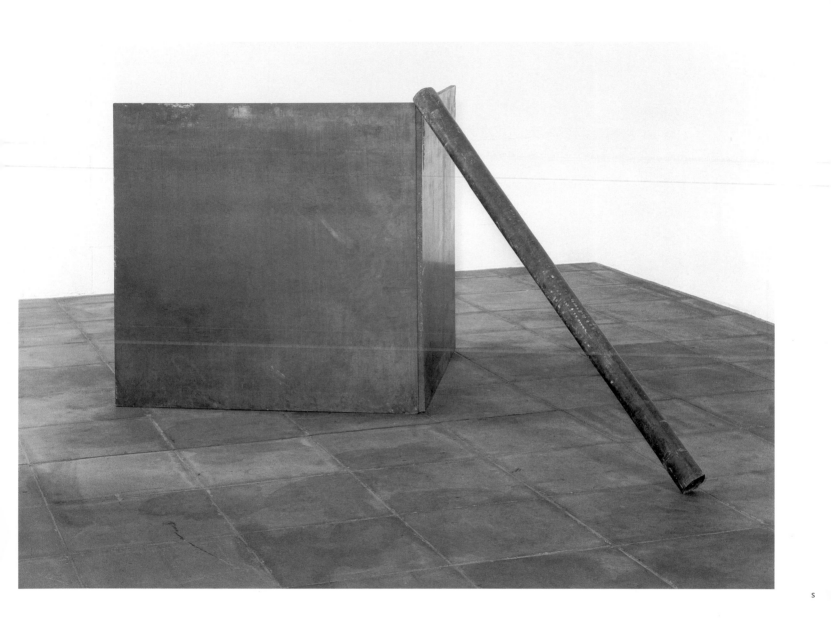

S

Richard Serra
Right Angle Corner Prop with Pole, 1969
Antimony lead
51³/₁₆ × 76³/₄ × 76³/₄ inches (130 × 194.9 × 194.9 cm)
Commentary on page 292

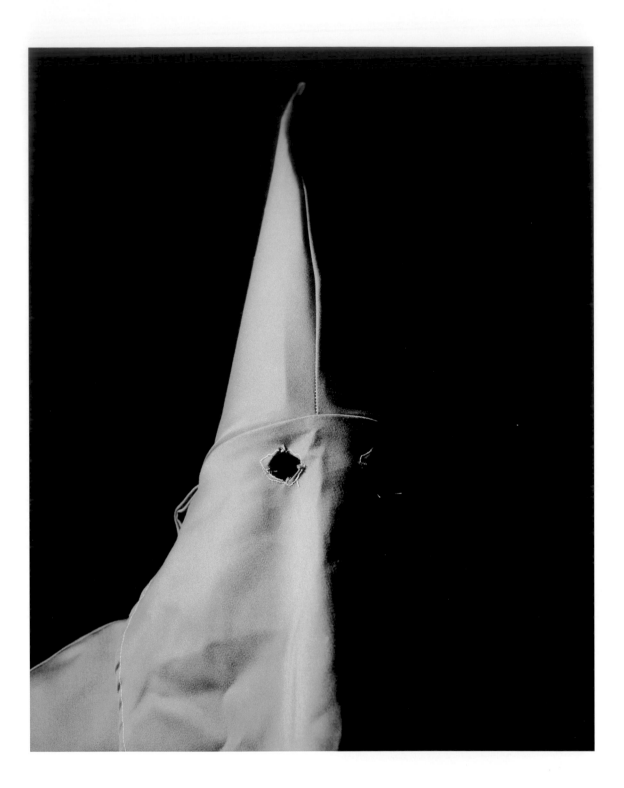

Andres Serrano
Klansman (Imperial Wizard III), 1990
Cibachrome print, edition of 4
60 × 49 ¹/₂ inches (152.4 × 125.7 cm)
Commentary on page 293

166

Ben Shahn
Allegory, 1948
Tempera on panel
36 ⅛ × 48 ⅛ inches (91.8 × 122.2 cm)
Commentary on page 295

Untitled, 1981
Cibachrome print
24 × 48 inches (61 × 121.9 cm)

anonymous star in fake movie scenes, firmly connect her to postmodernism's questioning of individuality, originality, and authorship.[2] By using "Untitled" with sequential numbering to identify each "film still," Sherman indicates that the images "refer" to movies that do not exist (and therefore have no author). Rosalind Krauss sums up this point best in *Cindy Sherman 1975–1993* by saying that Sherman produces "a copy *without an original.*"[3]

Like the very 1950s film genres she mimics—film noir, psycho-thrillers, melodramas, and B movies—her scenes are beautifully staged artifices. *Untitled Film Still #55,* 1980 is a night scene in which a blonde, self-assured, and unwitting Sherman walks down the center of an empty street surrounded by abandoned buildings. This scene is reminiscent of Alfred Hitchcock's 1958 film *Vertigo,* in which Kim Novak's character is the object of the male protagonist's sexual obsession. In viewing *Untitled Film Still #55,* we are privy to something that Sherman's character is

not—we sense that she is in danger, and we see no clue in her expression to indicate that she feels vulnerable. In fact, in each of the *Untitled Film Stills,* we can look directly at Sherman's protagonist, but our gaze is never acknowledged or returned. This dynamic occurs just as it would if watching a suspense movie's plot unfurl. As is often the case in movies, we are empowered by knowledge that the character lacks, yet we are unable to help. This creates a voyeuristic relationship between us and the observed, i.e., the female lead.[4]

Sherman last used black-and-white imagery in 1980, switching to color to challenge herself. To explain this shift, Sherman has said, "Black-and-white lends such a nostalgic feeling to photographs and I wanted to move on."[5] Even so, she continued to investigate the effects of visual imagery on our culture, and the issue of the gaze, which often places us in the position of assessing ourselves and others based on what we see.

The evolution of Sherman's work can be seen

Untitled #207, 1989
Cibachrome print
65 11/$_{32}$ × 49 13/$_{16}$ inches (166 × 126.5 cm)

s

Leon Polk Smith
Homage to Victory Boogie Woogie
No. 2, 1946–47
Oil on wood
29 1/2 inches (74.9 cm) diameter
Commentary on page 298

174

Nicolas de Staël
The Football Players, 1952
Oil on canvas
32 × 26 ³/₄ inches (81.3 × 67.9 cm)
Commentary on page 299

Clyfford Still
1956-J No. 1, Untitled, 1956
Oil on canvas
115 × 104³/₄ inches (292.1 × 266.1 cm)
Commentary on page 302

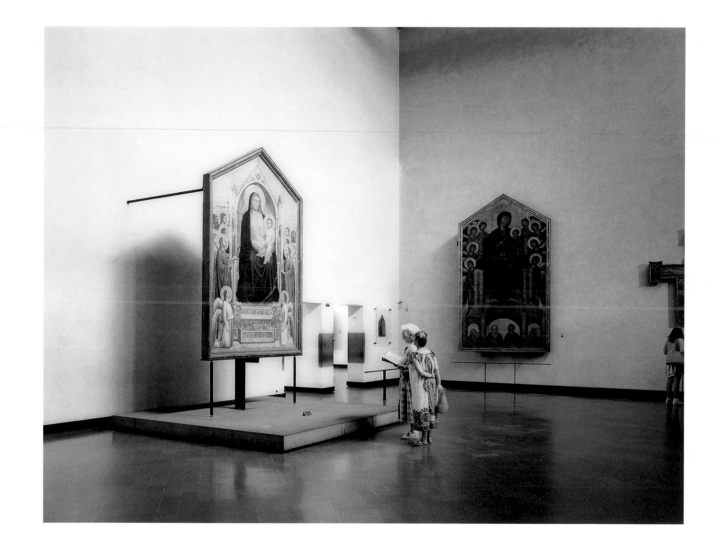

s

Thomas Struth
Uffizi I, Florence, 1989
C-print
70 × 66 1/2 inches (177.8 × 168.9 cm)
Commentary on page 304

Hiroshi Sugimoto
Alhambra, San Francisco, California, 1992
Black-and-white silver gelatin print,
edition of 25
20 × 24 inches (50.8 × 61 cm)
Commentary on page 304

S

Donald Sultan
Dead Plant November 1, 1988, 1988
Tar and latex paint on canvas
108 1/8 × 144 1/4 inches (274.6 × 366.4 cm)
Commentary on page 306

James Surls
On Being in the Wind, 1984
Cypress, pine, oak, and steel rod
148 × 132 × 100 inches (375.9 × 335.3 × 254 cm)
Commentary on page 307

Erick Swenson
Untitled, 2000
Mixed media
91 × 40 × 40 inches
(231.1 × 101.6 × 101.6 cm)
Commentary on page 308

Mark Tansey
Close Reading, 1990
Oil on canvas
121 1/2 × 46 1/8 inches (308.6 × 117.2 cm)
Commentary on page 308

184

Cy Twombly
Untitled (Rome), 1997
Bronze
65³/₄ × 13³/₄ × 13³/₄ inches (167 × 34.9 × 34.9 cm)
Commentary on page 310

Jacques Villeglé
Rue de Tolbiac, c'est normal, c'est normand, 1962
Ripped posters mounted on canvas
52 3/16 × 76 1/4 inches (132.6 × 193.7 cm)
Commentary on page 311

facing page:
Bill Viola
The Greeting, 1995
Video and and sound installation:
Color video projection on large vertical
screen mounted on wall in darkened
space, amplified stereo sound

168 × 258 × 306 inches
(426.7 × 655.3 × 777.2 cm)
Commentary on page 312

provided the foundation for and essence of his representation of her glamour. On top of the colors, the cropped publicity still, which had been transferred to a silkscreen, would be inked. The process permitted an almost mechanical repetition of his image, yet as Warhol worked and the screen became clogged with ink, he would apply differing pressures to the squeegeeing of the ink through the screen, and the image was printed off-register with the colors. This resulted in the variations evident in the Marilyns. No two are exactly the same. Warhol could have controlled the silkscreen process to achieve identical images; instead he allowed the accidental and personal to enter into his work. Similarly, he tempered the picture's rigid organization.

At first glance, *Twenty-Five Colored Marilyns* reads as an obviously grid-structured composition. However, except in the upper left corner, no lines occur in the painting to define a grid or box in the Marilyn heads. The images float on their blue background, and in doing so, subtly undermine the grid's inherent stability. Warhol further countered compositional stasis and rigidity by placing the blue rectangle asymmetrically on the canvas and setting it slightly askew. Finally, a wispy stroke and smudges of blue paint along the right side quietly contradict the grid's clarity and uniformity. These manipulations and tracks of the artist's presence counter the commonly held view (reinforced by the artist himself) that his work and Pop art in general was detached, impersonal, and mechanical in character.

The year *Twenty-Five Colored Marilyns* was completed, 1962, saw the widespread recognition of American Pop art. That year several of the major artists identified with Pop, such as Warhol, Roy Lichtenstein, Claes Oldenburg, James Rosenquist, and Tom Wesselmann, participated in group shows and had solo exhibitions. Warhol's *Campbell's Soup Cans* were seen at Los Angeles's Ferus Gallery during the summer and his *Marilyns*

and other silkscreen paintings were featured at the Stable Gallery in New York in the fall.[8] Pop art was the topic of heated discussion at an important symposium held at The Museum of Modern Art in New York in December 1962. Many critics and curators detested the new art, with its focus on popular culture, its impersonal style, and its humor—qualities that directly opposed the seriousness, individualism, and emotional depth of the reigning Abstract Expressionists. Others argued that an age of consumerism, mass media, and popular culture demanded a new kind of art. As Warhol stated, "The Pop artists did images that anybody walking down Broadway would recognize in a split second—comics, picnic tables, men's trousers, celebrities, shower curtains, refrigerators, Coke bottles— all the great modern things that the Abstract Expressionists tried so hard not to notice at all."[9]

Twenty-Five Colored Marilyns does indeed present a celebrity that anyone in 1962 would have known "in a split second." The immediate recognition of glamour and stardom personified continues, even if adolescents in the mid-1990s mistakenly assumed that the painting portrayed the pop music star Madonna (they were, of course, essentially correct). Warhol also reinforced a sense of the familiar by setting Marilyn's repeated faces in a gridlike format that recalls movies and advertisements. The repetitive likenesses in *Twenty-Five Colored Marilyns* bring to mind the frames that constitute a film. But while a movie projects images at twenty-four frames per second to produce a unified picture on a screen, Warhol, who began making films the following year, freeze-frames his twenty-five slightly varied images. The format of *Twenty-Five Colored Marilyns* (and its silkscreen technique) relates to the world of advertising, to which Warhol was intimately connected. During the 1950s he was one of the country's leading commercial illustrators, winning numerous awards for his work, including the prestigious Art Directors Club

Gun, 1982
Synthetic polymer paint and silkscreen ink
on canvas
72 × 92 inches (182.9 × 233.7 cm)

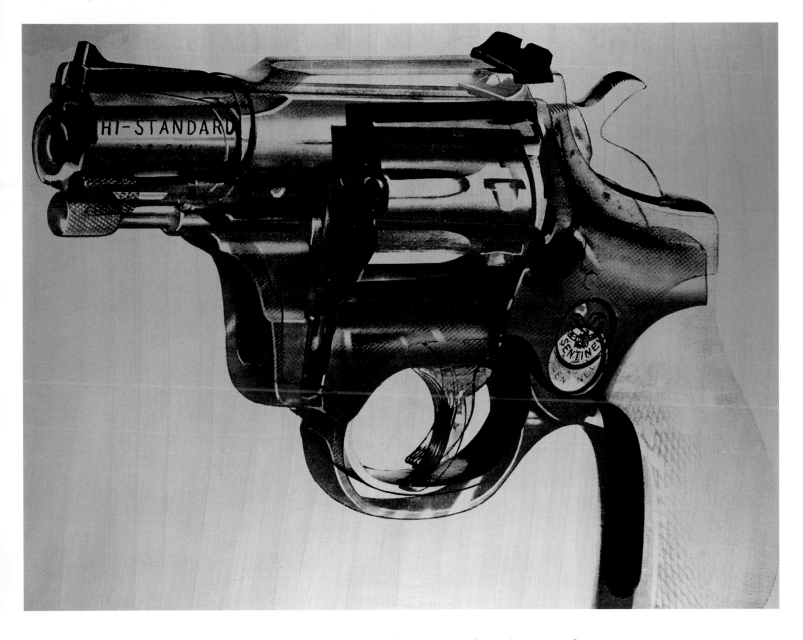

Medal in 1957. He certainly would have seen numerous grid layouts such as Charles Coffin's repeated photograph on the cover of *Vogue* for December 1954, and he used the format himself as early as 1955.[10] When asked the basis for his use of the repeated likeness, Warhol, always notoriously vague and indifferent in his responses to questions about his art, claimed, "I don't really know or remember. I think, at the time ... I liked the way repetition changed the same image. Also, I felt at the time, as I do now, that people can look at and absorb more than one image at a time."[11]

By employing the repetitive "framed" images of the celebrity, Warhol did tap into the familiar world of mass media and popular culture, which helps make *Twenty-Five Colored Marilyns* immediately accessible to viewers. But what message does the repeated image convey?

Like much Pop art, the visual accessibility of *Twenty-Five Colored Marilyns* masks an elusive content. Warhol's image of Marilyn has been interpreted as a celebration of sexual glamour, a funereal portrait, an empty shell of a person, the personification of self-invention, an emblem of

W

pathos, and being charged with (and devoid of) social comment. In *Twenty-Five Colored Marilyns*, is Warhol apotheosizing Marilyn's celebrity and beauty, or presenting her as a commodity—manufactured, packaged, promoted, distributed, and sold—like a can of soup? Is he critiquing the numbing effect of mass media blitz and saturation, or simulating its power to foment hype and create a "buzz"? Is he adopting the mass media's use of reproductions to expose and make familiar an individual's essence, or suggesting that the flood of images diminishes and masks a person's uniqueness? The questions that Warhol's art sparks are profound, and the responses they produce are endlessly debatable. This is because *Twenty-Five Colored Marilyns* simultaneously embraces and critiques mass culture: it embraces glamour, mass media, and fame, while critiquing (by drawing attention to) artifice, uniformity, and dominance. However *Twenty-Five Colored Marilyns* is read, it is clear that it and Warhol's other Marilyn portraits not only have contributed to maintaining Marilyn's aura, but also have attained their own degree of celebrity.[12] Warhol's paintings —"beautiful, vulgar, heart-breaking icons"[13]— have become famous for being famous, and have taken their place among "the great modern things."

Complementing *Twenty-Five Colored Marilyns* are two other large Warhol paintings: *Gun*, 1982 and *Self-Portrait*, 1986.[14] Spanning nearly his entire career as a fine artist, these three pictures exemplify Warhol's fascination with violence and death: *Twenty-Five Colored Marilyns* depicts a recently-deceased movie star, *Gun* emblematizes America's gun culture, and *Self-Portrait* evokes a ghostly image of death.

Gun formed part of the exhibition *Andy Warhol: Guns, Knives, Crosses*, held at Madrid's Galeria Fernando Vijande from December 1982 to January 1983. The exhibition was a success, with a single collector purchasing every work.[15] When Warhol was considering appropriate works to include in the Madrid exhibition, a friend suggested thinking of Spain in terms of the Inquisition and the Spanish Civil War. This prompted him to regard the images of guns and knives that he had painted since 1981 in a new light: he now related them to the 1936–39 struggle (the same war that triggered Robert Motherwell's *Elegies*). The crosses symbolized what he called "the Catholic thing."[16] Guns had appeared earlier in Warhol's art and carried other connotations. For instance, the American glamorization of guns and violence colors Warhol's 1962 pictures of gun-toting movie stars James Cagney as a gangster and Elvis Presley as a cowboy. A devastating consequence of America's gun culture was made obvious by the inclusion of the rifle in 1968's *Flash—November 22, 1963* and by its implied presence in the artist's several representations of First Lady Jacqueline Kennedy after her husband's assassination. *Gun* bore, then, multiple public and historical connotations; further, the picture was fraught with deep personal meaning for Warhol.

On 3 June 1968, Valerie Solanis, the founder and sole member of S.C.U.M. (Society for Cutting Up Men), entered Warhol's studio, The Factory.[17] Angry over his dismissal of a script that she wanted the artist to film, Solanis opened fire on him and a visiting art critic, Mario Amaya. Warhol nearly died from his gunshot wounds and was hospitalized for almost two months. While the weapon portrayed in *Gun*—a Hi-Standard .22-caliber Sentinel pistol—is not the .32-caliber revolver Solanis fired in her attack (she did carry a .22 pistol as a backup), it is difficult not to view the blown-up image of a handgun colored a bloody red as evoking the monumental terror and violence of the artist's near-fatal experience. Facing mortality is even more explicit in *Self-Portrait*.

Throughout his career, Andy Warhol recorded his own image. His richly colored self-portraits—fusions of painting, printmaking, and photography—frequently picture him as a passive observer/reflector, but they also show him

Self-Portrait, 1986
Synthetic polymer paint and silkscreen
ink on canvas
108 × 108 inches (274.3 × 274.3 cm)

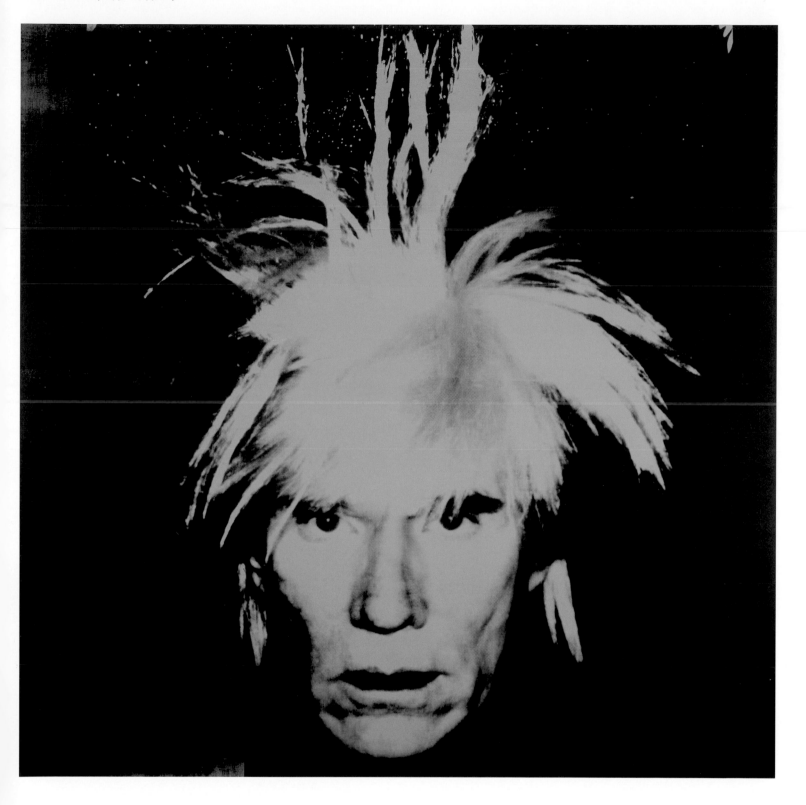

W

accompanied by a human skull, casting an ominous shadow, and hidden by camouflage. Unlike traditional self-portraits in which artists scrutinize themselves in mirrors—making the artist both subject and primary viewer of the portrait—Warhol's self-portraits derive from photographs of him gazing at a camera. This makes his self-portraits less about how Warhol literally sees, and *represents*, himself and more about how he *presents* himself to the camera. Lacking the inherently introspective nature associated with self-portraits, Warhol's images of himself are often characterized as masklike. In the Museum's *Self-Portrait*, however, the face is shockingly blunt and vulnerable, and the mask has been dropped to reveal an apparition of death.

The disembodied head bathed in green and seemingly hanging by strands of the fright wig that Warhol wore at this time gives the image a ghostly appearance. The gaunt features resemble a skull whose expressionless, fixed stare simultaneously faces death and is the face of death.[18] Whether or not *Self-Portrait*, which is one of several similar images from 1986, serves as a premonition of the artist's own unexpected death the following year (after gall-bladder surgery) remains moot. What is certain is that the disturbing, uncompromising, and colossal *Self-Portrait* presents an image that is extraordinarily tragic and heroic.

MARK THISTLETHWAITE

1 Peter Schjeldahl, "Barbarians at the Gate," *New Yorker* (15 May 2000): 102.
2 Christopher Makos's 1981 photograph *Altered State*, an homage to Man Ray's photograph of Marcel Duchamp as Rrose Selavy, shows Warhol at his most Marilynesque.
3 Mark Francis, "Still Life: Andy Warhol's Photography as a Form of Metaphysics," in *Andy Warhol Photography* (Zurich and New York: Edition Stemmle, 1999): 19.
4 Carl E. Rollyson Jr., *Marilyn Monroe: A Life of the Actress* (New York: Da Capo Press, 1993; orig. 1986): 56.
5 Quoted in Sara Doris, "Your Fifteen Minutes are Up: Fame, Obsolescence, and Camp in Warhol's Star Portraits, 1962–1967," in Wendy Grossman, ed., *Reframing Andy Warhol: Constructing American Myths, Heroes, and Cultural Icons* (College Park, Maryland: The Art Gallery at the University of Maryland, 1998): 30.
6 Ibid.
7 Ibid., 22.
8 The verso of *Twenty-Five Colored Marilyns* includes the inscription "Stable/Ferus." Vernon Nikkel, who had seen a reproduction of the work, purchased the painting from the Dwan Gallery of Los Angeles in 1963 (Vernon Nikkel in conversation with the author, 29 January 2001).
9 Andy Warhol and Pat Hackett, *POPism: The Warhol '60s* (New York and London: Harcourt Brace Jovanovich, 1980): 3.
10 See his *Happy Butterfly Day*, reproduced in Rainer Crone, *Andy Warhol: A Picture Show by the Artist* (New York: Rizzoli Publications, Inc., 1987): 147.
Another particularly relevant example is his 1961 book jacket design for *The Adventures of Maud Noakes*. See Jesse Kornbluth, *Pre-Pop Warhol* (New York: Panache Press of Random House, 1988): plate 52.
11 Gerard Malanga, "A Conversation with Andy Warhol," *The Print Collector's Newsletter* 1 (January–February 1971): 126.
12 These include a series of paintings from 1964, prints from 1967, and images from the *Reversals* series of paintings of 1979–86.
13 Michael Fried, "New York Letter," *Art International* 6 (December 1962): 57.
14 The Museum's collection also includes several serigraphs (silkscreens): a portfolio of ten *Flowers*, 1965; a portfolio of ten *Campbell's Soup Cans*, 1968; one *Mao Tse-Tung*, 1972; and eight of ten *Myths*, 1981.
15 Victor Bockris, *Warhol* (New York: Da Capo Press, 1997): 457.
16 Bob Colacello, *Holy Terror: Andy Warhol Close Up* (New York: HarperCollins, 1990): 462.
17 Solanis is sometimes spelled Solanas.
18 The image emphasizes gauntness, as is evident in a 1986 advertisement for Drexel Burnham, where Warhol sits in front of another self-portrait that utilizes the same photograph as the Museum's picture. In the ad, the real Warhol looks less frightening and healthier. Drexel Burnham's use of such a disturbing self-portrait in its advertisement testifies to the more than compensatory status of Andy Warhol as a celebrity.

Carrie Mae Weems

Carrie Mae Weems is both photographer and model for *Untitled* (Kitchen Table Series) of 1990, a body of work that focuses on a woman's interplay with family, friends, and a lover. The entire series consists of fourteen works (three are triptychs) and thirteen accompanying text panels that tell a story. The collection includes all of the text and three of the photographs: *Untitled* (Woman Standing Alone), *Untitled* (Nude), and *Untitled* (Woman Playing Solitaire). By simultaneously addressing and denying a number of race and gender stereotypes in *Kitchen Table Series*, Weems emphasizes that there is always more than one side to any story.

In the series, she uses an effective combination of black-and-white photography and text to unfurl a drama that centers on the actions of a woman independently coping with everyday life concerns. In casting herself as the protagonist, Weems undermines traditional representations of women, and her motivation for doing so in part relates to feminism and its history. When feminism gained momentum as a political movement in the late 1960s and early 1970s, some women artists focused on the female body in an attempt to create a universalized feminine vocabulary, or a "collective woman." As feminism evolved, however, an awareness of its limitations emerged and it was criticized for its white, Western, bourgeois standpoint. In "Issues in Black, White, and Color," Andrea Kirsh states that Weems's *Untitled* (Kitchen Table Series) is partly a response to the feminist British film critic Laura Mulvey's omissions of ethnic women in her analyses of women in film, especially in "Visual Pleasure and the Narrative Cinema."[1] Mulvey identifies actresses such as Marilyn Monroe, Lauren Bacall, and Greta Garbo as icons and recipients of the male gaze and male erotic fantasy.[2] Weems questions Mulvey's criticism, with its implicit "whiteness," on several levels.

The sequencing of Weems's images imitates film stills and venerates a black, female lead. In *Untitled* (Woman Standing Alone), she stares directly at the viewer. Her forthright posture dares criticism of her lifestyle choices or judgment of her ethnic background, and the accompanying text panel operates to emphasize her ethnicity, class, and mind-set. The text is composed of black American slang, with lines delivered in the third person that are appropriated from folklore, songs, movies, theater, and television shows. Much of the dialogue for *Kitchen Table Series* refers to the main character's feelings about her lover, and his about her, as she decides whether or not to stay in the relationship. The phrases support the heroine's self-sufficiency and also indicate her uncertainty: "…like just cause she was working and making so much dough, she was getting to where she didn't love him no mo, like he was bad luck, like he didn't have a dream, like he needed a night in Tunisia…."

The entire drama in *Kitchen Table Series* takes place around the kitchen table, a traditional symbol of women's private domestic domain. In *Untitled* (Woman Standing Alone) Weems leans on the table, boldly gazing dead on, while the single overhead lamp shines down on her, indicating that she has nothing to hide. Her pose, however, is slightly defensive. The austere space of the kitchen, with its minimal props (just the table, an overhead light, and a poster on the back wall), draws the viewer in, and it becomes an interrogation room.[3] In a sense, the tables have turned—the person under the light is traditionally asked the questions, but in this case, Weems could be leading the inquisition.

In *Untitled* (Nude) the woman is exposed, naked and vulnerable under the stark lamplight, but her arching body suggests ecstasy. Her strong arm and clinched fist grab the back of her own head to press it down against the kitchen table —the source of her power and limitations. With this image, Weems explores the balance between

w

Untitled (Kitchen Table Series), 1990
Three gelatin silver prints with text panels,
edition of 5
Each 27 1/4 × 27 inches (69.2 × 68.6 cm)

She was working, making long money, becoming what he called 'bourgie', he wasn't working and this was truly messing with his mind. He was starting to feel like a Black man wasn't supposed to have nothing, like some kind of conspiracy was being played out and he was the fall guy, like the mission was impossible, like it ain't a man's world, like just cause she was working and making so much dough, she was getting to where she didn't love him no mo, like he had bad luck, like he didn't have a dream, like he needed a night in Tunisia, like he needed to catch a freight train and ride, like if he felt tomorrow like he did today, come Sunday he'd pack up and make a get-away, like if he stayed, the kid would hate him for sure, like he just might have to contribute to the most confusing day in Harlem, like he had a tomb-stone disposition and a grave-yard mind. Like maybe a Black man just wasn't her kind.

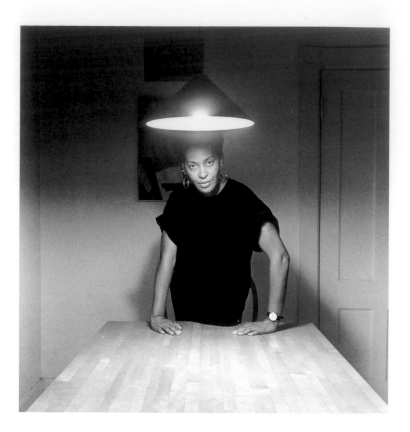

submission and autonomy, surrender and control. In *Untitled* (Woman Playing Solitaire), any sense of vulnerability is reconciled and the subject's resilient attitude resurfaces. Props that have been associated with stereotypical black American vices (cards, cigarettes, and alcohol) are present, as are the stereotypical signs of female consolation and comfort—a box of chocolates and Weems in her well-worn, comfortable nightgown. A deserted birdcage to the left indicates an empty nest—and her freedom. She enjoys solitude at home in her personal space, as head of the kitchen table.

Because of the episodic nature of the photographs and text in this series, they could be understood as film stills, although they are not. They could also be interpreted as being autobiographical, but how much they relate to Weems's life is unknown. In *On Photography*, Susan Sontag discusses the ways in which photographs often seem to represent reality, although they are usually contrived. Meaning in photographs is fluid and culturally determined but *feels* like reality and

knowledge, and therefore like power.[4] This idea is key to the impact of *Kitchen Table Series*: While it seemingly represents one person's strict reality, and probably represents *aspects* of reality for many people, it also legitimizes an atypical heroine who could be from life or film, and it highlights certain signs of race and gender as essential parts of this woman's identity.

Weems's candid approach owes much to her artistic predecessor Adrian Piper, who in the 1970s began to address issues of prejudice, specifically challenging what it means to be a black woman in American culture. Piper, a light-skinned black woman, has been privy throughout her lifetime to racist comments because she looks white. Like Weems, Piper's desire to confront racism and stereotypes directly was the impetus for many of her ongoing Conceptual works.

Weems's particular focus on stereotypes also connects to the work of one of her contemporaries, the photographer Cindy Sherman, especially Sherman's "film stills." Sherman and

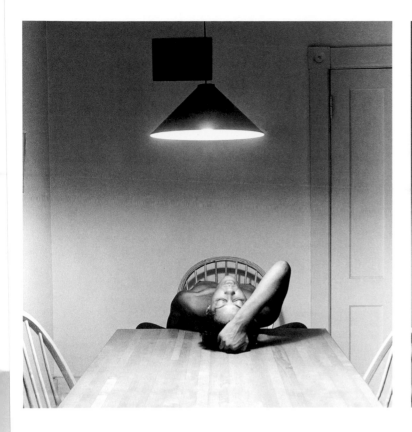
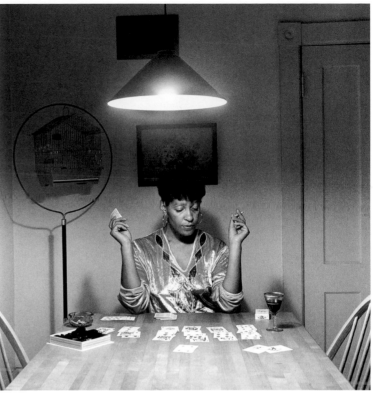

Weems share strong surface characteristics: their medium is often black-and-white photography; they use themselves as models; and they use mock-cinematic, narrative formats. Even with these similarities, Weems and Sherman have individual artistic concerns and express very different aspects of feminism. In the Museum's *Untitled (Film Still #55)* of 1980, for example, Sherman presents herself as a blonde, B-movie actress—the prototypical "American girl"—to expose society's steadfast acceptance of romantic and generic notions of women in film and society. Sherman's characters are convincing as movie stars, but are much less convincing as actual people (like B-movie characters themselves). By contrast, the woman in *Kitchen Table Series* could actually exist. In both cases, viewing the works is voyeuristic, but in Sherman's work we are passive witnesses watching the objectified starlet, whereas with Weems's series we are faced with an uncharacteristic protagonist.

In *Kitchen Table Series*, Weems informs us that there is no collective woman; rather, the artist asserts her authorial voice. By doing so, she surpasses the familiar "everywoman" in Western society, and discloses many other facets of womanhood. In this series, Weems's images and texts, with their confirmation and denial of race and gender stereotypes, emphasize that who she is and what she does is based on her discrimination, not the viewer's.

ANDREA KARNES

1 Andrea Kirsh and Susan Fisher Sterling, *Carrie Mae Weems* (Washington, D.C.: The National Museum of Women in the Arts, 1993): 15. Notes from Kirsh's essay explain that the author is aware that *Untitled (Kitchen Table Series)* is a reaction by Weems to Mulvey's text because it was the primary focus of Weems's lecture at the School of the Art Institute of Chicago on 20 April 1992.
2 See particularly Laura Mulvey, "Visual Pleasure and the Narrative Cinema," *Screen* 16 (Autumn 1975): 6–18. The source used for this text is from a reprint of Laura Mulvey, "Visual Pleasures and Narrative Cinema" in *Visual and Other Pleasures* (Bloomington: Indiana University Press, 1989).
3 The idea that Weems creates an interrogation room comes from Kirsh, 14.
4 Susan Sontag, *On Photography* (New York: Anchor Doubleday, 1977): 4.

w

Jackie Winsor
Green Piece, 1976–77
Painted wood, wire, and cement
32 1/$_2$ × 32 1/$_2$ × 32 1/$_2$ inches (82.6 × 82.6 × 82.6 cm)
Commentary on page 318

Commentaries by Michael Auping, Andrea Karnes, and Mark Thistlethwaite

JOSEF ALBERS	ADOLPH GOTTLIEB	PABLO PICASSO	CY TWOMBLY
CARL ANDRE	NANCY GRAVES	MICHELANGELO PISTOLETTO	JACQUES VILLEGLÉ
MILTON AVERY	RED GROOMS	SYLVIA PLIMACK MANGOLD	BILL VIOLA
STEPHAN BALKENHOL	PHILIP GUSTON	JACKSON POLLOCK	ANDY WARHOL
GEORG BASELITZ	RAYMOND HAINS	RICHARD PRINCE	CARRIE MAE WEEMS
DAVID BATES	JOSEPH HAVEL	MARTIN PURYEAR	WILLIAM WEGMAN
WILLIAM BAZIOTES	HOWARD HODGKIN	ROBERT RAUSCHENBERG	WILLIAM T. WILEY
BERND & HILLA BECHER	HANS HOFMANN	AD REINHARDT	JACKIE WINSOR
ROBERT BECHTLE	ROBERT IRWIN	GERHARD RICHTER	
LARRY BELL	ALAIN JACQUET	LINDA RIDGWAY	
LYNDA BENGLIS	JESS	SUSAN ROTHENBERG	
ED BLACKBURN	DONALD JUDD	MARK ROTHKO	
DENNIS BLAGG	CRAIG KAUFFMAN	THOMAS RUFF	
JONATHAN BOROFSKY	ELLSWORTH KELLY	EDWARD RUSCHA	
JULIE BOZZI	ANSELM KIEFER	LUCAS SAMARAS	
SOPHIE CALLE	SOL LEWITT	KURT SCHWITTERS	
ANTHONY CARO	ROY LICHTENSTEIN	SEAN SCULLY	
VIJA CELMINS	RICHARD LONG	GEORGE SEGAL	
JOHN CHAMBERLAIN	MORRIS LOUIS	RICHARD SERRA	
CHUCK CLOSE	SALLY MANN	ANDRES SERRANO	
CLYDE CONNELL	BRICE MARDEN	BEN SHAHN	
THOMAS JOSHUA COOPER	AGNES MARTIN	CINDY SHERMAN	
JOSEPH CORNELL	MELISSA MILLER	MICHAEL SINGER	
TONY CRAGG	RICHARD MISRACH	LEON POLK SMITH	
RICHARD DIEBENKORN	TATSUO MIYAJIMA	NICOLAS DE STAËL	
JIM DINE	HENRY MOORE	ANN STAUTBERG	
BARBARA ESS	YASUMASA MORIMURA	FRANK STELLA	
LYONEL FEININGER	ROBERT MOTHERWELL	CLYFFORD STILL	
VERNON FISHER	RON MUECK	THOMAS STRUTH	
DAN FLAVIN	VIK MUNIZ	HIROSHI SUGIMOTO	
FORT WORTH CIRCLE	BRUCE NAUMAN	DONALD SULTAN	
SAM FRANCIS	NIC NICOSIA	JAMES SURLS	
HAMISH FULTON	CLAES OLDENBURG	ERICK SWENSON	
GILBERT & GEORGE	TONY OURSLER	MARK TANSEY	

A B C D E F G H I J K L M N O P Q R S T U V W X Y Z

artists whose names appear in gray have an extended commentary in the plate section

Josef Albers
American, born Germany. 1888–1976

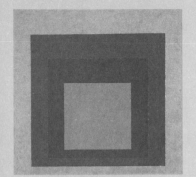

Homage to the Square
(La Tehuana), 1951
Oil on fiberboard
30³/₄ × 30³/₄ inches (78.1 × 78.1 cm)
Gift of Mrs. Anni Albers and
The Josef Albers Foundation, Inc.
1980.3.G.P.

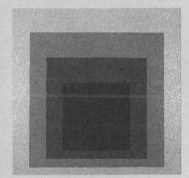

Homage to the Square, 1966
Oil on fiberboard
30³/₄ × 30³/₄ inches (78.1 × 78.1 cm)
Gift of Mrs. Anni Albers and
The Josef Albers Foundation, Inc.
1980.4.G.P.

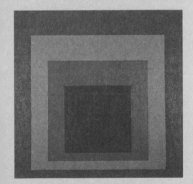

Homage to the Square, 1967
Oil on fiberboard
30³/₄ × 30³/₄ inches (78.1 × 78.1 cm)
Gift of Mrs. Anni Albers and
The Josef Albers Foundation, Inc.
1980.5.G.P.

One of the most immediately recognizable and influential series of paintings produced in the twentieth century is Josef Albers's *Homage to the Square*. Beginning the series in 1950, at age 62, Albers was to produce more than a thousand *Homage* paintings and prints, in four different formats.[1] The works became widely known (one appeared on a 1980 United States postage stamp) and influenced two generations of hard edge and Minimalist art (although Albers's paintings are truly neither). The collection of the Modern Art Museum of Fort Worth includes three *Homage to the Square* paintings, from 1951, 1966, and 1967.[2] All are the same size and have the same format of four color squares, but each evokes a differing mood and visual effects through its colors.

The *Homage to the Square* series represents the culmination of Albers's experiments with abstraction and his fascination with the perception of color. These interests first manifested themselves when he enrolled in the Weimar Bauhaus in 1920. Five years later he became a master at the Bauhaus and undertook teaching the important introductory course required of all students. When the Nazis forced the closing of the Bauhaus in 1933, Albers and his wife Anni, also an artist, immigrated to the United States to teach at Black Mountain College, near Asheville, North Carolina. After imparting Bauhaus principles at Black Mountain for sixteen years, Albers became chairman of the Department of Design at Yale University. Albers held this position for a decade, retiring in 1960. The many years he spent teaching color and working on the *Homage to the Square* series led him to publish, in 1963, his highly influential book *The Interaction of Color*. As a teacher and artist, Josef Albers had a profound impact on a wide range of artists, including Robert Rauschenberg, Kenneth Noland, and Ellsworth Kelly.

Albers constructed his *Homages* by laying in paint as thinly as possible with a palette knife directly on a white ground. He likened his technique to intarsia and mosaic. Paint generally came straight from the tube, and edges of the squares were painted without masking tape. Reproductions of the paintings make them appear harder-edged than they actually are. Albers would begin a composition with the center square and work his way out, never painting one square on top of another. The artist set his masonite support flat on a table, not vertically on an easel, which reinforced his notion of the paintings as "platters to serve color."[3] The mutability of color and the dynamism of color relationships formed the core of Albers's focused creative enterprise, as the artist once poetically expressed:

When I paint
I think and see
first and most—color
but color as motion

Color not only accompanying
form of lateral extension
and after being moved
remaining arrested

But of perpetual inner movement
as aggression—to and from the
 spectator
besides interaction and
 independence
with shape and hue and light

Color is a direct and frontal focus
and when closely felt
as a breathing and pulsating
—from within [4]

The concentric square configuration of Albers's paintings (comprising either three or four squares) facilitated his desire to focus on color directly and frontally and to imbue it with a "breathing and pulsating" presence. The squares are flat, yet they evoke depth through their suggestion of overlapping, and they appear to expand upward and outward while simultaneously remaining fixed. Albers achieved these effects by assigning a 1:2:3 ratio to the intervals between the different sides of the squares: the lateral intervals double those below the first square, while those at the top triple those at the bottom. Despite the obvious importance of the square format—the series, after all, is titled *Homage to the Square*—Albers maintained that the rectilinear configuration in itself had no aesthetic consequence and that color was always his primary concern and interest.

Of the three paintings in the Museum's collection, only one carries a subtitle: *La Tehuana*. Many of the *Homages* do have subtitles. Each of the thirty-six paintings in a 1964 exhibition devoted to the series included a subtitle, such as *Portal A*, *Coniferous*, *Gentle Hours*, and, reflecting Albers's view that each painting had a "different climate," *July, Harvest, Autumnal, Cool Rising, Summer Flux*, and *Dry Land*.[5] To refer to a person, as *La Tehuana* does, however, is unusual.

"La Tehuana" is a general term that refers to an Indian woman from the Isthmus of Tehuantepec in southern Mexico. An embroidered dress and a wide, lacy white headdress called a *huipil grande* are well-known features of traditional Tehuana garb. *Homage to the Square (La Tehuana)*, 1951, with its cadmium orange, alizarin crimson, pink, and yellow ochre, evokes a sense of the colorful Tehuana culture that Albers knew from his numerous trips to Mexico.[6] In 1935 Albers made the first of what would be fourteen trips to Mexico. The artist was a great admirer of indigenous Mexican artforms and was especially drawn to pre-Columbian art and architecture. He took a sabbatical from teaching at Black Mountain College in 1947 to spend a year painting in Mexico. Two years later, after resigning from the North Carolina school, Albers traveled to Mexico. It is appropriate that *La Tehuana*, one of the earlier works in the *Homage to the Square* series, should relate to his fondness for Mexican culture.

Homage to the Square (La Tehuana) and the artist's other compositions in the series offer more than academic exercises in color manipulation, and differ in aim from the idealist and mystical geometric abstractions of Piet Mondrian and Kazimir Malevich. Through his concentrated exploration of, and insightful feeling for, color, Josef Albers produced compositions that evoke an extraordinary range of "character and feeling," while affirming and celebrating the directness and subtlety of vision.[7]

MARK THISTLETHWAITE

1 Nicholas Fox Weber, "The Artist as Alchemist," in *Josef Albers: A Retrospective* (New York: Solomon R. Guggenheim Museum, 1988): 14.

The formats vary in number of squares (three or four) and in the size and proportions of the squares. The commencement of the series appears in the literature as occurring in both 1949 and 1950. The Josef and Anni Albers Foundation accepts the latter date. The *Homage to the Square* paintings were introduced to the public in a January 1952 exhibition at New York's Sidney Janis Gallery.

2 All were received as a gift from Mrs. Anni Albers and The Josef Albers Foundation in 1980.

3 Weber, 14.

4 Quoted in Eugen Gomringer, *Josef Albers: His Work as a Contribution to Visual Articulation in the Twentieth Century* (New York: George Wittenborn, 1968): 175.

5 Josef Albers, "On My 'Homage to the Square'," in *Josef Albers: Homage to the Square* (New York: Museum of Modern Art, 1964).

6 Albers would often inscribe the colors he used, and their manufacturers, on the back of the compositions. *Homage to the Square (La Tehuana)* bears an inscription on its right edge that lists the colors cited here, with both the alizarin crimson and pink indicated as being combined with zinc white. (Helen Mar Parkin, Treatment Report, 17 March 1992, Registrar's Files, Modern Art Museum of Fort Worth.) On the back of the painting is a more detailed inscription that also includes information on the type of ground used (four coats of casein mixed with linseed oil, varnish, and turpentine).

7 Albers, "On My 'Homage to the Square.'"

Most of my works—certainly the successful ones—have been ones that are in a way causeways—they cause you to make your way along them or around them or to move the spectator over them. They're like roads, but certainly not fixed point vistas. I think sculpture should have an infinite point of view. CARL ANDRE

Carl Andre
American, born 1935

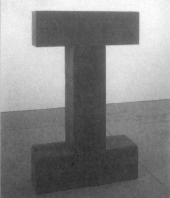

Tau and Threshold (Element Series), 1971
Western red cedar
60 × 36 × 12 inches
(152.4 × 91.4 × 30.5 cm)
Museum purchase
1999.1.P.S.

Slit, 1981
Steel and copper
Steel squares: each 1/4 × 19 3/4 × 19 3/4 inches (.5 × 50 × 50 cm)
Copper slats: each 1/4 × 1 3/16 × 19 3/4 inches (.5 × 3 × 50 cm)
Overall: 1/4 × 40 1/2 × 374 inches (.5 × 103 × 950 cm)
Gift of Anne and John Marion in honor of Michael Auping
2002.1.G.S.

A central figure in the development of the movement known as Minimalism, Carl Andre creates art that involves the symmetrical arrangement of units of basic building materials, which he terms "particles" or "elements." Inspired by the elemental nature of Constantin Brancusi's sculpture from the early part of the twentieth century, Andre has pushed sculpture to a kind of ground zero. The artist was particularly inspired by Brancusi's *Endless Column*, 1918, a series of repeated, carved wooden forms that sit directly on the floor while rising into the air.

Intrigued by the French sculptor's suggestion of an infinite serial form and his lack of distinction between sculpture and base, Andre set about exploring an extension of Brancusi's ideas. *Tau and Threshold (Element Series)* of 1971 pays homage to *Endless Column*, while deconstructing sculpture into an even more basic configuration. Andre abandons carving altogether in favor of simply stacking identical wooden units in an I shape. This elegantly primitive configuration—evoking images from Stonehenge to children's building blocks—utilizes what he calls "anaxial symmetry," which involves the absolute interchangeability of standardized units. Andre devised the *Element Series* in the early 1960s with the suggestion that the same identical units could be used to create different configurations endlessly. While some of the possible permutations were realized at a later date (*Tau and Threshold* was not made until 1971), many have never been built. *Tau and Threshold* addresses the architectonic and figurative possibilities of sculptural form in a radically fundamental way.

Eventually Andre rejected the anthropomorphic associations of verticality altogether, creating structures whose primary characteristic is horizontality, exemplified by the artist's arrangements of 3/8-inch-high, one-foot-square metal plates. The most common of these are his well-known "Plains," originally part of the monumental sculpture *37 Pieces of Work*, 1969, which the artist created for the ground floor of the Solomon R. Guggenheim Museum in New York for his retrospective in 1970. The work resulted in thirty-six "Plains," each measuring six by six feet (the thirty-seventh piece being the collective entity). Although low-lying—many have described Andre's works as the flattest sculptures in the history of art—their vertical reticence actually evokes a powerful spatial component, as if the space in a room is pressing down on the forms. As Andre describes it, "I don't think of them as being flat at all. I think, in a sense, that each piece supports a column of air that extends to the top of the atmosphere. They're zones. I hardly think of them as flat, any more than one would consider a country flat, just because if you look at it on a map it appears flat."[1]

Milton Avery
American, 1885–1965

Slit, 1981 is one of Andre's more expressive configurations, as well as one of the most revealing in regards to the artist's vision of an expanded space for sculpture. Consisting of parallel strands of steel plates bordering a thin line of small copper units, all of which stretches more than thirty-one feet in length, *Slit* is decidedly linear and potentially referential. Between 1960 and 1964, Andre worked as a brakeman and conductor for the Pennsylvania Railroad, an experience that reinforced not only his interest in industrial materials, but also his interest in sculpture and the perceptual qualities of vanishing points. The miles of tracks and lines of freight cars in flat, expansive landscapes increased his awareness of the relationship between an object and its surrounding space.

Although *Slit*'s linear configuration of parallel steel plates vaguely suggests railroad tracks, Andre sees it more broadly as simply a road, which—like his concept of anaxial symmetry and multiple, interchangeable parts—evokes multiple and interchangeable viewpoints. In discussing *Slit*, the artist commented, "A road doesn't reveal itself at any particular point or from any particular point. Roads appear and disappear. We either have to travel on them or beside them. But we don't have a single point of view for a road at all, except a moving one, moving along it. Most of my works—certainly the successful ones—have been ones that are in a way causeways—they cause you to make your way along them or around them or to move the spectator over them. They're like roads, but certainly not fixed point vistas. I think sculpture should have an infinite point of view."[2]

Andre's description suggests that to journey along *Slit* is to experience sculpture as a road—to understand it not as a fixed vertical marker or statue but as a guide to a never-attainable horizon. In other words, an endless road.

MICHAEL AUPING

1 Phyllis Tuchman, "An Interview with Carl Andre," *Artforum* 10 (June 1970): 60–61.

2 Ibid., 57.

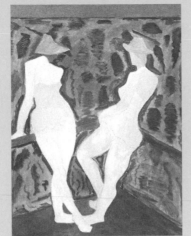

Two Figures, 1960
Oil on canvas
72 × 52 inches (182.9 × 132.1 cm)
Museum purchase, William E. Scott Foundation by exchange and Museum acquisition funds
1989.22.P.P.

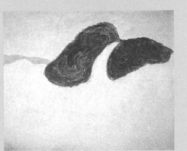

Dune Bushes, 1958
Oil on canvas
54 1/8 × 65 7/8 inches (137.5 × 167.3 cm)
Museum purchase, William E. Scott Foundation by exchange
1989.21.P.P.

Among the highlights of the Modern Art Museum's collection is its substantial holding of art produced by Milton Avery. This impressive body of work consists of nineteen objects: a watercolor, *Reflections*, 1958; an oil-on-paper work, *Night Harbor*, 1960; fourteen sheets of graphite and mixed media drawings (mostly undated); a sketchbook with forty-one graphite and ink drawings from Avery's 1952 (his only) trip to Europe; and two oil paintings, *Dune Bushes*,1958 and *Two Figures*, 1960. The number and variety of these works constitute a major resource for the study of this significant, although often neglected, American artist.[1]

Avery's significance is made

obvious, and a hint as to why his work has been overlooked suggested, in the eulogy delivered by Mark Rothko during the Avery memorial service at the Society for Ethical Culture in New York on 7 January 1965. Rothko, a leading Abstract Expressionist, a longtime friend of Avery's, and an artist much influenced by him, declared, "Avery is first a great poet. His is the poetry of sheer loveliness, of sheer beauty. Thanks to him this kind of poetry has been able to survive in our time."[2] The exquisite and lyrical beauty of Avery's art put it at odds with the dominant modernist critical discourses, which emphasized either a medium's inherent formal qualities or an artist's intense individualistic expression. Although one writer exulted that it was "a sustaining joy to look upon the works of Milton Avery and to find them so hearteningly beautiful,"[3] most critics discounted his art as lightweight, and slighted his uniqueness by dubbing him "the American Matisse." The highly influential art critic Clement Greenberg dismissed Avery in 1943 as being derivative, and described his art as "empty and sweet."[4] In the early 1990s, however, a new interest in and regard for the place of beauty in art emerged, largely spearheaded by the writings of Dave Hickey.[5] The Museum's acquisition of the numerous Avery compositions in 1989 presaged this changed attitude and permitted a timely reconsideration of the artist's work.

In re-viewing Avery's art, it becomes clear that his work, while clearly centered on communicating a sense of beauty, is also equally involved with the modernist concerns for formal qualities and personal expression. Avery himself neatly summarized this: "I work on two levels; I try to construct a picture in which shapes, spaces, colors form a set of unique relationships independent of subject matter. At the same time I try to capture and translate the excitement and emotion aroused in me by the impact of the original idea."[6] And while his art certainly relates to that of Matisse (the collection's undated drawings *Seated Nude* and *Reclining Nude* being particularly Matissean), it also grounds itself in an impressionistic engagement with nature.

Avery, who by 1911 was listing

himself as an artist, initially focused on producing small landscapes, painted outdoors and influenced by the work of the American Impressionist Ernest Lawson. Between 1905 and 1919, Avery intermittently attended classes at the Connecticut League of Art Students and the School of the Art Society of Hartford. One of his paintings appeared in the annual exhibition of the Wadsworth Atheneum in Hartford in 1915, and his first solo exhibition took place in the city's Green Gate Studio in 1924. The following year he moved to New York City. In 1926, Avery married Sally Michel, also an artist and the person who, through her various jobs as a freelance illustrator, allowed him the opportunity to pursue a career as a full-time artist. Avery's first New York exhibition occurred at the Frank K. M. Rehn Gallery in 1928, and at that time he met Adolph Gottlieb and Mark Rothko, who were to become his close friends. During the next two decades, Avery's watercolors, oils, and prints were exhibited widely. Following a heart attack in 1949, he experimented with the monotype, a printmaking medium of directness and fluidity. Avery soon incorporated these qualities, along with a greater simplicity, in paintings. Another significant change in his art occurred during the four summers from 1957 to 1960 that he spent in Provincetown, Massachusetts, when he moved to working on much larger canvases. *Dune Bushes* and *Two Figures* reflect these innovations and exemplify the best of Avery's mature work.

Both paintings derive from sketches the artist made during his Provincetown summers that are now part of the Museum's extensive Avery holdings. The ink-on-paper study for *Dune Bushes* evinces the immediacy with which the artist perceived the sandy landscape, and the rapidity with which he recorded his impressions of it. The finished oil painting shows his skill at distilling the scene in order to "capture…some of the beauty, mystery, and timelessness of nature."[7] The painting also exemplifies what Greenberg, who came to admire Avery's work just at this moment, regarded as the artist's remarkable ability to create a picture that "floats but…also coheres and stays in place, as tight as a drum and as open as light."[8] *Dune Bushes*' lightness, freshness, and delicacy

of colors are hallmarks of Avery's art. As he eliminated and simplified forms, "leaving nothing but color and pattern," Avery pushed his imagery to the very edge of abstraction.[9]

Yet here and in his other works, including *Two Figures*, he remains resolutely committed to conveying the look, as well as the feeling, of nature.

Two Figures pictures two women in faintly defined bathing suits leaning against the railing at the end of a pier. Although they appear generic, the women are Avery's wife Sally (his favorite and frequent model) and Tirza Karlis, a friend and Provincetown art dealer.[10] Intriguingly, Avery colors the pier with the cool blue-gray of the ocean, while he renders the sea in an ochre or woodlike hue. The composition suggests the vastness of the sea by the high horizon line that encompasses the figures, while the water's natural continual flux is conveyed by thin, squiggly washes of paint. After his experience with monotypes, Avery frequently diluted his pigment with turpentine to achieve such fluidity and expressiveness. The canvas is further animated by the visual dynamics of the women's bodies, which alternately read as positive forms and negative spaces. These figures, like the compositional elements in *Dune Bushes* and in much of Avery's work, are simultaneously representational and abstract, allusive and elusive, and embedded in the beauty of both nature and painting.

MARK THISTLETHWAITE

1 The works are reproduced and discussed in Marla Price, *Milton Avery: Works from the 1950s in the Collection of the Modern Art Museum of Fort Worth* (Fort Worth: Modern Art Museum of Fort Worth, 1990).

2 Rothko's eulogy appears in Barbara Haskell, *Milton Avery* (New York: Whitney Museum of American Art in association with Harper & Row, 1982): 181.

3 Adelyn D. Breeskin, introduction to *Milton Avery* (Washington, D.C.: National Collection of Fine Arts, The Smithsonian Institution, 1969): n.p.

4 Clement Greenberg, "Art— Charles Burchfield, Milton Avery, Eugene Berman," *The Nation* 157 (13 November 1943): 565. Greenberg was later to reconsider his position and admire Avery's work (see below).

5 See Dave Hickey, *The Invisible Dragon: Four Essays on Beauty* (Los Angeles: Art issues Press, 1993).

6 Quoted in Bonnie Lee Grad, *Milton Avery* (Royal Oak, Michigan: Strathcona, 1981): 8.

7 Quoted in Bridget Moore, *Milton Avery: Paintings and Works on Paper* (New York: DC Moore Gallery, 1999): n.p.

8 Clement Greenberg, *Art and Culture* (Boston: Beacon Press, 1961): 200.

9 Quoted in Price, 15.

10 Identification of these figures was kindly provided by Marla Price.

Stephan Balkenhol
German, born 1957

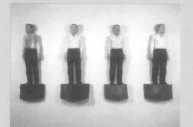

4 Figures, 2000
Painted wood, four figures, each 65 × 19 × 14 inches (165.1 × 48.3 × 35.6 cm)
Museum purchase,
Sid W. Richardson Foundation Endowment Fund
2001.1.1–4.P.S.

In *4 Figures*, 2000 Stephan Balkenhol depicts four versions of the same rudimentary but realistically rendered modern Anglo man. Each figure is scaled down, and has an unevenly painted surface—the effect of using a broad paintbrush, which leaves much of the natural wood exposed (often to indicate Caucasian skin tone). The figures, carved from tree trunks, hang on the wall like reliefs and sit atop their pedestals, which are left to look like the natural logs used to create them. *4 Figures* is characteristic of Balkenhol's work, visually and in its connections to the German woodcarving tradition and to sculpture's classical past. In this work the artist not only pays homage to the history of sculpture, but also critiques it with humor and irony that borders on kitsch. Rather than commemorating a hero, like typical sculpture from antiquity through the Renaissance and beyond; or beautifully and smoothly crafting a religious scene or icon, like traditional German woodwork, Balkenhol roughly chisels wood to depict ordinary people.

The man in *4 Figures* has short brown hair and blue eyes and is seen in a frontal pose, at slightly varied angles, with stiff posture and a blank stare. His pose and deadpan expression bring to mind traditional Greek kouros figures, which depicted anonymous male nudes and were often placed in burial grounds to guard the dead. The stance and attitude of *4 Figures* also recall the emotionless wood and stone statuary of ancient Egypt, used to honor pharaohs and queens.[1]

However, Balkenhol's man wears a white, long-sleeved shirt and black pants and shoes, making him pedestrian and recognizable as a contemporary, working-class citizen.

From 1976 to 1982 Balkenhol studied art at the Hockschule für Bildende Künst in Hamburg, Germany, where the staff included the influential artists Nam June Paik, Sigmar Polke, and the young artist's major professor, Ulrich Rückriem, known for his contributions to Minimalism. Notably, figuration was taboo when Balkenhol was a student; in keeping with the times, his professors in Hamburg were focused on Minimalism, Conceptualism, and Process-oriented artmaking. But during the 1980s, when Balkenhol matured as an artist, a figurative presence in the art world reemerged.

In Germany, Georg Baselitz, who works primarily as a painter, but who also creates drawings, prints, and sculpture, was exploring figuration. Like Balkenhol, Baselitz carves crude figural works from massive tree trunks. But unlike the younger artist, Baselitz uses an aggressive execution to create sculpture that is emphatically emotional and expressive. Balkenhol's generalizations have a completely different effect. His work implies a sign of the times, or a collective cultural mindset.

Conceptually, Balkenhol's work relates more closely to that of Jeff Koons, an American artist of his generation. Both play on consumerism and kitsch. However, Balkenhol's visual style and his use of repetition address commercialism and mass production in a very different way. Koons comments most directly on celebrity life, including famous icons in pop culture, whereas Balkenhol's references are subtler and more sober in tone.

His focus on the common man also relates to the photographic tradition of typology, which is especially prevalent in the work of German photographers, from August Sander to Bernd and Hilla Becher and their students Thomas Ruff and Thomas Struth. These photographers present their subjects with a detached, serial, and systematic approach. Their point is often simply to document their chosen subject matter, presenting data, but as objectively as possible, without making an obvious personal

statement. By depicting four straight-forward views of a single subject, Balkenhol's *4 Figures* mirrors the typological approach of these photographers. He, too, represents a type.

Balkenhol removes his work from the realm of portraiture, and even from reality, depicting familiar yet anonymous people whose stories are undisclosed, and by altering scale to create figures that are larger or smaller than life-size. This visual device helps capture our imagination in a way that life-size sculpture cannot. His use of repetition has a similar effect—seeing the face and plain clothes four times makes the man seem more generic, diluting the impact of individuality and leaving the question of his personal, psychological, and emotional state open-ended.

ANDREA KARNES

1 For an in-depth discussion of Balkenhol's work, especially in relation to classical sculpture and scale, see Neal Benezra's introductory essay in *Stephan Balkenhol: Sculptures and Drawings* (Washington, D.C. and Stuttgart: Hirshhorn Museum and Sculpture Garden in association with Hatje Cantz Publishers, 1996).

Georg Baselitz
German, born 1938

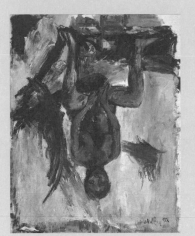

Elke, 1976
Oil on canvas
98 1/2 × 75 inches (250.2 × 190.5 cm)
Museum purchase,
The Friends of Art Endowment Fund
1994.2.P.P.

The demands of the painting dictated the character of the portrait. I'm not trying to paint a story. GEORG BASELITZ

You can lose the model, but you don't lose the subject. The painting takes its course but Elke comes in and out of the picture. It's complicated. I begin with an idea, but as I work, the picture takes over. Then there is the struggle between the idea that I preconceived in advance and the picture that fights for its own life.... You have to fight the conventions of the genre and the subject itself in order to make something new. The point of portraiture is to leave the portrait behind so that you can go forward.[1]

Portraiture has always been one of the most fundamental ways of contemplating ourselves and our relationship with others. Greek legend has it that the first work of art ever made was a portrait from the silhouette of a loved one's shadow cast upon the wall.[2] Such a minimal description was apparently enough to trigger a Corinthian woman's memory of her departed lover. Although its form has changed radically over the centuries, and particularly during the twentieth century, portraiture has lost none of its attraction and intrigue. In an age

of Conceptual art, large-scale Earth art projects, performance art, and site-specific art, portraiture quietly remains one of the most widely practiced forms of representation today. Every artist of note has engaged it in one way or another, often stretching its definition in new directions.

Among those who have significantly complicated our view of this ancient genre is the German artist Georg Baselitz. Over the past three decades, Baselitz has invented a series of pictorial strategies that range from the unconventional to the disorienting. His most well-known device in this regard is the practice of turning his figures upside down.

Prominent among these are images of the artist's wife, Elke Kretzschmar Baselitz. Married to Baselitz for more than thirty years, Elke has been a part of the artist's imagery almost from the beginning. The *Elke* paintings constitute the largest single group of Baselitz's portraits, making them a constant, a kind of litmus of the artist's representational wanderings. Moreover, they are a meditation on the open-ended evolution of the twentieth-century portrait, unfolding as it has from an analysis of a subject's physical characteristics, personality, and moods, to an analysis of the artist.

Baselitz executed his first painting of Elke in 1969 (*Portrait Elke I*, Private collection). The fact that the subject is upside down notwithstanding, it is a relatively traditional portrait. The artist focused his attention on the head and face, where in traditional portraiture the personality of the subject typically makes itself felt. Placing her head squarely in the center of the canvas, the artist depicted a beautiful but unsmiling woman with short-cropped hair. Those who know Elke would easily recognize her. The background of the portrait is a slightly foggy blue-gray which, along with Elke's ambiguous expression, projects an edgy, melancholic atmosphere.

Subsequent portraits of Elke have been increasingly subjective. *Elke II: Fingerpainting on Elke's Head*, 1972 (Private collection), painted three years later, is also a shoulder-length portrait, but the mood is quite different. Elke stares out of the picture with bright-eyed enthusiasm.

She is wearing a yellow blouse and is placed against a sparkling blue background. Two yellow daubs of paint, like butterflies, float in the lower right section of the painting. The artist, in a moment of self-mockery, says of the sweetness and optimism apparent in *Elke II*, "I probably had too much wine to drink when I painted that." He then goes on to say, "The demands of the painting dictated the character of the portrait. I'm not trying to paint a story."

Elke also downplays her role in the making of these portraits. "I was just available. We live very closely together since we met in 1958. We hardly spend any time apart. So I am always around....In Georg's paintings, the subject doesn't always matter—if the image is a tree, a flower, a bird, or me. What is important is the painting itself."[3] Nonetheless, Elke is clearly an emotional vehicle, inspiring a mood or memory. She points out that the first portrait was inspired by a photograph taken while they were visiting friends in East Germany when the Berlin Wall still divided the country. "We were sitting at a table. It was a difficult and emotional moment. We were very happy to see our friends, but we were conscious of the separation that existed between East and West. We grew up in the East and then moved to the West. Unless you have experienced that kind of move, it's hard to explain the conflicted feelings." Through both Elke's face and the sober atmosphere of the dull blue background in the painting, Baselitz imparts the ambiguous emotional tone associated with the memory of that day.

It is possible, then, to say that Elke's psychological disposition at that moment is part of the meaning of the painting. For Baselitz, to read this type of content into his portraits is not inaccurate, but it is to read them backwards. He challenges himself essentially to deny or suppress specific emotions and focus on pure visual structure. Baselitz's first instinct is to attack and dismantle his subject. He does not want his subject dictating how he should paint. For Baselitz, the model is essentially an excuse to paint, to engage in the struggle of representation, to represent his process of constructing a painting through his subject. He paints his subjects upside down so that the subject cannot dominate that process. It's important to know that Baselitz did not paint these early pictures right-side up and then, as a purely conceptual act, turn them upside down. Holding a photograph in one hand, he paints the image as being naturally upside down. This disorients and distances him not only from the image of Elke, but from the conventions of portraiture, so that what is left is an invention rather than a transcription. The integrity of Baselitz's method is proven when one turns his pictures "right-side up." They simply do not work. Their existence as a system of line, shape, and color is intrinsically wed to being painted upside down.

In a unique double portrait (*Bedroom*, 1975, North Carolina Museum of Art), Baselitz and Elke, both nude, sit in chairs side by side, looking away from each other in a distracted manner. Baselitz's pinkish skin is placed against a blue background, while Elke's dark flesh is contrasted with a background of warm reds and yellows. Both figures stand out, but their upside-down position and the expressive paint-handling employed to depict their forms neutralizes their differences. They are simply two entities that balance a composition, not unlike two apples in a Paul Cézanne still life.

By the time the artist painted the Modern Art Museum's *Elke*, 1976, both the figure of Elke and her surrounding pictorial field had become increasingly expressive and more abstract. The subject remains seated, but not on a chair. As if to suggest a chair-like support, Baselitz adds a huge brushstroke underneath the seat of the model. A typical interior setting has been replaced by an abstract, gestural field of brush-marks, and Elke's body is intertwined with a field that radiates an explosive, painterly velocity. Large arcing gestures are puzzled together with tonal zones that coalesce into stormy grays and blues, with occasional bursts of pink and green. This new pictorial energy is made even more forceful by the increased size of the 1970s portraits. In portraits from the mid-1970s forward, Elke's body becomes increasingly mutable and at the mercy of the artist's intuitive distortions. A tremendous plasticity sweeps everything together so that blunt cursive gestures, filigree strokes, drips, splatters, broken scumbles, and opaque overpainting run into one dancing optical medley. The potency is in the allusiveness. The figure turns into ground, imagery becomes abstraction, and vice versa. The model and the painting have become one.

MICHAEL AUPING

1 Quotes from the artist are from conversations with the author, 5–6 December 1996.
2 On this subject, see Robert Rosenblum's excellent essay "The Origin of Painting: A Problem in the Iconography of Romantic Classicism," *The Art Bulletin* (December 1957): 279–90. Also, George Levitine's addendum, *The Art Bulletin* (December 1958): 329–31.
3 Quotes from Elke Kretzschmar Baselitz are from a conversation with the author, 6 December 1996.

David Bates
American, born 1952

Night Heron, 1986–87
Oil on canvas
96 × 78 inches (243.8 × 198.1 cm)
Museum purchase, The Benjamin
J. Tillar Memorial Trust
1987.4.P.P.

Man with Snake, 1995
Painted wood
88 × 49³/₄ × 14¹/₂ inches
(223.5 × 126.4 × 36.8 cm)
Museum purchase, Sid W.
Richardson Foundation
Endowment Fund
1996.13.P.S.

Night Heron, 1986–87 comes from Dallas artist David Bates's body of work inspired by the Grassy Lake area in southwestern Arkansas. Its vegetation and range of wildlife, including mammals, reptiles, fish, and fowl, have been a long-term theme for Bates, and in the subseries that includes Night Heron, the artist specifically concentrated on the figures in this landscape. The painting depicts a night heron holding a fish in its bill. The heron is perched on a cypress branch amid a jungle of lush plant life. During the time Bates created this work, he was also painting great blue herons, snake birds, and anhinga, in what he refers to as "bird portraits."[1] Bates has described the setting that inspired this group of pictures:

> When I painted Night Heron, I was enamored by the subject and its surroundings. The place was so rich, and I really wanted to document it. Not with realism—though I wanted to be explicit about what you see in the work—but with paint. The Grassy Lake was packed with birds; it was like their neighborhood. The lake is beautiful, but the inspiration for this body of work came from focusing in on the birds' world. The lily pads and cypress trees were all part of their environment, so I put them in the painting.

For Night Heron, Bates used a combination of expressive realism and abstraction that creates dynamic patterns of color. The artist laid thick slabs of paint onto his canvas with a trowel and then rebuilt the heron and its Grassy Lake environment from memory, drawing into the chunks of pigment with a paintbrush. Looking at the overall portrait, it clearly represents the regal night heron in its native surroundings, but breaking the painting down into smaller sections reveals a series of individual abstract compositions. Of this style and technique, Bates said, "The large scale of my work helps me because I can do little abstract works in paint that come together like a bird." The bird's breast, for example, is represented by a white rectangle roughly outlined in thick black pigment and loosely filled in with dabs of black, gray, and taupe that make up its feathers. Within the rectangle, there

is an inverted triangle, whose shape and rhythmic dashes of color are echoed below in the bird's thighs.

The collection includes several other works by Bates, including a painted wood relief titled Man with Snake, 1995. Bates sees this relief as a natural extension of the thick paint used to make Night Heron. He points out that the man's head, made with a square, carved-out piece of wood and painted with black and white pigments, is a variation on the rectangle used for the bird's breast in Night Heron. This work also comes from the Grassy Lake series: "In 1975, I saw this guy at Grassy Lake who found a snake and held it up in his hand. I'm terrified of snakes, but to me the scene was symbolically loaded. I made a little collage immediately after seeing the man with the snake and I have since continued to elaborate on the subject."

The work, with its rudimentary cutout wood shapes, spare color, and the man's featureless face, is decidedly more abstract than Night Heron. Bates spoke about this evolution:

> I began to take more liberties with this subject matter because I had used it so many times—twenty years by the time I made the Museum's Man with Snake. The bird paintings were more literal, because the theme was new. Man with Snake is more psychological. I never figured that using less information could tell more of a story until I started making works like this one. The pared-down subject made the narrative broader.

Although their style and medium vary, Night Heron and Man with Snake share a mystic sense of place that has inspired Bates since his first trip to the Grassy Lake in 1982.

ANDREA KARNES

1 Quotes from the artist are from
a conversation with the author,
22 August 2001.

William Baziotes
American, 1912–1963

Sea Phantoms, 1952
Oil on canvas
40¹/₄ × 60 inches (102.2 × 152.4 cm)
Gift of Anne and John Marion
2000.9.G.P.

The idea of a phantom is a strong presence in the works of William Baziotes, including the Modern Art Museum's Sea Phantoms, 1952. This painting characterizes his mature style of 1944 to 1962, a time when he created enigmatic landscapes with careful attention to spatial arrangements. Like his early work, Sea Phantoms was inspired by the Surrealists' automatic drawings, but in a subtler way. Typical of Baziotes's painting technique, the shapes in this painting appear to float in space, defying traditional compositions in which the main attraction is at the center of the canvas. The flat patterned forms and gray background of Sea Phantoms were created with a nearly dry brush and thin layers of pigment. In Sea Phantoms, as in many of his works, the artist uses recurring motifs, such as the light blue sphere that radiates white lines at the upper right of the canvas. These forms represent Baziotes's personal symbolic language, which often remains mysterious to viewers of his work.

The color scheme of Sea Phantoms evokes an aquatic view, and his biomorphic, abstract shapes verge on figuration. The form at the lower right of the canvas, for example, is a black, anthropomorphic silhouette with curves partially outlined in gray, suggesting a female figure. The canvas comprises blue and black shapes on a dark gray background, with small areas of light gray highlight that, when contrasted with the predominantly dark painting, glow intensely, suggesting the fantastic, an important quality found in Surrealism.

Baziotes developed an interest in Surrealism when he met many of the artists associated with the movement

while teaching at various schools and museums in New York, such as the Queens Museum. At New York University, he developed close friendships with several Surrealists who migrated to the United States after World War II, including Matta (Roberto Matta Echaurren), who became influential not only to Baziotes, but also to his friend and colleague Robert Motherwell. Matta was instrumental in introducing the younger men to other important artists, which led to their inclusion in a Surrealist exhibition in New York in 1942: *First Papers of Surrealism*, organized by André Breton. In 1924 Breton's *Surrealist Manifesto* described Surrealism as "the superior reality of dreams," and Baziotes's work carried on in this tradition in the 1940s and 1950s.[1]

The most overt link to Surrealism in Baziotes's work, however, is to the Spanish Surrealist Joan Miró. Miró's free-association, hallucinatory landscapes epitomize the Surrealists' focus on the unconscious, and his scattered compositions and flat patterned shapes of repetitive motifs (including radiating forms, like the one seen in *Sea Phantoms*) are all elements that appear in Baziotes's work, reinvented with his personal style. Baziotes also shares an affinity with one of Surrealism's forerunners, the Italian artist Giorgio de Chirico, who created metaphysical landscapes in flattened shapes, using low-range, saturated color. De Chirico's otherworldly landscapes displace reality, an idea that appealed to the Surrealists and to Baziotes.

Baziotes was also associated with the first-generation Abstract Expressionists. He especially shares a kinship with those in the group who, like him, focused on abstract landscapes and used personal and repetitive symbolism. Adolph Gottlieb's "pictographs" and "burst" paintings and Arshile Gorky's imaginary landscapes, for example, often incorporate mysterious suspended forms that hint at representation. In *Sea Phantoms* this technique is especially apparent in the peaks and valleys of the simple azure blue shape at upper canvas, which could represent a line of ocean waves with rolling crests.

Sea Phantoms is mythological and dreamlike, as well as Darwinian in its suggestion of growth and evolving

life. Its elusive meaning is personal to the artist and provocative to viewers. Of his work and the impulse to find meaning in it, Baziotes made a dramatic statement that reveals how he felt about any artist who unlocks the truth of their imagery, solving the mystery of creative impetus: "[He/she should]…smash the mirror and whip himself into a despair. A despair that only the madman in a cage can ever know." Baziotes then quotes one of his literary heroes, the French poet Charles Baudelaire, who said, "I have a horror of being easily understood."[2]

ANDREA KARNES

1 In William S. Rubin, *Dada, Surrealism, and their Heritage* (New York: The Museum of Modern Art, 1968): 64.
2 William Baziotes, *c.* 1957, quoted in *William Baziotes: Late Work 1946–1962* (New York: Marlborough Gallery, 1971): 7.

Bernd and Hilla Becher
German, born 1931 and 1934

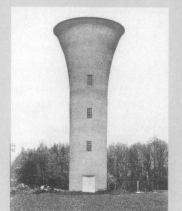 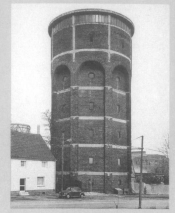

Maisoncelles, Seine-Marne, France, 1972
Gelatin silver print, edition 4/5
24 × 20 inches (61 × 50.8 cm)
Museum purchase made possible by a grant from The Burnett Foundation
1995.32.P.Ph.

Bochum, Germany, 1980, 1992
Gelatin silver print
24 × 20 inches (61 × 50.8 cm)
Museum purchase made possible by a grant from The Burnett Foundation
1995.33.P.Ph.

The German husband-and-wife team of Bernd and Hilla Becher have been collaborating since the late 1950s, photographing industrial architecture in the "straight," or documentary style used in traditional black-and-white photography. The Bechers most often photograph structures throughout Europe and America—such as grain elevators, silos, blast furnaces, houses, and water towers—that have a definite life span and then become obsolete, often to be demolished. Of their subject matter, Bernd Becher has said, "This is a nomadic architecture…it lasts fifty or sixty or seventy years, and then it goes away." Hilla Becher adds, "It's not like the pyramids, for eternity…so we thought it was worth documenting."[1]

The Modern Art Museum owns five works from the Bechers' *Water Tower* series, each of which is titled by its location. As with all of their pictures, the Bechers strive for objectivity by using a strict systematic approach to photograph each tower. The dispassionate quality of the Bechers' work is due in part to photography's inherent distancing as a medium, but it is amplified by their unique artistic vision. When asked about their choice to use photography to convey their desired artistic sensibility, Bernd Becher responds, "The constant distance [of photographs] facilitates comparison of the

buildings and minimizes distortion."[2]

For each of their images, the Bechers begin by discerning which tower in a particular region is the archetype for the area. They only document the structures that they determine to be the best representation in a particular "class" of towers, and they photograph each one in almost exactly the same way. The camera angle is always frontal, the shot is taken high and from the center, and the tower occupies the majority of pictorial space. The light is direct and dull gray, the result of photographing in the early morning on cloudy days, making the pictures absent of luminosity but evenly lit, further lending to the impartial quality of their work. As much of the background as possible is eliminated; clouds and shadows are absent, so that the backdrop to each tower is like a blank screen, which enhances the shape and tones of the structure itself.

Meaning in the Bechers' austere industrial landscapes might at first seem straightforward, but deeper analysis makes clear that what is absent from their scenes is as important as what is present. Although no people are in view, the towers and their limited surroundings become emblematic of a particular society by revealing vernacular connections between the structures and the people of a region who live with and

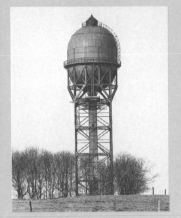

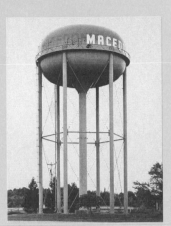

Water Tower, Dortmund-Grevel, Germany, 1965/printed 1993
Gelatin silver print, edition 1/5
24 × 20 inches (61 × 50.8 cm)
Museum purchase made possible by a grant from The Burnett Foundation
1995.31.P.Ph.

Béziers, Hérault, France, 1984
Gelatin silver print
24 × 20 inches (61 × 50.8 cm)
Museum purchase made possible by a grant from The Burnett Foundation
1995.35.P.Ph.

Water Tower, Macedonia, Ohio, USA, 1982
Gelatin silver print
24 × 20 inches (61 × 50.8 cm)
Museum purchase made possible by a grant from The Burnett Foundation
1995.34.P.Ph.

design them. For example, in *Water Tower, Macedonia, Ohio, USA*, 1982, "Bob" is scrawled on the top of the tower in spray paint. In *Bochum, Germany, 1980*, printed in 1992, a Volkswagen is parked just to the left of the tower. The Volkswagen—like the graffiti "Bob"—offers clues about the location, as does the architecture of each tower, so that even without the title, nationality is often obvious.

The Bechers' conceptual philosophy and style is often defined as "typology," the encyclopedic study, analysis, or classification of a particular subject based on types of categories.[3] Of the evolution of their method, Bernd Becher has said, "The further we progressed and the more photographs of buildings we made, the more it became necessary to sort them. The photographs should be compared with each other to show differences in architectural style, which is what led us to develop the typologies."[4]

The counterpart to typology is physiognomy, which applies to classifying people rather than objects, and both ideas are integral to contemporary German photography. One of the Bechers' photographic predecessors, the German photographer August Sander (1876–1964), initiated this approach by using physiognomy to conduct his long-term project of photographing individuals in

German society, recording differences in social positions. He photographed a butcher in a blood-stained apron, for example, and a young businessman, wearing a coat and hat, on his way to work in the morning. Like the Bechers and their industrial sites, Sander attempted to show the truest possible image of his subject, representing humanity by recording it with photography and in the process, revealing hierarchies of class and trade. In 1934, however, the Nazi party (who used the same physiognomic philosophy to spread racial hatred) confiscated Sander's work and banned his book *Face of Our Time* (1929), because it exposed character diversities that violated the Nazis' genetic ideal.

Although Sander's project was halted, his legacy was carried forward by artists like the Bechers. Because of their philosophical and stylistic approach, which they have used for decades, the layered meaning of their imagery taps into multiple artistic movements. They have been connected to Conceptual art, postmodernism, and Minimal art, and they have influenced numerous artists.[5] During the Bechers' process of picture making, they have uncovered revelations that have broadened the scope of fine art photography. In fact, the artists' formal and conceptual concerns transgress not only basic historical documentation, but also

photography itself. In 1990 their photographs of obsolete industrial architecture shattered convention by winning the prestigious award for Best Sculpture at the Venice Biennale.

ANDREA KARNES

1 Quoted in Glenn Zorpette, "Dynamic Duos," *ARTnews* 93 (Summer 1994): 166.

2 Quoted in an interview with Angela Grauerholz and Anne Ramsden, "Photographing Industrial Architecture: An Interview with Bernd and Hilla Becher," *Parachute* (Montreal) 22 (Spring 1981): 15.

3 The Bechers are also considered to be part of the photography movement known as New Topographics. This group of artists focused on landscape, but drained their pictures of romance, nostalgia, and heroism, creating works that reflect the opposite sensibility of the landscape photographers who came before them, especially those like Timothy O'Sullivan and Ansel Adams, who portrayed the American West. The exhibition *New Topographics: Photographers of a Man-Altered Landscape*, curated by William Jenkins and presented at the Eastman House in Rochester, New York in 1975, featured the Bechers along with Robert Adams, Lewis Baltz, Nicholas Nixon, and others. The exhibition established the movement in a public way, but the Bechers had been using their system since the 1950s.

4 Grauerholz, 18.

5 The German artists Thomas Ruff, Thomas Struth, and Andreas Gursky, all represented in the Museum's collection, were students of Bernd Becher's at the Kunstakademie in Düsseldorf and were inspired by his and Hilla's collaborations. Ruff, Struth, and Gursky also produce work in a typological mode.

Robert Bechtle
American, born 1932

'63 Bel Air, 1973
Oil on canvas
48 × 69 inches (121.9 × 175.3 cm)
Museum purchase,
Sid W. Richardson Foundation
Endowment Fund
1996.14.P.P.

I try to avoid composing too much, trying instead for a kind of "real estate photo" look....I try for a kind of neutrality or transparency of style that minimizes any artfulness that might prevent the viewer from responding directly to the subject matter. I would like someone looking at the picture to have to deal with the subject without any clues as to just what his reaction should be. ROBERT BECHTLE

Robert Bechtle has spent the past four decades documenting scenes of his Bay Area surroundings, following a procedure that involves taking snapshots of manicured suburban lawns, undistinguished stucco homes, parking lots, and parked cars with a cool, seemingly dispassionate vision, then translating the photographs into paint on canvas.

Since the camera's invention in the nineteenth century, photographs have served as stimuli and ancillary source material for painters, but they had never been as implicated into the painting process as they have been in the paintings of the so-called Photo-realists, among whom Bechtle is often identified as a pioneer. One of the things that distinguishes the Photorealists from the contemporaneous Pop artists is the former's attention to the way a camera records. While both groups use the photograph as a basis from which to paint, the Photorealists pay acute attention to the camera's merciless consumption of visual information. The Pop artists often appropriated and emphasized the idealizations of comics, advertising, and Hollywood films; Bechtle, on the other hand, avoids a glamorous interpretation of his environment in favor of simply presenting the facts.

Such precision is not without its ironies. For Bechtle, the photograph both creates new subject matter and becomes a subject itself. In documenting his immediate surroundings through the intermediary use of the camera, he is also documenting a particular way of seeing the world, acknowledging the fact that photographs have become the filter through which we experience reality.

Born in San Francisco in 1923, and later attending the California College of Arts and Crafts and the University of California at Berkeley, Bechtle began painting directly from photographs in the early 1960s as an alternative to the personal expressionism of the Bay Area Figurative tradition. By the time he painted *'63 Bel Air*, 1973 a decade later, Bechtle had developed a radical and apparently unromantic visual philosophy: "I try to avoid composing too much, trying instead for a kind of 'real estate photo' lookI try for a kind of neutrality or transparency of style that minimizes any artfulness that might prevent the viewer from responding directly to the subject matter. I would like someone looking at the picture to have to deal with the subject without any clues as to just what his reaction should be."[1]

Bechtle's deadpan remarks notwithstanding, his paintings are the result of a sophisticated complex of decisions designed to balance his interest in photography and painting. While his images suggest the casual immediacy of a snapshot, the surfaces of his paintings are the result of a subtle quality of touch that transcends the photographic and is peculiar to Bechtle. Over months of work, Bechtle builds up his images, layering each canvas with feathery brushstrokes that modulate the effect of light on objects in a manner that is clearly in the realm of painting. This soft painterliness is modified by Bechtle's sense of compositional restraint. While many of the Photorealists—Richard Estes, Ralph Goings, and Richard McLean, among others—engage in a baroque drama of accumulated details and surface reflections, Bechtle distinguishes himself with atmospheric minimalism.

His subdued car reflections, sidewalks, and stucco walls hit by long light reflect a dry humanism, even pathos, that separates them from the harder styles and showmanship of other artists working within this movement. The irony of Bechtle's work is that the "neutrality" he speaks of is a fallacy. Almost all of Bechtle's paintings depict people or places that have been a part of his life, as he grew up and then settled in a suburban Bay Area neighborhood. As Bechtle puts it, "This is where I live and part of who I am. I don't need to go to New York or L.A. These streets have the visual and emotional content that define a specific place—the place where I live."[2]

There is clearly a latent sentiment to these sunny but melancholic cars, streets, and homes. From Edward Hopper's lonely New York vignettes to Ed Ruscha's humorously laconic views of Los Angeles, American artists have found a way of portraying their world with an ironic mix of detachment and sentiment. Bechtle is a peculiar amalgamation of the former and the latter.

MICHAEL AUPING

1 The artist in conversation with the author, 15 February 1980.
2 Ibid.

Larry Bell
American, born 1939

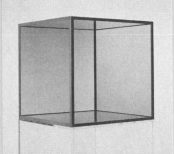

Untitled from *Terminal Series*, 1968
Glass and chrome
12 1/8 × 12 1/8 × 12 1/4 inches
(30.8 × 30.8 × 31.1 cm)
Museum purchase, The Benjamin
J. Tillar Memorial Trust
1968.18.P.S.

Larry Bell's glass cube manifests the "less is more" aesthetic that drove much twentieth-century geometric abstraction. Reducing compositional elements to a minimum is, however, a risky artistic endeavor; viewers often find the work simplistic, without visual interest, and nothing more than a modernist joke. Artists, on the other hand, have conceived reductivism as a means to distill form to a purer essence, to focus on a medium's constituent elements, and to produce a distraction-free work that can induce a contemplative, even spiritual, attitude. As Larry Bell's *Untitled*, 1968 demonstrates, condensing form can also intensify perceptual experience.

Untitled sits on a thirty-eight-inch-high Plexiglas pedestal.[1] The height and transparency of this base, which allows light to enter the cube from below, contributes to a sense that *Untitled* is floating in space. At the same time, the pedestal is clearly a sculptural support and, as such, signals that it is elevating a work of art (rather than merely holding "a glass box"). The cube itself is an immaculate fabrication of smoke-colored glass framed by chrome strips. To achieve the subtle tinting, Bell employed a High Vacuum Optical Coating Machine, originally manufactured for the United States Air Force to coat the glass surfaces of fighter plane cockpits.[2] This vacuum chamber allowed the artist to chemically bind four extraordinarily thin layers of atomized mineral/metal compounds to the glass.[3] Bell aimed

to achieve a gradient coating that would fade subtly from the edges toward the center of each glass pane.[4] This, and the accompanying shifting nuances of color and light that the artist intended, are less evident in *Untitled* than in other works in the *Terminal Series*. Instead, *Untitled*'s greater overall surface and formal consistency evince a wholeness, perfection, and preciousness that evoke the aura of a Platonic ideal.

The artist would probably disagree with this reading of his work, because for him the perceptual, not the philosophical, carries primary significance. He aimed for a pristine state in order to eliminate any distractions to the viewer's perception of the piece. Even after the work left his studio, his concern with how it looked continued: in a note to Henry Hopkins, the Museum's director when *Untitled* was acquired, Bell recommended dusting the top of the piece daily.[5] The artist's attention to the fabrication and care of his works recalls that of the modernist master Constantin Brancusi, whose bases were also integral to his sculptures. Bell's concern, however, relates more directly to the "finish fetish" and "light and surface" aesthetic characterizing the L.A. Look of the 1960s. In fact, artist and critic Peter Plagens designated Larry Bell's art "*the* embodiment" of the cool elegance and simplicity associated with that "look."[6]

Bell had his first solo exhibition, at the Ferus Gallery in Los Angeles, in 1962. He was the youngest and last member of that important gallery's stable of avant-garde artists, which included Edward Kienholz, Ed Ruscha, Craig Kauffman, Billy Al Bengston, and Robert Irwin. The latter, who had been Bell's teacher at the Chouinard Art Institute in the late 1950s, profoundly influenced the younger artist's interest in developing a perceptually oriented art. By 1962, Bell had moved from Abstract Expressionist–influenced painting to shaped canvases with false perspectives to mirrored boxes to glass cubes with checkered patterns and geometric shapes sandblasted and vacuum-coated onto them. In 1964 he began creating clear glass boxes whose sides showed subtle, variable iridescent colors produced by the vacuum

chamber process. As viewers moved around a cube and the light shifted, their perception of the piece changed. The following year Bell moved from making unique objects to making repeated cubic forms. The same year—1965—Pace Gallery presented his first one-person exhibition in New York City. The epitome of his glass cubes—the body of work for which Bell is most highly recognized and regarded—is the *Terminal Series* of 1968–69. The artist intended these works to be "very light-interactive," and to be installed so that light was not put directly on them, but on the area they reflect: "That is when the color (if any) will be most active."[7] In other words, if the sculpture were placed near a corner of a gallery, the light should be on the walls of the corner, rather than on the work itself.[8] The *Terminal Series* (the last of Bell's glass cube sculptures) consists of approximately twenty-five pieces.[9] According to the artist, the Museum's *Untitled* is "one of the best" of the series.[10]

Larry Bell's production of glass cubes coincides with the emergence of Minimalist art, and his work is often considered in the context of that movement. Works of his appeared in the Jewish Museum's 1966 *Primary Structures* exhibition, which is generally credited with introducing Minimalism to a wide audience. Like Minimalist art, Bell's forms display clarity, nonreferentiality, factory fabrication, and literalness. Also like Minimalism, his art places emphasis on the direct experience of the object. His cubes are, again like much Minimalist art, nonhierarchical, in that no single view of a piece assumes priority over another. However, Bell's cubes do differ significantly from Minimalism: his glass objects dematerialize the physical literalness of Minimalist art, and the varying coloristic qualities of the transparent sides oppose Minimalism's solid colors and uniform texture. Where the Minimalist asserted the phenomenological presence of the object, Bell emphasized its perceptual complexities and subtleties. *Untitled*, for example, is a three-dimensional form, yet because of its transparency, its exterior and interior are perceived simultaneously and coequally. Although empty, the box contains

light and space, producing what might be considered a negative solid. In *Untitled*, mass, space, and volume merge as one. Unlike a Minimalist cube, of which only three sides may be seen at a time, all six planes comprising Bell's glass cube are taken in at once. Viewers' perceptions of *Untitled* are constantly changing as they move around the piece, due to effects of artificial and natural light and the awareness of the gallery interior, which is always glimpsed in, and framed by, the piece. *Untitled* is neither as Minimalist nor as minimal as it looks.

When Edgar Degas installed a glass box in the 1880 Impressionist exhibition, it was to hold his sculpture *The Little Fourteen-Year-Old Dancer*. Degas failed, however, to complete his work in time, and the case remained empty. There was no art. Larry Bell's *Untitled* initially appears to be a vacant case awaiting its object. But here there is art. By simultaneously dissolving and shaping form and space, and containing and reflecting light, *Untitled* plays with, focuses on, and expands our sense of perception. In the process, *Untitled* reaffirms art's fundamentally visual character.

MARK THISTLETHWAITE

1 The artist intended all of the pieces in this series to be fifty inches high, no matter the size of the individual cube. The artist in an e-mail message to the author, 18 April 2001.
2 Douglas Davis, *Art and the Future* (New York: Praeger Publishers, 1973): 44.
3 John Coplans, *Serial Imagery* (Pasadena: Pasadena Art Museum, 1968): 60.
4 Bell e-mail message, 18 April 2001.
5 Postcard from the artist to Henry T. Hopkins, postmarked 9 December 1968, Registrar's Files, Modern Art Museum of Fort Worth.
6 Peter Plagens, *The Sunshine Muse: Contemporary Art on the West Coast* (New York: Praeger Publishers, 1974): 122–25.
7 Bell e-mail message, 18 April 2001.
8 Ibid.
9 Ibid.
10 Bell postcard, 9 December 1968.

Lynda Benglis
American, born 1941

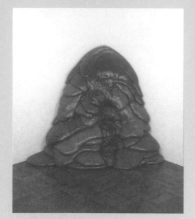

For Carl Andre, 1970
Acrylic foam
56 1/4 × 53 1/2 × 46 3/16 inches
(142.9 × 135.9 × 117.3 cm)
Museum purchase, The Benjamin
J. Tillar Memorial Trust
1970.27.P.S.

Lynda Benglis's *For Carl Andre*, 1970—a black, frozen mass that oozes from the corner of the Museum's gallery—is visually one of the most peculiar pieces in the permanent collection. It is also a milestone commission for the Museum, because it is from Benglis's famous series of poured sculpture executed in the early 1970s. Understanding *For Carl Andre* requires thinking back to the ideologies and art movements of the 1960s and 1970s, when, like most of her contemporaries, Benglis was acting on the changing socio-political climate of the time, often by creating artwork that was irreverent and sarcastic in nature. By 1970, when this piece was commissioned, Abstract Expressionism, Pop art, and Minimalism were momentous movements, and feminism was in full force, affecting much of the art made by women. *For Carl Andre* integrates many of the main principles of these existing movements, working for them or against them.

Benglis mixed the low-art materials of Pop with the gestural movements of Abstract Expressionism in this piece, but the most overt reference is to the Minimalists, a predominantly male group of painters and sculptors in which the artist Carl Andre was a pivotal figure. Coming to prominence in the late 1960s, the Minimalists used detached processes, often shunning direct, hands-on produc-

tion in part to distinguish themselves from Abstract Expressionism, the prevailing American movement of the 1950s and 1960s. Instead of creating works that invoked personal character or emotion, they embraced a machine aesthetic, often using industrial materials and simplified geometric shapes in repetitious grid formations to make the object itself, rather than the content, the focus of their art.

Benglis uses Andre's name in her piece, but the point she makes is not strictly pejorative. The work is an ironic and humorous homage to Andre's art, which is characteristically made of ordered, flat, modular shapes combined with simple slabs of metal or stone that sit directly on the floor or, like Benglis's piece, are installed in the corner. Like much of Andre's work, *For Carl Andre* is an abstract sculpture, but in stark contrast with his static, shiny objects, hers is unstructured, composed of layered, ambiguous, and illusionistic organic shapes that bring to mind ocean waves or volcanic ash. Of her process, the work, and its relationship to Carl Andre, Benglis has said:

I made a triangular, organic yet rigid black polyurethane work for the Fort Worth Art Museum called *For Carl Andre*. It's the only polyurethane corner piece of that scale, poured in place, still in existence. I always wanted to approach organic form in a very direct way, in the way that he [Andre] approached geometric form. It has to do with knowing about materials. I found, in approaching organic form, that it was quite necessary to know about the change of the matter and the timing and the flow of the material. I felt I wanted to define for myself the organic phenomena; what nature itself would suggest to me in sculpture. I wanted it to be very primal, suggestive but not too specific; very iconographic, but also very open.[1]

Like many artists, Benglis was building on what existing art movements had done, but doing so in her own way. The physicality involved in creating *For Carl Andre*—the mixing of polyurethane, resin, pigment, and quick pour to create the cascading effect—was partially a

break with Minimalist doctrines, and it also aligns her with the feminist movement. In contrast to what was perceived as the traditional, passive female role in Western society, Benglis's method is active and virile. She became an important artist, and had an impact on the art scene, even before Judy Chicago's infamous *Dinner Party* of 1979, which blatantly addressed feminist issues in relation to art history and is widely considered the embodiment of first-phase feminism.[2] *For Carl Andre* hints at Benglis's feminist concerns, but a later work of hers proved to be a much more outrageously defiant commentary about being a female artist in the 1970s. In 1974, Benglis used herself as the model for an advertisement that she placed in the November issue of *Artforum*. In the picture, Benglis is nude, sporting a slicked-back haircut and sunglasses and posing arrogantly, strategically covering her pubic area with a large plastic phallus. While the work addressed feminist issues, it also mocked consumerism—as if showing her "penis" by way of mass media legitimized her art.

For Carl Andre was not the same kind of flip statement. Rather, the sculpture showed that Benglis was aware of the movements of her time, and that she was engaged in an important artistic dialogue with several of them.[3] She is also associated with the post-Minimalists, a group for which the artist Eva Hesse was an important forerunner and which includes Jackie Winsor, Bruce Nauman, and Richard Tuttle. The post-Minimalists created works using the Minimalist artistic vocabulary, but refocusing it on the human touch, often using ephemeral, rather than mass-produced, materials. They placed a new emphasis on antiform objects (as opposed to the Minimalists' geometric works) and the revival of the gestural, painterly style of the Abstract Expressionists.

For Carl Andre—unlike Minimalist sculpture or Abstract Expressionist paintings—is unheroic. It is unsightly, a murky heap bubbling from the corner that suggests an active, organic form. The counter-dynamics at work in this piece—male/female, beautiful/ugly, natural/man-made, freeform/structured, abstract/representational—mirror the conflicting ideological and artistic

developments of the time. The piece acknowledges a debt to the artists of the 1950s and 1960s—the Abstract Expressionists and the Minimalists—and shows one artist striving to expand the boundaries of art.

ANDREA KARNES

1 Ned Rifkin and Marcia Tucker, *Lynda Benglis: Early Work* (New York: The New Museum, 1982): 11.
2 The style seen in *The Dinner Party* is also known as *essentialism* because it focused on depicting female anatomical imagery in order to create a feminine vocabulary in art. In the early stages of feminism, women artists were encouraged to use innovative materials and formats, not as part of the folk or craft tradition normally associated with the female artist, but to create art that was on a par with their male counterparts.
3 Along with Minimalism, Abstract Expressionism, and feminism, Benglis's work relates to the Pop art movement. Like the Pop artists, Benglis used unconventional materials to create her poured pieces. The soft, foaming appearance of *For Carl Andre* (although it dried hard) was certainly influenced by Claes Oldenburg's "soft sculpture," such as the Museum's *Tube and Contents*. Oldenburg and Benglis aimed to present a specific aesthetic in which the visual and the tactile battle each other for dominance. Both pieces are freeform, oversized, and out of scale; they also have a fun-house appeal and seem almost haphazard.

Ed Blackburn
American, born 1940

Hoppy Serves a Writ, 1982
Acrylic on canvas
61 7/8 × 83 3/4 inches (157.2 × 212.7 cm)
Gift of the Director's Council, 1992
1992.1.G.P.

Throughout history artists have borrowed ideas, styles, and forms from others, and since the nineteenth century they have also looked to mass media and popular culture as sources. The directness and obviousness of this borrowing intensified in the 1950s, with works by artists such as Jasper Johns and Robert Rauschenberg. In the 1960s, the Pop artists' appropriation of mass media images and consumer goods produced an art of parody and irony. With the advent of postmodernism in the 1970s, appropriation—taking another's image and making it your own—became a major artistic strategy. Postmodernists continued the Pop artists' tack, and also employed appropriation in order to question notions of artistic uniqueness and authenticity. As a prime example of appropriation, Ed Blackburn's *Hoppy Serves a Writ*, 1982 aligns not only with postmodernist concerns, but also with traditional and modernist concepts of art.

Hoppy Serves a Writ takes as its source an eight-by-ten-inch black-and-white photographic still from the 1943 movie of the same title.[1] Of the sixty-six Hopalong Cassidy films starring William Boyd that were released from 1935 to 1948, this movie was considered one of the best, and was the last based on a story by Clarence E. Mulford, the creator of the cowboy hero.[2] In the film, Hopalong Cassidy is a sheriff attempting to trap rustlers into returning to Texas, where he can serve his writ. Among those actors featured in the movie were perennial villain Victor Jory, George Reeves (who later gained fame playing Superman on television), and a young Robert Mitchum (appearing in

one of his first films). The publicity still that Blackburn selected shows Hoppy and one of the Jordan Brothers gang (Jory) clutching each other during a barroom scuffle.[3] Blackburn maintained a close relationship with his movie-still source, since he was fundamentally concerned with producing a painting of a photograph. Yet differences between the photograph and painting occur.

Blackburn's picture replicates the photograph's composition, but at a much larger size. The hand-held intimacy of the photograph is replaced by the public museum experience of the painting. The painting adheres to the black-and-white nature of the photograph, although Blackburn features grays rather than black. The artist worked dark to light, first laying in a dark gray ground, which is directly evident in the coats of the standing figures. Projecting a slide of the photograph onto the canvas (an action reminiscent of projecting a film onto a screen), the artist roughly outlined the compositional forms. Noticeably different from the movie still is the painting's expressionistic network of white paint strokes, particularly those animating the forms of the two protagonists. This flickering brushwork defines the two major figures, conveys the intense action of their struggle, and suggests the projected light of "a moving picture." The gestural handling of the white paint also registers the artist's presence as creator and reminds the viewer that *Hoppy Serves a Writ* is first and foremost a painting.

The traditional elements of painting—manipulating paint, delineating form, suggesting depth, and conveying narrative—have long fascinated Blackburn. During the early 1960s, he studied art at the University of Texas at Austin, the Brooklyn Museum of Art, and the University of California at Berkeley. He worked initially in an expressionistic, painterly manner with bright colors. Blackburn accepted the modernist notion of respecting the canvas's intrinsic flatness, and he was drawn to the Pop artists' recognition of the power and aesthetics of popular culture.[4] The complex and contradictory relationship between painting and narrative, addressed by Pop and postmodernist artists alike,

intrigued Blackburn as well. All these concerns and interests coalesce in *Hoppy Serves a Writ*.

The initial stage in the painting's creation was the selection of a photograph. Since 1971, the artist had been producing paintings that included media-derived images, such as newspaper and magazine photographs. His first composition incorporating a movie photograph was *Still Life (with Elvis Movie and Blue Boy)*, 1981. The opportunity to create a new body of work for a 1982 exhibition at the Modern Art Museum of Fort Worth triggered the series of Western B-movie-still paintings that includes *Hoppy Serves a Writ*.[5] The artist's deep interest in film and Fort Worth's reputation as "Cowtown" and "Where the West Begins" influenced his choice of subject matter. Blackburn has described the process of selecting the photograph as "critical" and requiring a great amount of time.[6] The artist wanted a photograph that actually looked like a movie still and was "loaded" with all sorts of feelings, "kind of 'used-up' so familiar that [it was] ready to be 're-seen.'"[7] Like Pop artists, Blackburn wanted to make the familiar unfamiliar. The image and its story had to be immediately recognizable to the viewer, even though the movie itself might not be. *Hoppy Serves a Writ* is, then, not intended to merely depict two men fighting; rather, it is to be seen as a painting of a photograph derived from a Western movie, a cultural artifact so familiar and generic as to be cliché and overlooked.

Although Blackburn's major interest centered on the painting as a visual experience, he did conceive of *Hoppy Serves a Writ* as entering into the tradition of figurative painting treating the human condition.[8] The size of the canvas and scale of the figures are intentionally those associated with history painting, a mode which, from the Renaissance into the nineteenth century, represented the moral and ethical dimensions and consequences of human stories and events. *Hoppy Serves a Writ* does evoke deep-seated American myths of the Wild West, rugged individualism, and good versus evil. Blackburn painted the work at a time when many Americans yearned for the "good old days" when the values embodied in these myths were

believed to be dominant. Nostalgia, however, is a sentiment the artist wished to avoid. For him, it has a limiting effect: it "puts you too close" emotionally and overwhelms the visual experience of the painting.[9] By appropriating a photograph, which is once removed from the movie itself, Blackburn hoped to cause the viewer "to step back" in order to respond more fully to the picture.[10] The artist's emphasis on the visuality of the painting also accounts for his view of narrative. Unlike history painters, who saw narrative as a unifying agent, Blackburn perceives narrative as being disruptive.

In *Hoppy Serves a Writ* the artist strove to achieve pictorial integrity, what he calls "singleness."[11] The painting should be comprehensible at a glance. Contradicting this visual immediacy, however, is the narrative, which unfolds over time. The problematics of narrative in painting have a long history, and have especially intrigued postmodernists. Blackburn regards narrative as encroaching on painting's singleness, but to him this generates a welcome tension. Narrative's disruption of the visual experience causes the viewer to have "to put the picture back together," that is, to view it as a painting, not as an illustration of a story.[12] "It's interesting to me to paint something that's about something [that suggests a narrative] but that will still remain purely visual."[13] The narrative in *Hoppy Serves a Writ* performs, then, the same functions as the white brushstrokes—to shape form and, more significantly, to refocus attention on the painting as a painting.

A seemingly simple image appropriated from popular culture, *Hoppy Serves a Writ* proves to be a complex, nuanced, and intriguing picture. It is a work about photography, movies, and American myths. Ultimately, though, it is about painting.

MARK THISTLETHWAITE

1 A few sources cite a 1942 release date, and one indicates it was released on 12 March 1942 ("Feature Films," *Hopalong Cassidy* Web site [http://www.hopalong.com]. Accessed 18 January 2001). However, the 1943 release date is most commonly cited in the literature.

2 George N. Fenin and William K. Everson, *The Western: From Silents to Cinerama* (New York: Bonanza, 1962): 208; Phil Hardy, *The Film Encyclopedia: The Western* (New York: William Morrow & Company, 1983): 137.

3 The image is related to the movie's poster, which pictures the two men locked in combat, with Hopalong Cassidy having the upper hand.

4 An example of the Pop influence on the artist is his painting *Pop Post* of 1972 in the Modern Art Museum's collection. Intriguingly, the work, with its implication of being "post-Pop," came at the moment when the term "postmodernism" began to gain wide currency.

5 This was part of a collaborative exhibition with Texas Christian University. A retrospective of Blackburn's work from 1971 to 1981 appeared at TCU, and new work was shown at the Modern Art Museum of Fort Worth (which was then the Fort Worth Art Museum). See *Ed Blackburn* (Fort Worth: Texas Christian University in association with the Modern Art Museum of Fort Worth, 1982).

6 The artist in conversation with the author, 19 January 2001.

7 Marvin L. Moon and Gregory E. Moon, "Interview with Ed Blackburn," *Trends* (Fall 1985): 28–29.

8 Conversation with the author, 19 January 2001.

9 Ibid.

10 Ibid.

11 Ibid.

12 Ibid.

13 Susan Freudenheim, "Ed Blackburn's Moving Pictures," *Texas Homes* (September 1984): 26.

Dennis Blagg
American, born 1951

Passover, 1997
Oil on canvas
44 × 121 7/8 inches (111.8 × 309.6 cm)
Museum purchase
1998.8.P.P.

For the last decade, Dennis Blagg's subject has been anonymous roadside views of southwest Texas. Working from his own observations and taking his camera along to record his chosen sites at dusk or in the early morning half-light, Blagg often merges several photographed images into one painting. The usual result is a panoramic, horizontal, idealized picture viewed from a low vantage point, with distinguished light and dark areas and realistic textural detail of arid Texas terrain. *Passover*, 1997 exemplifies this style. In the work, Blagg's palette consists mostly of the smoky blue, gray green, yellow, brown, beige, and rose tones that best describe the area around Big Bend National Park.

In an artist's statement, Blagg wrote about this work:

> This portrait of Pummel Peak is one of a handful of paintings that I consider some of the best artwork that I've done. The peak is caught in a passing storm; the desert is still wet with rain as the sun lights up the color in the foreground. In contrast to this, the dark sky casts a haunting shadow over Pummel Peak. After fifteen years of watching this spot, the right moment had finally come. I added the tall stalks of yucca and lechuguilla spears at the end to give the painting a graceful flow. The final result is more "unreal" than realistic—based more on an emotional feeling for the landscape that says something about a personal transition. I feel that it is an autobiographical painting about overcoming the darkness of depression.[1]

His choice of descriptive words, including "portrait," for *Passover* reveals that the painting is an ideal composite, as are many traditional portraits of people. In discussing

Passover, Blagg also candidly states that painting it was healing for him. And it can be similarly therapeutic for viewers. Seeing the work is like traveling vicariously to the place depicted—it takes us out of our own reality, as art often does.

Whether or not one is familiar with the landscape of Big Bend, in *Passover* it feels recognizable. The big sky and rough, beautiful topography—combined with Blagg's subtle color, light, perspective, and texture—evoke the legendary and mythic status of Texas. At the same time, looking closely at each brushstroke, the painting becomes less pristine and more painterly—each shrub, cactus, and rock formation breaks down into a series of individual abstract marks and shapes. This and other aspects of the painting, such as the almost mystical light and Blagg's imaginary additions to the scene, make it at times hyper-real.

Blagg, who is a longtime resident of Fort Worth, was born in Oklahoma City but grew up in Seminole, Texas, south of Lubbock. He is a self-taught artist and his subject matter clearly comes from his personal experience of growing up in west Texas. The idea that his paintings are autobiographical is intriguing, considering that they are uninhabited by people, and this gives his work multilayered meaning outside of the pure aesthetic and formal qualities of traditional landscape painting. Creating *Passover* involved environment, memory, photography, paint, imagination, careful study, and personal life experience. It conveys the feeling of the vastness and power of nature, but also an immediacy of real space and time.

ANDREA KARNES

1 This statement appears in *Big Bend Landscapes: Paintings and Drawings by Dennis Blagg* (College Station, Texas: Texas A&M University Press, 2002).

Jonathan Borofsky
American, born 1942

*Self-Portrait with Big Ears
(Learning to be Free)*, 1980/1994
Latex on wall, dimensions variable
Museum purchase
1995.27.P.Dr.

When you are inside the room, I want to give you the sense that you are inside my head. JONATHAN BOROFSKY

Looking back on it now I see it as a reaction to Minimalism, like everyone's saying now. But I was really fond of Minimalist work.... My counting represents that side of me. But there was the other side—the more emotional, intuitive side—that was crying to be heard.[1]

In 1974 Jonathan Borofsky invited Sol LeWitt, a key figure in the development of Minimal art and often referred to as the father of Conceptual art, to visit his New York studio. Preparing for an exhibition at the Paula Cooper Gallery, Borofsky had packed his studio to capacity with personal notations, figurative drawings on paper, and paintings on canvas, which he had scattered around the room and tacked to the wall, floor to ceiling. He told LeWitt he wanted his upcoming exhibition to retain the same sense of density and raw energy that existed in his studio. LeWitt, who in the late 1960s developed the idea of applying geometric formulations in pencil onto architectural surfaces, suggested that he draw directly on the wall. With this encouragement, Borofsky created a rambling installation that included his now well-known dream drawings.

The evolution of Jonathan Borofsky's art rehearses the story of much of his generation, and is a poignant reflection of the consolidation of two distinct generational philosophies: one engaging a ratio-nalist philosophy based on reducing art to a basic idea or concept, and one (of a younger generation) seeking to instill in art a more personal and expressionist content. Following his graduation in art from Yale University in 1966, Borofsky moved to New York and found himself seeking a personal and iden-tifiable style of artmaking. Initially, Borofsky embraced the intellectually rigorous and reductive art of the Minimalists and Conceptualists. The mural-like color fields of the Abstract Expressionists had been transformed by the Minimalists into stark, monu-mental sculptural geometries; while the Conceptualists pressed the reductivist impulse to its seemingly logical extreme, eliminating the object altogether and focusing on art as pure idea.

Borofsky's radical response to this environment was his *Thought Book* (1967–69), in which the artist spent his studio time writing down his thoughts about art, the universe, phi-losophy, and the nature of existence; and *Counting*, a work begun in 1969 and still in progress after three decades, in which the artist began a sequence of counting on paper from one to infinity. A conceptual variation on Constantin Brancusi's Endless Column, the counting has reached almost six million and now exists as a four-foot-high column of loose sheets of paper. Borofsky describes this seemingly arcane project as follows:

The counting piece was the culmination of a period of what was labeled conceptual work—just pen, pencil, and paper, and using the mind, more or less, as a device to exercise daily. It was the clearest, cleanest, most direct exercise that I could do that still had a mind-to-hand-to-pencil-to-paper event occurring. It was very linear and very conceptual. There was no intuition involved and everything was planned out ahead of time. All I had to do was get up the next day, pick up my pencil, see what number I was on, and continue counting from there.[2]

The intuitive qualities that Borofsky would subsequently investigate seeped into his art gradually. Out of sheer boredom, the artist eventually began making drawings on the borders of the counting sheets. Simultaneously, he also started recording his dreams with cryptic pencil drawings. Confessional, even sentimental in content, many of Borofsky's dreams dealt with fundamental human relationships. The artist realized that while he embraced the intellectual character-istics of Minimal and Conceptual art, he also felt an impulse to reintroduce personal subject matter, autobiog-raphy, and symbolism into his art. He began to exhibit his dream drawings, and in an effort to combine the two sides of his artmaking personality, he assigned each drawing a number based on when the drawing was done in relation to the number he had reached at that time in his ongoing counting.

Since the early 1970s Borofsky has worked in a wide range of media, preferring to create a dialogue between his art and the architecture that surrounds it. In this regard, his signature format has been the auto-biographical wall drawing. Borofsky's breakthrough with this format came when he discovered the possibilities of transferring his drawings to larger surfaces through the use of an opaque projector. This provided not only greater flexibility, but also an adventurous sense of scale. Placing his projector on a pedestal with wheels, Borofsky discovered he could spray his drawings over thousands of square feet of wall space. The pro-jected image, which the artist uses as a template into which he paints directly on the wall, sprawls over any surface, potentially wrapping around floor, wall, and ceiling.

Borofsky seldom "cleans up" his original, often spontaneous drawings. Copying precisely its projected image on the wall is a way of preserving the naked integrity of the original nota-tion, no matter how cryptic or strange. Indeed, Borofsky relies on the imme-diacy of the original drawn image to convey the sense of a fleeting thought. His use of a projector is a practical tool for activating the space of a room, as well as a metaphor for the fact that he is literally projecting his thoughts into the room.

Although drawn primarily from the artist's personal reflections and dreams, Borofsky's images typically address archetypal themes. Animals appear frequently in Borofsky's reper-toire of symbols. In some cases a dog or bird will take on the aggressive qualities of a human in a particular situation. In other cases, the artist himself will assume animalistic traits, as in the Museum's monu-mental *Self-Portrait with Big Ears (Learning to be Free)*, 1980/1994. Originally commissioned to create a piece for the Solarium of the Museum's Montgomery Street location, Borofsky draws himself over the corners, door, and ceiling of the space as a hybrid creature with huge ears. The artist describes the image as "me as a dog or maybe a rabbit and my wanting to hear what they can hear. They have a special kind of radar. I also see the ears like anten-nae that send and receive energy." He also notes the broader implica-tions of the image in regard to man's presumption of superiority over animals, noting that "they [animals] tap subtle levels of perception that can make our senses seem crude."[3]

A central characteristic of Borofsky's art has been his ambition to make public space private. It is not a coincidence that in many of the artist's environments, one enters through an image of the artist's head. As the artist describes it, "When you are inside the room, I want to give you the sense that you are inside my head."[4]

MICHAEL AUPING

1 The artist quoted in Joan Simon, "An Interview with Jonathan Borofsky," *Art in America* 9 (November 1981): 162.
2 Quoted in Richard Marshall and Mark Rosenthal, *Jonathan Borofsky* (Philadelphia: Philadel-phia Museum of Art in associa-tion with the Whitney Museum of American Art, 1984): 33.
3 The artist in conversation with the author, 30 April 1994.
4 Ibid.

Julie Bozzi
American, born 1943

Embankment—Air Base, 2000
Oil on linen
4 × 10 inches (10.2 × 25.4 cm)
Museum purchase,
Sid W. Richardson Foundation
Endowment Fund
2001.2.P.P.

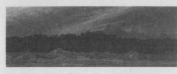

*Rubble Piles from Burial Plots—
Cemetery*, 1999
Oil on linen
4 × 10 inches (10.2 × 25.4 cm)
Museum purchase,
Sid W. Richardson Foundation
Endowment Fund
2001.3.P.P.

Julie Bozzi's landscapes depict the spaces between the picturesque events we tend to seek out as we scan a panorama. What they lack in heroic impact, however, they make up for in their subconscious familiarity as American places. Each of her small paintings reveals the ordinary intersections of nature and culture, such as the backdrops that camouflage man-made structures, or small pockets of natural growth within urban spaces. Yet even with titles that clearly name the site depicted, her scenes go beyond the edge of the canvas, literally and figuratively.

A resident of Texas since 1980, Bozzi often paints areas around Fort Worth and Dallas, along the Gulf Coast, and in the eastern Texas Piney Woods. Her approach involves sitting in her car near dusk in front of the chosen site and painting directly onto the canvas, sometimes deleting a tree or two, but never adding anything imaginary to the scene. The format of her works—narrow vistas—echoes the view through her car windshield.

Embankment—Airbase, 2000 shows a glimpse of an air force runway and the grassy embankment that abuts it.[1] The picture plane is divided into three horizontal bands.

The lower canvas depicts green-yellow grass, the center represents the brownish embankment, and the top third of the painting is gray sky. Bozzi layers paint with a nearly dry brush, using this neutral color palette to reflect the Texas terrain in most seasons, and her small canvases shimmer like the evening light by which she paints.

In *Embankment*, as with most of her landscapes, Bozzi strives for neutrality, often flattening out areas like the embankment and omitting perspective points such as receding objects or winding roads that move back into the distance. But her concentrated, almost voyeuristic sensibility and scaled-down scenes often work to undo her objectivity. Rather, she enhances the vulner-ability of her landscapes—the places are vulnerable to begin with, in that no one looks at them and they are not "important"—and then she makes them small. Ultimately her views make us focus our attention as binoculars or a telescope would do, changing the way we look at the everyday. In fact, her landscapes can be haunting in their suggestion of an underlying story behind the scene.

In an artist's statement Bozzi acknowledges the mythic aspect of Texas and its influence on her work. She is particularly drawn to the dark sides of the myth: the infamous grassy knoll in Dallas linked to the assassination of President John F. Kennedy, the clock tower on the campus of the University of Texas at Austin that deranged Vietnam veteran Charles Whitman climbed to gun down innocent victims, the roadside field on the outskirts of Denton where the notorious serial killer Henry Lee Lucas dumped the body of his girlfriend, the prairie field near Waco where the Branch Davidian standoff ended in flames. These events occurred in various nondescript patches of land in Texas, any of which could be subjects for Bozzi's paintings, making her seemingly benign landscapes potentially disquieting.

In 1975, after receiving her master's degree as a ceramicist at the University of California in Davis, Bozzi attended the Skowhegan School of Painting and Sculpture in Maine. At Skowhegan she began to paint small landscapes for the first time. Bozzi describes the atmos-

phere at Skowhegan and the student curriculum: "Everyone packed up their paints and easels and headed out into the surrounding fields, and I thought the whole process was so nineteenth century."[2] She eventually embraced this nineteenth-century plein-air technique, which was first used by the Impressionists in the 1870s. Working outdoors only long enough to sketch what they saw directly onto their canvases, the Impressionists then retreated to the studio to apply the paint and finish their works. In a sense, Bozzi's method surpasses theirs: she paints directly onto the canvas, returning to the specific place every evening to capture the same light until the picture is complete.

Before the Impressionists began their plein-air excursions, landscape aesthetics came into their own early in the nineteenth century with two distinct movements, and Bozzi's work relates to each of them. The Romantic painters of the early 1800s depicted moody scenes meant to connect nature to spirituality. Although Bozzi's modest depictions of dirt mounds and shrubs would appear to be light years away from the dramatic vistas portrayed by many of these nineteenth-century painters, her commonplace images evoke an oblique, but poignant connection to artists such as the German Romantic painter Caspar David Friedrich (1774–1840). Friedrich often depicted empty churches, obsolete architecture, and large dead trees on the edge of a horizon, as if to suggest a certain existential landscape of ruin, or of an indeterminate future. For Bozzi, suburban parking lots, cemeteries (seen in works such as the Museum's *Rubble Piles from Burial Plots—Cemetery*, 1999), and construction sites offer a similar hidden sublime. Hers, too, are landscapes in transition.

Bozzi's work also connects to a countermovement initiated in the late 1800s by the Realist painters, who created landscapes in response to the idealized scenes of their Romantic predecessors. Clearly Bozzi used the Realist painters as a point of departure: like them, she paints unsentimental, solemn imagery, often using ordinary subjects and presenting them in a straightforward manner; but she

stretches their idea to its outermost points. The Realist painters were influenced by the advent of photo-graphy, and Bozzi too creates views linked to a photographic aesthetic—from snapshots to film stills to photojournalism. But Bozzi's images relate to photography in contemporary terms, which often means depicting detached, seemingly unbiased scenes.

Despite her Realist painting vocabulary, when she is asked about her favorite painters Bozzi mentions Friedrich's melancholy landscapes. She is specific about which of his works appeal to her:

> I like Friedrich's landscapes without people. Landscapes without figures are more neutral; when people are added, they are a scale indicator and they create an inconsistency—the work becomes about the people, or barns, or houses instead of the land. Friedrich's people look like little dolls, but when he omitted the figures, he made pure landscapes.

Needless to say, Bozzi's paintings do not show people, but her slivers of concrete sidewalks—or in the case of the Museum's works, the embank-ment and cemetery—seemingly provide evidence.

ANDREA KARNES

1 The airstrip depicted in this painting comes from the Naval Air Station Carswell Joint Reserve Base (formerly Carswell Air Force Base) in Fort Worth.
2 Quotes from the artist are from a conversation with the author, 21 August 2001.

Sophie Calle
French, born 1953

The Blind #19, 1986
Color photograph, black-and-white photograph, text, and wooden shelf
Overall 47$\frac{1}{4}$ × 51$\frac{3}{4}$ inches
(120 × 131.4 cm)
Museum purchase made possible by a grant from The Burnett Foundation
1995.36.P.Ph.

I spent one year with blind people who were born blind, who had never seen, and I asked them what their image of beauty was. Each work is composed of a portrait of the blind man or woman, and color photography trying to represent what beauty is to their eyes.

SOPHIE CALLE

By the late 1970s/early 1980s, the French artist Sophie Calle was somewhat of an underground figure in her own country. Not known as an artist at that time, she was (and is) more like an eccentric adventurer whose obsessions include exhibitionism and voyeurism. Calle's first well-known project, completed in 1979, was a book that chronicled the results of her following strangers around Paris to document their daily activities—from banal to perverse. On one hand, she was a self-employed private investigator who recorded what anonymous Parisians did in their daily existence. On the other hand, she was a stalker whose victims where completely unaware of her intrusion into their personal lives. Calle has continued to play out her social investigations, presenting them in a broad range of media including books, films, and grids of framed photographs and text, such as *The Blind #19*, 1986.

This work comes from a series in which Calle asked blind people to describe beauty and then translated their descriptions into visual form. The results are surprising—they reveal the depth of photography's inadequacy in explaining what it is to be blind, and they demonstrate how blind people and sighted people use descriptive language differently. Of this series, Calle has said:

I spent one year with blind people who were born blind, who had never seen, and I asked them what their image of beauty was. Each work is composed of a portrait of the blind man or woman, and color photography trying to represent what beauty is to their eyes. Sometimes I made the photographs: for example, a man described a painting he had in his house, so I went to photograph that painting. Some of the people also took photographs themselves, trying to turn the camera in the direction where they thought beauty was.[1]

There are three components to *The Blind #19*. The top left side of the installation is a framed, black-and-white close-up shot and tightly cropped frontal picture of a woman wearing dark sunglasses. To the right of this photograph is a framed quote that relays the woman's concept of beauty:

The man I live with is the most beautiful thing I know. Even though he could be a few inches taller. I've never come across absolute perfection. I prefer well-built men. It's a question of size and shape. Facial features don't mean much to me. What pleases me aesthetically is a man's body, slim and muscular.

Beneath the quote is a color photograph that sits on a wooden shelf. It portrays a man lying on a bed turned away from the camera, with contrasting plays of light and dark falling on his bare, muscular back—Calle's interpretation of the woman's description.

In studying this work, do sighted people gain insight into what it means to be blind? *The Blind #19* brings us directly into the featured woman's vision, yet we fall short, as does photography as a mechanical reproduction of her idea of beauty. In a larger realm, all communication is interpretive and one never really knows how universally understood a description is, whether visual, written, or spoken. Calle critiques photography as a visual mode of expression for a non-visual concept, and reveals its shortcomings. The work also speaks to the notion of beauty, which is based on an entirely different set of conditions for a blind person. A statement such as "facial features don't mean much to me" is rarely heard from a sighted person describing another's beauty.

But what also becomes apparent is the intense level of voyeurism that Calle, and we as viewers, are immediately involved in. We might assume that the blind people in this series are willing participants, but can they really know the full ramifications of letting Calle invade their privacy for museum display? What is it like to be "on view" at the discretion of multitudes of people whose concepts of art and beauty are often based on visual cues?

We gaze directly at the woman in the picture, who cannot see us. We read her words, and we see Calle's visual interpretation of them. But the woman has no control over Calle's decisions and how they really correspond to her concept of beauty, or to ours as onlookers. We can discern whether we think Calle's representation of the woman and her concept of beauty are accurate, but the woman herself cannot tell us if Calle's visual translation is correct.

In viewing this work, we have yet another kind of uncertainty to reconcile: We do not know how much of this story is real and how much of it is the artist's creation. The woman in the picture may not be blind at all, and the quote may have been fabricated, by Calle or by someone else. When questioned about this notion in relation to several of her bodies of work, the artist responded:

Everything is real, everything is true in the works, there is just generally one lie included, but the lie is related to a frustration.... One of the blinds [multimedia pieces from the blind series] is completely fake: I wanted a certain answer that never came, so one of the blinds is the gift I gave myself. So every time there is a lie, and generally there is only one in each work: it is what I would have liked to find, and didn't.[2]

The Modern Art Museum's work could be Calle's gift to herself. If it is, all who view it are making decisions about blind people—their situation and their concept of beauty—based on what the artist wanted to find, but did not. We might initially think of the blind person in the picture as having been exploited, but we may actually be the most vulnerable participants in this work.

ANDREA KARNES

1 Bice Curiger, "Sophie Calle in Conversation with Bice Curiger," *ICA Document Series* 12 (London: Institute of Contemporary Art, 1993): 34
2 Ibid.,37.

Anthony Caro
British, born 1924

All sculpture in some way has to do with the body. ANTHONY CARO

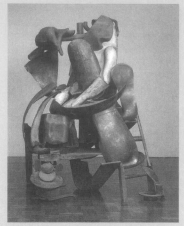

*The Descent from the Cross
(after Rubens)*, 1987–88
Steel, rusted and waxed
96 × 73 × 63 inches
(243.8 × 185.4 × 160 cm)
Museum purchase,
Sid W. Richardson Foundation
Endowment Fund
1989.7.P.S.

Since 1965, when the influential art critic Clement Greenberg declared it "breakthrough" work, Anthony Caro's art has epitomized high modernist sculpture.[1] The British artist's early welded and painted steel sculptures, set on the ground rather than a pedestal, manifest a highly resolved play of openness, weightlessness, relationality (part-to-part and part-to-whole), and "radical abstractness."[2] Caro began working with rusted steel in 1970, as he continued his exploration of abstract sculpture. Given his art's abstract character and the modernist disdain for illusionism, it is surprising to find Caro producing a work as obviously referential as *The Descent from the Cross (after Rubens)*, 1987–88. Yet this later work does relate to the artist's ongoing interest in addressing aspects of the human body and in pushing the boundaries of abstraction.

Throughout the 1950s, Caro produced figurative sculpture. Under the influence of Henry Moore, whom he assisted from 1951 to 1953, he embraced qualities of so-called primitive art. Unlike Moore, however, Caro was drawn to modeling rather than carving and to expressionistic surfaces. Caro's work at this time was less about depicting the human form and more about disclosing

bodily weight, movement, and energy. By the end of the decade, he grew increasingly dissatisfied with figurative work and began considering the possibilities of abstraction. By chance, he met Clement Greenberg in London in 1959, and was subsequently encouraged to rethink his art. That same year, he received a grant to travel to the United States, where he reconnected with Greenberg, and through him met Kenneth Noland, Helen Frankenthaler, and David Smith. Upon his return to London, Caro immediately began to create a welded steel, abstract piece. For this work and those that were to follow, the artist found inspiration in the welded, collage-like sculpture of Smith and the earlier iron and steel pieces by Pablo Picasso and Julio González. By the late 1960s, Greenberg and Michael Fried had published important, widely read critical essays asserting Caro's position as the modernist sculptor of the era.

Caro secured his reputation during the 1970s and 1980s by producing an extensive and diverse body of work. He introduced pedestals—calling them "tables"—into his work, only to have his sculptures grip, overlap, and float off them. Some works comprised massive slabs, and others, thin, linear elements. Most display an open, airy feeling, but many are denser and centralized. All emphasize the composition as a set of formal relationships that addresses the body, for, as Caro has stated, "all sculpture in some way has to do with the body."[3] This often translates into a viewer's empathizing with a sculpture's physicality, and feeling the urge to move around it in order to grasp it visually. Caro's abstract pieces do not, however, imitate the body; rather they render, in Michael Fried's words, "the livedness of the body."[4] His sculpture speaks to our familiarity with the body and evokes a sense of it *as actually lived*—as possessed *from within* so to speak."[5] Caro himself has indicated he wants his sculpture to possess "that feeling of being alive, of jumping, of dancing almost."[6] His abstractions express bodily dynamics without depicting the figure, even when, as in *The Descent from the Cross (after Rubens)*, he derives his composition from a figurative source.

Peter Paul Rubens's monumental *The Descent from the Cross*, 1611–12, created as the central panel of the altarpiece for the Antwerp Cathedral in Belgium, is one of the great Baroque paintings.[7] Through striking colors, dramatic modeling, and theatrical gestures, glances, and gazes, the painter moves the viewer's eyes ceaselessly around the composition. Yet he avoids chaos and succeeds in unifying the twisting, turning, stretching, and straining figures by focusing their attention and emotions on Christ, and by melding them to the dynamic compositional diagonal on which he descends. No doubt Anthony Caro was particularly drawn to the energetic "livedness" of these massive bodies and the way Rubens, as metaphorically described by one art historian, "*welds* disconnected figures into a compact group."[8] Caro literally welds forms together to breathe three-dimensional life into Rubens's two-dimensional image. While the sculptor attends closely to the painter's composition, Caro produces not merely a diagram-in-the-round of the Rubens painting, but a sculpture emanating its own immediate and vital presence.

Caro's *The Descent from the Cross* brings actual physicality and palpability to the robust illusionism of Rubens's composition. The nearly fourteen-foot-high oil painting was intended to be elevated and viewed from a distance, while Caro's eight-foot-high sculpture rests on the ground, occupies our space, and allows us to walk around it. The sculpture is literally and metaphorically grounded compared to the painting, which, despite rendering the Descent, exuberantly thrusts vertically. Less monumental than the altarpiece, the sculpture is more directly accessible to the viewer. Art critic Mark Stevens observes that "the Rubens is magisterial, but the Caro belongs to you and me. It is both more intellectual and more ordinary. One moment it looks fresh, the next it looks rusted."[9] As a sculptor working from a famous image, Caro was challenged not only to reference the frontality of the painting, but also to achieve a cohesive visual unity for the viewer moving around the piece. Using a multitude of diverse, mainly curving, coloristically rusted, and waxed steel

forms, Caro conveys the restless vitality of the Rubens without precisely illustrating it. The sculptor does, however, quote three elements from the painting: the cross, the ladder, and the plate at the foot of the ladder. Otherwise, the sculpture's abstract shapes suggest, rather than replicate, the figural gesture, movement, and placement animating the altarpiece.

For an artist whose work has been regarded as having rejuvenated modernist abstract sculpture, the art historical and implicit figurative aspects of *The Descent from the Cross (after Rubens)* would appear to make the sculpture an anomaly. But it is one of several works Caro produced in the mid- to late 1980s that refer to past art and artists. *Table Piece Y49 after Picasso*, 1985 not only pays homage to Picasso, whose sculpture had helped fuel Caro's move to welded abstract sculpture, it also links the British artist to a past master, just as the Spaniard himself had done in numerous paintings from the last two decades of his life. The same year he produced *Table Piece Y49 after Picasso*, Caro visited Greece for the first time and was captivated by the Temple of Zeus at Olympia. This led to his *After Olympia*, 1986–87. During this time, the sculptor also created *Rape of the Sabines*, 1985–86 and *Variations on an Indian Theme*, 1984–86, in which he returned to modeling forms under the impact of Indian sculpture of the eleventh century B.C. Following *The Descent from the Cross (after Rubens)*, Caro produced *The Descent from the Cross (after Rembrandt)*, 1988–89 and two versions after Edouard Manet's *Le Déjeuner sur l'herbe* in 1989.[10] By looking to the past, Caro was not only following in the footsteps of Picasso, he was also in step with the contemporary postmodernist interest in appropriation. Caro, like the modernist painter Frank Stella, also found in earlier art a way to reinvigorate abstraction. Stella was enamored of the spatial dynamics of Baroque painting, particularly that of Caravaggio, and his widely read 1986 publication *Working Space* includes a full-page reproduction of Rubens's *The Descent from the Cross*. In referencing Rubens's composition, Caro's timely work straddled the concerns of both modernists and postmodernists.

Caro produced *The Descent from the Cross (after Rubens)* when he was becoming intrigued by the relationship between sculpture and architecture. In 1984 he created *Child's Tower Room*, then in 1987 collaborated with Frank Gehry and others on *Architectural Village*. Since then he has created several pieces which engage in a dialogue with architecture, exhibited works at the Tate Gallery under the title *Sculpture into Architecture*, and participated in the design of London's Millennium Bridge. Caro coined the term "sculptitecture" to describe both his blurring of the boundaries between sculpture and architecture, and the notion that sculpture could be climbed upon and inhabited. While *The Descent from the Cross (after Rubens)* does not truly exemplify "sculptitecture," its inclusion of the cross and ladder hint at architectural possibilities.

The Descent from the Cross (after Rubens) is more complexly allusive than Caro's earlier works, and thus appears unusual in his art. However, the piece is firmly embedded in the artist's association of sculpture with the body and his commitment to expanding the character of modernist sculpture. Nevertheless, Caro has acknowledged a shift in his art: "In the 1960s we did everything to avoid allowing our work to look like an insect or piece of furniture. Now abstraction is so firmly established within the language of sculpture that it no longer requires that sort of defence."[11] The artist has also recently affirmed the fundamental spirit of the individual innovation that drives modernism: "You have got to take risks and surprise yourself."[12] In *The Descent from the Cross (after Rubens)*, Anthony Caro took a risk and produced a masterful surprise.

MARK THISTLETHWAITE

1 Greenberg quoted in Richard Whelan, *Anthony Caro* (New York: E. P. Dutton & Company, 1975): 87.
2 Michael Fried, introduction to *Anthony Caro* (London: Hayward Gallery, 1969): 12.
3 Caro in a 1972 interview with Phyllis Tuchman, quoted in Whelan, 115.
4 Fried, 5.
5 Ibid.
6 Karen Wilkin, *Caro* (Munich: Prestel, 1991).
7 The altarpiece, in triptych form, was completed in 1614, with the attachment of the wings.
8 From Hans Gerhard Evers, *Peter Paul Rubens* (Munich: F. Bruckman, 1942), translated in John Rupert Martin, *Rubens: The Antwerp Altarpieces* (New York: W. W. Norton & Company, 1969): 121. The italics are added.
9 Mark Stevens, "Sculpted Essences," *The New Republic* 201 (4 September 1989): 28.
10 Another of Caro's works from this time is a small steel piece titled *Table Piece "For Rubens,"* 1988–89.
11 Wilkin.
12 *Anthony Caro: New Sculptures— A Survey* (London: Annely Juda Fine Art, 1998): 7.

Vija Celmins
American, born Latvia 1939

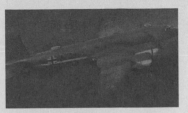

C

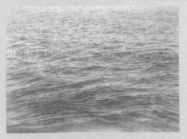

German Plane, 1966
Oil on canvas
16 × 26 1/8 inches (40.6 × 66.4 cm)
Museum purchase,
Sid W. Richardson Foundation
Endowment Fund
1996.2.P.P.

Untitled, 1970
Pencil and acrylic on paper
12 3/4 × 17 1/2 inches (32.4 × 44.5 cm)
Museum purchase, The Benjamin
J. Tillar Memorial Trust
1972.40.P.Dr.

Night Sky #17, 2000–01
Oil on linen, mounted on wood
31 × 38 inches (78.7 × 96.5 cm)
Gift of Anne and John Marion
2002.3.G.P.

Commentary on page 37

John Chamberlain
American, born 1927

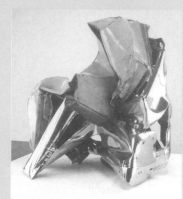

That's where I get the idea that everybody makes sculpture every day, whether in the way they wad up a newspaper or the way they throw the towel over the rack or the way they wad up the toilet paper. That's all very personal and very exact and in some sense very skillful on their part, but it is discarded as useless information. But it's not useless.

JOHN CHAMBERLAIN

Scull's Angel, 1974
Welded painted steel
29 × 45 × 38 inches
(73.7 × 114.3 × 96.5 cm)
Gift of Mr. and Mrs. Max Walen
1975.43.G.S.

While visiting Larry Rivers's Southampton home in the late 1950s, John Chamberlain accidentally ran his car over the fenders of a 1929 Ford that happened to be lying in the yard. When he inspected the damage, Chamberlain decided he liked the wrinkled forms that were created. He asked Rivers if he could have the damaged metal and went back to his studio to weld the two fenders together. The resulting work, *Shortstop*, 1957 (Dia Center for the Arts, New York), is a delicately crushed structure that encloses a hidden central space. A pivotal moment in Chamberlain's career, the creation of this small, eccentrically shaped form announced the artist's discovery of auto parts as a material suitable for sculpture, as well as his use of compression as a technique for creating sculpture.

Since 1957 Chamberlain has applied this technique to a wide range of found sheet-metal items; among them, parts from washing machines, stoves, toys, refrigerators, airplanes, lunch boxes, trains, coffee cans, air conditioners, ceilings, and oil drums. He has also experimented with polyurethane foam and paper, gently squeezing these materials with his hands. The artist has said, "That's where I get the idea that everybody makes sculpture every day, whether in the way they wad up a newspaper or the way they throw the towel over the rack or the way they wad up the toilet paper. That's all very personal and very exact and in

some sense very skillful on their part, but it is discarded as useless information. But it's not useless."[1] Chamberlain's material experimentations notwithstanding, automobile parts have been by far his favorite material, becoming one of the signature elements of his art. The artist has said, "That is a material that offers the right resistance for my nervous system."[2] In his many auto-part sculptures, compression is accomplished with a large sheet-metal crusher, which the artist sees as a machine equivalent of the hand.

Chamberlain's approach to sculptural form has been substantially informed by his appreciation of the found and manipulated objects welded together by the sculptor David Smith, and also by the paintings of Franz Kline and Willem de Kooning. While attending school at the Art Institute of Chicago, and later Black Mountain College in North Carolina, Chamberlain came under the influence of Kline and de Kooning, who had both spent time at Black Mountain. Speaking of Kline's bold, calligraphic gestures, Chamberlain cites the sense of "force" and "velocity" in Kline's images as a significant influence.[3]

If Kline provided the impetus for Chamberlain's gestural compression, de Kooning offered a model for composition and assembly. Like de Kooning's complex, interwoven couplings of paint strokes, the polychromed sheet-metal units of a work like *Scull's Angel*, 1974 interlock in a surprisingly precise fashion. What at first appears as an explosion of violent, uncontained energy is in fact a unitary field of tightly knit, baroque folds of steel. Chamberlain's sculptures are the result of precise assembly, an assembly based on what the artist refers to as "the Fit."

His technique involves the spontaneous trial-and-error process of tightly connecting crushed and twisted parts together to create a form. The work's balance, or what the artist refers to as "the Stance," is supported by precise fit and gravity. Welding is often done after the fact and essentially for the purpose of having fewer parts to reassemble when the work is moved.

Chamberlain's use of color has often been compared to that of de Kooning, a surprising comparison considering that Chamberlain's color is essentially found, and is dependent on the changing aesthetics of the auto industry. Chamberlain explains what he sees as the similarity: "De Kooning and Detroit [the automobile industry] use a lot of white in their color. It's basically the same formula or equation."[4] Yet despite this fact, Chamberlain's color relates to more than just personal taste. By the fact that they are commercially chosen, his colored surfaces reflect the consumer tastes of society at large.

While Chamberlain's art of the 1960s pays homage to the gestural procedures of the Action Painting branch of Abstract Expressionism, it is also reflective of the burgeoning Pop art movement of the 1960s and 1970s. His use of the automobile—perhaps America's most prominent cultural icon—relates directly to the consumer imagery of Pop. By the 1970s Chamberlain's art reflected a conscious synthesis of these two critical movements in American art. *Scull's Angel* is a mature example of this blending.

The title *Scull's Angel* refers to the New York taxi and limousine baron Robert Scull, a prominent collector of Pop art and a sometime drinking companion of the artist. Like a

previous generation of artists, Chamberlain's generation was prone to late-night drinking sessions at various artists' hangouts, and on occasion Scull would provide his "angels" to drive artists home. The term *angel* is occasionally used to designate a patron of the arts. Scull was also a relentless bargainer, expecting favors in the form of lower prices for art in exchange for his help.[5] The fact that *Scull's Angel* appears to be made of parts of a smashed and deformed taxi fender may be an ironic comment on the artist's "twisted" relationship to the collector.

MICHAEL AUPING

1 Julie Sylvester, "Auto/Bio: Conversations with John Chamberlain," in *John Chamberlain: A Catalogue Raisonné of the Sculpture 1954–1985* (New York: Hudson Hills Press, 1986): 12.

2 The artist in conversation with the author, 26 July 1984. On this point, also see Michael Auping, *John Chamberlain: Reliefs 1960–1982* (Sarasota: The John and Mable Ringling Museum of Art, 1983).

3 Phyllis Tuchman, "An Interview with John Chamberlain," *Artforum* vol. X no. 6 (February 1972): 40.

4 The artist in conversation with the author, 2 April 1987. Also see Michael Auping, "John Chamberlain," in *Structure to Resemblance: Work by Eight American Sculptors* (Buffalo: Albright-Knox Art Gallery, 1987).

5 The artist in conversation with the author, 3 March 1987.

Chuck Close
American, born 1940

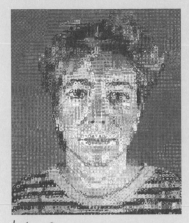

Judy, 1989–90
Oil on canvas
72 × 60 inches (182.9 × 152.4 cm)
Gift of Anne Burnett Tandy in
memory of Ollie Lake Burnett,
by exchange
1990.8.G.P.

For three decades Chuck Close has created portraits in a variety of media, including paintings, photographs, collages, and prints. The faces in his works are those of his friends and family—and periodically his own—usually depicted in a straightforward manner, showing little emotion. Often the subject appears incidental to the style in which the portrait is made. In *Judy*, 1989–90, Close combines a large-scale, colorful presentation with sculptor Judy Pfaff's matter-of-fact expression to present a view of the human face that is at once dry yet psychologically intense. *Judy* was painted at a time when Close was primarily using his artist friends as models, and it was one of his first major paintings made with bright colors and expressionistic brushwork, qualities that have since become hallmarks of his mid-career style.

Close's painted portraits are always made by working from a photograph rather than a live model. For *Judy*, he used a color Polaroid, but for much of his earlier work, he used black-and-white photographs. In the painting Pfaff is shown in a direct frontal view from head to shoulders, posed like a photo-identification card—a driver's license or a passport—but Close has changed the context. He presents a blown-up version made in a painterly style that clashes with Pfaff's deadpan stare and blurs the boundaries between realism and abstraction. Close's method for creating *Judy* involved working from a squared grid, painting in each section with repetitive patterns of abstract shapes. Dots, squares, ovals, and lozenges made primarily with pink, orange, yellow, and blue pigments create an overall mosaic effect. Studying *Judy* involves a mental back-and-forth between seeing the composite portrait of Pfaff and seeing the individual squares of the grid, which are abstract mini-compositions on their own.

More than anything else, the image creates an awareness of surface—of a photograph, of a canvas, and of a face—and how it is transformed through Close's process. Although the work is figurative, the shallow space of the canvas is similar to many second-generation Abstract Expressionists, who sought to achieve flatness on the surface of a canvas. Close's grid system, however, is technically more akin to his contemporaries the Minimalists, who used man-made materials to create abstract, geometric works that made the object, rather than emotional or psychological content, the focus. Although his early portraits convey the visual crispness of Minimalism and the flatness of Abstract Expressionism, these formal qualities were used by Close to describe human subjects, something that was rarely done at the time.

As a student, Close studied Abstract Expressionism and made paintings stylistically similar to those of Willem de Kooning's, but rather than compete within the prevailing movement, Close and other artists of his generation began to work against it. One of the most radical ways to transgress abstraction was to bring representation back into their work. Artists of the 1960s and 1970s took several different avenues to do this, ranging from American Pop art to Photorealism. Close's work has affinities with each of these movements, but it also diverges from them. The Pop artists used everyday objects and non-traditional materials to make art that was influenced by advertisements. Its irreverent nature clearly broke with the modernist tradition of what was considered art. Close was also inspired by the everyday—witness the ordinary poses of his sitters—but his work had a more serious tone and was less engaged with the impact of commercialism.

The Photorealists, such as Robert Bechtle, took a different approach. They made paintings of urban scenes that were absent of people and suggested the depth of field and dispassionate sensibility of a camera. Although Close's work was photo-based, it was not as straightforward as that of the Photorealist painters, whose work never included the human face. Other artists, such as Philip Pearlstein, focused on human anatomy in artificially lit surroundings to flatten out and exaggerate the plays of light and shadow and mimic photography. Pearlstein and other realist painters of this time, however, worked from live models to depict figures whose faces were often completely cropped out of the scene, or who are seemingly unaware of the presence of viewers. Quite the opposite is true of Close. His portraits are derived from close-up photographs of people who look directly, even defiantly, out at us.

ANDREA KARNES

Clyde Connell
American, 1901–1998

Guardian No. 4, 1988
Redwood, paper, glue, and metal
91 × 12 ¹/₄ × 3 ¹/₂ inches
(231.1 × 31.1 × 8.9 cm)
Anonymous gift
1991.33.G.S.

Clyde Connell experienced firsthand the patriarchal Southern culture of twentieth-century America. Born to a privileged white family, she grew up on a large plantation and lived most of her life, which spanned almost the entire century, in Louisiana. Like all of her work, the content of the Modern Art Museum's *Guardian No. 4*, 1988 comes from her own life experiences and her empathy for the oppressed—particularly women and rural, Southern blacks. These concerns led to her fundamental artistic theme, which is investigating the human condition, both sociologically and geographically. *Guardian No. 4* is a story told through ordered, abstract symbolism, like Egyptian hieroglyphs, Native American totems, or cave paintings. In a way, Connell's primitive mode of communication interprets the past to make sense of the present.

Connell made *Guardian No. 4* using found and natural materials from around Lake Bistaneau, an isolated, swampy area on the outskirts of Shreveport, Louisiana, where she lived and worked for the last fifty years of her life. The surface of *Guardian No. 4* is overlaid with a

series of simplified geometric shapes and rusted metal parts found on her property. Its support is a vertical redwood plank covered in a grayish-brown, pulpy, papier-mâché "skin" that is scattered throughout with dark-brown dimples.[1] The idea that this form is anthropomorphic is enhanced by the verticality and skinlike surface of the piece, and further reinforced by the curved wood support and the carved-out opening at the base of the work, which breaks its solidity. Though the overall structure appears as a larger-than-life human form, the graphics on its surface suggest that it is inhabited by several figures, and that it contains more than a single story. Various elements in *Guardian No. 4*, for example, can evoke a female figure, a sentry holding a club, or a prison guard's key ring. The work's title indicates protection or guardianship; but who is the guard looking after, and what does this mysterious narrative convey?

Although Connell presents symbols of human tyranny, whether or not the figure is being protected or imprisoned is unknown. In a discussion with Michael Sartisky about her *Bound People* series of 1983–87, a body of work created just before *Guardian No. 4*, the artist's own statement reveals that her symbolism is less ambiguous than it might at first appear. She says that *Bound People* includes anyone who is "being bound by your community and ideas and the customs that bind you and you just can't break them." She specifically addresses modern American women, stating, "I have found very few women in my day that really broke out of the customs and the ideas of what women should be."[2]

Connell's symbolism was heavily influenced by her environment and experiences in Louisiana. In 1949, her husband was appointed superintendent of the Caddo Parish Penal Farm in Greenwood, Louisiana, a minimum-security facility with mostly black inmates. This was a significant move for Connell, as she had her first permanent studio on the prison grounds. During these years, she worked in an expressive mode, creating woodcuts and paintings of African American inmates.[3] The prison's cotton fields reminded her of her plantation upbringing. Reminiscing about her past, Connell

recalled a woman named Susan, a black caretaker and matriarchal figure in the home of her youth. The memory of Susan's singing and mournful wailing stirred the artist's interest in abstract modes of communication.[4] Susan's deep, guttural sound was the feeling Connell wanted to evoke in her art, and she began to move from figuration to non-representational imagery. Her discovery of Abstract Expressionism in 1952 ultimately motivated this artistic shift. She was especially drawn to Adolph Gottlieb's pictograph paintings of the 1940s, which were influenced by Surrealism and psychology. Gottlieb created symbols that were meant to represent subconscious and non-verbal thought processes—precisely what Connell was investigating.

Numerous messages emerge from *Guardian No. 4*—private, universal, spiritual, and primal. In this piece, the idea of guardianship is a dichotomy: The guard either keeps us out, or keeps us in. Likewise, a multifaceted picture is also true of Connell the person, and her legendary status as Louisiana's matriarch. She was a white woman who involved herself in black culture; a Christian who created pagan-like structures; and an artist who was regionally revered and nationally renowned.

ANDREA KARNES

1 This technique involved boiling a mixture of newspaper and glue, and was perfected and ritualized by Connell as a part of her creative process. For details about the method, see Charlotte Moser, *Clyde Connell* (Austin: The University of Texas, 1988): 37.
2 Quoted in Michael Sartisky, "Abstracting the Essence," in *Clyde Connell: Daughter of the Bayou* (Shreveport: Meadows Museum of Art, 2000): 40.
3 Moser, 27.
4 Ibid., 29.

Thomas Joshua Cooper

American, born 1946
Lives and works in Scotland

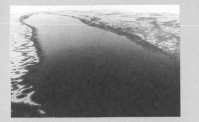

Snow Storm Life Line I, Rio Grande River Crossing at the Source of the Rio Grande, Mineral County, Colorado, 1995, 1995
Framed silver gelatin print, selenium and gold chloride toned, edition 1/3
30¹/₄ × 38¹/₂ inches (76.8 × 97.8 cm)
Museum purchase
2000.13.a.P.Ph.

Snow Storm Life Line II, The Rio Grande—Looking North, Bridge Street, Albuquerque, New Mexico, 1995, 1995
Framed silver gelatin print, selenium and gold chloride toned, edition 1/3
30¹/₄ × 38¹/₂ inches (76.8 × 97.8 cm)
Museum purchase
2000.13.b.P.Ph.

Boca Chica (Little Mouth), The Mouth of the Rio Grande at the Gulf of Mexico, Texas, Mexico Border, 1996–97, 1996–97
Framed silver gelatin print, selenium and gold chloride toned, edition 2/3
31 × 39 inches (78.7 × 99 cm)
Museum purchase
2000.16.P.Ph.

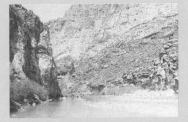

Last Light—Brightest Light (Message to Robert Adams) The Rio Grande Entering St. Elena Canyon, The Big Bend, Texas, 1996–97, 1996–97
Framed silver gelatin print, selenium and gold chloride toned, edition of 3, AP2
30¹/₄ × 38¹/₂ inches (76.8 × 97.8 cm)
Museum purchase
2000.18.a.P.Ph.

Last Light—Brightest Light (Message to Robert Adams) The Rio Grande Leaving Boquillas Canyon, The Big Bend, Texas, 1996–97, 1996–97
Framed silver gelatin print, selenium and gold chloride toned, edition of 3, AP2
30¹/₄ × 38¹/₂ inches (76.8 × 97.8 cm)
Museum purchase
2000.18.b.P.Ph.

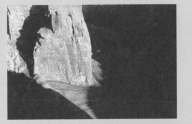

from *The Great River, Rio Grande River Crossings, The Source to the Sea: A Premonitional Work, (Message to Timothy H. O'Sullivan), Antelope Ruins, Canyon del Muerto, (Navajo Tribal Territory), Arizona, U.S.A., 1994–95*
Framed silver gelatin prints, selenium and gold chloride toned, edition 1/3
Diptych, each 30¹/₂ × 38⁵/₈ inches (77.5 × 98.1 cm)
Gift of Anne and John Marion
2002.5.a–b.G.Ph.

Commentary on page 44

Joseph Cornell
American, 1903–1972

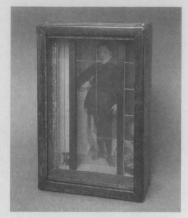

Untitled (Medici Boy), 1953
Wood, glass, oil, and paper
18 1/4 × 11 3/8 × 5 1/2 inches
(46.4 × 28.9 × 14 cm)
Museum purchase, The Benjamin
J. Tillar Memorial Trust
1968.16.P.S.

Joseph Cornell is best known for his small, shallow wooden boxes containing fragile and ephemeral materials that possessed personal and symbolic meaning for him. He began constructing shadowboxes, assembling collages, and making experimental films in the early 1930s. The Modern Art Museum's work *Untitled (Medici Boy)*, 1953 features a photographic reproduction of a detail from a painting of a young boy, one of his favorite images throughout the 1950s. At the time, the boy in the painting was believed to be a member of the famous Medici family of Florence, Italy, and it was attributed to the Italian Renaissance artist Giovanni Battista Moroni. However, the work is now firmly ascribed to Sofonisba Anguissola from Cremona, Italy, who was influenced by Moroni and is one of the few recognized female artists of the Renaissance.

As it turns out, the Anguissola painting actually does not depict a Medici family member. Currently in the collection of the Walters Art Museum in Baltimore, Maryland, the picture is entitled *Portrait of Marchese Massimiliano Stampa*, 1557. It was commissioned to commemorate nine-year-old Massimiliano Stampa's becoming the third marchese of the small northern Italian city of Soncinco, in the province of Cremona.[1] It depicts Stampa leaning against a mantle with gloves in his left hand and a sword by his right side, an indication of his new position of power. His dog is curled up at his feet, sleeping. Although he did not know the image was Anguissola's, Cornell used her painting as the central section of several of his boxes—an interesting coincidence since he had studied her work in books, and greatly admired it.

For *Untitled (Medici Boy)*, Cornell used transparent blue glass, sectioned off like windowpanes, in front of the image of Stampa. The inside walls of the box are covered with marbled, metallic gold paper, and at the bottom of the box are two small wooden cubes covered with cutout details of the boy's image, suggesting children's toy blocks. Cornell was influenced by the penny arcades that he played as a child around his home in Utopia Parkway, New York. The blocks at the bottom of the box might represent a coveted prize for the arcade player.

Rather than looking inside a wooden cube, we psychologically enter a room by gazing into Cornell's box. But the glass enclosure acts as a barrier to us, enhancing the curiosity of its contents, yet making them unattainable. With its distressed wood, tinted glass, and Victorian-style wallpaper, the box looks antique and evokes feelings of nostalgia, fantasy, and melancholy.

Cornell influenced countless artists that followed him, but his mix of high- and low-art materials made him a particularly important precursor to the Pop art movement of the 1960s, especially to artists like Robert Rauschenberg, who created Pop versions of mixed-media constructions that were influenced by advertising and mass media. Cornell's appropriated imagery also influenced many postmodern artists. His use of existing masterworks from art history to make his own art distorted nostalgia and changed the meaning of the borrowed image, just as postmodern artists today recycle existing pictures and relate them to the present. Whereas Cornell's pastiche of images were perhaps used to incarnate his imagination, the artists who came after him borrowed pictures in a self-conscious manner to make political or artistic points in their work.

Cornell was drawn to the European movements of Dada and Surrealism, especially to the collages of Max Ernst. Like the Dadaists and Surrealists, Cornell combined seemingly incongruent man-made and natural materials to create new meaning. However, he disagreed with the Surrealists' focus on the unconscious implications of dreams and their interest in Sigmund Freud's psychoanalytic theories. Unlike the art of the Dadaists, Cornell's works were neither political nor nihilistic. Nonetheless, his work was often exhibited with both groups, and in 1936–37, he was included in Alfred Barr's major exhibition *Fantastic Art, Dada, Surrealism* at The Museum of Modern Art in New York.

The legend of Cornell's life is often incorporated into his artistic discourse. He is described as a reclusive genius and bibliophile with an affinity for the French Symbolist poets such as Stéphane Mallarmé, who favored metaphor over literal language. He made frequent visits to Manhattan to pursue his cultural interests—art, music, literature, theater, ballet, and natural science. Cornell's naïve obsession with stardom and his vivid imagination are intriguing components of his legend, and are widely considered to be the driving force behind his desire to make art. He was not only an artist, but also a collector—of everything from postage stamps to magazine pictures to little wooden blocks and marbles. His basement studio in Long Island housed his collection, which was his own contemporary cabinet of curiosity, to admire and to use for his collages, constructions, and experimental films. Cornell lived most of his life in Utopia Parkway, using his personal obsession with images and objects to create private worlds in precious boxed environments that continue to intrigue all who peer in.

ANDREA KARNES

1 Information on the Anguissola painting was found in Federico Zeri, *Italian Paintings in the Walters Art Gallery* (Baltimore: Walters Art Gallery, 1976) and Eric M. Zafron, *Fifty Old Master Paintings from the Walters Art Gallery* (Baltimore: Walters Art Gallery, 1988).

Tony Cragg
British, born 1949

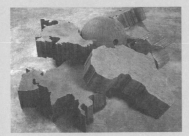

Ball Contact, 1990
Eight pieces of steel
36 × 85 × 72 inches
(91.4 × 216 × 182.9 cm)
installed (variable)
Museum purchase
1991.14.P.S.

Tony Cragg's *Ball Contact*, 1990 clearly conveys a message about man's impact on the environment. Cragg recreated the shapes of the earth's seven continents in heavy, rusted steel cutouts with flat fronts and corrugated sides, giving them the appearance of having been extracted directly from the surface of the earth. They lie in a random pile with a large steel bowling ball, a reference to a familiar Western pastime, at their center. The ball is the source of chaos—it has apparently crashed into the earth, destroying its continuity. Cragg has defined his fundamental artistic concerns as being "man's relation to his environment. The relationship between objects, materials, and images. The creation of objects that don't exist in the natural world or in the functional world which can reflect and transmit information and feelings about the contemporary world and my own existence."[1]

Although the concept of man and nature has been the impetus of Cragg's work since his career began in the late 1970s, his overall oeuvre is stylistically eclectic. He has worked in a wide array of media, from small natural and found painted objects arranged and color coded in grid patterns on the floor to massive works made with man-made materials and machine-fashioned parts, such as *Ball Contact*. There is, however, logic to his artistic shifts—his work is always in direct dialogue with the history of modern sculpture, especially with his British predecessors who matured in the 1950s, 1960s, and early 1970s.

In the 1950s British sculptors such as Anthony Caro helped establish the rules of modernist sculpture, which directly correlated to modernist abstract painting. Caro's work, like that of his contemporaries, is characterized by gestural and abstract yet anthropomorphic forms, often presented in heroic scale. The modernist sculptural language adhered to by Caro, however, was ruptured by the next generation of British sculptors, including Gilbert & George and Richard Long.

In the 1960s Gilbert & George approached high modernism with humor and complete irreverence by using their own bodies to create "living sculpture." They chose crowded thoroughfares and city squares in London as locations and posed without moving for unsuspecting passersby, documenting their performance/sculpture with photographs. Their innovations made everything from the natural to the material world fair game for sculpture.

At the same time, Richard Long was using materials from nature, arranged according to a Minimalist framework, as a part of his reaction to modernism. His work *Cornwall Summer Circle*, 1995, for example, is a circle made of stones arranged on the floor. The artist culled the stones directly from nature. The circle suggests spirituality, a romanticized natural environment meant for man's contemplative interaction. Long's work coalesces man and nature in a positive light. His influence is apparent on Cragg, who has also united natural and found objects to comment on the fusion of nature and culture, but with a decidedly rougher edge. Cragg, like Long, works in a Minimalist vocabulary, often creating low-lying works like *Ball Contact* that are placed directly on the floor. Also invoking Minimalism is Cragg's emphasis on material and the way the pieces work within a part-to-whole relationship.

Cragg graduated with a master's degree from the Royal College of Art in London in 1977. By 1978 he was teaching at the Kunstakademie in Düsseldorf. In 1981 he was included in a seminal exhibition announcing a new generation of British sculptors, *Objects and Sculpture*, which was presented at the Institute of Contemporary Art in London and the Arnolfini Gallery in Bristol. The show also included Anish Kapoor, Antony Gormley, and Richard Deacon, and although their work did not address exactly the same concerns as Cragg's, these artists shared an interest in creating avant-garde art using aspects of urban culture as source material. In 1988 Cragg represented Great Britain at the Venice Biennale and was awarded the prestigious Turner Prize from the Tate Gallery in London. Rounding out the year was his promotion to Professor at the Kunstakademie.

From his early sculpture that rebelled against modernism to later works like *Ball Contact*, Cragg has been recognized for his important artistic innovations. *Ball Contact* shows his reverence for man-made materials and a new focus on the object itself, while its content remains pointed at man's intervening presence in nature.

ANDREA KARNES

1 Quoted in Jan Debbaut, "The Metamorphosis of the Object," in *Tony Cragg* (Eindhoven: Stedelijk Van Abbemuseum, 1989): 5.

Richard Diebenkorn
American, 1922–1993

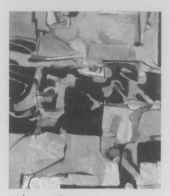

Urbana #6, 1953
Oil on canvas
68 5/16 × 57 15/16 inches
(173.5 × 147.2 cm)
Museum purchase,
Sid W. Richardson Foundation
Endowment Fund, 1996.1.P.P.

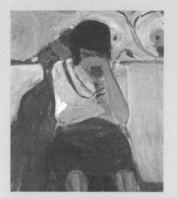

Girl with Flowered Background, 1962
Oil on canvas
40 × 34 inches (101.6 × 86.4 cm)
Museum purchase,
Sid W. Richardson Foundation
Endowment Fund, 1991.11.P.P.

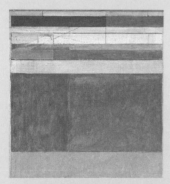

Ocean Park #105, 1978
Oil and charcoal on canvas
99 7/8 × 93 inches (253.7 × 236.2 cm)
Museum purchase, Sid W. Richardson
Foundation Endowment Fund and
The Burnett Foundation, 1991.12.P.P.

Commentary on page 50

Jim Dine
American, born 1935

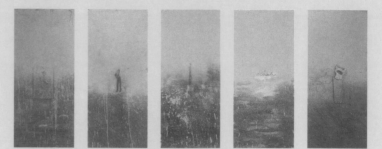

The Art of Painting, 1972
Mixed media on canvas with objects
Five panels, each 72 × 30 inches
(182.9 × 76.2 cm)
Museum purchase, The Benjamin
J. Tillar Memorial Trust
1973.47.P.P.

What does it mean to title a work *The Art of Painting*? Is the intention to suggest a celebration of a fundamental human activity, or to reveal art's everyday processes, techniques, and tools? Does the title signify that the "art" of painting centers on creativity and imagination, or on craftsmanship and professionalism? Does it imply that painting produces an art object that is both artificial and real? All of these questions pertain to Jim Dine's *The Art of Painting*, 1972 and his ongoing concern for "painting that's about painting."[1]

Five tall panels comprise *The Art of Painting*. Each consists of enamel and acrylic on canvas with objects attached. Roughly half of each unit is covered with flat, light blue paint that drips onto and merges with a mixture of colors, primarily greens, below. At the center of four of the panels hangs an implement associated with painting: palette, metal shears, paintbrush, and miter box saw. The canvases with the palette and shears also include nails and hooks. The fifth panel does not feature a tool, but instead is inscribed with the word "bluish." Each panel is numbered on the back; the palette is on number one, the shears on number two, the paintbrush on three, "bluish" on four, and the saw on number five. The incorporation of actual objects into his art has been a career-long practice for Dine, with tools being one of his signature motifs.[2]

Jim Dine became known in 1960 as one of the primary figures involved with Happenings, or what he preferred to call "painter's theater."[3] At the same time, he was creating works influenced by Robert Rauschenberg and Jasper Johns that combined real objects, such as clothing, shoes, and a bedspring, with painting. In 1962, Dine was included in *The New Realists* exhibition at New York's Sidney Janis Gallery. This seminal show featured artists of the emergent Pop art movement. Dine became associated with the movement, but has adamantly maintained that he was not a Pop artist: "I'm not part of the movement because I'm too subjective. Pop is concerned with exteriors. I'm concerned with *interiors*."[4] Dine's art has always been more personally expressive and intense than that of the Pop artists, and without Pop's sense of irony. While Dine, like the Pop artists, has appropriated and incorporated the commonplace into his work, his use and understanding of objects are more personal and multilayered.

The Art of Painting dates from his second series of paintings that included actual tools. Earlier in 1962, during a three-month burst of activity, Dine created about thirty "tool" paintings. Then, from 1963 to 1970, tools appeared only occasionally in his work. They resurfaced as a focus of interest in 1972. Dine and his family had returned from four years in London to settle in Putney, Vermont in 1971. On a trip to New York City that year, Dine saw an exhibition of small ballpoint pen drawings by Cy Twombly that so inspired him that he told his wife, "Let's get out of here. I'm going back to Vermont to work."[5] Over the next year, Dine produced *Fifty-Two Drawings for Cy Twombly*, 1972, small pencil works that depict a variety of

implements. He also created a number of paintings that incorporated tools, including the Museum's multi-panel *The Art of Painting*.[6]

Tools appeal to Dine for many reasons, but three stand out: their connection to his adolescence, their association with work and the worker, and their formal beauty. From the age of nine to eighteen, Dine worked summers in his grandfather's hardware store and his father's plumbing supply and paint store. Although the work bored him, he admired the two store's arrangements of tools. This early admiration conditioned the display element inherent in *The Art of Painting*, in which the tools are centered on individual "stages."[7] His early familiarity with tools also manifested a feeling of kinship: tools became "objects of affection . . . like relatives of mine, as though their last name was Dine."[8] He has spoken of tools as self-portraits, and made the connection explicit in such works as his series of drypoints entitled *Thirty Bones of My Body*, 1972, which presents hair-sprouting tools, and the sculpture *Twins in the Forest*, 1989, which Dine characterizes as a dual self-portrait surrounded by a "forest" of tools that provides "a support system for my soul."[9]

As a teenager, Dine's support system consisted mainly of his grandparents, with whom he lived. His grandfather instilled in him a deep respect for working with one's hands, a feeling for "the dignity of it. There is no greater thing you can do than to work with your hands. That's what I do."[10] By setting the tools of his trade across the surfaces of *The Art of Painting*, Dine emphasizes the hand labor and craft aspects of painting, and proclaims the idea of painter-as-worker. For him, tools are imbued with history, the presence of the human hand, and "the need in the human hand that created those objects. There was no author. There were authors every time anybody used one, they found a better way to make it."[11] Dine also finds extraordinary beauty in a tool's marriage of form and function: "Sometimes I can almost go to my knees, it's so beautiful!"[12] With its palette, shears, brush, and saw, *The Art of Painting* exemplifies the artist's respect for tools as embodiments of identity, memory, history, labor, and beauty.

The Art of Painting is rich in artistic associations and visual rewards. Each canvas's portions of color imply a landscape. Dine makes the allusion obvious in a related work, *The Art of Painting No. 2*, 1973, by more sharply dividing the color areas and by describing the upper portion as the cold Vermont sky and the lower part as grass.[13] In the Modern Art Museum's composition, the lower element offers a more ethereal, lyrical, and expansive notion of landscape. Stylistically, the canvases merge the Color Field and gestural sides of Abstract Expressionism, a movement closer to Dine than is Pop art. "I am a student and child of Abstract Expressionism. I simply learned to paint by looking at those paintings."[14] His work shares with the earlier movement an engagement with subjectivity and expressionism. Dine has also likened his relationship to Abstract Expressionism to that of a son and father, and has observed that like many sons, he rejects aspects of his father. Most notably, his inclusion of actual, commonplace objects in his painting counters the transcendental spirit of Abstract Expressionism. The tool not only is present in all its mundane materiality, but, as an object hanging on the painting, it also breaks and simultaneously asserts the physical fact of the canvas's flatness. Taking an implement out of its normal context allows Dine to present the familiar in an unfamiliar way and to enrich both our conception and our perception of it. In his hands, the tool may recall or evoke a religious icon, a *trompe l'oeil* painting, a body part, an experience of work, and myriad other associations.[15]

Given Dine's predilection for tools, it is surprising to find one of *The Art of Painting*'s panels inscribed with a word, rather than carrying an implement. The word—"bluish"—might be perceived as objectlike, functioning primarily as a form or shape. The artist has metaphorically linked objects and words by describing his objects as providing "a vocabulary of feelings."[16] Words have appeared in Dine's work from the beginning, and in 1969 Dine completed a large canvas filled entirely with people's names. Often, as in the Museum's 1971 etching *Paintbrush*, a transparent connection is made between word and image— the inscription and image define the same object. "Bluish" in *The Art of Painting* is less direct. The word names its canvas's color, but only partially; other colors appear below it. As a color description, "blu*ish*" is inherently imprecise and less matter-of-fact than "blue." Compared to the concreteness of the implements, the word is vague. The palette is definitely a palette, but what is "bluish"? a color? a mood? a category?

In *The Art of Painting*, "bluish" might be understood as signifying the intuitive, personal, and subjective aspects of artmaking. How does an artist formulate and express meaning in a work of art? How can meaning be described and explained? The inexactness of "bluish" suggests that meaning, whether articulated by the artist or others, remains tentative and elusive. While the tools in *The Art of Painting* speak to the physical process of constructing a painting, the word addresses the interior vision motivating the painter. Jim Dine reminds us that the art of painting is a complicated affair of work and thought, of the hand and the mind.

MARK THISTLETHWAITE

1 David Schapiro, *Jim Dine: Painting What One Is* (New York: Harry N. Abrams, 1981): 208.
2 Another motif for which the artist is known is the heart, as seen in the Museum's *Large Heart Drawing #7*, 1970.
3 John Gruen, "Jim Dine and the Life of Objects," *Art News* 76 (September 1977): 39.
4 A 1966 remark quoted in Gruen, 38.
5 Jean E. Feinberg, *Jim Dine* (New York: Abbeville Press, 1995): 24.
6 The Modern Art Museum's collection also includes two related Dine etchings from about the same time: *Paintbrush*, 1971 and *Four German Brushes*, 1973.
7 *Jim Dine: Walking Memory, 1959–1969* (New York: Solomon R. Guggenheim Museum, 1999): 133.
8 Feinberg, 24.
9 Marco Livingstone, *Jim Dine: The Alchemy of Images* (New York: Monacelli Press, 1998): 325.
10 *Jim Dine: Walking Memory*, 132.
11 Ibid.
12 Ibid.
13 Graham W. J. Beal, *Jim Dine: Five Themes* (Minneapolis and New York: Walker Art Center in association with Abbeville Press, 1984): 56. *The Art of Painting no. 2* is in the collection of the Art Museum, Princeton University. It also consists of five panels; however, each is shorter and wider and has two hanging implements. None of the panels show a word replacing a tool.
14 *Jim Dine: Walking Memory*, 100.
15 Although Dine's objects are real, they bring to mind nineteenth-century *trompe l'oeil* paintings by William Harnett and John Peto. Dine has spoken of being a "fan" of such work and amazed by them (*Jim Dine: Walking Memory*, 116). In 1969 he created an installation titled *Five Chicken Wire Hearts (for John Peto)*. The work was destroyed, then rebuilt in 1998.
16 Gruen, 38.

Barbara Ess
American, born 1948

no title, 1989
Monochrome color photograph,
AP2
73 × 50 inches (185.4 × 127 cm)
Museum purchase made possible by
a grant from The Burnett Foundation
1995.6.P.Ph.

no title, 1989
Monochrome color photograph,
AP 4/4
96 × 50 inches (243.8 × 127 cm)
Museum purchase made possible by
a grant from The Burnett Foundation
1995.5.P.Ph.

no title, 1991
Monochrome color photograph,
edition 1/4
50 × 62 inches (127 × 157.5 cm)
Museum purchase made possible by
a grant from The Burnett Foundation
1995.7.P.Ph.

no title, 1994
Monochrome color photograph,
edition 3/3,
47 × 60 inches (119.4 × 152.4 cm)
Museum purchase made possible by
a grant from The Burnett Foundation
1995.4.P.Ph.

The Museum's collection includes
four large-scale photographs by
Barbara Ess, each made in her signa-
ture style, using black-and-white film
and a simple pinhole camera and
then printing on color photographic
paper. Her choice of equipment and
process makes pictures with a soft
focus, especially around the edges.
Usually printed with just one earthy
color, such as amber or muted blue-
black, her images become ambient,
shadowy, and flickering.

In an artist's statement from the
Museum's archives, Ess wrote, "My
work is about the subjective nature
of personal experience and also the
human desire to 'break out' of the
self, to know and make sense of the
physically manifest world."[1] With
this conceptual focus in mind, it is
clear that the effects of a pinhole
camera would appeal to her, best
expressing the gap between reality
and how we often mentally transcend
it. Because her camera has no lens
or viewfinder, the pictures she prints

*In a way I try to photograph what cannot
be photographed.* BARBARA ESS

are somewhat of a surprise; even
though she sets up the shot, she
cannot control exactly what the
camera records. In the printing
process, however, Ess makes
decisions about framing, cropping,
color, and scale to produce the final
photograph, which is always dream-
like and psychologically intense.

In one respect, her photographs
are clearly figurative, yet they are also
blurred, with space distorted to the
point of abstraction. Each is entitled
"no title", reinforcing the idea that
they are not direct representations
of specific places or things. Rather,
the imagery works within the realm
of ambiguity and metaphor—it is
meant to trigger memory and
nostalgia based on personal experi-
ence and the associations we make
with what we see.

Varied symbolism and meaning
can be found within each of the
Museum's pictures. At center frame
of the vertical piece no title, 1989 is
a stuffed ram's head enveloped in a
soft orange glow. Its eyes and nose
glisten as if animated, yet it is clearly
lifeless, cleanly cut at the neck and
mounted on a wood backdrop.
Similarly, no title, 1994 is a fluttery
glimpse of a spread white wing and
a faint bird's body that resembles a
dove seemingly caught in a struggle.
No title, 1991 is an intense orange
blurred face, disfigured by the close-
up view. All three of these images
verge on the supernatural—receding
and hazy—and are enigmatic to the
point of being distressing. Perhaps
the most unsettling, however, is no
title, 1989, a vertical, predominantly
black-and-white image of what
appears to be an infant left alone
on a bed.

Like these images, all of Ess's
works have a distinct narrative
quality. Not surprisingly, she studied
filmmaking in the early 1970s at the
London School of Film Technique.
Yet her pictures, more like film stills
than a complete story, are unre-
solved. As such, they initiate a range
of emotions, from anxiety and
helplessness to being captivated by
a fantasy and the romantic aesthetic
quality of her old-fashioned method.

Her pictures not only relate
to film, they also hark back to the

nineteenth-century approach to
fine-art photography known as
Pictorialism and to the well-known
amateur photographer Julia Margaret
Cameron. The Pictorialists and
Cameron often included nature,
women, and children as subject
matter, creating tableau vivant
imagery that either reinforced fixed
notions about society and women
and children, including moral
messages, or—as is most often the
case with Cameron and Ess—evoked
moody, open-ended narratives.

Of her intent as a photographer,
Ess has said, "In a way I try to
photograph what cannot be pho-
tographed."[2] Her success in this
endeavor is evident in the Modern's
four pictures, each of which
potentially and probably sparks a
memory that relates to reality, but
is not an exact representation of it.

ANDREA KARNES

1 Barbara Ess, "Statement of
 Plans," undated, Registrar's
 Files, Modern Art Museum of
 Fort Worth.
2 "Barbara Ess," *Camera Austria*
 27 (October 1988): 17.

Lyonel Feininger
American, 1871–1956

Manhattan II, 1940
Oil on canvas
38 1/8 × 28 5/8 inches (96.8 × 72.7 cm)
Purchase made possible by
anonymous contributions, 1946
1946.6.G.P.

Throughout his career Lyonel Feininger focused on several major themes, including cityscapes and seascapes that he sometimes reduced to smaller components, such as churches and sailboats. *Manhattan II*, 1940 belongs to Feininger's body of work that depicts New York City skyscrapers. Painted the year he began the series, it depicts a Manhattan street scene from a close-up perspective. Tall buildings line each side of the street, and a wide strip of sky runs through the middle. In this painting Feininger used a muted palette of blues and browns with areas of white and cream to add contrast to the darker forms. He defined light and shadow with vertical planes of color that vary in density from opaque to transparent. The main light source in the painting comes from the large whitish-blue structure at the center of the canvas. Two crisscrossed diagonals divide the scene into four unequal quadrants and suggest rays of sunlight beaming down. Two blocks of heavily applied brown pigment flank the canvas's sides, creating movement from the bottom right of the picture plane through the center and to the top left. In *Manhattan II*, multiple perspectives and strong diagonals intensify the rhythmic movement of a crowded street and echo the hustle and bustle of city life.

Feininger's dynamic between space and form, and his use of geometric and flat planes of color and multiple perspectives were influenced by Cubism, but his uneven angular shapes and depiction of light and shadow diverged from it. Cubism was out of fashion by the end of World War I, and in the period between the World Wars (approximately 1919 to 1939), several new art movements took shape. He, along with the emerging artists of the time with whom he exhibited, used the Cubist vocabulary as a point of departure.

Feininger left New York for Europe at the age of sixteen, eventually settling in Germany for the next fifty years. Several art movements were developing during that time. A second wave of German Expressionism was gaining momentum, and its adherents were using bright colors straight from the tube and large blocks of painterly brushwork to express feeling, movement, and sound. Like theirs, Feininger's work conveyed emotion and sensory qualities, yet he had a different artistic sensibility than these new German Expressionists. Concurrently, Dada and *Neue Sachlichkeit* (New Objectivity) artists were producing nihilistic art in response to political disillusionment following the war. Feininger's work was not overtly political.

In other countries, outgrowths of Cubism flourished—Purism in France and Precisionism in America—and Feininger's work had closer affinities to these two groups. The Precisionists included Charles Demuth and Louis Lozowich, who, like Feininger, often depicted cityscapes with a reverence for the machine age and architectural imagery. Their European counterparts, the Purists, included Le Corbusier and Amédée Ozanfant. The Purist movement was an outgrowth of the post–World War I socio-political ideology "call (or return) to order." Return to order was fueled by France's attempt to recover from the trauma of war. In art, that meant looking back to classical subject matter but making it contemporary. Feininger's work was not as austere as many of the artists working in the Purist or Precisionist mode although his themes, like theirs, ranged from elements in nature to metropolitan

life. He was especially engaged with the sights and sounds of New York and Germany, the two places where he lived during his formative years. He often depicted these cities with a romantic sensibility, drawing from his memories of the past to rouse nostalgia.

Before he began seriously painting in 1907, Feininger made a living as an illustrator. Two of his cartoon series, *The Kin-der-Kids* and *Wee Willie Winkie's World*, were published in *The Chicago Sunday Tribune* from 1906 to 1907. During those same years, some of his drawings were reproduced in European publications like the Parisian magazine *Le Témoin*. However, his most significant career move was as a core staff member of the Bauhaus, where he worked from 1919 to 1932.

Founded in 1919 in the Weimar Republic, the Bauhaus, lead by Walter Gropius, was the most influential school of design and architecture in the world. Along with Feininger, the staff included an important circle of artists, among them Wassily Kandinsky and Paul Klee. In the early 1930s the Bauhaus experienced problems from the rising Fascist government of Adolf Hitler and the National Socialist party, and in 1933 was forced to close.

Artists living in Germany after World War I survived great devastation, but life under the Nazi regime was even worse. In 1933 Hitler and the National Socialist party included Feininger in their exhibition of "degenerate art"; soon after, his work, along with that of several of his contemporaries, was banned. Because of Germany's mounting instability, Feininger moved back to America in 1937, two years before Hitler invaded Poland and instigated World War II in Europe. Feininger was not alone in fleeing to the United States. Among the influx of European artists, writers, musicians, and actors were such major artists as Josef Albers, Max Beckmann, Max Ernst, and Piet Mondrian, most of whom settled along the East Coast. These artists, including Feininger, would have a major impact on the evolution of American art.[1]

Although their styles varied, Feininger, Kandinsky, Klee, and Alexei Jawlensky formed an artistic group known as Die Blaue Vier (the Blue Four), which was promoted in the

United States, especially in California, by the American dealer and collector Emmy "Galka" Scheyer.[2] Feininger's association with Die Blaue Vier and his subsequent fame on the West Coast led to a job at Mills College in Oakland, California. Broad acceptance in America, however, was more difficult to achieve than his success in Europe. In 1929 the National Gallery in Berlin organized a major retrospective of Feininger's work. This led to his being included in *Nineteen Living Americans*, a group show at The Museum of Modern Art in New York. His reviews from the MoMA show were tinged with hostility from U.S. art critics, who resented his being named one of the nineteen Americans (even though he had always retained his American citizenship). Feininger's difficult time with American museums, collectors, and critics ended when he resettled in California, where he was recognized as a significant contributor to modernism. Although he lived in California when he created *Manhattan II*, he was able to recall New York City well enough from memory to create an entire series based on its skyscrapers.

Manhattan II exemplifies Feininger's late style. It acknowledges Cubism as his cornerstone, but also reveals his own innovations, including his treatment of light, depth, and shadow. Feininger's mix of ordered, linear forms with irregular, angular shapes evokes the movement of the urban environment that inspired *Manhattan II*. The painting transcends its own literal subject matter to effectively place us in the lively atmosphere of a busy New York City street, where buildings tower overhead and fragments of light shine through.

ANDREA KARNES

1 See Stephanie Barron with Sabine Eckmann, *Exiles + Emigrés: The Flight of European Artists from Hitler* (New York and Los Angeles: Harry N. Abrams, Inc. in association with the Los Angeles County Museum of Art, 1997).
2 Amy Baker Sandback, "Blue Heights Drive," *Artforum 7* (March 1990): 123.

Vernon Fisher
American, born 1943

Lunga Point, 1974
Acrylic and thread on vinyl
58¹/₈ × 63¹/₂ inches (147.6 × 161.3 cm)
Museum purchase, The Benjamin
J. Tillar Memorial Trust
1975.9.P.P.

84 Sparrows, 1979
Acrylic and graphite on
laminated paper
69 × 176 inches (175.3 × 447 cm)
Museum purchase, The Benjamin
J. Tillar Memorial Trust
1982.2.P.P.

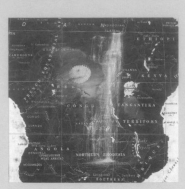

Private Africa, 1995
Oil on blackboard slating on wood
92⁷/₈ × 93⁹/₁₆ inches
(235.9 × 237.6 cm)
Museum purchase
1995.28.P.P.

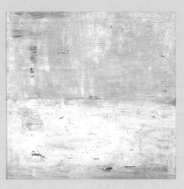

Tunis, 1999
Acrylic on canvas, cast epoxy
Painting: 84 × 84 inches
(213.4 × 213.4)
Overall dimensions variable
Museum purchase,
The Friends of Art Endowment Fund
2000.1.P.P.

Commentary on page 58

Dan Flavin
American, 1933–1996

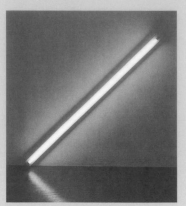

Diagonal of May 25, 1963, 1963
Warm white fluorescent light
Edition 2/3
96 inches (243.8 cm)
Gift of Barbara Rose, by exchange
with Dia Center for the Arts
2002.62.G.S.

Although Dan Flavin is invariably described as one of the patriarchs of Minimalist sculpture—along with his colleagues Donald Judd, Sol LeWitt, Carl Andre, and Robert Morris—he generally rejected the appellation "Minimalist" and even the term "sculpture" as too confining a designation, often pointing out that his works are ephemeral, temporary, and installed in relation to given architectural conditions. Flavin began making his signature works of industrially prefabricated fluorescent tubes and fixtures in 1963. Emanating different colors of light, Flavin's installations have an indeterminate volume and appear virtually without mass, and it is true that their ethereal presence remains distinct from the emphatic physicality of most Minimalist sculpture. A more rigorous connection can be seen with Marcel Duchamp's Readymades, which offer an important precedent for Flavin's off-the-shelf materials and his reliance on the common, found object. Like Duchamp, Flavin considered his works to be "proposals" rather than sculptures, part of a system of investigations rather than static objects.

Diagonal of May 25, 1963, 1963 is one of Flavin's first and most important investigations into the formal possibilities of using standard fluorescent light fixtures in commercially available colors. The image of the diagonal was a critical early theme executed by the artist, in series and

according to simple mathematical configurations. Flavin made a number of diagonal "proposals" in different colors, alternating their angles from right to left. He executed the first diagonal in gold light, subsequently making diagonals in green, yellow, and red. The Museum's *Diagonal of May 25, 1963* may be the most conceptually and formally pure work in the series: pure white, ultraviolet light.

In his 1965 essay "'…in daylight or cool white.' an autobiographical sketch," Flavin refers to the *Diagonal of May 25, 1963* as a "diagonal of personal ecstasy" describing its "forty-five degrees above horizontal" position as one of "dynamic equilibrium." The artist envisioned the diagonal as a contemporary symbol that "in the possible extent of its dissemination as a common strip of light or a shimmering slice across anybody's wall, had the potential for becoming a modern technological fetish."[1]

Inspired by the great visionaries of pure abstraction, from early twentieth-century pioneers such as Kazimir Malevich and Vladimir Tatlin to the Abstract Expressionists Mark Rothko and Barnett Newman, Flavin continued the challenge of opening a new type of space that would create a dramatic intimacy between image and spectator. Rothko's paintings offer a particularly apt precedent for Flavin's radical extensions. It is, after all, light that activates the space in the works of both artists. Rothko's floating rectangles are often described as glowing, amorphous veils of light. As if unconsciously looking out from one of Rothko's paintings toward Flavin's lights, Lawrence Alloway wrote that in Rothko's work "light does not fall on objects or areas but is generated by the entire picture. The light source is within the picture, not visibly located, but diffused throughout the whole area."[2] Rothko felt that the effect of his pictures should be direct and intimate, and that the pictures should be viewed not from a distance but at close proximity, a position that would exaggerate the paintings' qualities of effusiveness and expanse, characteristics inherent in light.

Indeed, Flavin's *Diagonal of May 25, 1963* provides a poignant extension of what the Abstract Expressionist critic Clement Greenberg noted in

later Abstract Expressionist painting as an "urge…to go beyond the cabinet picture…to a kind of picture that, without actually becoming identified with the wall like a mural, would 'spread' over it and acknowledge its physical reality."[3] Flavin's fluorescent bars of light set wall, spectator, and room into relief to the extent that the question invariably poses itself: Where does the artwork begin and end? Typically a painting or sculpture is defined by the light that shines on it. In Flavin's case, the artwork itself shines outward toward us, engulfing us in the process. The achievement of Flavin's art comes in the development of an active space that radically shifts meaning from the object as art to the spectator's awareness of his or her own perceptions as he or she moves through a light-filled space. In the end, the readymade qualities of Flavin's commercially manufactured light objects cannot be separated from the light they emit, which reaches out to the world around it. In this sense, Flavin has balanced a cool, Duchampian detachment and material objectivity with subjective, lyrical beauty.

MICHAEL AUPING

1 Dan Flavin, "'… in daylight or cool white.' an autobiographical sketch," *Artforum* 4 (December 1965): 20–24.

2 Lawrence Alloway, "The American Sublime," in *Topics in American Art Since 1945* (New York: W. W. Norton & Company, 1975): 38.

3 Clement Greenberg, "The Situation at the Moment," *Partisan Review* (January 1948): 83.

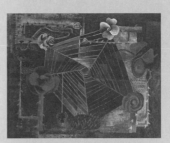

Bill Bomar
American, 1919–1990
The Web and Roses, c. 1948
Oil on canvas
24 1/4 × 28 1/8 inches (62.2 × 71.4 cm)
Purchase Prize, 1948 Leonard Brothers Exhibition, 1948.3.G.P.

Cynthia Brants
American, born 1924
The Celebrity, 1950
Oil on canvas
38 × 24 inches (96.5 × 61 cm)
Museum purchase, 1951.1.P.P.

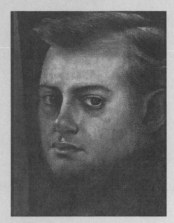

Dickson Reeder
American, 1912–1970
Self-Portrait, undated
Oil on canvas board
9 × 12 inches (22.9 × 30.5 cm)
Gift of the Maude von Turk Taylor Collection, 1964.1.8.G.P.

Bror Utter
American, 1913–1993
Trio, undated
Oil on canvas
30 × 40 inches (76.2 × 101.6 cm)
Gift of Bertram M. Newhouse in honor of Sallie M. Gillespie 1953.11.G.P.

Kelly Fearing
American, born 1918
The Kite Flyers, 1945
Oil on canvas
16 × 22 inches (40.6 × 55.9 cm)
Leonard Brothers Prize Award 1945.6.G.P.

Commentary on page 63

The people involved in the Fort Worth Circle were interested in visual art, theater, dance, music, and literature. We gathered at the Reeders' house almost every Saturday night for great soirées—sometimes musicians and dancers would come along. Classical music was always going on the phonograph and inevitably we would burst into dance, creating our own ballets. Never was there a party without dance. The Reeders had their school, of course [Children's School of Theater and Design, 1945–1958], so we often raided their costume box to complement our improvised ballets. I think of my days in Fort Worth as really decadent and romantic. KELLY FEARING

Sam Francis
American, 1923–1994

Untitled from *Mako Series*, 1967
Oil on canvas
73 1/8 × 42 inches (185.7 × 106.7 cm)
Gift of the artist
1968.38.G.P.

In 1944, at the age of twenty-one, the American artist Sam Francis began painting while in an Army hospital in Denver, where he was recovering from a United States Air Corps flight-training emergency landing that led to spinal tuberculosis. This experience of painting from his hospital bed had a fundamental and lasting impact on his work—it made him focus on the flat space of a canvas and the challenge of creating illusion within it. Of his initial experience with painting, Francis has said, "The first time I started playing with liquid paint, letting it fall, you know, it ran off the paper onto the sheets, onto the floor. It was really nice."[1] These early works were mostly portraits and landscapes, but as he regained his health and became more immersed in painting, his style evolved toward abstraction. In the 1950s Francis traveled extensively, and by the latter part of that decade he maintained studios in Los Angeles, Paris, and Tokyo. These cities figure prominently in his work: His canvases often relate to each one's distinct culture, landscape, and light.

Untitled from *Mako Series*, 1967 was created while Francis was primarily living in Japan. He began the *Mako Series* in 1966, one year after marrying his third wife, Mako Idemitsu, whom he met in Tokyo. Like all of the works in this series, *Untitled* characterizes Francis's mid-career style. The works of this period came to be known as "edge paintings." *Untitled* is a pristine white painting with narrow slivers of color surrounding its perimeter. The bright, masked-off areas of red, yellow, blue, orange, pink, and green, when juxtaposed with the stark white center, create a complex dynamic. Although the ratio of white to color is imbalanced in favor of white, the wedges of saturated pigments along its borders visually compete for dominance, advancing within the pictorial space.

Japanese aesthetics helped establish the particular vision seen in *Untitled*, especially the way Francis addressed scale, space, and color. Rather than relating to Tokyo as an urban hub, however, the spaciousness of *Untitled* suggests the openness of light, sky, and sea around Japan, and it incorporates the idea of balanced opposites seen in Japanese landscape. The subtle and spiritual qualities of Japanese landscape, in which emptiness is not a void, but rather an integral space, extends to Francis's cool, crisp canvases with white centers. In *Untitled*, whiteness creates a contemplative, well-defined space that is balanced with color.

In his early mature style, Francis created abstract enigmatic paintings with cell-like forms in muted shades of blue, black, red, and yellow that appear to float and link together, covering most of the canvas space. These works also relate to the ecology of the world around us, especially to botany, which Francis studied as an undergraduate at the University of California, Berkeley until he changed his focus to psychology and medicine. Like *Untitled*, these embryonic paintings address illusion, space, and color as it relates to light, nature, and organic form.

Although his artistic concerns were shaped by his time spent abroad as much as they were by his American experience, Francis is often considered part of the second wave of the American movement Abstract Expressionism. The first generation of Abstract Expressionism is generally characterized by epic-scale, abstract paintings invoking freedom of expression, but by the late 1950s the "second generation" was broadening the scope of the movement. Abstract Expressionism opened up to work that leaned toward figuration, like that of Philip Guston; to fluid and organic abstractions, like Francis's early works; and to more geometric abstractions, like *Untitled* from *Mako Series*. In 1955, little more than a decade after Francis began painting, The Museum of Modern Art in New York purchased *Black and Red*, 1953, marking the first public sale of his work. In the late 1950s two important exhibitions made their way across Europe, establishing Abstract Expressionism as an international success, and Sam Francis's work was included in both shows. The first of these was in 1958, entitled *The New American Painting*. Organized by The Museum of Modern Art in New York, it traveled throughout Europe; and in 1959, *Documenta II*, an international exhibition in Kassel, Germany, chiefly featured American Abstract Expressionist painters.

In the 1960s, with *Untitled* and other edge paintings, Francis refined his long-term exploration of the relationship between the canvas's center and edge, defining a breakthrough style within his oeuvre. As the 1970s approached, however, the artist reverted back to a more expressionistic painting vocabulary, saying of *Mako Series*, "Mako was a very austere muse who led me into very deep cold water."[2]

ANDREA KARNES

1 Quoted in Pontus Hulten, *Sam Francis* (Bonn: Kunst- und Ausstellungshalle der Bundersrepublik, 1993): 21.
2 Quoted in Peter Selz, *Sam Francis*, rev. ed. (New York: Harry N. Abrams, Inc., 1982): 101.

Hamish Fulton

British, born 1946

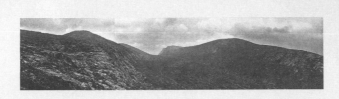

Glen Tamanisdale Isle of Lewis a Five Day 100 Mile Walk Outer Hebrides Scotland, Early 1976, 1976
Gelatin silver print
43 3/4 × 99 inches (111.1 × 251.5 cm)
Museum purchase made possible by a grant from The Burnett Foundation
1995.1.P.Ph.

Watching the horizon is a natural tendency of a walker or hiker. It follows me as a continuous line between the point of origin of the walk and the eventual destination. It's also a means of coordinating my direction.

HAMISH FULTON

Since 1969 Hamish Fulton's art has stemmed from journeys he has made in various landscapes. The artist refers to his artworks simply as "walks,"[1] committing himself to the ideology "no walk, no work." As modest as this project may first appear, Fulton engages nature's trails on a McLuhanesque scale. Over the past three decades, the artist has "walked" more than 15,000 miles in Nepal, India, Bolivia, Canada, Peru, Iceland, England, Scotland, Wales, Ireland, the United States, Mexico, Australia, Switzerland, France, Italy, Portugal, Spain, Japan, and Lapland.

Fulton has approached this global project with Zen humility. Never preaching about or exaggerating his involvement with nature, he is more realist than romantic. The essence of a Fulton walk is simply that he "be there," moving through the landscape in search of little more than a place to sleep at the end of the day and an openness to whatever images, sounds, or thoughts might present themselves during the journey. The resulting artwork is part document, part poetic memory.

He represents each walk through the combined media of words and photographs, words and drawings, or more recently, simply words; distilling his experience of a given journey into fundamental facts that he records in an ongoing diary. The texts that accompany his photographs invariably relay location, time, distance, and in a number of cases, the weather or topographical conditions during a walk. By doing so, Fulton expands our understanding of the context of a journey and its physical implications. We can compare time to distance covered and measure that along with terrain and weather to more fully appreciate actual conditions rather than just appreciating the scenery. A few of his walks have been long and strenuous, covering eighty-two continuous miles without sleep. He is inspired by walkers and mountaineers of the central highlands of England and Scotland, such as Doug Scott and the late Don Whillans. At the same time, Fulton readily admits that many of his journeys are relatively modest by competitive hiking or mountaineering standards. He points out that enjoyment, or in extreme cases just staying alive on a journey, is not enhanced by competition or showmanship. Fulton moves gently and practically through the landscape, one footstep at a time. When Fulton takes his photographs, he is not "picturing" a scenic viewpoint, but is in the process of navigating and living in it. What is eventually hung on a wall or arranged on the page of a book, then, is an event of sorts that reflects the process of allowing oneself, mind and body, to enter nature.

Fulton's ideology developed out of personal and historical conditions. Born in London in 1946, Fulton grew up in Newcastle, a shipbuilding city on the northeast coast of England. In high school, he became fascinated with Native Americans, reading about their history and philosophy; of particular interest were *Wooden Leg*, 1931, by T. B. Marquis and *Black Elk Speaks: Being the Life Story of a Holy Man of the Agalala Sioux*, 1932, recounted by John G. Neihardt.

Fulton's attraction to Native North American tribes, which has continued throughout his career, stems principally from their profound respect for the mystery of nature.

Between 1964 and 1969 Fulton embarked on a formal education in art, attending Hammersmith College of Art (1964–66), St. Martin's School of Art (1966–68), and the Royal College of Art (1969). His experience at St. Martin's should be singled out, as he arrived there with a new generation of artists that included Richard Long and the performance artist team Gilbert & George. In the late 1960s and early 1970s St. Martin's would be a focal point for reorienting British sculpture away from the Surrealism of Henry Moore and the industrial formalism of Anthony Caro (who taught at St. Martin's) toward a more conceptual approach to artmaking. Fulton's crucial decision in those years was not to make art isolated in his studio, but in fact to carry his studio on his back (tent, camping utensils, journal, pen, and camera), engaging the world on foot.

Fulton's global studio results in a remarkable variation in imagery and effect. His early British walks came out of his attraction to trails or paths that have a unique history. His *Straight Line Walk*, 1969 (Private collection) relates to the artist's fascination with the prehistoric "ley" system of walking paths discovered in England in the 1920s by Alfred Watkins, who developed a theory that the ancient people of Britain made many long, straight lines, or pathways, through the land that connected ancient sites. Fulton's own "ley" took the form of a straight-line walk across agricultural land that joins the prehistoric sites of Five Knolls, Edlesborough Hill, and Beacon Hill. *Hollow Lane*, 1971 (Private collection) depicts a section of the Pilgrims Way between the cathedrals of Winchester and Canterbury, a path worn beneath the level of the surrounding fields by heavy rains and the feet of previous travelers.

In the early 1970s Fulton began to seek out more challenging and less inhabited sites, places that in Fulton's terms were "more inhabited by nature than people." Moreover, Fulton became attracted to sites that are known less for their scenic beauty than for their raw physical power.

Gilbert & George

Gilbert: British, born Italy 1943
George: British, born 1942

The Museum's *Glen Tamanisdale Isle of Lewis a Five Day 100 Mile Walk Outer Hebrides Scotland, Early 1976*, 1976 is precisely such a work, and represents the artist's continued fascination with skylines. Fulton has said, "Watching the horizon is a natural tendency of a walker or hiker. It follows me as a continuous line between the point of origin of the walk and the eventual destination. It's also a means of coordinating my direction." The many horizon lines Fulton has photographed over his thirty-year career accentuate the unique character of the ground we stand on, reminding us that we live on a huge, many-faced rock, floating in space.

Glen Tamanisdale presents a composite panoramic photograph that depicts a partially sunlit landscape of undulating hills and peaks on a remote island to the northwest of Scotland. Fulton's factual caption, printed lightly in pencil below the image, and the grainy contrast the artist has created between landmass and sky highlights the vertical and horizontal drama of the surface of the island and the mysterious, murky space and ocean beyond it. Fulton's text allows us to imagine the mental and physical epiphanies involved in taking a 100-mile walk over a cold, relatively barren stretch of land in five days, carrying tent and food, eventually reaching this point. As one curator has argued, such images are essentially "sculptural" in the sense that they do not simply illustrate the land, but impart a strong, physical involvement with it.[2] An immense horizontal image, *Glen Tamanisdale* constitutes a genuinely awe-struck stare over the horizon, evoking emotions about what a skyline, or horizon, symbolizes—a distant, often ungraspable end to a journey and the mystery of what lies beyond our given place and time, what might be the edge of something far larger than ourselves.

MICHAEL AUPING

1 Quotes from the artist are from numerous conversations with the author, 1981–1990.
2 R. H. Fuchs, "Photography as Sculpture: On Hamish Fulton," *Studio International* (October 1973): 128–29.

Mental No. 3, 1976
Photo piece, twenty-five panels
Overall 121 × 102 inches
(307.3 × 259 cm)
Museum purchase made possible by a grant from The Burnett Foundation
1998.13.P.Ph.

The late 1960s was a period of radical change in regard to the conception of what constitutes art. In America and Europe, the practice of art could not be accurately reduced to a general scheme or style. As Harold Szeeman pointed out at the time, it was more a matter of "attitude." In 1969, writing a catalogue introduction to the seminal exhibition *When Attitudes Become Form*, Szeeman noted that "the major characteristic of today is no longer articulation of space but human activity; the activity of the artist has become the dominant theme and content."[1] Szeeman's modest, seemingly obvious statement gained meaning by his inclusion of artists in the exhibition whose works had little to do with the formal balancing of forms on a pictorial surface or in a sculptural space. Rather, these works were performed, involving actions that extended out from the "picture" as it were, to engage and involve a world outside of "art" and the formalist discourse that had dominated it since the mid-1940s. For Gilbert & George and their contemporaries at St. Martin's —Richard Long and Hamish Fulton —Szeeman's sense of "attitude" was critical. What was important was not the look of an object, but developing a commitment to an idea that allowed these artists to free themselves from the "object" and the studio, to be informed as well as transformed by a world outside of an insulated art context.

Gilbert & George met at St. Martin's School of Art in 1967. Their subsequent and ongoing collaboration is unique in contemporary art. What sets them apart is their seamless integration of art and artmaker. In 1972 George explained, "We developed a new concept of art, 'art for all,' in which our bodies became the substance of our work."[2] In 1973 the artists proclaimed:

WE ARE ONLY HUMAN
SCULPTURES

We are only human sculptures in that we get up every day, walking sometimes, reading rarely, eating often, thinking always, smoking moderately, enjoying enjoyment, looking, relaxing to see, loving nightly, finding amusement, encouraging life, fighting boredom, being natural, daydreaming, travelling along, drawing occasionally, talking lightly, tea drinking, feeling tired, dancing sometimes, philosophising a lot, criticising never, whistling tunefully, dying very slowly, laughing nervously, greeting politely, and waiting till the day breaks.[3]

From 1969 the artists presented themselves as "living sculptures." With painted faces and hands, dressed identically in conservative suits, the two young men sang songs and performed slow, mechanical movements accompanied by a tape playing the song "Underneath the Arches." By the 1970s the artists had integrated the performative aspects of their art with photography, creating large-scale photo works made of numerous framed panels that juxtaposed portraits of the artists with images of their surroundings, particularly areas of London and its countryside. Taken on an almost daily basis, these individual photo panels became what the artists saw as the building blocks of a life experience, using images of themselves as a form of expressive sign language in which they contemplated various decisions. *Mental #3*, 1976 is a classic work from the mid-1970s in which the artists contemplate the dilemma of choosing between urban culture and nature. Images of the artists against brilliant red backgrounds are displayed in a cruciform shape

surrounded on all four quadrants by alternating black-and-white panels of blossoms and London street life. Rather than advocating a single position, the artists' stances and faces reflect feelings of conflict and indecision, evoking poses of thoughtful bewilderment, searching, and longing.

Suggesting the stained glass windows of a church, *Mental #3* evokes a secular meditation on where people put their faith and what motives drive their decisions. The artists eschew notions of purity for the more complex philosophy that there is good and evil in every decision:

George: We also became conscious that we had arranged some of the red panels in *Mental* to form a cross. As red panels alternate with black-and-white ones. And there is an alternation of night-scenes and day-scenes. Gilbert: Always opposites. And I think that, as two people, we are light and dark and good and bad.[4]

MICHAEL AUPING

1 Harold Szeeman, *When Attitudes Become Form* (London: Institute of Contemporary Art, 1968).
2 Donald Zee, "The Odd Couple," *Daily Mirror* (5 September 1972).
3 Quoted in Bruce D. Kurtz, *Contemporary Art 1965–1990* (Englewood Cliffs: Prentice Hall, 1992): 43.
4 Quoted in *The Words of Gilbert & George With Portraits of the Artists from 1968 to 1997*, ed. Robert Violette with Hans-Ulrich Obrist (London: Thames & Hudson in association with Violette Editions, 1997): 157–58.

Adolph Gottlieb
American, 1903–1974

Apaquogue, 1961
Oil on canvas
72 1/4 × 90 1/4 inches
(183.5 × 229.2 cm)
Museum purchase, The Benjamin
J. Tillar Memorial Trust
1984.3.P.P.

Adolph Gottlieb's painting *Apaquogue*, 1961 was named after a road near the ocean in an area of East Hampton by the artist's home. It belongs to his late-career *Burst* series, begun in 1957 and widely considered his signature style, although his early *Pictograph* series, begun in 1941, is also a seminal body of work. In his *Pictograph* works, Gottlieb painted primitive-seeming symbols and personalized hieroglyphs on large-scale canvases using loose, patterned grids to depict a metaphoric and cryptic narrative. His Burst paintings are derived from his Pictographs, but in a more abstracted style and with a simplification of both form and content.

Apaquogue is divided into two distinct parts. The top half of the canvas has three radiating spheres painted in three different shades of red: crimson, pale pink, and salmon. These haloed discs hover over the bottom half of the canvas, which is composed of linear yet gestural scribbles and splashes of black paint applied with a broad brush. Gottlieb left two broad bands of bare canvas exposed at the top and center of the painting, but these spaces are not simply empty; they are integral components of the overall composition. The space between the bursts and scribbles organizes the arrangement of forms and creates an unseen horizon line, reinforced by the other blank space above the bursts. *Apaquogue*, like all of Gottlieb's *Burst* paintings, is sometimes referred to as an "imaginary landscape." As such, the painting evokes a setting sun over ocean waves.

Gottlieb first studied painting with the American urban realists John Sloan and Robert Henri at the Art Students League in New York City. He subsequently traveled abroad, spending time in Paris, Munich, and Berlin, looking at works by important European modernists and was particularly influenced by Henri Matisse, Pablo Picasso, Joan Miró, and the French Surrealists. Gottlieb began to mature as an artist in New York in the early 1940s and was a central figure in the American Abstract Expressionist movement, also called the New York School. The latter name is used to specify the core group of artists who worked in New York City in the mid-1940s. The New York School also includes William Baziotes, Willem de Kooning, Arshile Gorky, Hans Hofmann, Franz Kline, Robert Motherwell, Barnett Newman, Jackson Pollock, Ad Reinhardt, Mark Rothko, and Clyfford Still.

The artists associated with this group certainly produced distinct imagery, but under the umbrella of Abstract Expressionism, they share formal similarities. Their work can be characterized as abstract, gestural painting with an emphasis on surface quality, texture, and brushwork, rendered in heroic scale. They also used a non-hierarchical approach to the canvas, i.e., an all-over composition that is not center-focused, but rather, all parts—sides, top, bottom, and mid-section—are equally important.

Generally speaking, the content of the Abstract Expressionists' work resulted from the anxiety and uncertainty of their place and time—America following World War II. To express their mental and emotional states, they often drew from literature and were influenced by archaic symbolism, Greek and Roman mythology, primitive art, and Native American art. These artists believed that the psychological and emotional impact that painting possessed was best understood visually, not verbally. American artists were sometimes viewed abroad as lacking an important art historical tradition from which to either adhere or diverge; however, one of the Abstract Expressionists' main tenets as a new avant-garde group was to establish themselves internationally, acknowledging their influences and points of departure in both American and European traditions.

Apaquogue is named for a road near the artist's home, but it might also refer to the Montauk Indian Country of the northeastern United States—Gottlieb's way of connecting to a Native American tradition. Of his own work, Gottlieb said, "Paint quality is meaningless if it does not express quality of feeling. The idea that a painting is merely an arrangement of lines, colors, and forms is boring. Subjective images do not have to have rational association, but the act of painting must be rational, objective, and consciously disciplined. I consider myself a traditionalist, but I believe in the spirit of tradition, not in the restatement of restatements. I love all paintings that look the way I feel."[1] Although *Apaquogue* was created after this statement was made, it seems a fitting visual counterpart to the artist's words.

ANDREA KARNES

1 Quoted in *The New Decade* (New York: Whitney Museum of American Art, 1955): 35–36.

G

Nancy Graves
American, 1940–1995

Molucca Seas, 1972
Acrylic and ink on canvas
102 1/16 × 72 inches (259.2 × 182.9 cm)
Gift of Janie C. Lee
1985.35.G.P.

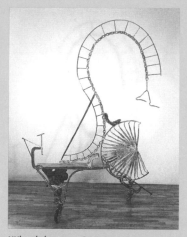

Wheelabout, 1985
Bronze and stainless steel with
polyurethane paint
92 3/4 × 70 × 31 1/2 inches
(235.6 × 177.8 × 80 cm)
Gift of Anne H. Bass and Sid R. Bass
1985.36.G.S.

Nancy Graves used a variety of
materials to create paintings,
sculptures, drawings, and prints,
several of which are in the collection
of the Modern Art Museum.[1] Among
the most important works by
Graves in the permanent collection
are *Molucca Seas*, 1972, an early
painting that depicts the ocean floor
as seen from a satellite map, and
Wheelabout, 1985, a sculpture that
conveys Graves's focus on move-
ment within a balanced composition.

In 1969, at the age of twenty-nine,
Graves was established as an
important art world figure when the
Whitney Museum of American Art
organized *Nancy Graves: Camels*.
The realistic, life-size camels were
made of wool, steel, burlap, hide,
wax, and oil paint. Graves, who was
always interested in natural science
and history, made the camels with
natural history museum dioramas in
mind. By recreating and recontex-
tualizing diorama props in a modern
art museum setting, she exposed the
nature of museum dioramas. Her
camels, even further removed from
a "natural" setting, pointed to the
ways in which museums create false
histories while maintaining an
authoritative tone.

Graves retained her interest in
science and history, but by 1972
she had temporarily abandoned
sculpture to focus on making
paintings. The *Camouflage* series,
executed in a pointillist style, was
her first body of work on canvas.
Molucca Seas was painted the
same year, and it continued her
investigation of figure/ground
relationships while it demonstrated
her engagement with the blurred
boundaries of realism and
abstraction. In it, Graves used a
limited palette of blue and white
pigments with patches of ink
drawing. Working from an aerial view
of the Molucca Seas—a body of
water in the Pacific Ocean, off the
coast of Indonesia—enhanced her
investigation of pictorial space. There
is no focal point, and the surface is
uniformly dense yet open, with
darker and lighter areas of color used
to convey the space and mass of the
ocean floor (although space takes
precedence over mass in Graves's
work). The artist's breakdown of
visual information into abstract
marks and shapes evokes what is
represented—the ocean—but her
combination of close-cropped,
enlarged views and her technique
distort real space and scale.

Molucca Seas and the Museum's
sculpture *Wheelabout* are vastly
divergent stylistically, although both
reveal Graves's interest in natural
science. For this sculpture, she
combined shapes culled from nature
with found objects from everyday life.
Graves's sculpture from the 1980s
has strong affinities with the Pop art
movement of the 1960s, chiefly a

whimsical attitude and use of
ordinary objects.

Wheelabout was made with direct
fabricated and stainless-steel casts,
molten bronze spills, sand casting,
and polyurethane paint. It contains
diverse cast shapes, including wood,
industrial parts, and plants, along
with attached parts, such as its three
wheels. Some of the work's
components, such as the clothes-
hanger shape that dangles from the
stainless steel S curve and the wheels
at the base of the piece, are move-
able; and in its very title, *Wheelabout*
evokes movement. The work is
painted in bright colors—sky blue
and pink, with bursts of red and
yellow—which give it a playful spirit.
The three attached wheels that
support the piece and the palmetto
frond's spoke-like appearance make
the work look like a ridiculous
tricycle. Its complementary shapes,
such as the large protruding S curve
counterbalanced by the cast plant
leaf semicircle toward the base of the
piece, endow these incongruent
materials with a sense of balance
and harmony.

From the mystical and meditative
power of *Molucca Seas* to the lively,
childlike charm of *Wheelabout*, Nancy
Graves created an expansive body
of work in a wide range of styles and
materials. The Modern Art Museum
is fortunate to have several of her
works in the collection that exemplify
this diversity.

ANDREA KARNES

1 For a detailed discussion of
 Graves's works in all media and
 a catalogue raisonné of her
 sculpture see E. A. Carmean, Jr.
 et al., *The Sculpture of Nancy
 Graves* (New York and Fort
 Worth: Hudson Hills Press in
 association with the Fort Worth
 Art Museum, 1987).

Red Grooms
American, born 1937

Ruckus Rodeo, 1975–76
Sculpture wire, celastic, acrylic,
canvas, and burlap
174 × 606 × 294 inches
(442 × 1539.2 × 746.8 cm)
Museum purchase and commission
with funds from the National
Endowment for the Arts and
The Benjamin J. Tillar Memorial Trust
1976.1.P.S.

One of the most popular works in
the Museum's collection is Red
Grooms's immense *Ruckus Rodeo*,
1975–76. An example of what the
artist calls a "sculpto-pictorama,"
Ruckus Rodeo never fails to delight
visitors. Its cast of garishly colored,
wildly expressionistic characters
offers a wonderfully cartoonish and
operatic vision of a rodeo, with all its
attendant excitement, danger, beauty,
and humor. *Ruckus Rodeo* is loud,
brash, and thoroughly engaging.

The Museum approached Grooms
in 1975 about creating a work for
a major exhibition to be held the
following year. This exhibition, *The
Great American Rodeo*, was organized
to celebrate both the seventy-fifth
anniversary of the Museum's
founding and the nation's bicenten-
nial. The show was to include
Grooms and ten other American
artists.[1] At the time Grooms
accepted the commission, he was
deeply involved in an even larger
project that was also to open in 1976:
Ruckus Manhattan, a "sculptural
novel" about New York City.
Nevertheless, the artist traveled to
Fort Worth to view the Southwestern
Exposition and Fat Stock Show and
Rodeo. This huge annual event
occurs in and around the Will Rogers
Memorial Coliseum, a short walk
from the Museum. The copious
drawings he made from his daily
visits to the rodeo led to a nearly

seven-foot-long composition (also in
the Museum's collection) that served
as the working drawing for *Ruckus
Rodeo*. Grooms returned to New
York, where his Ruckus Construction
Company fabricated the innumerable
parts of the work. He and his crew
arrived in Fort Worth to install *Ruckus
Rodeo* in time for the exhibition
opening, which coincided with the
1976 Fat Stock Show.

Ruckus Rodeo relates not only to
this annual major exposition, but
also to the heritage of Fort Worth
and the mythology of the American
West. Fort Worth—nicknamed
"Cowtown"—prides itself on its
Western heritage, including its con-
nections to the Chisholm Trail and
Butch Cassidy's Hole in the Wall
Gang, and its being home to the first
indoor rodeo. Local citizens find
Ruckus Rodeo to be a humorous and
delightful portrayal of a rodeo.
The glitz, guts, and glory of *Ruckus
Rodeo* also resonate with a much
larger audience because of the
prominent place given the cowboy
and the taming of the West in the
American imagination. Grooms's
comically heroic representation
perpetuates and spoofs this fascina-
tion with the West.

Although commissioned by the
Museum for its galleries, *Ruckus
Rodeo* is not truly site-specific instal-
lation art, since it was not designed
for a specific location nor created
on site. An appealing aspect of the
work is that it can be shown in
different venues and, in fact, it is
often "on the road." The term
"sculpto-pictorama," which Grooms
coined jokingly, suits *Ruckus Rodeo*
perfectly.[2] As a mixed media piece,
the composition includes three-
dimensional sculptural forms as well
as painting on canvas. Its size—
more than fifty feet across—and
breadth of imagery parallel the sweep
of earlier American panoramas.
"Sculpto-pictorama" also has the
ring of theatricality about it, which
is appropriate to *Ruckus Rodeo*'s
carnivalesque presence and
heightened artificiality; it is not
surprising to learn that P. T. Barnum
is one of Grooms's heroes.[3] Further,
the vitality, immediacy, and slapdash
look of the work evoke a "Hey,
kids, let's put on a show!" attitude
and energy. In this regard, *Ruckus
Rodeo* relates to work from early
in Grooms's career.

Grooms, who grew up in
Nashville, had from childhood
shown an affinity and talent for art.
By the age of nineteen, he had
studied briefly at the Art Institute of
Chicago and the New School in New
York. In 1957 he attended Hans
Hofmann's summer school in
Provincetown, Massachusetts. Not
enamored of abstract painting,
Grooms remarked that Hofmann
"gave me something neat to react
against."[4] However, the colorful
expressionism and visual "push and
pull" of *Ruckus Rodeo* suggest that
Grooms did absorb Hofmann's
teachings. Shortly after his summer
in Provincetown, Grooms moved to
Manhattan, where he became a
pioneer performance artist and
artist-filmmaker. He was one of the
seminal artists involved in
Happenings, although he preferred
the term "plays" because he was less
interested in audience participation
than were Allan Kaprow, Claes
Oldenburg, and others. The
purposely makeshift sets with their
skewed forms that he produced for
his plays and movies hint at the later
raucous rodeo piece. This expres-
sionistic sensibility, which marked
Grooms's art from the beginning,
effectively served to distance him
from the Pop art movement, even
though his work is deeply embedded
in popular culture. His dynamically
idiosyncratic art, with its handmade
appearance, contrasts with the cool,
impersonal fabrication favored by
Pop artists. His works display a
comic-strip feeling, which results not
from Pop appropriation but from
personal invention. In many ways,
Grooms's works, including *Ruckus
Rodeo*, align less with Pop art and
more with American Scene painting
of the 1930s, especially the
remarkably energetic compositions
of Reginald Marsh.

Grooms produced his first sculp-
tures in 1963 and the first "sculpto-
pictorama," *City of Chicago*, 1968, five
years later. His interest in free-
standing sculptural forms ("stick
outs," as he calls them) was condi-
tioned both by theater stage flats and
his admiration for the cutout figures
created by the American painter Alex
Katz. *City of Chicago* and *Ruckus
Manhattan* are sculpture environ-
ments through which viewers are
intended to walk. *Ruckus Rodeo*, like
an actual rodeo, can be approached

very closely, but generally the arena
is not to be entered. It is not "safe"
to do so, as the cowboy being carried
out on a stretcher, the bucking
bronco, and Butter the sixteen-foot-
high Brahma bull all make aggres-
sively clear. This very large work—
1,237 square feet—is so compacted
with diverse activities, body
language, and facial expressions that
some distance is required in order to
take it all in. As if experiencing a real
rodeo, viewers find themselves trying
to take in the full spectacle, while
simultaneously focusing on the
details of various episodes and events.

"Ruckus," Grooms has explained,
is "a beautiful Southern word
meaning 'a disorderly commotion.'"[5]
In *Ruckus Rodeo*, Red Grooms
captures not only the pageantry and
ritual of a rodeo, but also the color,
excitement, and wonder of its "disor-
derly commotion." His outlandish
Texas-sized figures and animals both
poke fun at the rodeo and pay
homage to its grand sense of spectacle.

MARK THISTLETHWAITE

1 Among the other artists included
was Grooms's wife and
collaborator, Mimi Gross.
2 Ilka Scobie, "Red Grooms: An
Interview," *International
Sculpture Center Web Special*
(http://www.sculpture.org/
documents/webspec/redgrooms
/redgroom.htm). Accessed
2 April 2001.
3 Judd Tully, *Red Grooms and
Ruckus Manhattan* (New York:
George Braziller, 1977): 8.
4 Carter Ratcliff, "Red
Grooms's Human Comedy,"
Portfolio 3 (March/April
1981): 60.
5 Grace Glueck, "The City's
Biggest Gallery Show Twits
the City," *The New York Times*,
13 June 1976: 35.

Philip Guston
American, born Canada. 1913–1980

Untitled, 1952
Ink on paper
18 × 23 inches (45.7 × 58.4 cm)
Gift of Musa and Tom Mayer
1999.8.G.Dr.

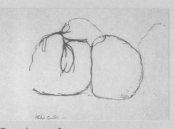

Drawing, 1965
Ink on paper
16¹/₂ × 23¹/₂ inches (41.9 × 59.7 cm)
Gift of Musa and Tom Mayer
1999.3.G.Dr.

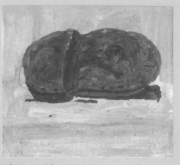

Shoe, 1968
Acrylic on panel
30 × 32 inches (76.2 × 81.3 cm)
Gift of Musa and Tom Mayer
1999.6.G.P.

There is something ridiculous and miserly in the myth we inherit from abstract art: that painting is autonomous, pure and for itself, and therefore we habitually define its ingredients and define its limits. But painting is 'impure.' It is the adjustment of impurities which forces painting's continuity. We are image-makers and image-ridden.

PHILIP GUSTON

Full Brush, 1966
Ink on paper
17¹/₂ × 22³/₄ inches (44.5 × 57.8 cm)
Gift of Musa and Tom Mayer
1999.4.G.Dr.

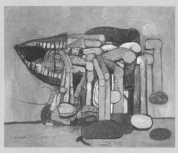

Painter's Forms II, 1978
Oil on canvas
75 × 108 inches (190.5 × 274.3 cm)
Museum purchase,
The Friends of Art Endowment Fund
1999.5.P.P.

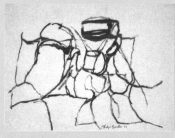

Untitled, 1963
Ink on paper
18 × 24 inches (45.7 × 61 cm)
Gift of Musa and Tom Mayer
1999.9.G.Dr.

The Light, 1964
Oil on canvas
69 × 78 inches (175.3 × 198.1 cm)
Museum purchase,
The Friends of Art Endowment Fund
1999.7.P.P.

Wharf, 1976
Oil on canvas
80 × 116 inches (203.2 × 294.6 cm)
Museum purchase,
The Friends of Art Endowment Fund
1994.3.P.P.

Commentary on page 74

Raymond Hains
French, born 1926

SEITA, 1966–67
Painted wood
60 1/2 × 47 1/4 × 33 1/2 inches
(153.7 × 120 × 85.1 cm)
Museum purchase,
Sid W. Richardson Foundation
Endowment Fund
2001.5.P.S.

In 1960 Raymond Hains signed a manifesto written by the art critic Pierre Restany announcing the movement Nouveau Réalisme. In doing so, he became one of eight artists involved in this official, but loosely defined group, which also included Arman, François Dufrêne, Yves Klein, Martial Raysse, Daniel Spoerri, Jean Tinguely, and Jacques Villeglé. The group's simple, two-sentence manifesto read: "The Nouveaux Réalistes have become conscious of their collective singularity. Nouveau Réalisme = New approaches to perceptions of reality."[1]

The Nouveaux Réalistes embraced individual artistic style and addressed contemporary culture using a wide array of sources taken from advertising and everyday life. Their art comprised objects, collages, posters, and other mixed-media works. Rather than the more popular abstract modes of artmaking, such as Lyrical Abstraction in France and other parts of Europe, and Abstract Expressionism across the Atlantic, this group created representational works, as reflected in their group name, using realism. These characteristics aligned them with the American and British Pop art movement. Like Pop artists, they incorporated aspects of daily life and used found objects in order to comment on capitalism, mass production, and the ways in which the media shapes our identities and ideologies.

Hains, along with Villeglé, also represented in the Museum's collection, is best known as an *affichiste* (literally "poster designer"), for a technique that the two artists created. The affichistes carried on in the same spirit as the Dadaists and Pop artists, and were forerunners to the German Fluxus movement of 1962 and Italian Arte Povera, which began in 1967. Hains and Villeglé were branded "affichistes" because they made collages and assemblages from remnants of flyers and illegally torn-down posters from around Paris. They used a streetwise sensibility to comment on contemporary culture and to downplay traditional aesthetic value, thus adding unconventional materials and styles to what could be considered "high art."

Hains's *SEITA*, 1966–67, a jumbo matchbook made of wood, was created four years after the Nouveaux Réalistes disbanded.[2] Although different stylistically from his work of the early 1960s, *SEITA* typifies his focus of the mid-1960s, when he began to develop his mature style, branching out to use numerous common household items as subjects. Besides freestanding sculpture like the Museum's work, Hains has used the matchbook motif to create wall-mounted pieces.

SEITA, which is slightly smaller than human scale, can be likened to the Pop artist Claes Oldenburg's giant sculptures of domestic objects that were also begun in the 1960s. Of his own style and work, Oldenburg has said, "I'm not an abstract artist. I'm a realist. The way I look at it, abstraction is not sufficiently complicated; abstraction doesn't relate enough to everyday life. You see, that's my realist bias. I'm using these objects because I want to employ the world around me, which I feel a relationship with."[3] Hains's works and his use of common objects come from a similar sensibility. Oldenburg's quote, however, is only part of the story in the case of both artists. Like Oldenburg, Hains starts with an object and depicts it in a highly representational mode, but he also departs from realism by using a blown-up scale, thus distorting the matchbook seen in *SEITA*, for example, past the point of strict realism and into the realm of semi-abstraction.

ANDREA KARNES

1 "Les Nouveaux réalistes ont pris conscience de leur singularité. Nouveau réalisme=Nouvelles approches perceptives du réel."
2 In 1962 Yves Klein, one of the most prominent members of the Nouveaux Réalistes, died of a heart attack at the age of thirty-four. His untimely death is seen as a major factor in the dissolution of the group, which was most active from 1959 to 1962.
3 Martin Friedman and Claes Oldenburg, *Oldenburg: Six Themes* (Minnesota: Walker Art Center, 1975): 9.

H

Joseph Havel
American, born 1954

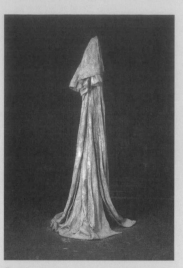

Drape, 1999
Bronze
119 × 56 × 56 inches
(302.3 × 142.2 × 142.2 cm)
Museum purchase,
Sid W. Richardson Foundation
Endowment Fund
2001.6.P.S.

I'm interested in capturing the ordinary, whether it be an object or a momentary event. I want to make it permanent but make it seem like it isn't.[1]

Joseph Havel's art traffics in the paradox of opposing materials and appearances. What appears to be a floating, ghostlike apparition of cloth is in fact a heavy bronze sculpture. Havel began working with draped fabrics in 1997, when the folds of a bedsheet caught his eye. The mature result of that initial recognition was *Bedsheet*, 1998, an approximately seven-foot-high sheet that was initially tied at the top, suspended from his studio ceiling, and manipulated to create various folds. When the artist was satisfied with the final configuration, something invariably transient was translated into the hard permanence of bronze. The sequential process of this improbable transformation reveals its own ironies.

Havel often begins by hanging or draping different cloth materials throughout his studio, allowing gravity to dictate a natural configuration. From this starting point, he makes numerous drawings, along with photographs, documenting the complex of folds and wrinkles and then suggesting revisions through the drawing process. Havel then applies wax to the fabric to stiffen it, incorporating the drawing revisions, as well as making new ones as he manipulates the wax and cloth, generally drawing directly onto the form. When the form is finally set to the artist's satisfaction, the waxed cloth is cut into sections, each of which is in turn subtly manipulated again by the artist. From these intermediate stages of development and artistic license, bronze casts are made of the sections, which are then reassembled and welded into the final form. "The results," Havel puts it, "are various stages of idealizations of the 'natural.'"

Havel received his BFA from the University of Minnesota with an emphasis in drawing and a strong interest in ceramics. Drawing and ceramics play opposite but critical roles in Havel's hybrid process of arriving at forms: one being fluid but precise (drawing), and the other involving a slower manipulation of a more resistant material. Havel also acknowledges the importance of his interest in painting as a source of inspiration. In 1986 he traveled in Europe, particularly Italy, which inspired a block of drawings based on Mannerist paintings he had seen. "Sometimes," Havel has said, "I forget whether I'm painting or making sculpture. The drawing and application of wax makes me feel like a painter but then I get into bending the forms and welding."

The Modern Art Museum's *Drape*, 1999 is an almost ten-foot tower of cascading cloth, reassembled from more than seventy sections of material that has been drawn over, waxed, and massaged into a flowing figurative presence. The visceral quality of the folds clearly references the ability of painting to make inert material sensuous, as well as the sculptor's challenge of bringing dynamic physical form into space. Tied off three quarters of the way up the drape, creating a crowning or secondary cascade of cloth, *Drape* could directly refer to Rodin's famous sculpture of the poet Honoré de Balzac, in which the poet is depicted wearing a full-length cape with a winglike piece of cloth flying off his shoulder (1897, Musée d'Orsay, Paris). When asked about this possible reference, the artist remarks, "I think about Rodin's *Balzac* a lot and sometimes it creeps into the work. It definitely seems like it did here. But remember, it's just an old drape that could have just fallen that way."

MICHAEL AUPING

1 Quotes from the artist are from conversations with the author, 1999–2001.

Howard Hodgkin

British, born 1932

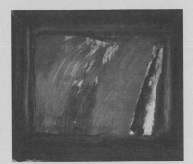

After Matisse, 1995–99
Oil on wood
43³/₈ × 49⁵/₈ inches (110.2 × 126 cm)
Gift of Anne and John Marion in honor of Marla Price
2002.16.G.P

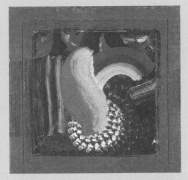

Dinner in Palazzo Albrizzi, 1984–88
Oil on wood
46¹/₄ × 46¹/₄ inches (117.5 × 117.5 cm)
Museum purchase,
Sid W. Richardson Foundation Endowment Fund
1988.3.P.P.

It's a matter of translating the meaning of a series of impressions and memories of a moment or place. I'm not speaking of illustration but something like distillation, a distillation of memory.[1]

Howard Hodgkin likes to think of himself as a realist painter using abstract means, though by no means making abstract paintings. An acute student of appearances, Hodgkin is less interested in illusionistic realism than what he calls "pictorial equivalents," which more accurately reflect the elusive and fragmented nature of perception. As Hodgkin puts it, "If you are in a room with a group of people, you never really see the whole thing, as gathered in a photograph. You see parts and relationships between parts, and they are what ultimately add up to the kinds of tensions that make that moment memorable." Hodgkin's modestly sized paintings on wood, which often seem impulsively rendered, are in fact a radically condensed and calculated translation of these "tensions" into color, mark, and texture. They are also the result of a unique blend of artistic influences.

Hodgkin was born in London in 1932, and two events from his teenage years stand out as pointing him in the direction of art. In 1945 he visited an exhibition of works by Pablo Picasso and Henri Matisse at the Victoria and Albert Museum. He was particularly inspired by the paintings of Matisse. Of perhaps equal significance was Hodgkin's introduction to Indian miniature painting. It would be several decades before these and other divergent influences would come together to help form the artist's mature vision.

Hodgkin's approach to color from his early years has always had a Matissean quality; not so much in the character of particular colors—Hodgkin's colors are often harder and more intense, sometimes applied straight from the tube without mixing—but in his reliance on color to carry the emotional content of the work. Hodgkin also acknowledges a debt to Édouard Vuillard. *Intimiste* is the term often employed to describe the subtle moods evoked by Vuillard's best-known depictions of middle-class Parisian life. Gentle domestic scenes, which depict friends and family caught in moments of reflection in homey interiors, are brought to life through the soothing and illusionistic magic of Vuillard's subtle tonal variations and attention to patterning and light, so typical of his work after 1900. However, Hodgkin—who has described himself as "a fanatical admirer of Vuillard"—is less interested in the Vuillard who has been popularized in art history books and museum posters than in the lesser-known and more radical work of Vuillard's early years; the Vuillard of the 1890s. It is in this period of Vuillard's art that the boundary between representation and abstraction—or what one of Vuillard's favorite critics called "unforeseen . . . reality"[2]—is intriguingly blurred. Rather than presenting a subject that is acutely modeled and absolutely apparent, Vuillard's early imagery looks as though it is in a constant process of formation. As Andrew Ritchie points out in his catalogue for a Vuillard retrospective at The Museum of Modern Art in New York, "The secret charm of so many of Vuillard's small panels of the '90s is the result of his never quite 'naming' an object, as the poet Stéphane Mallarmé puts it. He 'suggests' it, he 'evokes' it, by knitting it into an amazingly complex tapestry. And by a process of telescoping planes in a picture . . . the foreground, middleground, and background overlap and fuse into a pulsating space that bears a kind of relation to the fusion of imagery in a poem by Mallarmé."[3] Under Mallarmé's inspiration, Vuillard's introspective exploration of an intimate, interior reality is now seen as a significant contribution to the Symbolist movement of the 1890s.

Like Vuillard, Hodgkin derives his subject matter from the environments, encounters, and activities that make up his daily life. Often set in sitting rooms, bedrooms, bathrooms, kitchens, hotels, museums, gardens, and parks, Hodgkin's combined memory of the environments, social interactions, and artifacts in these settings allows him to recast the psychological and visual energy of a particular moment. What we see in a comparison of Hodgkin and early Vuillard is the glimpse of an affinity or sensibility that carries with it a flexibility in the definition of "representation," a flexibility that Hodgkin takes full advantage of. Hodgkin's vocabulary, having absorbed a century of fragmentation and abstraction, transforms Vuillard's interiors and landscapes into something dreamlike and condensed. Hodgkin's marks and gestures have the tactile and animated quality of Vuillard's carefully orchestrated strokes, but they are magnified and thickened, creating an even greater tension between illusionistic space and surface materiality. One's initial impression of Hodgkin's images is that there is something there waiting to be recognized, but that recognizable thing or person has been subtly broken apart and dematerialized.

Hodgkin took his first trip to India in the 1960s. Having admired Indian art since he was a teenager, Hodgkin would eventually become a passionate collector of Indian paintings and drawings. Memories of his various trips to India would also be the subject of a number of paintings. His study of Indian painting, particularly its bold coloration, intimate size, and qualities of patterned illusion, have been a significant influence on Hodgkin's paintings.

Many of Hodgkin's most memorable works involve the visual reconstruction of a social gathering in an enclosed space. The Modern Art Museum's *Dinner in Palazzo Albrizzi*, 1984–88, for example, commemorates a dinner party given by the critic Robert Hughes following the opening of a survey of Hodgkin's works at the British pavilion in the 1984 Venice Biennale. Hodgkin remembers the evening as being "full of energy, joy, and candlelight. There was an emotional fullness about the interactions that always stuck with me." In order to reconstruct the visual texture of the moment, Hodgkin has choreographed his own pictorial interactions between invented marks, coded patterns, and a vibrating quality of dark/light contrasts that evoke a celebratory intensity. From a central spiral of blue and white dabs of paint emerges a twisting, flamelike form. Elusive faces huddle together just above. As Hodgkin remarks:

Dinner parties are a particularly fascinating subject. When the light is creating spots and shadows and the patterns of the furniture and clothing and the psychological intimacy is apparent, it's a real challenge to capture the flickering quality of the moment.

Like all of the artist's mature works, *Palazzo Albrizzi* is painted on wood. Wood appeals to Hodgkin because of the number of under-images he applies before settling on the final composition. Wood retains its rigidity, its ability to hold up under the artist's many revisions. He has been known to spend months and even years revising a single work. *Palazzo Albrizzi* also incorporates Hodgkin's painted patterned borders over raised framing edges, which act as a strong focusing device, creating a kind of pictorial compression and directing the eye into the picture (another nod to Matisse and the

French artist's use of windows to create a subtle layering of space and the sense of peeking in on a private scene). Hodgkin describes the importance of emphasizing the framing edge:

My pictures often include a frame which I paint on as part of the painting. I sometimes go to immense lengths to, as it were, fortify them before they leave the studio. The more evanescent the emotion I want to convey, the thicker the panel, the heavier the framing, the more elaborate the border, so that this delicate thing will remain protected and intact.[4]

Hodgkin has served as a trustee of the Tate and National Galleries of London, and with a studio in the Bloomsbury area behind the British Museum, he spends a good deal of time in museums. He remains an enthusiastic student of the language of painting, particularly when it comes to those artists he especially admires. In rare cases, he has paid homage to these artists with paintings that interpret his understanding of their "pictorial voice." The Modern Art Museum's *After Matisse*, 1995–99 is one of these pictures. Following two previous homages, *After Corot*, 1979–82 and *After Degas*, 1993, *After Matisse* summarizes Hodgkin's immense admiration for the French artist. Typically, the artist is not responding to a single work by Matisse, but to certain relationships he sees within Matisse's work as a whole. In regard to *After Matisse*, Hodgkin remarks:

I attempted a number of previous *After Matisse* paintings that didn't work, and as such no longer exist. Understanding Matisse's painting has been such a huge part of my development that it was not going to be easy to hit the right mark. I was interested in trying to get some of the strength of Matisse and at the same time some of that relaxed tension it seems only he is capable of.

After Matisse is an intense reduction of Matisse's bold and simplified forms. A dark green border contains two dominant light green forms that conceal a pinkish interior background. The contrast between

these colors and the hide-and-seek character of the fleshlike under-color sets up a gentle, erotic tension that one associates with Matisse's greatest works. Also apparent in *After Matisse* is a sense of effortless painthandling that is the result of a very studied vision. Not unlike the French master, Hodgkin knows how to hide his trials and errors, covering them with a final, perfectly poised flourish of line and stroke. What appears in Hodgkin's paintings to be brushstrokes laid down with remarkable spontaneity are in fact the final stage in a series of innumerable adjustments. This studied, overt expressionism may also be the artist's way of poking fun at one of his heroes, suggesting a spontaneity to which Matisse could never succumb.

In the final analysis it is the purely formal qualities of Hodgkin's paintings, regardless of the source of their inspiration, that determine their lasting significance. *After Matisse* projects a poetic dissonance that is the ultimate subject of all effective paintings, and that dissonance is carried through the simplicity of a brushstroke. Hodgkin's rich strokes of color flirt with being out of control, but his studied talent for adjusting the size of his marks to the projective power of his color keep the image in perfect pitch. *After Matisse* comes very close to creating a seamless melding of color, gesture, and scale.

MICHAEL AUPING

1 Unless otherwise indicated, quotes from the artist are from a conversation with the author, 13 September 2001.
2 Andrew Carnduff Ritchie, *Édouard Vuillard* (New York: The Museum of Modern Art, 1954): 13.
3 Ritchie, 16.
4 Quoted in Patrick Kinmouth, "Howard Hodgkin," *Vogue* UK (June 1984): 140–41.

Hans Hofmann
American, born Germany. 1880–1966

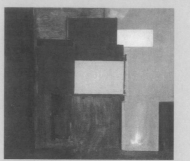

To Miz—Pax Vobiscum, 1964
Oil on canvas
77 3/8 × 83 5/8 inches
(196.5 × 212.4 cm)
Museum purchase
1987.3.P.P.

Hans Hofmann painted *To Miz— Pax Vobiscum*, 1964 near the end of his long career as an eminent painter and influential teacher. Stylistically, the Modern Art Museum's painting, with its striking rectangular planes of color, exemplifies Hofmann's late style, while, chronologically and personally, the composition suggests an occasion of closure and renewal for the artist.

By 1964 Hofmann was well established as a major artist and celebrated as a charismatic and inspiring teacher. Born in Bavaria, Hofmann studied art in Munich before moving to Paris in 1904. There he became friends with, among others, Henri Matisse, Georges Braque, and Pablo Picasso. From them, he absorbed the lessons of Fauvism and Cubism that were to continually inform his art. The late *To Miz—Pax Vobiscum*, for example, combines Fauvism's expressive coloration with the mass-space simultaneity of Cubism. With the outbreak of World War I in 1914, Hofmann returned to Germany, where he remained until 1930. In 1932, after teaching two summers at the Berkeley campus of the University of California, the artist moved to New York City (he was to become a United States citizen in 1941). Hofmann opened an art school in 1933, and for the next twenty-five years the classes he taught in New York and in Provincetown during the summers influenced legions of artists, including Lee Krasner, Louise Nevelson, Helen Frankenthaler, Red Grooms, Larry Rivers, Allan Kaprow,

and Richard Stankiewicz. Art historian Irving Sandler echoed the view of many when he declared, "Hofmann was the greatest art teacher of the twentieth century, that is, if a teacher's stature is measured by the number of students who achieve a national and international reputation in their own right."[1]

Hofmann was a generation older than the Abstract Expressionists, but he was, and is, often considered part of the New York School. During the 1940s and 1950s his paintings were seen at Peggy Guggenheim's Art of This Century Gallery, Samuel Kootz's gallery, and other venues exhibiting works by such Abstract Expressionists as Jackson Pollock, Barnett Newman, Mark Rothko, and Clyfford Still. In fact, the first use of the term "Abstract Expressionism" in connection with New York artists occurred in a 1946 review of Hofmann's work. Art critic Robert M. Coates wrote that Hofmann "is certainly one of the most uncompromising representatives of what some people call the spatter-and-daub school of painting and I, more politely, have christened Abstract Expressionism."[2] Hofmann was one of "The Irascibles" protesting a 1950 exhibition at the Metropolitan Museum of Art, although he missed posing for the now-iconic *Life* magazine photograph of the Abstract Expressionist group.[3] The improvisational look, spatial ambiguities and dynamics, and suggestive expressionism of Hofmann's work clearly aligned it with the art of the New York School. Hofmann's famous concept of "push and pull" resonated with, and probably influenced, a number of the Abstract Expressionists in their desire to actively confront painting's traditional three-dimensional illusionism with the canvas's inherent two-dimensionality.

Hans Hofmann coined the term "push and pull" to signify a composition's ability to evoke flatness and depth simultaneously. The artist believed that this was the essence of painting and "only from the varied counterplay of push and pull, and from its variation in intensities, will plastic creation result."[4] "Push and pull" is abundantly evident in *To Miz—Pax Vobiscum*, where abutting and overlapping planes, the range and

juxtaposition of colors, and the variations in paint texture and brushwork produce a dynamic play and tension between surface and space. The slabs of color—their edges crisp and soft, their colors flat and modulated—command and fascinate the viewer's eye. Hofmann had begun working with the color slabs in 1955, in part as a result of his pinning rectangles of colored construction paper on student canvases in order to demonstrate the fundamentals of "push and pull."[5] The ceaseless movement between flatness and space in *To Miz—Pax Vobiscum* not only reflects what Hofmann considered the essential concern of painting, but also, perhaps more importantly, his view of painting as expressive of a life force, "a metaphor for life itself—more lifelike than the imitation of nature."[6] This latter notion is particularly relevant to the Museum's painting, as it is a composition which, through its intense color and spatial dynamics, exalts the life of Hofmann's wife and his own continuing vital engagement with painting.

Maria Wolfegg Hofmann, known as Miz, died in 1963. She had met the artist in 1900 and married him in 1924. The death of the woman he had known for so many years, and of whom he said "lived my art and for my art," profoundly affected Hofmann.[7] He initially expressed his grief with the uncharacteristically somber black and red splashes of *In the Vastness of Sorrowful Thoughts*, 1963 (University Art Museum, University of California, Berkeley). However, Hofmann soon followed this with *To Miz—Pax Vobiscum*, rendered in the intense, bold colors typical of his late style. The artist spoke of this large, vivid composition, created during his period of mourning, as expressing his "negative ecstasy."[8] This oxymoronic phrase might be understood as a variation on the Romantic poet John Keats's concept of negative capability: "That is, when man is capable of being in uncertainties, mysteries, doubts, without any irritable reaching after fact and reason."[9] Keats believed the artist must be receptive to the unknown by relying on intuition and must allow beauty to overcome and obliterate every other consideration.

The "negative ecstasy" that Hofmann associated with *To Miz—Pax Vobiscum* can be conceived as his acceptance of the mystery of life and death, and his ability to feel and express its beauty in his art. That the painting, unlike the earlier *In the Vastness of Sorrowful Thoughts*, offered Hofmann a sense of emotional resolution is further suggested by the Latin phrase he included in the painting's dedicatory title: "Pax vobiscum" means "peace be with you."

To Miz—Pax Vobiscum is one of three compositions Hofmann painted as memorials. *Memoria in Aeterne*, 1962 (Private collection) was dedicated to the artists Arthur Carles, Arshile Gorky, Jackson Pollock, Bradley Walker Tomlin, and Franz Kline. The following year Hofmann painted *To J.F.K.: A Thousand Roots Did Die With Thee*, 1963 (Hirshhorn Museum and Sculpture Garden, Smithsonian Institution, Washington, D.C.). The artist also dedicated a series of paintings to his second wife, Renate Schmidt Hofmann, in 1965.[10]

The Museum's painting dates, then, from a pivotal moment in Hofmann's personal and artistic life. In 1964 Hofmann completed *To Miz—Pax Vobiscum* and remarried. With renewed vitality and inspiration, the eighty-four-year-old painter moved forward, but only after having celebrated the woman he called his "muse" in the radiant *To Miz—Pax Vobiscum*.

MARK THISTLETHWAITE

1 Irving Sandler, "Hans Hofmann: The Dialectical Master," in Cynthia Goodman, *Hans Hofmann* (New York and Munich: Whitney Museum of American Art in association with Prestel-Verlag, 1990): 86.
2 Robert M. Coates, "The Art Galleries: At Home and Abroad," *The New Yorker* (3 March 1946): 75.
3 The photograph, taken by Nina Leen, appeared in the 15 January 1951 issue of *Life*.
4 Hofmann quoted in William C. Seitz, *Hans Hofmann* (New York: The Museum of Modern Art, 1963): 27.
5 Sandler, 97, n. 23.
6 Ibid., 80.
7 Cynthia Goodman, *Hans Hofmann* (New York: Abbeville Press, 1986): 96.
8 Ibid.
9 M. H. Abrams, ed., *The Norton Anthology of English Literature*, 6th ed., vol. 2 (New York: W. W. Norton & Company, 1993): 831. Keats defined "negative capability" in an 1817 letter to his brothers, George and Thomas.
10 Initially Hofmann included eleven paintings in what he called the *Renate Series*. However, he then eliminated two of the works. The series of nine paintings was given by his widow to the Metropolitan Museum of Art in New York in 1972.

Robert Irwin
American, born 1928

Untitled, 1968
Plastic, lighting
53 5/8 inches (136.2 cm) diameter
Museum purchase, The Benjamin J. Tillar Memorial Trust
1969.14.P.S.

In an age saturated with printed and electronically generated reproductions, works of art are most often known secondhand. The convenience, practicality, and economics of reproductions allow a viewing opportunity that otherwise might not be possible. But a reproduction inherently alters the actual work of art's size, scale, texture, color, volume, and compositional nuances. However, because we willingly suspend disbelief, we conflate the reproduced image with the actual work of art and presume to know the artwork through its reproduction. In fact, we really perceive the art only in terms of the reproduction. In the 1960s Robert Irwin found the inherent limitations of reproductions and the misplaced authority assigned to them to be so problematic that he refused to allow photographs of his artwork to be published. "How can you photograph a state of being?" he asked.[1] For him, reproductions were incapable of capturing the physical presence and perceptual dynamics that were essential to the experience of viewing his works, including the Museum's *Untitled*, 1968.

Formed of acrylic resin, *Untitled* is a convex disc that projects, by means of a clear plastic tube, twenty-four inches from the wall. Multiple coats of a white hue have been spray-painted onto the disc's surface. As the opaque paint moves toward the edges, it thins to transparency. Dividing the circle in half horizontally is a three-inch-wide band whose dark

opaque color also becomes increasingly lighter and transparent toward the edges. Four floodlights—two on the floor and two mounted on the ceiling—bathe the object in light and create a pattern of overlapping shadows. The disc, wall, light, and shadows merge to offer a shifting sense of palpability and indeterminacy, and a play between the real and the illusionistic. In appearing dematerialized, *Untitled* answers a question Irwin had posed to himself: "How do I paint a painting that doesn't begin and end at the edge but rather starts to take in and become involved with the space or environment around it?"[2]

The California-born artist began his career in the late 1950s painting gestural, Abstract Expressionist–influenced works. Although he had studied art in Los Angeles at the Otis Art Institute, the Jepson Institute, and the Chouinard Art Institute, Irwin feels that the artists Billy Al Bengston, Ed Moses, and Craig Kauffman had "more to do with my education than any school I went to."[3] Irwin became an integral figure in the burgeoning Los Angeles art scene, showing his paintings at the Ferus Gallery and teaching such students as Ed Ruscha and Larry Bell. During the 1960s Irwin eliminated expressive gesturalism from his paintings and began to maximize their physicality. He painted monochromatic works that included a few narrow horizontal lines, and a series of dot paintings (1964–67) that featured thousands of green and red dots on bowed canvases that seemed to glow and vibrate. His concern with visual perception and formal physicality led him in 1966 to the convex disc format, which resulted in the body of work that gained him an international reputation.

Irwin has explained that he adopted the circular shape because the traditionally rectilinear format of painting no longer made sense to him: "Composing a world within this square canvas…seemed to me to be very arbitrary. I sensed the world around me opening up, not closed in."[4] The artist liked the neutrality and "evenness of presence" of a circle, which has no corners to distract as focal points.[5] The method by which Irwin treated the surface of the disc, installed it, and lit it allowed him to produce a work that appeared

to dissolve into its environment. Initially, the discs were fabricated of aluminum and sprayed with lacquer paint. Their elegant clarity, attention to finish, and concern with light immediately identified them with the L.A. Look of the 1960s. But achieving a provocative perceptual experience was key to the artist: "Visually it was very ambiguous which was more real, the object or its shadow. They were basically equal they occupied space differently, but there was no separation in terms of your visual acuity in determining that one was more real than the other. And that was the real beauty of those things, that they achieved a balance between space occupied and unoccupied in which both became intensely occupied at the level of perceptual energy."[6] Irwin felt that the use of transparent plastic would more readily allow him to attain his goal, but it was not until 1968 that he discovered a satisfactory cast-acrylic process. The Museum's *Untitled* is from this second series, which ended in 1969. These new discs were slightly smaller in diameter than the earlier metal ones, projected farther from the wall, and included a horizontal band to enhance the visual ambiguity of the work. The bar does this by its being variously seen as occupying the surface, floating freely, cutting through the disc, and sinking back into space. The artist intended that this phenomenon of "perceptual energy," and not symbolic meanings, would inform the experience of *Untitled*.

Irwin acknowledges that viewers want to make associations with the pattern of shadows and attach interpretations to them. Often the shadows are linked to configurations of flowers, four-leaf clovers, butterflies, and mandalas. Irwin is clear, however, that such readings are not what his art is about, stating, "My art has never been about ideas….it has always been about experience."[7] Robert Irwin's *Untitled* is less an art object and more a site/sight for experiencing the beauty, wonder, and complexity of visual perception.

At the time he was creating *Untitled*, the artist was becoming involved in a dialogue and collaboration with Edward Wortz, head of the Life Sciences Department of the Garrett Aerospace Open

Research Facility. This occurred under the auspices of the Art and Technology project organized by the Los Angeles County Museum of Art. James Turrell, another artist working with light and space, also participated with Irwin and Wortz. The experience was life- and career-changing for Irwin, who stopped producing paintings and closed his studio in 1970. He now perceived that art, "like time or space, has not physical being; it is really our awareness and attentiveness to the aesthetic potential in the nature of all things and the nature of ourselves."[8] Irwin devoted himself to reading, lecturing, and traveling extensively, and to working "*in response*."[9] By this, he meant that he would try to respond directly to any situation in which he found himself. In 1975 the Modern Art Museum invited the artist to produce works for a variety of spaces in its building, under the title *Robert Irwin: Continuing Responses*, 1975/76. Over the next year and a half, Irwin created seven installations, with one—a nylon scrim veil on a stairway landing—left permanently.[10] He also conceived of twelve "incidental sculptures" for the city of Fort Worth, but this part of the project was never realized.[11] The works Irwin produced and envisioned in response to the Museum's invitation were important in anticipating the direction taken by much of his later gallery, museum, and public installations.

These works have also built upon the question that had led Irwin to the disc paintings: How can one paint a painting that does not begin or end at the edge and that becomes involved in its environment? A work such as *Untitled* helped Irwin resolve that question, by "more or less transcending painting" and convincing him "there was no reason for me to go on being a painter."[12] *Untitled* dates then from a crucial moment in Robert Irwin's career, as his perception of art and of perception itself were being reshaped.

MARK THISTLETHWAITE

1 Quoted in Douglas Davis, "The Searcher," *Newsweek* 86 (29 December 1975): 53.
2 Quoted in Lawrence Weschler, *Seeing is Forgetting the Name of the Thing One Sees* (Berkeley and Los Angeles: University of California Press, 1982): 99.
3 Quoted in Michele D. De Angelus, "Visually Haptic Space: The Twentieth Century Luminism of Irwin and Bell," in Maurice Tuchman, *Art in Los Angeles: Seventeen Artists in the Sixties* (Los Angeles: Los Angeles County Museum of Art, 1981): 30.
4 Quoted in an interview with Jan Butterfield, "The State of the Real: Robert Irwin Discusses the Activities of an Extended Consciousness—Part 1," *Arts Magazine* 46 (June 1972): 49.
5 Quoted in Weschler, 101.
6 Ibid., 104.
7 Robert Irwin in an interview with Jan Butterfield, "'Reshaping the Shape of Things,' Part 2: The Myth of the Artist," *Arts Magazine* 47 (September–October 1972): 32.
8 Robert Irwin, *Robert Irwin* (New York: Whitney Museum of American Art, 1977): 31.
9 Ibid., 23.
10 The Museum acquired three of the other installations: a black string work for the upper galleries, a scrim veil with black metal for the Solarium, and a wood and sheetrock work for the front entrance. All of these works were created for the Museum's Montgomery Street location, which it occupied from 1954 to 2002.
11 The collection includes three felt-tip pen drawings with transfer lettering related to this aspect of the project: *Grass Hill Continuing Responses Project Proposal April 1976*, 1976; *Continuing Responses/Project Proposal/March 1976 Trinity River Leap Fort Worth, Texas*, 1976; and *Continuing Responses Projects Fort Worth Art Museum*, 1975/76.
12 Weschler, 107.

Alain Jacquet

French, born 1939

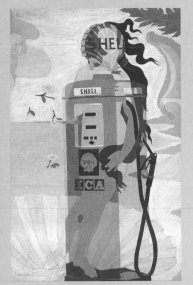

Camouflage Botticelli (Birth of Venus),
1963–64
Oil on canvas
90³/₄ × 55¹/₂ inches (230.5 × 141 cm)
Museum purchase,
Sid W. Richardson Foundation
Endowment Fund
2001.9.P.P.

Between 1962 and 1964 Alain Jacquet created his *Camouflage* series, to which *Camouflage Botticelli (Birth of Venus)*, 1963–64 belongs. For this piece Jacquet reproduced Sandro Botticelli's important Renaissance painting [1] of a curvaceous, nude Venus with flowing golden hair, posed on a floating cockle shell, and he overlaid it on a gas pump that bears the word "Shell," complete with the oil corporation's scallop-shaped logo. Jacquet makes a humorous connection between Venus—the shell being one of her attributes, according to Roman mythology—and the corporate logo. Other paintings in the *Camouflage* series are based on works by Michelangelo, Piet Mondrian, Roy Lichtenstein, Giorgio de Chirico, and (moving from the art to the entertainment industry) Walt Disney. Each work contains its own flip visual pun, and *Camouflage Botticelli* is the masterwork of the group.

Jacquet's use of a well-known artwork connects him to one of his French predecessors, the Dada artist Marcel Duchamp, and especially to Duchamp's famous manipulated photograph of Leonardo da Vinci's *Mona Lisa*.[2] In Duchamp's version, *Mona Lisa* is graffitied with a pointed moustache and beard. Beneath the picture the title, *L.H.O.O.Q.*, appears, meaningless letters that, when pronounced aloud together in French, sound like "she has a hot ass." Botticelli's *Birth of Venus*—a symbol of beauty and sensuality, like da Vinci's *Mona Lisa*—is endowed with contemporary sexual innuendo and humor in much the same vein as Duchamp's work, but, perhaps less simplistically, it points to the corporate world and its impact on society.

In *Camouflage Botticelli*, the sensual Venus is juxtaposed with a gas hose and nozzle, a symbol for male sexual anatomy. The center of Venus's body is adorned with the oil corporation's shell logo, meant to signify her pubis. Yet, camouflaged (as the title states and the style of paint confirms), Jacquet's symbolism is subtler than Duchamp's blatant and outrageous verbal pun.

Although he is not directly associated with the small group of French artists from the 1960s known as the Nouveaux Réalistes, or with American or British Pop art of that decade, Jacquet shares close affinities with both movements. His ironic use of the everyday—advertising and corporate logos—and his play on mechanically reproduced imagery makes his art a kind of commentary on the way commercialism affects contemporary culture. These qualities especially align him with his Pop and Nouveau Réaliste contemporaries, with whom his work has been exhibited numerous times throughout Europe and America.

ANDREA KARNES

1 *Birth of Venus* (c. 1485–86, Uffizi, Florence).
2 *Mona Lisa*, c. 1505–14, Louvre, Paris. Duchamp's version is *L.H.O.O.Q.*, 1919.

Jess

American, born 1923

Montana Xibalba: Translation #2,
1963
Oil on canvas mounted on wood
29³/₄ × 33 inches (75.6 × 83.8 cm)
Museum purchase,
The Friends of Art Endowment Fund
1996.16.P.P.

At the time, I was involved with nuclear energy, the direction it was going seemed questionable, nightmarish in many ways.

JESS

Early in a career that began relatively late in life by today's standards, Jess retired to his house and studio in the Inner Mission District of San Francisco, rarely admitting visitors. A recluse of sorts, Jess lives in a three-story Victorian-style house, a densely packed warehouse of disparate literature, including books on folklore, the occult, and world mythologies; popular gossip tabloids; entire volumes of *Scientific American*; and a collection of rare fairy tales and children's books. His subject matter, broadly speaking, is an elegy to romance and symbolism, cross-referencing "picture-symbols" across wide expanses of time, from images of ancient ritual costume to the latest Barbra Streisand poster.

Jess's background constitutes one of the more interesting stories in postwar American art. He was born Burgess Collins in 1923 in Long Beach, California. Although many of his works refer to the imagination of children, little is known of the artist's own childhood. According to Jess, he severed relations and ended all contact with his family in the 1950s, symbolized by the rejection of his surname when he began his career as an artist. The son of a civil engineer and amateur geologist-prospector, Jess's initial inclinations were in the area of science. He entered the California Institute of

Technology as a chemistry major in 1942, but in 1943 he was called into the United States Army. Between 1944 and 1946 he was assigned to the Special Engineer Corps at the Manhattan Project in Oak Ridge, Tennessee, where he was involved with the production of plutonium for the atomic bomb.

Following his discharge from the army in 1946, Jess returned to California and completed his bachelor of science degree in chemistry with honors. Shortly after his graduation in 1948, he went to work for General Electric Laboratories on the Hanford Atomic Energy Project in Washington, where he was involved again with plutonium production. While living in Richland, Washington, a small company town near the G.E. Laboratories, Jess became a "Sunday painter," spending weekends in an adult education painting class. He recalls, "Art became an antidote to the scientific method. Even though I learned a great deal from my involvement with science, that type of 'objective' thinking was not for me … the real truth—if there is such a thing—that you can learn from science is how little we know about reality. Art seemed to address this more openly. To me, art could be a very inwardly directed thing—which may be where science is going anyway—and that appealed to me. At the time, I was involved with nuclear energy, the direction it was going seemed questionable, nightmarish in many ways."[1]

It was in 1949 that Jess had what he refers to simply as "the dream," in which he envisioned the earth being destroyed in the year 1975. Such fears were undoubtedly part of a more pervasive anxiety experienced internationally following the devastation of World War II and its horrific conclusion in Hiroshima. Jess was particularly menaced by the fact that the bomb was dropped on 6 August 1945, his 22nd birthday. Some eight weeks after his vision, he left his job with General Electric and moved to the San Francisco Bay Area. He decided to become an artist, with the conviction that in what little time he might have left, he needed to rediscover a sense of value in society.

Under the GI Bill, Jess eventually entered the California School of Fine Arts (now the San Francisco Art Institute), where he studied with Clyfford Still and David Park. Jess was inspired by Still's gothic abstractions, in which light and color seeped out of thick, murky globs of paint; and by Park's generalized figuration, made of thick, impastoed slabs of paint. Formally, Jess's painting would develop to embody the unlikely pairing of Still and Park, but with a unique twist that carries his art into the realm of visionary narrative. He became intrigued with the idea of transforming Still's craggy fields of paint and Park's primitive figuration into romantic fantasies, eventually developing a body of collage and painting that is a hybrid of abstraction, figuration, Surrealism, and popular culture.

It is Jess's interest in popular culture that has allowed many critics and historians to attempt to situate him within a larger mainstream of American art. Jess first attracted national attention when he was included in the Oakland Art Museum's widely publicized 1963 exhibition *Pop Art U.S.A.*[2] He was anointed as an ancestor of the then-burgeoning movement that would establish the careers of numerous American artists who have now become household names: Andy Warhol, Claes Oldenburg, Ed Ruscha, Roy Lichtenstein, and others. Although there is some justification for seeing Jess as an eccentric precursor to these artists, his philosophy indicates significant differences. While Pop art is often large-scale, bold, and ironic, if not cynical; Jess's art is intimate, enigmatic, and, perhaps most daringly, sentimental. Moreover, while Pop is a distinct reflection of a particular consumer moment, Jess's art cross-references images and symbols across wide expanses of history.

The ultimate result of this time scanning is the artist's *Translation* series, a cycle of thirty-two paintings completed between 1959 and 1976. The term *Translation* refers to the fact that they are faithful reproductions in oil paint of photographs, engravings, or black-and-white printed reproductions whose images have mythic meaning to the artist. Each image is part of a grand meditation on science, myth, and art. A key symbol within the series is the sun, the ultimate nuclear generator.

Each *Translation* begins as an intricate pencil drawing and progresses to enlargements and a diagrammed canvas. Jess then paints into the sections, as in a coloring book. The process involves a series of "events," in which the color and texture of each section is a result of the mood and spirit of the moment. The thick, radiant surfaces of all the paintings reveal a dense archeology of layers, built up over months of contemplation and careful craftsmanship.

The image for the Museum's *Montana Xibalba: Translation #2*, 1963 is taken from a 1944 University of Montana yearbook, which Jess found in a junk shop. The photograph that attracted his attention depicted a soccer game, which the artist immediately recognized as symbolizing an ancient pre-Columbian myth. In the cosmology of the Mayan civilization, the birth of the sun and the moon resulted from a ball game between two earthly heroes and the Lords of Xibalba, a realm akin to Hades, or hell. The movements of the planets were thought to be determined by the action of the game. Thus, in Jess's *Montana Xibalba*, the yellow soccer ball represents the sun and the peculiar-looking University of Montana athletes, the heroes. "I was also struck," says the artist, "by the number 8 on the jersey, which to me has always seemed to be an infinity symbol or Möbius strip stood on end."

As indicated in the title, *Montana Xibalba* is the second in the *Translation* series. By the second *Translation*, the artist came to the realization that the careful layering of paint was crucial to the life of the final image. *Translation #1 (Laying a Standard)*, executed in 1959, took the artist approximately one month to paint, as he slowly and meditatively applied thick layers of oil paint into the carefully outlined pencil diagram that makes up the image. *Montana Xibalba*, however, took more than three months to complete. *Montana Xibalba* is constructed of six to eight layers of oil paint within each mosaic section. In order to keep the thick surface from sagging down the canvas, Jess had to place the painting flat while he worked. The final result is an image that appears to have grown into being, almost like a mold.

As the artist describes it, "These mythic images are chosen, or more properly they choose me, and then take on a life of their own, like science and art."

MICHAEL AUPING

1 Quotes from the artist are from conversations with the author, 1983–1993. For a detailed description of the artist and his art, see Michael Auping, *Jess: A Grand Collage* (Buffalo, NY: Albright-Knox Art Gallery, 1993).
2 John Coplans, *Pop Art U.S.A.* (Oakland: Oakland Art Museum, 1963): 20.

Donald Judd
American, 1928–1994

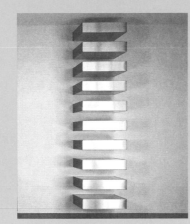

Untitled, 1967
Stainless steel and Plexiglas
Ten units, each 9¹/₈ × 40 × 31 inches
(23.2 × 101.6 × 78.7 cm)
Overall 190¹/₈ × 40 × 31 inches
(482.9 × 101.6 × 78.7 cm)
Museum purchase, The Benjamin
J. Tillar Memorial Trust
1970.18.P.S.

This work which is neither painting nor sculpture challenges both....Three dimensions are real space. That gets rid of the problem of illusion and literal space, space in and around marks and colors.... Actual Space is intrinsically more powerful and specific than paint on a flat surface.

DONALD JUDD

Donald Judd's *Untitled*, 1967 is an early "stacked" sculpture made during the rise of the Minimalist movement, of which Judd—despite his resistance to group affiliations—is considered a figurehead. This piece, like all of his work, is left untitled in order to avoid association with anything other than the object itself, and it represents one of the artist's most important motifs. It comprises ten identical steel-framed units with transparent orange Plexiglas tops and bottoms, evenly spaced on the wall from floor to ceiling. Like other Minimalist works, *Untitled* extends the heroic and monumental qualities of Abstract Expressionism, but it does so by a different formalist means. Rather than gesture, Judd relied on geometry—serial and repetitious forms driven by the fundamental principles of mathematics and logic. His objects are purposefully cool and detached, a result of his

hands-off approach and adherence to the machine aesthetic. In fact, he often had his works industrially fabricated, using subdued colors, as seen in *Untitled*.

With this piece, Judd delved deeper into his investigation of spatial relationships—of the art object as its own qualifier and of the object in relation to its environment. Judd, who was not only an artist but also an important art critic, frequently wrote about his artistic concerns. Of his exploration of space in relation to objects, he wrote, "My work with the whole room began with part of it [the room]. In 1965 I made a work that extended from the floor to the ceiling. This extended the definition of space between the units to those below and above."[1] He was describing his first stacked piece.

Untitled, with its simple design of pristine steel units evenly spaced on the wall from floor to ceiling, engages the space around it and implicates architecture. Even the ambient orange glow that the stacked boxes emit becomes a part of the work's spatial dynamics. Indeed, Judd did not label his work as sculpture per se. In his seminal 1965 article "Specific Object," he defines three-dimensionality as opposed to painting or sculpture: "This work which is neither painting nor sculpture challenges both Three dimensions are real space. That gets rid of the problem of illusion and literal space, space in and around marks and colors Actual Space is intrinsically more powerful and specific than paint on a flat surface."[2] He also discusses the problem of neutrality, arguing that three-dimensional work is more neutral than painting or sculpture, especially because it incorporates materials such as Formica, aluminum, and Plexiglas, which at the time did not have a host of implied meanings. Another significant point in the essay, which shaped Minimalist works to come, is his idea that the parts of a three-dimensional object are equal to its whole. "In the new work the shape, image, color, and surface are single and not partial and scattered. There aren't any neutral or moderate areas or parts, any connections or transitional areas."[3] In other words, unity must prevail.

Judd's emphasis on neutrality and unity, and space over mass, and his

exploration of real space and the illusion of space were all manifested in *Untitled*, and soon after its creation, he began to completely command his spaces. In 1971 the artist bought an abandoned army barracks in Marfa, Texas, close to the Mexican border. The industrial, stripped-down site appealed to Judd's sensibilities as an artist, and he redesigned the compound to coexist with his sculpture, meeting his exact specifications. Now known as the Chinati Foundation, the grounds include indoor and outdoor works by Judd, Carl Andre, John Chamberlain, Ilya Kabakov, Dan Flavin, and others. In the years since its creation, the Marfa compound has become a place of international pilgrimage for people who want to see Judd's work presented in the manner he intended. *Untitled*, which was acquired by the Museum in 1970, only three years after it was made and at the peak of Minimalism, is an important precursor to Judd's Chinati Foundation galleries, and is an iconic artwork within the Minimalist movement.

ANDREA KARNES

1 Donald Judd, "Some Aspects of Color in General and Red and Black in Particular," *Artforum* 10 (Summer 1994). This article was published to commemorate Donald Judd after his unexpected death in February 1994. It is considered his last formal written statement.
2 *Donald Judd: Complete Writings 1959–1975* (New York: New York University Press, 1975): 181.
3 Ibid., 187.

Craig Kauffman
American, born 1932

Untitled, 1967
Vacuum-formed Plexiglas and acrylic
56 × 31 × 4 inches
(142.2 × 78.7 × 10.2 cm)
Museum purchase, The Benjamin
J. Tillar Memorial Trust
1968.4.P.S.

A native of California, Craig Kauffman developed as an artist at the same time that Los Angeles emerged as an internationally recognized art center. After attending the University of Southern California and the University of California, Los Angeles, he had his first one-person exhibition at the Felix Landau Gallery, Los Angeles in 1953, at the age of twenty. Like most ambitious artists of the period, his works were heavily influenced by the Abstract Expressionists, particularly the works of Arshile Gorky, Mark Rothko, and Franz Kline. Through his friend and classmate Walter Hopps, a co-founder of the Ferus Gallery in Los Angeles, Kauffman was also introduced to the works of Marcel Duchamp.

Although Kauffman's early Abstract Expressionist works were highly influential on a growing Southern California art scene, it is his work of the 1960s that established his international reputation, specifically as an early pioneer of the movement variously referred to with terms such as "light and space" and "finish fetish." Kauffman, along with peers such as Robert Irwin, Larry Bell, and Peter Alexander, developed a unique

hybrid of painting and sculpture that involved the manipulation of light through various plastic forms.

The Modern Art Museum's *Untitled*, 1967 is a poignant example of the aesthetic and technical influences that helped develop this relatively coherent and ground-breaking movement. In the early 1960s Kauffman was one of the first to experiment with plastics as a support for painting. His interest in plastic commercial signage and the burgeoning postwar plastics industry in Southern California led him to engage the industrial process of vacuum-forming to make wall-bound objects that both refract and absorb light. In *Untitled*, an essentially geometric shape is softened by gentle curves. An echo of his early interest in Rothko's floating, cloud-like forms, *Untitled* is also a potent fusion of Pop art and Minimalism, which were competing forces in the 1960s. Kauffman's interest in popular culture extended beyond plastic signage to include the customizing of automobiles and motorcycles in Southern California in the 1950s and 1960s, which can be seen in the luminescent sheen of his cherry-red form and the pin-striping that is evident on the left and right edges of the shape. By infusing his plastic material with color, as well as spray-painting it from the back, he demonstrates Minimalism's rejection of gestural marking and interest in a unitary object in which color, surface, and form are completely integrated.

MICHAEL AUPING

Ellsworth Kelly
American, born 1923

Curved Red on Blue, 1963
Oil on canvas
105 1/4 × 84 3/8 inches
(267.3 × 214.3 cm)
Museum purchase, The Benjamin
J. Tillar Memorial Trust
1968.10.P.P.

In the early 1960s Ellsworth Kelly rented a studio at Coenties Slip in Lower Manhattan, residing in a group of buildings that also housed the studios of Agnes Martin, Jack Youngerman, James Rosenquist, and Robert Indiana, all of whom shared with Kelly an interest in flat, reductive forms. "We were all interested in transforming reality—things we saw outside the studio—into forms that were summarized to the point of being abstract or almost abstract."[1] In retrospect, Kelly's sensibility was somehow *exactly* centered between the real and the abstract, to the point that there was little distinction. According to the artist, the Modern Art Museum's *Curved Red on Blue*, 1963 was likely painted at his Coenties Slip studio.

Throughout his fifty-year career, Kelly's art reflects his fascination with form as it presents itself to him on a daily basis, whether it be the shape of a shadow, an architectural detail, the curve of a hill, or the edge of a leaf. During the early 1960s Kelly was particularly intrigued by the character of various curved forms. "The curve is a form that exists in nature but can also be manipulated to appear abstract. I was fascinated by the different effects you could achieve with a simple curve." Beginning with drawings and collages and eventually in large-scale paintings, Kelly's work of the early 1960s explored the transformational qualities of various

curves, using both color and edge to divide the ground of a sheet of paper or canvas. Of critical importance to Kelly was that the curved form not appear as a figure sitting on or against a background, but rather be an integral segment of the surface of the image as a whole. He wanted each image to appear as an abstract or semiabstract composition, not as a reductive still life or landscape.

Curved Red on Blue began as a collage from the same year. That the collage and painting are almost identical except for size and material indicates Kelly's pleasure with the image. *Curved Red on Blue* consists of an enigmatic red curve dividing an otherwise blue canvas. The canvas barely contains the red form, which pushes against all four edges of the canvas. As with so many of Kelly's forms, it is difficult to identify the exact source of the curve. It relates to numerous sketches the artist made the subsequent year, all of which depict a curved form flexing its presence within a paper sheet or drawn frame. Although it initially appears as a question mark without its dot, it also relates to the various plant stems the artist would draw around the same time. The hooklike form in *Curved Red on Blue* predicts the looping curve of the stem in a drawing from 1968 titled *Water Lily*. Indeed, Kelly has acknowledged *Curved Red on Blue* as a seminal work that opened up a career-long investigation of the curve and its transformational possibilities. "It was one of those paintings," Kelly has said, "that seemed to work immediately, as an abstract composition and an echo of something seen."

MICHAEL AUPING

1 Quotes from the artist are
from a letter to the author,
25 September 2001.

Anselm Kiefer
German, born 1945

Quaternity, 1973
Oil and charcoal on burlap
117 1/2 × 170 1/4 inches
(298.4 × 432.4 cm)
Museum purchase,
The Friends of Art Endowment Fund
1997.3.P.P.

There is no point in destroying the building. Its memory could do more harm than the bricks it is made of. It's better to transform the space—to create a space for something new. It's like an open book waiting for the next chapter. ANSELM KIEFER

*Papst Alexander VI: Die goldene Bulle
(Pope Alexander VI: The Golden Bull)*,
1996
Emulsion, acrylic, and gold leaf
on canvas
130 × 218 3/4 inches (330.2 × 555.6 cm)
Museum purchase,
The Friends of Art Endowment Fund
1998.9.P.P.

Aschenblume, 1983–97
Oil, emulsion, acrylic paint, clay, ash,
earth, and dried sunflower on canvas
149 5/8 × 299 1/4 inches (380 × 760 cm)
Gift of Anne and John Marion in
honor of Michael Auping
2002.17.G.P.

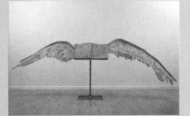

Book with Wings, 1992–94
Lead, tin, and steel
74 3/4 × 208 5/8 × 43 3/8 inches
(189.9 × 529.9 × 110.2 cm)
Museum purchase,
Sid W. Richardson Foundation
Endowment Fund
2000.22.P.S.

Commentary on page 90

Sol LeWitt
American, born 1928

In conceptual art, the idea or concept is the most important aspect of the work....When the artist uses a conceptual form of art, it means that all of the planning and decisions are made beforehand and the execution is a perfunctory affair. SOL LEWITT

Wall Drawing #302, 1976
Grid and arcs from the midpoints
of three sides in black pencil
Dimensions variable
Gift of Angela Westwater, New York
1999.11.G.Dr.

Working in the offices of the architect I. M. Pei in 1955 and 1956, Sol LeWitt became an early proponent of expanding the social role of art by exploring a merger between architecture and art. His simple but timely solution was to draw directly on the wall. Although he was initially recognized for his sculptural objects and works using language, LeWitt's preferred territory has been the wall, the most basic architectural unit of any building.

LeWitt began as a painter, using the grid as a basic image and compositional structure. By the early 1960s his geometric images had migrated out from the wall, becoming reliefs in which a square was telescoped into smaller units. This fundamental vocabulary eventually became sculptural and floor-bound. His skeletal cubic constructions in stark black or white filled a given space like crystalline structures. These simple forms, first shown in 1966 in New York, remain among the clearest and most elegant examples of what would become known as Minimalist sculpture.

LeWitt gained recognition in the United States and abroad not only through his surprisingly reductive forms but also through his theoretical writings. In his landmark statement of 1967, *Paragraphs on Conceptual Art*, LeWitt defined the movement that would emerge as a natural extension of the Minimalists' rational methodology: "In conceptual art, the idea or concept is the most important aspect of the work.... When the artist uses a conceptual form of art, it means that all of the planning and decisions are made

beforehand and the execution is a perfunctory affair."[1]

For LeWitt, language became the perfect vehicle to initiate his concept of the wall drawing. After analyzing the dimensions and surface character of a particular wall or set of walls, LeWitt creates a drawing verbally, describing a set of lines and/or marks appropriate to those walls, i.e., "straight lines about twelve inches long, touching and crossing, uniformly dispersed with maximum density, covering the entire surface of the wall." For LeWitt, a wall drawing is not a spontaneous notation, but rather a systematic concept in the form of a set of instructions that can exist as art whether or not it is executed. As a result of LeWitt's conceptualization of the act of drawing, it is not necessary that the artist be the one to physically execute the drawing. It is not uncommon for LeWitt, after seeing floor plans and elevations of a given room or building, to fax or phone his instructions for a drawing to an assistant, who executes the work. LeWitt notes that his conceptual strategies partially evolved from his knowledge of the architectural process: "Working in an architectural office, meeting architects, knowing architects had a big effect. An architect doesn't go off with a shovel and dig his foundation and lay every brick. He's still an artist."[2] In many cases, depending on the scale of the work, more than one assistant executes the work. Thus, LeWitt's wall drawings involve one author—LeWitt—and many collaborators—those who actually perform the drawings on the wall.

Some of LeWitt's instructions allow little room for variation by the draftsperson, while others demand a certain amount of individual decision-making. Regardless, the artist recognizes that all of his drawings look slightly different when done by different individuals. This

dialogue between the specificness of the wall and the particular temperament of the draftsperson interests LeWitt as an element of spontaneity or chance. LeWitt envisions his role as parallel to that of a composer/conductor, his wall drawings being "like a musical score that could be redone by any or some people. I like the idea that the same work can exist in two or more places at the same time."[3] Most of his drawings disappear beneath a layer of paint at the conclusion of the exhibition for which they are made. As such, they exist for a given duration. The temporary nature of LeWitt's wall drawings remains one of their unique and still-controversial aspects. Museums and private collectors of LeWitt's wall drawings essentially purchase an idea, the initial physical manifestation of which is a set of instructions on paper signed by the artist.

LeWitt executed his first wall drawing for a group show at the Paula Cooper Gallery, New York in 1968, and has since produced some 800 wall drawings in a remarkable range of architectural settings. The Modern Art Museum's *Wall Drawing #302*, 1976 is a spare and elegant example of the artist's combination of arcs and grids. The signed certificate for *Wall Drawing #302* specifies, "Grid and arcs from the midpoints of three sides. Black pencil." The result is three overlapping half circles, or arches. LeWitt has acknowledged the inspiration of Italian art and architecture on the evolution of his wall drawings, and *Wall Drawing #302* reflects that influence. "The geometry of Italian architecture, the columns and arches," the artist has commented, "have always fascinated me, and, of course, the frescoes."[4] In fact, LeWitt's wall drawings can be interpreted as a melding of drawing and fresco. LeWitt has been visiting Italy continually since 1969. He

purchased a home in Umbria in 1976 (the year *Wall Drawing #302* was first produced) and lived there full-time between 1980 and 1986. He continues to spend a part of each year in Umbria. LeWitt has said, "You can't not be affected by that."[5]

Over the past three decades LeWitt's wall drawings have come to be the purest and most far-reaching result of the artist's pioneering role in the development of Minimal and Conceptual art. The term *wall drawing* has become a standard part of the vocabulary of contemporary art, LeWitt often being credited with originating the term and the basic philosophy that guides it. In his typically matter-of-fact manner, however, LeWitt acknowledges his relatively late entry into this artistic arena. As he puts it, "I think the cave men came first."[6]

MICHAEL AUPING

1 Sol LeWitt, "Paragraphs on Conceptual Art," *Artforum* 10 (June 1967): 79–83. Reprinted in *Sol LeWitt* (New York: The Museum of Modern Art, 1978): 166.
2 Quoted in Andrea Miller-Keller, "Excerpts from a Correspondence, 1981–1983," *Sol LeWitt Wall Drawings* (Amsterdam, Eindhoven, and Hartford, Conn.: Stedelijk Museum, Stedelijk Van Abbemuseum, and Wadsworth Atheneum, 1984): 22.
3 Ibid., 21.
4 The artist in conversation with the author, 13 October 1994.
5 Ibid.
6 Miller-Keller, 21.

Roy Lichtenstein
American, 1923–1997

Mr. Bellamy, 1961
Oil on canvas
56 1/4 × 42 1/8 inches
(142.9 × 107 cm)
Museum purchase, The Benjamin
J. Tillar Memorial Trust, Acquired
from the Collection of Vernon Nikkel,
Clovis, New Mexico, 1982
1982.3.P.P.

…my work is actually different from comic strips in that every mark is really in a different place, however slight the differences seem to some. The difference is often not great, but it is crucial.

ROY LICHTENSTEIN

Roy Lichtenstein's comics-based compositions rival Andy Warhol's images of Campbell's Soup cans and Marilyn Monroe as the best known and most influential examples of Pop art. Lichtenstein's comic-book paintings, such as *Mr. Bellamy*, 1961, have attained such renown and familiarity that it is easily forgotten that they were produced only briefly (1961–65) and that, as part of his early Pop work, they provoked tremendous controversy.

Art historian and critic Robert Rosenblum has vividly recalled how Lichtenstein's first exhibition at New York's Leo Castelli Gallery, in early 1962, "dumbfounded with horror or delight everyone who saw it." The gallery's walls "seemed to have been invaded by a sudden attack of the ugliest kind of reality that had always been kept far away from the sacred spaces where art was to be worshiped," and the works' "impact was so strong that they usually stunned rational response. Suddenly,

the art world seemed divided into passionate pros and cons, with former friends turning into enemies."[1] Reviewing Lichtenstein's work the following year, the *New York Times* art critic Brian O'Doherty charged the artist with continuing "to make a sow's ear out of a sow's ear" and declared him "one of the worst artists in America."[2] *Life* magazine followed suit by headlining an article about Lichtenstein "Is he the worst artist in the U.S.?" The title reflected O'Doherty's sentiments and referred to an earlier, well-known *Life* article, "Jackson Pollock: Is he the greatest living painter in the United States?" For those who championed the intensely rugged individualism manifested in the art of Pollock and his fellow Abstract Expressionists, the work of Lichtenstein and other Pop artists appeared impersonal, vacuous, and "flaccid."[3] Critics linked Pop to Nazi and Soviet art, as well as to Marxism and Chinese Communism.[4]

To imitate a comic book so directly as Lichtenstein did in *Mr. Bellamy* was to invite controversy. Although substantially larger than its source, the painting appeared to be a mere copy, lacking artistic originality and creativity. Further, Lichtenstein reproduced a reproduction of the lowest commercial and intellectual kind. In 1961 comic books were still tainted by the public outcry and Senate subcommittee investigations of the early 1950s concerning the perceived connections between comics and juvenile delinquency. Despite the adoption in 1954 of industry-based guidelines—the Comics Code Authority—the value and influence of comic books remained suspect. To offer, as *Mr. Bellamy* and Lichtenstein's other early Pop paintings do, comic-book images as high art was a radical and provocative gesture.

Lichtenstein acknowledged Pop art's "involvement with what I think to be the most brazen and threatening characteristics of our culture, things we hate, but which are also powerful in their impingement on us."[5] The willingness to recognize and delineate the simultaneously repellent and seductive character of mass culture forms the core of Pop art. Turning to commercial art, consumable goods, commonplace objects, and the mass media as

subject matter was taboo in the art world dominated by the Abstract Expressionists, but necessary to a younger generation staking out its own territory. Lichtenstein himself had adopted an Abstract Expressionist manner during the years 1957 to 1961. His comic book–derived compositions broke completely with this approach and reasserted an earlier interest in working from mass-reproduced commercial images.

After attending a class taught by Reginald Marsh at the Arts Students League and receiving undergraduate and graduate degrees in art from The Ohio State University, Roy Lichtenstein began painting what he described as "mostly reinterpretations of those artists concerned with the opening of the West, such as Remington, with a subject matter of cowboys, Indians, treaty signings, a sort of Western official art in a style broadly influenced by modern painting."[6] Lichtenstein was, in essence, producing history paintings, including two childlike versions of the most reproduced of all American history paintings, Emanuel Leutze's *Washington Crossing the Delaware*, 1851 (Metropolitan Museum of Art, New York). During the period of 1951 to 1957, Lichtenstein appropriated images from books, such as *Album of American History* (1945–46), and based at least one picture on a nineteenth-century advertisement. The concentrated narrative expression required of history painting was to resurface in *Mr. Bellamy* and the artist's other comic-book pictures.

Lichtenstein had begun rendering Mickey Mouse, Donald Duck, Bugs Bunny, and other cartoon characters as early as 1957. By 1960 he was embedding them in his abstract paintings, and in 1961 he produced his first truly Pop painting, *Look Mickey*, 1961, which shows Mickey Mouse and Donald Duck fishing. Andy Warhol was creating similar paintings at the same time. Neither artist was aware of the other's work, and when Warhol learned of Lichtenstein's art, he stopped painting cartoon images. *Mr. Bellamy*, completed the same year as *Look Mickey*, departed from the portrayal of famous cartoon characters and was one of the first in a series featuring soldiers engaged in scenes of action or moments of drama.[7]

Mr. Bellamy shows a military officer, possibly a pilot (whose branch of service is not clear), wondering about the man to whom he is to report. An airplane in the distance suggests the scene takes place at an air base or airport; perhaps, since the officer is reporting to a civilian, it is an aircraft manufacturing plant, part of the military-industrial complex. As in his other works, Lichtenstein pulls the protagonist close to the front of the composition, but in this case he includes an atypical elaborate arrangement of forms behind the figure. The comic-book source for *Mr. Bellamy* is not known, but clearly the painting derives from such comics magazines as *All-American Men at War*, from which he was appropriating images at the time.

Thick black outlines, flat primary colors, stylized forms, a thought balloon, and especially Benday dots declare *Mr. Bellamy*'s comic-book origins. The Benday process, invented by newspaper engraver Benjamin Day in 1879, mechanically produces shading effects by using screens of various dot patterns. A means to an end, Benday dots are not intended to draw attention to themselves. However, in Lichtenstein's hands they are enlarged and obvious—coloring the sky and the figure's face—and arbitrary—floating on the man's right arm, lower right hip area, and left jacket pocket. They signify "reproduction" and are as essential to his work as drips are to Pollock's paintings. They are also individually executed (rather than produced with a screen), as can be seen by lightly penciled circles and the dots' lack of perfect uniformity.

Although the source for *Mr. Bellamy* has not been identified, it is certain, based on Lichtenstein's other comic book–based paintings, that the artist modified the source in order to make a striking work of art. Typically he would eliminate distracting details and simplify and unify compositional forms in order to achieve immediate visual impact and coherence. He would transform what was essentially an illustrational mode into what he conceived of as *the* comic-book style.[8] The artist explained, "What I do is form, whereas the comic strip is not formed in the sense I'm using the word; the comics have shapes but

there has been no effort to make them intensely unified. The purpose is different; one intends to depict and I intend to unify. And my work is actually different from comic strips in that every mark is really in a different place, however slight the differences seem to some. The difference is often not great, but it is crucial."[9] *Mr. Bellamy* also differs from its source by being a discrete aesthetic object that conveys its story in a single frame, rather than a component in a sequence of panels that present a narrative unfolding over several pages. In this respect, *Mr. Bellamy* resembles the history paintings the artist produced earlier in his career.

Mr. Bellamy may be unique among Lichtenstein's comic-book paintings because of its personal content. In 1961 the director of the Green Gallery, an important New York venue for presenting the work of emerging artists, was Richard Bellamy.[10] Artists who exhibited at his gallery included James Rosenquist, Claes Oldenburg, Tom Wesselmann, Larry Poons, Lucas Samaras, Donald Judd, Dan Flavin, and Robert Morris. It is this influential "Mr. Bellamy" to whom the officer, as a surrogate for an artist, will introduce himself. The soldier also specifically stands in for Lichtenstein, who during World War II had served in the United States Army and had been scheduled to participate in a pilot-training program.[11] The Green Gallery opened in late 1960, about the time Lichtenstein was ending his eight-year affiliation with the John Heller Gallery. The painting suggests the artist may have fantasized showing his new body of work to *Mr. (Richard) Bellamy*. It was actually Ivan Karp of the Leo Castelli Gallery who saw the works, and the artist became associated with that gallery.

The sense of anticipation and anxiety coolly expressed in *Mr. Bellamy* can be read as representing Roy Lichtenstein's own feelings as an artist stepping forward to gain recognition for his new Pop work. Historically, *Mr. Bellamy* is one of the first of those paintings that did indeed establish his reputation.

MARK THISTLETHWAITE

1 Robert Rosenblum, "Roy Lichtenstein: Past, Present, Future," in *On American Art: Selected Essays by Robert Rosenblum* (New York: Harry N. Abrams, Inc., 1999): 198–199.

2 Brian O'Doherty, "Lichtenstein: Doubtful but Definite Triumph of the Banal," *The New York Times* (27 October 1963): 21.

3 See Peter Selz, "The Flaccid Art," in Carol Anne Mahsun, ed., *Pop Art: The Critical Dialogue* (Ann Arbor: UMI Research Press, 1989): 77–82. Selz's article originally appeared in the summer 1963 issue of *Partisan Review*.

4 Ibid. See also Max Kozloff, "Art," *The Nation* 197 (2 November 1963): 286.

5 G. R. Swenson, "What Is Pop Art?," *Art News* 62 (November 1963): 25.

6 John Coplans, "An Interview with Roy Lichtenstein," *Artforum* 2 (October 1963): 30.

7 Diane Waldman, *Roy Lichtenstein* (New York: Solomon R. Guggenheim Museum, 1993): 47.

8 Kirk Varnedoe and Adam Gopnik, *High & Low: Modern Art and Popular Culture* (New York: Museum of Modern Art, 1990): 199.

9 Swenson, 62–63.

10 Bellamy directed the 15 West 57th Street gallery from 1960 to 1965. The collector Robert Scull's promise to annually purchase $18,000 worth of art provided initial and crucial support for the gallery.

11 Lichtenstein was drafted in 1943. The pilot-training program was terminated, and he saw active duty in the Engineer Battalion of the Sixty-Ninth Division of the Ninth Army. He was discharged in January 1946 as Private First Class, receiving a medal for Meritorious Service (Waldman, 365).

Richard Long
British, born 1945

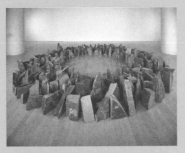

Cornwall Summer Circle, 1995
Cornish slate from Delabole
189 inches (480.1 cm) diameter
Museum purchase,
Sid W. Richardson Foundation
Endowment Fund
1996.3.P.S.

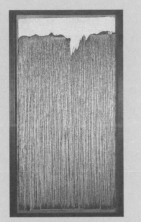

Untitled, 1992
Mississippi mud on rice paper
72 × 36 ½ inches (182.9 × 92.7 cm)
Gift of the Director's Council, 1994
1994.1.G.Dr.

I like the fact that all stones are different, in the same way as fingerprints or snowflakes, so no two circles can be alike.

RICHARD LONG

Using the artist's direct interaction with nature and natural materials as the subject matter of his art, Richard Long reinforces our innate desire to create a man-made symbol of harmony that parallels nature's own order. The landscape is in essence his studio. During solitary journeys across various terrain throughout the world, Long arranges temporary archetypal forms—circles, spirals, lines—employing found materials such as stone, wood, or mud available at each site. The artist walks and camps on the land in order to allow nature and place to make its impression on him. Because the simple and often ephemeral sculptures that result are generally created in remote areas, they are in a sense private rituals, which he may or may not record with a single photograph and brief text describing the distance, time, and conditions of the journey. Over many years of working, Long has achieved a form of landscape art that is as intensely private as it is public, and as intimate as it can be monumental. "I like the idea," Long has said, "that my work can range from the intervention of leaving a circle of stones at a place, to merely rearranging a few stones here and there around the landscape over many miles and days, to making art only by walking, and so having no intervention at all."[1] Long's walks may take place over a day or many weeks, walking a small continent coast to coast.

Long also brings his experiences of nature indoors, creating similar works on the walls and floors of galleries and museums. These simple and contemplative forms act as a memory image of the ephemeral sculptures he makes on his remote walks. They also evoke an iconic presence, relating back to prehistoric structures and markings. Long has been particularly attracted to the austere beauty of stone and the profound simplicity of the circle shape, a form that has been continuously recreated by all cultures in every age. Although the artist's sculptures conform to a few basic shapes, they vary remarkably depending on the choice of stone. Over his many years of working with stone, Long has learned to carefully handpick each rock or fragment with a view to making a sculpture that has a powerful visual presence, as well as a sense of nature's profound variety of shape, color, and texture. "I like the fact," Long has commented, "that all stones are different, in the same way as fingerprints or snowflakes, so no two circles can be alike."

Cornwall Summer Circle, 1995 represents a distinct side of Long's natural vocabulary. While many of his stone works are very low to the floor, creating a strong horizontal presence that parallels the character of an expanding landscape, *Cornwall Summer Circle* is jagged and vertical. The work's 237 blue-gray slate stones, chosen by Long from an ancient quarry in Cornwall, seem to stand up rather than lie down, evoking the steep mountain terrain of traditional Asian landscape painting. There, as in Zen rock gardens, scale becomes not only exaggerated, but strangely ambiguous. At times, *Cornwall Summer Circle* suggests hundreds of mountains in the form of a circle.

In recent years, Long has also shown a special interest in rivers, specifically the River Avon in England and the Mississippi River in the United States. The rich silt from the beds of these famous rivers has been used to create a series of drawings on paper, such as the Modern Art Museum's *Untitled*, 1992, as well as large-scale mud drawings applied directly onto museum walls. These mud works are another aspect of Long's elevation of the most basic of natural materials to an intimate and at times monumental presence. Pouring the mud over the surface of a sheet of paper or gallery wall, Long creates sensuous fields of silt that expose the tactile qualities of earth itself. The results are elemental paintings that remind us that paint is simply a form of ground dirt. In many instances, he uses his hands to make circles, spirals, or rectangles. "The speed of the hand gestures is important," Long has said, "because that's what makes the splashes, which show the wateriness of the mud, and water is the main subject and content of these works; they show its nature."

Long's journeys have taken him to many remote parts of the world, from the Arctic Circle to South America, from Africa to Europe to Asia. What he discovers there is echoed in what we see here—an appreciation of the most basic elements of nature.

MICHAEL AUPING

1 Quotes from the artist are from a letter to the author, 6 April 1996.

Morris Louis
American, 1912–1962

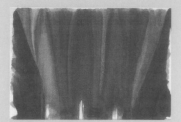

Dalet Kaf, 1959
Acrylic resin (Magna) on canvas
100⅝ × 143 inches
(255.6 × 363.2 cm)
Museum purchase made possible by
a grant from The Burnett Foundation
1986.5.P.P.

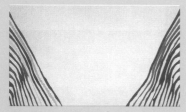

Beta Mu, 1960
Acrylic resin (Magna) on canvas
102 × 170⅛ inches
(259.1 × 432.1 cm)
Museum purchase, The Benjamin
J. Tillar Memorial Trust
1980.6.P.P.

Morris Louis is best known for his "stain" paintings, which he made by pouring a mixture of paint and turpentine directly onto unsized and unstretched canvas. By allowing the pigments to flood and drip down the canvas, which he tilted and manipulated, Louis created abstract shapes and fields of color. His first stained canvas was completed in 1954 (his earlier works were done in a more figurative, expressionist mode), and from 1954 to 1959 he used the stain method to create his *Veil* series, which marked the beginning of his mature style and comprises some of his most ambitious and lush stained paintings. The Modern Art Museum owns nineteen works by Louis, including paintings, prints, and collages. Of the eight canvases in the collection, four are from his *Veil* series, and *Dalet Kaf,* 1959, with its shimmering surface of harmonized color, is a key painting within this body of work.

Broad diagonal wing shapes of dark, yet transparent black and brown pigments flank each side of the canvas in *Dalet Kaf.* Under these wings, smaller diagonals of bright pink, yellow, green, and blue show through. From the edges inward, bands of muted brown, green, yellow, pink, blue, and purple successively become more vertical, ranging in width from narrow to wide. All along the work's perimeters, areas of unprimed canvas are exposed. The prominent ribbons of beige-brown, purple, and rust-brown at the center of the painting are thinned out at the lower edges, tapering off near the bottom to reveal drips and vertical patches of raw canvas. The various shapes and sizes of canvas that show through the saturated color balance the overall composition, offering small breaks of openness, or breathing spaces. Louis's repetitious use of subdued colors to create symmetry and a sense of unity between his medium and support, and his choice to let canvas show through, as in *Dalet Kaf,* characterize his *Veil* series.

Louis's peer Helen Frankenthaler, one of the few women besides Lee Krasner and Elaine de Kooning to be recognized within the Abstract Expressionist movement, was the first artist to pour pigment onto unsized canvas to create stains. Her work *Mountains and Sea,* 1952 (National Gallery of Art, Washington, D.C.) is largely considered the first painting of the Color Field movement, an outgrowth of Abstract Expressionism that also includes Morris Louis and Kenneth Noland. The famous story of Louis and Noland's first meeting with Frankenthaler in 1953, arranged by the influential modernist critic Clement Greenberg, is well documented.[1] It is said to have changed Louis's and Noland's painting styles forever and to have preoccupied their every thought for the next year, when Louis initiated his *Veil* series.

Rather than abstraction in the mode of the "first generation" Abstract Expressionists, who emphasized personal experience and formal painting concerns, "second generation" Color Field painters used abstraction to solve problems of color and space within the two-dimensional canvas plane. Color Field paintings are generally created in monumental scale, in keeping with Abstract Expressionism, and are often made, like Frankenthaler's, Noland's, and Louis's works, with large areas of saturated colors. Greenberg, who had helped Jackson Pollock and other Abstract Expressionists rise to fame, was instrumental to the Color Field movement. He advised Louis on his work, and the artist was receptive to these critiques. Believing that painting should emphasize its distinctions from all other media, Greenberg wrote, "Color . . . was shared with sculpture as well as the theater. Flatness, two-dimensionality, was the only condition painting shared with no other art, and so Modernist painting oriented itself to flatness as it did to nothing else."[2] Louis's work epitomized modernism's main tenets as laid out by Greenberg—purity of color and flatness of paint.

By 1960 Louis's *Veil* series was complete, and his style began to change. He still poured paint onto canvases that were loosely tacked to their stretchers, which he maneuvered to make his colors run; but instead of large floods of muted color, Louis let unprimed canvas dominate his paintings. He began to use thin vertical and diagonal lines in smaller areas, typically along the edges. The Museum's work *Beta Mu,* 1960 represents his late style. It is a large-scale, horizontally oriented canvas with soaked yet bright stripes of green, yellow, blue, red, orange, pink, and brown. They are organic diagonals that echo the black wing shapes of *Dalet Kaf,* but in a much more open manner. The largest portion of the canvas, the V-shaped center, is completely bare. Louis's late style exemplifies his evolution from solid color to spacious canvases with sparse color, although his artistic focus always remained on investigations of pure color and space. Morris Louis's oeuvre is well represented in the Modern Art Museum's collection, and *Dalet Kaf* and *Beta Mu* are two of the most important works of his mid- and late-career artistic innovations.

ANDREA KARNES

1 For a full account of Louis's first meeting with Frankenthaler, and his relationship with Kenneth Noland and Clement Greenberg, see John Elderfield's exhibition catalogue *Morris Louis* (New York: The Museum of Modern Art, 1986). This account of the story is taken from that book.
2 Clement Greenberg, "Modernist Painting," in Francis Frascina and Charles Harrison, eds., *Modern Art and Modernism* (New York: Harper & Row Publishers, 1982): 5–10. Originally printed in *Art and Literature* 4 (Spring 1965): 193–201.

Sally Mann
American, born 1951

The New Mothers, 1989
Gelatin silver print, edition 8/25
20 × 24 inches (50.8 × 61 cm)
Museum purchase made possible
by a grant from The Burnett
Foundation
1998.14.P.Ph.

Many of these pictures are intimate, some are fictions and some are fantastic, but most are of ordinary things every mother has seen —a wet bed, a bloody nose, candy cigarettes.

SALLY MANN

From the mid-1980s to the early 1990s, Sally Mann photographed her three pre-adolescent children, Emmett, Jessie, and Virginia, at the family's summer cabin in Lexington, Virginia. The resultant body of work is the subject of her 1992 monograph *Immediate Family*, which includes sixty black-and-white photographs and an introductory text written by Mann. From this series, *The New Mothers*, 1989 features Mann's two daughters, Jessie and Virginia. Like most of the images in *Immediate Family*, this picture is seductive and nostalgic. With its romantic, transitory glimpse of childhood, it depicts two children in a summer setting, barefoot in the grass, posing with baby dolls, pretending to be mothers—a kind of child's role-playing that most of us have seen or experienced. But by studying the children's bold gestures and rebellious expressions, we are faced with uncharacteristic looks and actions that reveal a darker side of childhood.

In the introductory text to *Immediate Family* Mann writes, "Many of these pictures are intimate, some are fictions and some are fantastic, but most are of ordinary things every mother has seen—a wet bed, a bloody nose, candy cigarettes."[1] In some respects, *The New Mothers* shows "ordinary things every mother has seen," but Jessie

and Virginia's imitative poses change the idea of childhood innocence. Jessie is in the center of the image posturing dismissively, her left leg and hip bowing out, flicking an upside down candy cigarette with her left hand while she inattentively rests her right hand on the stroller that holds her baby doll. Virginia stands to Jessie's left, hand on hip, wearing heart-shaped glasses, suggesting Stanley Kubrick's film version of Vladimir Nabokov's 1955 novel *Lolita*. These girls evoke signs of adult sexuality and cynicism.

Because it seems to depict reality, *The New Mothers* can be disturbing; but by the very aim of the camera and click of the shutter, Mann has framed the situation according to her own creative choices, which reflect both art and life. A passage from her introductory text elucidates that *Immediate Family*'s imagery is based on reality and metaphor: "In this confluence of past and future, reality and symbol, are Emmett, Jessie, and Virginia."[2]

In *The New Mothers*, the background trees and foreground shadows appear to be "burned in," a darkroom technique used in printing photographs to create dark areas, and in this image, they form a subtle, convex shape. By contrast, the children in the center almost glow as a result of a "dodged" technique used to make areas lighter. The faint suggestion of a circular shape around the edges of the print creates a voyeuristic view of the children in the center, like seeing something through a camera lens, or from a distance. As viewers, we have the sensation of "peering in" at the girls and in this sense, our looking seems predatory. Mann's children, however, meet our gaze and defiantly stare directly back at us. Yet their challenge to us is undone by the realization that they are only pretending to be mothers, in a painful transitional stage between childhood and adulthood.

Mann's childhood depictions are shaped by artistic investigations of identity that began in the 1960s and 1970s. Although many artists of that time focused on race, gender, and sexual orientation, some addressed a wider range of taboo subjects, including the exploration of childhood sexuality and the questioning of the established, idealized state of

childhood.[3] Robert Mapplethorpe's *Rosie*, 1976, for example, depicts a toddler sitting on a bench, legs apart, seemingly unaware that she is exposing her genitals. At the time of its initial public debut, *Rosie* escaped an all-out conservative backlash. However, thirteen years later, in 1989, the photograph resurfaced as part of the retrospective *Robert Mapplethorpe: A Perfect Moment* and became one of the signposts for the "cultural wars." During this period in America, sexually explicit imagery and "obscene" (a vaguely defined term) depictions of children were isolated in the press as a hotbed for moral and political debate. Although not directly involved in the debate, as was Mapplethorpe's *Rosie*, the imagery in Mann's *Immediate Family*, including *The New Mothers*, might be seen in part as a response to the exploration of childhood identity and the swirling controversies that ensued. Mann's representations of children, depicted in the realist vocabulary of photography, challenge childhood naïveté by acknowledging and presenting multiple other aspects of childhood.

ANDREA KARNES

1 Quoted in Sally Mann, *Immediate Family* (New York: Aperture Foundation, 1992).
2 Ibid.
3 For more information about the changing perception of children, especially in artistic representations, see Anne Higonnet, *Pictures of Innocence: The History and Crisis of Ideal Childhood* (London: Thames & Hudson, 1998).

M

Brice Marden
American, born 1938

Urdan, 1970–71
Oil and wax on canvas
70 × 60⅝ inches (177.8 × 154 cm)
Museum purchase, The Benjamin
J. Tillar Memorial Trust
1971.26.P.P.

Brice Marden had his first one-person show in New York in 1966, the same year that he became Robert Rauschenberg's studio assistant. The Modern Art Museum's painting *Urdan*, 1970–71 was originally titled *Bob's House #2*, inspired by Rauschenberg's house in Captiva, Florida, on the Gulf of Mexico. Of the work, Marden writes, "The horizontality relates to the seascape in Captiva. I repainted the canvas as *Urdan* when I felt a compulsive need to use orange after a conversation with my wife, Helen, about her travels in India, which the title also relates to."[1]

Urdan holds a special place for Marden: "This was my first painting in a museum collection, thanks to Henry Hopkins [director of the Modern Art Museum from 1968 to 1973]." The work is an important example of the artist's long-term focus on monochromatic painting that began in the mid-1960s. *Urdan* is a horizontal diptych made from two rectangles equal in size and in two colors, orange-beige in the top section and blue-gray at the bottom. It marks one of the first times that the artist diverged from his typically vertical format. Marden's encaustic technique, used to create the overall matte and subdued colors of *Urdan*, involved mixing oil pigments with wax and turpentine and applying them directly onto the surface with a paintbrush, spatula, and palette knife. In a sense, the artist attempted to create even coverage, but because of his wax-and-pigment medium, the painting's surface is irregular.

It varies in density—the wax is rough and patchy in sections—especially along its center seam, which is a thin crease of open space where the two separate panels come together. The unusual combination of orange and blue disallows one panel to advance or recede against the other, which paradoxically unifies their contrast. With *Urdan* and his other monochromatic works, Marden investigates surface and color and its interplay with two-dimensional space.

As an artist maturing in the late 1960s, Marden was influenced by aspects of the prevailing American art movements. Abstract Expressionism was the art of Marden's youth, and his work directly connects to artists in the group who fall outside of the category Action Painting, a term often used to characterize the style of Jackson Pollock and Willem de Kooning. Marden—like Clyfford Still, Barnett Newman, Ad Reinhardt, and Mark Rothko—used abstraction to create quiet, pensive works rather than exuberant imagery. Rothko's elusive fields of color made from saturated pigments and Reinhardt's subtle monochromes perhaps connect most directly to Marden's artistic sensibility. His work also relates to Pop and Minimalism. The medium used in *Urdan* recalls the Pop artist Jasper Johns's encaustic paintings of flags and targets; and the work's pared-down artistic vocabulary relates to the Minimalists, but unlike Minimalist works, *Urdan* reveals the human touch in its imperfect surface.

Urdan offers an early view into Brice Marden's artistic fixation—abstract forms, melted colors, and tactile surface. On one hand, his approach is premeditated—his self-imposed restrictions prevent major deviations in color and shape. On the other hand, by limiting the factors at play, Marden liberates the exploration of surface. *Urdan*, with its stripped-down colors and horizontal division, evokes a landscape or seascape in which the rudimentary center line separates earth from sea or sky, but ultimately its simplicity invites multiple interpretations.

ANDREA KARNES

1 Quotes are from a written
 statement by the artist,
 5 September 2001.

Agnes Martin
American, born Canada 1912

Leaf, 1965
Acrylic and graphite on canvas
72 1/16 × 72 1/8 inches (183 × 183.2 cm)
Museum purchase,
Sid W. Richardson Foundation
Endowment Fund
1993.10.P.P.

On a Clear Day (detail), 1973
Portfolio of thirty screenprints
Each 12 × 12 inches (30.5 × 30.5 cm)
Purchased in part with funds from
the National Endowment for the Arts
and in part with funds from The
Benjamin J. Tillar Memorial Trust
1977.2.1–30.P.Pr.

Untitled, 1977
India ink, graphite,
and gesso on canvas
72 × 72 inches (182.9 × 182.9 cm)
Gift of Anne and John Marion
2000.23.G.P.

Untitled XVI, 1996
Pencil and acrylic on canvas
60 × 60 inches (152.4 × 152.4 cm)
Museum purchase,
The Friends of Art Endowment Fund
2000.2.P.P.

Commentary on page 104

Melissa Miller

American, born 1951

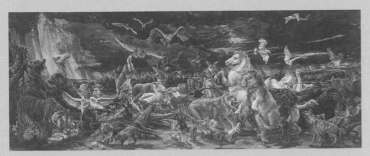

The Ark, 1986
Oil on linen, two panels
Overall 67 × 168 inches
(170.2 × 426.2 cm)
Museum purchase, The Benjamin
J. Tillar Memorial Trust
1986.17.P.P.

The Old Testament story of Noah's Ark is the subject of Melissa Miller's 1986 diptych *The Ark*. She decided to omit both Noah and the ark from the scene, however, making the animals the primary focus. The tension between doom and salvation in the story sets the stage for Miller's depiction. Her version of the ark attests to her ability to convey a variety of conflicting human emotions using the dynamics between the animals, from fierce and violent quarreling to quiet nestling. She explains that she was drawn to the subject of the ark for a number of reasons:

> I chose the story of Noah's Ark as an excuse to combine ten years' worth of themes I had been exploring in my work. I painted pending storms and disastrous weather situations to represent how easily the illusion of control we have in our lives can be disrupted. Using animal activity as metaphors for human behavior, I depicted themes of curiosity and observation, risk and temptation, predator and prey, and tender or antagonistic interaction among couples. Storms and chaos also provided an excuse for the expressive brushstroke I enjoyed.[1]

Through the animals' poses and actions, Miller creates a striking connection between their behavior and our own. Despite their instinctive appetites as predator and prey, the animals must endure the impending voyage and coexist in order to reestablish life on earth after the Flood. They occupy the space in a kind of cautious cohabitation, and the hesitation in discerning friend or foe is the artist's reminder to us that this environment is not exactly harmonious. Miller makes clear that she intended to stress conflict over tranquility:

> As a child, I saw depictions of the ark where animals were congenially lined up and waiting. Having observed both wild and domesticated animals, I was sure that such an event would not be orderly. So my conception of the painting goes back to childhood.

Miller's animal paintings are an extension of the tradition of genre narratives that were prevalent in the seventeenth, eighteenth, and nineteenth centuries, which relay anecdotal and moral messages through symbolism. Her sensibility is indebted to the narrative paintings of the nineteenth-century American artist William H. Beard, for example, who portrayed dancing and romping bears in *The March of Silenus*, c. 1862 to characterize human imprudence and fragility. The calligraphic arrangement of Miller's painting also shares an affinity with the work of nineteenth-century French Romantic painters, especially that of Eugène Delacroix and Théodore Géricault. Miller's narration and the composition of *The Ark* recall Géricault's epic scenes and vibrant imagery. The approaching storm in *The Ark* compels the viewer's eye from the background to the densely populated foreground and through the center of the picture plane, evoking Géricault's ominous heavens and strong composition in works such as *Raft of the Medusa*, 1819 (Louvre, Paris).

Miller's painterly style and choice of color, however, create a different mood. Rich gold, orange, and warm brown tones set against the circular motion of the cool blue sky suggest an illusory, fantastic scene similar to storybook illustrations or comic books. This bit of whimsy adds irony when coupled with Miller's emphasis on the vulnerability and aggression of the animal kingdom.

The Ark represents Miller's move from abstraction in her early career, to landscapes that periodically included animals, to paintings that feature animals. As a student at Yale Summer Art School, Miller studied with the American Abstract Expressionist Philip Guston, during his visiting professorship in the mid-1970s. This experience proved significant in her choice to depict representational subject matter, given that Guston reengaged figurative painting during an era in which abstraction was prominent. The influence on Miller of Guston and other Abstract Expressionists is most evident in the scale of *The Ark*, its vigorous brushwork, and the reference to abstract gesture seen in the landscape and sky.

Although the use of animals and other figurative themes in paintings was taboo when Miller began to mature as an artist, she and many of her contemporaries associated with New Image Painting took a cue from Guston and began using representation again.[2] In the process of moving away from abstraction, they often endowed their work with contemporary symbolism. An example of this from the Modern Art Museum's collection, Susan Rothenberg's *Cabin Fever*, 1976 depicts a horse—the focal point of Rothenberg's art for many years—but not just a realistic horse; rather, it is personal and psychological and, as in Miller's work, its meaning exists between figuration and metaphor.

ANDREA KARNES

1 Quotes from the artist are from a conversation with the author, 6 October 2000.
2 The phrase "New Image Painting" originates from an exhibition organized by the Whitney Museum of American Art in 1978. It featured the work of ten artists, including several women, who focused on depicting everyday objects in a representational, yet simplified manner. The painter Philip Guston is thought to be the force behind this return to figuration.

M

Richard Misrach
American, born 1949

Dead Animals #1, 1987/1998
Chromogenic color print
40 × 50 inches (101.6 × 127 cm)
Museum purchase
1999.12.P.Ph.

Flooded Gazebo, Salton Sea,
1984/1998
Chromogenic color print
40 × 50 inches (101.6 × 127 cm)
Museum purchase
1999.14.P.Ph.

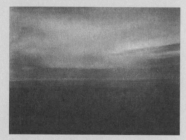

Salton Sea (Brown), 1985/1998
Chromogenic color print
40 × 50 inches (101.6 × 127 cm)
Museum purchase
1999.15.P.Ph.

*Desert Fire #136 (Agricultural Control
Burn)*, 1984/1998
Chromogenic color print
40 × 50 inches (101.6 × 127 cm)
Museum purchase
1999.13.P.Ph.

The desert is a larger metaphor for our times.

RICHARD MISRACH

In 1980 Richard Misrach began an ongoing series of photographs entitled *Desert Cantos*, in which he records various stages of man's impact on the desert. *Dead Animals #1*, 1987/1998 is part of this body of work, but it comes from a sub-category entitled *The Pit*, the most controversial work in the series. These pictures show sheep, cows, pigs, and horses that have died suddenly from mysterious causes and are then dumped in open burial grounds throughout Nevada. In the images, the animals are distended and contorted in various stages of decay, the cause of their deaths questionable. The area around the animals is scattered with industrial rubble—spilled oil and other liquids, metal drums, and plastic containers—indicative of our injured environment. But the picture is also remarkably poetic and beautiful. Misrach has framed the shot to create a harmonious composition of shapes and colors, emphasizing the warm earth tones of the land and the livestock. By making work that evokes both beauty and destruction, Misrach walks a thin line between aesthetics and politics. In fact, suppressing one aspect of his images becomes necessary to fully appreciate the other—making the beauty of the work a malign beauty.

The Museum's collection includes three other photographs by Misrach, also from *Desert Cantos*. *Desert Fire #136 (Agricultural Control Burn)*, 1984/1998 depicts a fierce blaze—not a natural occurrence, but a human decision to tamper with the land, the burning off of old crops in order to reuse soil. In this picture the sun glows through a haze of smoke and flames, creating an eerie sense of disaster. *Flooded Gazebo, Salton Sea*, 1984/1998 and *Salton Sea (Brown)*, 1985/1998 show California's largest lake, considered a natural wonder and famous for its oddities. It is a terminal lake that originated in 1905, when a Colorado River canal designed to bring water to California's Imperial Valley burst and flooded the region. In *Flooded Gazebo*, Misrach contrasts brown, wooden,

half-flooded structures with reflective, ice-blue water. Calm though obviously damaged, the site is completely uninhabited, bringing to mind images of war-torn villages. In *Salton Sea (Brown)*, the bottom half of the composition is divided almost equally between land and sea, and the top half is sky. Misrach cropped out anything that is clearly man-made; however, the body of water itself is unnatural.

Throughout its history, the Salton Sea has been ill-fated. It has no outlet, and therefore continues to elevate, flooding nearby homes and businesses that once flourished along its shores. Already twenty-five percent saltier than most of our oceans, it constantly becomes more saline, raising its level of toxicity to various species of fish and fowl. It is the drainage pool for nearby agricultural pollutants, farm chemicals, silt, and the industrial waste and poorly treated sewage that flow in from the New River in Mexicali, Mexico. It is also one of California's most productive fisheries, supporting an abundance of thriving fish and wildlife. The water is rich in nutrients, yet the salt levels and overcrowded conditions make the lake an unstable ecosystem. In the 1950s it was filled with game fish and became a popular tourist site, but as problems have arisen, it has become a point of contention. The divide between those who want to save it and those who await its final demise makes it a perfect source for Misrach.

Using photography to document man's impact on nature is a practice that has fallen in and out of favor throughout the medium's history. In the late nineteenth and early twentieth centuries, photographers such as Timothy O'Sullivan and Ansel Adams who portrayed the "great American West" conveyed a majestic and heroic terrain, untouched by man. There were also photographers during this period who documented man-made alterations to the landscape, like factories and railroad tracks, in order to promote urbanism and attract potential settlers to developing

American cities. By the 1930s, ravaged lands—farms and coal mines—were documented by photographers associated with the Farm Security Administration (FSA) project to express the trauma and devastation of the Great Depression. But in the latter half of the twentieth century, perceptions of the traditional American landscape have been directly overturned in the hands of artists like Misrach, who became a photographer in the 1970s.

Of the concept behind *Desert Cantos* Misrach has said, "The desert is a larger metaphor for our times."[1] In *The Pit*, the desert is shown to be a perpetual dumping ground for dead animals. Their bodies decay and go back into the soil, which implies a diseased food chain for future American dwellers, and for us now. Misrach uses the macabre to point out the effects of limitless expansion, portraying Ansel Adams's great American West in a different light.

ANDREA KARNES

1 Steven Jenkins, "A Conversation with Richard Misrach," *Artweek* 28 (July 1997): 21.

Tatsuo Miyajima
Japanese, born 1957

Time in Blue No. 29, 1996
Sixty-one blue LED counters
and IC electrical wire on black
wooden panel
175 1/2 × 89 × 3 7/8 inches
(445.8 × 226.1 × 9.8 cm)
Museum purchase
1998.12.P.S.

*I use numbers and technology because they are a world
language. They can be a basis for discussion and thinking.*

TATSUO MIYAJIMA

The subject of Tatsuo Miyajima's work is time, a phenomenon so fundamental to our psyche, indeed our very sense of existence, that it eludes us. Its definition remains a mystery; its shape and measurement a scientific and spiritual challenge. In the final paragraph of his popular book *A Brief History of Time*, Stephen Hawking imagines a "complete theory" of time that could be broadly understood by everyone, not simply a few specialists. "Then we shall all," Hawking speculates, "philosophers, scientists, and just ordinary people, be able to take part in the discussion of the question of why it is that we and the universe exist. If we find the answer to that, it would be the ultimate triumph of human reason—for then we would know the mind of God."[1]

Like Hawking, Miyajima sees our understanding of time as fundamental to a basic definition of religion and spirituality. The artist, who began studying Buddhist philosophy when he was twenty-three years old, refers to Buddhism simply as "a religion about time."[2] Miyajima's continuously changing numerical images address the enormous challenge of visualizing the complexity of a vast universe— as defined by both Buddhist philosophy and modern physics— where the individual is a tiny but significant unit within an immense, incomprehensible whole.

Born in middle-class east Tokyo, the artist originally aspired to be a carpenter, like his father. He eventually gravitated to the study of art, and after high school submitted a series of applications to the rigorous program at the Tokyo University of Fine Arts and Music. Until he was finally accepted, he worked at a data research company for meteorological observation, a temporary job that engendered his awareness of ideas about time and measurement: "I started to think then in very basic ways about time, and about differences of people and relationships in society—all very basic, not clear, but something that was important for me in the future."

In the work *Sea of Time*, 1988 (Collection of the artist), Miyajima strung together 300 separate counting units, operating synchronically but at different speeds. The artist explains, "Each machine operates in sync with another machine. As the 'time' counted by one mechanism reaches 99, a second machine will count 1; when the next 99 is reached by the first mechanism, the second will count 2, etc." Thus, *Sea of Time* visualizes hundreds of different "times," all counting within the same visual field; this symbolizes no absolute time but rather a network of individual rhythms. For Miyajima, time is comparable to color in that it is unique and personal for everyone. Miyajima's Buddhist beliefs are also reflected in the circular repetition of counting from one to ninety-nine and returning again to one, suggesting a revolving cycle of time, and the concept of death and rebirth. Zero, which indicates an end, is never used. Miyajima describes *Sea of Time* as depicting "a kind of world or universe. Each counter could be a different person or a different planet. And these counters together make the whole world, the universe." Scattered over the entire floor of a room, *Sea of Time* immerses the viewer in a spatial as well as temporal experience.

The Modern Art Museum's *Time in Blue No. 29*, 1996 reflects

Miyajima's continued fascination with electronic flashing numbers, his primary means of effecting —both literally and metaphorically— a degree of "enlightenment" on the constant presence of time. *Time in Blue No. 29* consists of a large wall of bright blue LED counters, arranged randomly and counting at different rates. At the time Miyajima created the work, the technology to produce a blue LED had only recently been developed to the point that it was bright enough for his purposes, allowing him to finally create a work he had conceived of a number of years before. Miyajima's fascination with the color blue can on the one hand be traced to his long-standing admiration for the great blue canvases of Yves Klein and Barnett Newman. Like his predecessors, Miyajima gravitates to the mystery and symbolism of blue. For Miyajima, "color has the suggestion of form and image: red is a square, yellow is a triangle, blue is a circle. So blue is like no form. Blue is like chaos." Most poignantly perhaps, blue is the color of the sky. It is not lost on Miyajima, of course, that in looking at the sky, ancient people discovered the first clock.

It is often argued that Japan's current avant-garde refutes the nature-centered aesthetics so long associated with Japanese art in favor of an ironic commentary on the commercial and technological realities of the urban Japanese environment. Nature and technological progress, so the argument goes, are at loggerheads, with nature the ultimate loser. Miyajima's art, however, disputes the idea that technology is necessarily in opposition to nature, although he is fearful of viewing nature as a fixed image of pastoral beauty. In discussing his electronic devices, the artist points out that "electricity is nature," the blood of our electronic world. The artist typically describes his intentions in expansively philosophical terms: "It is not about creating a beautiful image or system; it is more about

creating an inner spiritual quality in the world. My idea of the future is not a pictorial image but a spiritual concept." Ultimately Miyajima's art invokes a form of secular humanism. He believes that art is one way of triggering moments of enlightenment and self-fulfillment without recourse to supernaturalism. He particularly acknowledges the influence of the philosopher Daisaku Ikeda, whose lectures and writings reflect a form of Buddhism embodied in a movement known as Soka Gakkai International. Ikeda stresses the need to integrate technology and spirituality toward creating a "global unity of mankind." Miyajima reflects Ikeda's philosophy when he remarks, "I use numbers and technology because they are a world language. They can be a basis for discussion and thinking." In Miyajima's eyes, the theater of time is the ultimate common denominator.

MICHAEL AUPING

1 Stephen W. Hawking, *A Brief History of Time: From the Big Bang to Black Holes* (New York: Bantam Books, 1988): 175.
2 Quotes from the artist are from conversations with the author, 12–14 September 1995. Also see Michael Auping, *Tatsuo Miyajima Big Time* (Fort Worth: Modern Art Museum of Fort Worth, 1996). This is an adapted version of that essay.

Henry Moore
British, 1898–1986

Two-Piece Reclining Figure No.2,
1960
Bronze with bronze base
50 × 113 × 54 inches
(127 × 287 × 137 cm)
Gift of Ruth Carter Stevenson,
by exchange, 2002.19.G.S.

I think, for instance, that Cézanne's Bathers compositions were a subject that freed him to try out all sorts of things that he didn't quite know. With me I think the reclining figure gave me a chance, a kind of subject matter, to create new forms within it. HENRY MOORE

An idea can come along and you have to go on without knowing exactly what it means. I wish that I could be even freer from the tie of its meaning. Nevertheless it has a significance and you develop it and carry it further without an absolute easy explanation. I think, for instance, that Cézanne's *Bathers* compositions were a subject that freed him to try out all sorts of things that he didn't quite know. With me I think the reclining figure gave me a chance, a kind of subject matter, to create new forms within it.[1]

The father of modern British sculpture and one of the critical innovators of sculptural form in the twentieth century, Henry Moore created works that embody an evolution which over half a century reflects the artist's interest in classical Greek sculpture, Mexican art of the pre-Columbian period, Italian painting of the Renaissance, Surrealism, and eventually various forms of pure abstraction. In its title, subject, and ambiguously suggestive forms, the Museum's *Two-Piece Reclining Figure No. 2,* 1960 is an example of this kind of synthesis, which Moore's best works achieved.
 The theme of the reclining figure,

which occupied the artist's attention from an early stage in his career, plays a particularly poignant role in the development of Moore's ideas. As Moore remembered it, "The *Two-Piece Reclining Figures* must have been working around in the back of my mind for years, really. As long ago as 1934 I had done a number of smaller pieces composed of separate forms, two- and three-piece carvings in ironstone, ebony, alabaster, and other materials. They were all more abstract than theseI did the first one in two pieces almost without intending to. But after I'd done it, then the second one became a conscious idea. I realised what an advantage a separated two-piece composition could have in relating figures to landscape."[2]
 Moore would continue to explore this subject, and became especially focused on it in the early 1960s. *Two-Piece Reclining Figure No. 2* is a classic example of Moore's mature vision of a sculpture that creates multiple suggestions in the viewer's mind. Initially appearing abstract, its numerous references become clear over prolonged viewing. One of the elements, for example, has a vertical, neck-like form that identifies it as the upper section of a torso; below that is the suggestion of shoulders and arms, partially carved away to resemble the cliff-like formations of the second section, which could be hips and legs. As the artist once described these ambiguous creatures, "In many of my reclining figures the head and neck part of the sculpture, sometimes the torso part too, is upright, giving contrast to the horizontal direction of the whole sculpture. Also in my reclining figures I have often made a sort of looming leg—the top leg in the sculpture projecting over the lower leg which gives a sense of thrust and power—as a large branch of a tree might move outwards from the main limb—or as a seaside cliff might overhang from below if you are on the beach."[3]
 While Moore is rightly associated with the development of abstract form and the Surrealist associations of simply articulated shapes, his finest works invariably revolve around an acute understanding of the human form and its portrayal throughout history, and how that form can relate to landscape. Simultaneously referring to Greek

reclining figures and the reclining Chac Mool figures of pre-Columbian America, *Two-Piece Reclining Figure No. 2* is also a primitive odalisque, emerging from the earth like an essential form of nature.

MICHAEL AUPING

1 The artist quoted in Philip James, ed., *The Documents of 20th-Century Art: Henry Moore on Sculpture*, rev. ed. (New York: The Viking Press, Inc., 1971): 284.
2 Ibid., 285.
3 Ibid., 290.

Yasumasa Morimura

Japanese, born 1951

Self-Portrait (Actress)/
After Elizabeth Taylor 2, 1996
Ilfachrome photograph mounted
on Plexiglas, edition 3/10
47¹/₄ × 37³/₈ inches (120 × 94.9 cm)
Museum purchase made possible by
a grant from The Burnett Foundation
1998.15.P.Ph.

Self-Portrait (Actress)/After Elizabeth Taylor 2, 1996 shows the artist Yasumasa Morimura posed as one of Hollywood's most famous heroines. In the picture, Morimura's long jet-black coif, heavy eyelashes, arched tadpole eyebrows, red lipstick, and beauty mark are displayed to represent Elizabeth Taylor's trademarks. The Western props and costume— a rustic fence post in the background, cowboy hat, blouse, riding pants, and the belt that accents Morimura's small waist and curvaceous hips—remind us of Taylor from the time of the movie *Giant,* released in 1956 and co-starring James Dean and Rock Hudson. Morimura painstakingly reenacts these details, yet the artist's Japanese features are readily apparent, so that we immediately know something is amiss. We recognize that this picture is a sign for Taylor, but we also know that it is not her. At a glance, one might assume that the photograph shows a famous Japanese actress masquerading as Taylor— but Morimura is a Japanese man, making the picture even more provocative. What drives him to do this?

Morimura lives and works in downtown Osaka, where, since the mid-1980s, he has used himself as a model for photographs that challenge such basic dichotomies as male/female, East/West, and original/copy by re-creating various

female movie stars and characters from iconic paintings. To emulate Hollywood actresses like Taylor, Morimura defies both race and gender, making his pictures humorous, but also shocking and strange. Of his use of photography to express his concepts, Morimura has said, "Photography for me is a mirror—rather like a magic mirror. The world inside the mirror exists independently. It is not really a true reflection of reality, and photography is like this."[1] Still, mirrors and photographs often make us believe what we see.

As Morimura must do in order to create his various personas, when we look at his work with knowledge of the details, we must also contend with his age, his Japanese features, and his maleness. The impact of his work, however, is different than the shock value of the drag queen. His is not the combination of hairy legs under fishnet pantyhose, for instance, that makes drag curious and irreverent. Rather, Morimura's work is psychologically complex and multilayered on its own terms, and it relates to postmodern concepts of investigating identity.

Morimura's pictures are humorous—they are as theatrical and contrived as the many celebrities he imitates. Yet to most of us raised in Western culture, deceptions of Hollywood are more readily acceptable than those of Morimura. In Japanese culture, however, Morimura's feminine masquerade might be recognized for its reference to the well-known tradition of Kabuki theater. Kabuki began in Kyoto in the seventeenth century, and although it was founded by a female dancer, Okuni, the roles have almost always been acted out by men called *onnagata.* To Western culture, the instruments used to create sound and music in Kabuki, and its costumes, streamers, confetti, projectiles, and pyrotechnics, are often mysterious. But it is the makeup that is the most prominent element of Kabuki's bizarre and fantastic atmosphere, and the process of getting into character for Kabuki is similar to Morimura's. Each actor first waxes his eyebrows and spreads oil over them to create a smooth surface. *Oshiroi,* white face cream, is then applied all over the face. Red lines called *mehari* are added to accent the eyes, and

eyebrows are drawn on. As a final touch, a cupid's bow of red lipstick is applied to the center of the lips. The ritual of applying the traditional Kabuki makeup not only helps the actor portray a certain kind of expression, it also helps the actor *become* the character.[2]

Like *onnagata,* Morimura transforms himself into his characters, acknowledging his limitations, but doing all he can to compensate for his differences. He uses pancake makeup to hide facial hair, and he binds parts of his body, waxes, shaves, and uses prosthetic parts. His ritual may be more easily understood by his own culture, but because his series depicts Western women, in a way his work becomes foreign to both Japanese people and Westerners. His particular version of East meets West is also a poignant comment on societal concepts of beauty. His photographs are beautiful, but there is always a sadness present, in that he can never be what he emulates. Then again, he might not really want to. Although he goes through a very elaborate process to replicate Taylor, Morimura lets himself be seen; he does not fully erase his own identity—from his sight, or from ours.

Using photography, Morimura investigates the body—his own—to confront Western power and how it not only shapes the Western view of the East, but also influences Asian cultures.[3] We gaze upon him, reading his photograph and questioning our beliefs about men and women, East and West, and so on. The kinds of uncertainty or uneasiness we might feel when deciphering his work, and the type of inquiry about our own identity and others that this leads to, is part of his point. With this work, Morimura emphasizes the complications that we all face in understanding, creating, and reconciling our identities.

ANDREA KARNES

1 Peter Plagens, with Kay Itoi in Tokyo, "The Great Impersonator: In the Weirdest Meeting of East and West since 'Godzilla vs. The Smog Monster,' Photographer Yasumasa Morimura remakes the Old Master," *Newsweek* (6 April 1992): 46.

2 For more information about Kabuki theater, history, and makeup, see Ichimura Manjiro, *Kabuki for Everyone* Web site (http://www.fix.co.jp/kabuki/kabuki.html). Accessed 5 August 2001.

3 This theory was first elaborated on by Edward Said, and has become influential not only in political and sociological discourses on colonialism and post-colonialism, but also in relation to culture and art. Identifying what he calls "Orientalism," Said proposes that the East has been defined by the West as its contrasting image (the Occident being the dominant power structure). As a result, colonization is historically defined by the West as having a positive impact on the East, depicting it not as a two-way relationship but as a power situation. For more information on this theory, see Edward Said, *Orientalism* (New York: Vintage, 1979).

M

Robert Motherwell
American, 1915–1991

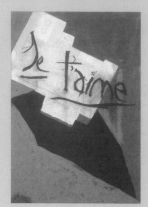

Elegy to the Spanish Republic, 1960
Boucour Magna paint on canvas
72 × 96 ¹/₄ inches (182.9 × 244.5 cm)
Museum purchase,
The Friends of Art Endowment Fund
1993.23.P.P.

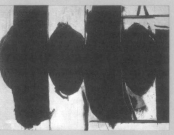

Je t'aime with Gauloise Blue, 1976
Acrylic, collage, and charcoal
on canvas
36 × 24 inches (91.4 × 61 cm)
Museum purchase,
The Friends of Art Endowment Fund
1993.31.P.P.

Spanish Picture with Window, 1941
Oil on canvas
42 × 34 inches (106.7 × 86.4 cm)
Museum purchase, The Friends of
Art Endowment Fund
1993.17.P.P.

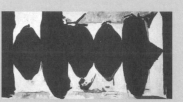

*Open #150 in Black and Cream
(Rothko Elegy)*, 1970
Acrylic on canvas
69 × 204 ¹/₄ inches (175.3 × 518.8 cm)
Museum purchase, The Friends of
Art Endowment Fund
1999.22.P.P.

Elegy to the Spanish Republic No. 171,
1988–90
Acrylic on canvas
84 × 168 ¹/₈ inches (213.4 × 427 cm)
Museum purchase,
The Friends of Art Endowment Fund
1993.24.P.P.

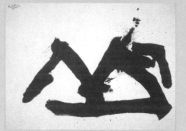

Stephen's Iron Crown, 1981
Acrylic on oil-sized canvas
88 × 120 ¹/₈ inches (223.5 × 305.1 cm)
Museum purchase,
Sid W. Richardson Foundation
Endowment Fund
1985.1.P.P.

Commentary on page 115

Ron Mueck
British, born Australia 1958

Untitled (Seated Woman), 1999
Silicone, acrylic, polyurethane
foam, and fabric
25 1/4 × 17 × 16 1/2 inches
(64.1 × 43.2 × 41.9 cm)
Museum purchase
2000.3.P.S.

My wife's grandmother is such a strong woman, I thought it would be disrespectful to make her too pitiful. I don't want to sound too sentimental, but basically she is looking to the future, without much of it left—still facing upward a bit. RON MUECK

Ron Mueck's sculpture *Untitled (Seated Woman),* 1999 depicts an elderly woman sitting forward with her clasped hands resting on her legs and her head lowered, seemingly in an introspective moment, unaware of our presence. This work, like all of Mueck's sculpture, is stunningly realistic, except in scale. Mueck's figures are often larger or smaller than life-size, and this creates his work's greatest impact. In the case of *Seated Woman,* scrupulous attention to detail and props on a small scale evoke wide-ranging emotional responses— the woman's demeanor and diminished size make her seem precious and sweet, as well as helpless and sad. Of his decision to alter scale, Mueck has said, "I change the scale intuitively, really—avoiding life size because it's ordinary. There's no math involved; I usually do a sketch on paper and if it looks good to me, then I use that scale for the actual piece. The shift in scale draws you in, and in some ways engages you at a different level."[1]

Mueck's figures come from real life and imagination. *Seated Woman* is based on his wife's grandmother. "I wanted to make a little old lady, and my wife's grandmother was readily accessible and a great character. I really did not intend it to, but the piece started to become closer to a portrait of her as I went along, and I started thinking of it as a portrait. But I didn't want to get bogged down with feeling that I had to be completely accurate, so at one point I just had to put away the photograph of her and make the piece in its own right."

To create *Seated Woman,* as with most of his sculpture, Mueck makes a mold from clay and then casts it in silicone, touching up and adding color and props as he progresses. Not surprisingly, he began his career as a puppeteer and puppet maker. He also worked on children's television shows from 1979 to 1983 and then moved from Australia to London, where he worked making special-effects models for advertising, television, and films, including *Labyrinth* and *The Story Teller.*

In a sense, Mueck's sculpture extends the idea of photo-based art, which usually manifests itself in the form of paintings. Like realistic paintings based on photographs, and photographs themselves, his art offers us a glimpse at something "real," but not life scale. Because his subject is isolated (an effect often created in paintings and photographs by cropping and framing), we focus in on it in a new way. Through his creative process, Mueck makes a poignant and psychologically charged portrait.

Mueck is new to the art world; his first sculpture was shown in 1996 at the Hayward Gallery in London as part of the exhibition *Spellbound.* His work was noticed in the show by advertising mogul and art collector Charles Saatchi, known for focusing his collection on the works of artists from Great Britain. Many of these artists, because of Saatchi, are now known collectively as the YBAs (Young British Artists), and Mueck is associated with this group. In 1997 Mueck's *Dead Dad,* 1996–97 was shown in the Royal Academy's exhibition of Charles Saatchi's collection, *Sensation,* and it was one

of the most critically acclaimed pieces in the show.[2] *Dead Dad* is a three-foot-long sculpture of Mueck's father lying naked on the floor; his emaciated frame and lifeless and aged skin are chilling reminders of the transience of life. Like *Dead Dad, Untitled (Seated Woman)* is powerful—its uncanny believability compels us to look closely.

Mueck has said of *Seated Woman,* "When I started the piece, I wanted it to be sad; originally I had her head hanging much lower, but I raised it some. My wife's grandmother is such a strong woman, I thought it would be disrespectful to make her too pitiful. I don't want to sound too sentimental, but basically she is looking to the future, without much of it left—still facing upward a bit. Although she was quite well when I made this piece, my wife's grandmother is ill now, so it's a little tough to look at and think about at the moment."

ANDREA KARNES

1 Quotes from the artist are from a conversation with the author, 10 September 2001.
2 *Dead Dad* traveled to Brooklyn in 1999 with the controversial second showing of the exhibition *Sensation.*

M

Vik Muniz

Brazilian, born 1961

The Doubting of Thomas, 2000
Cibachrome
45 × 60 inches (114.3 × 152.4 cm)
Gift of the Director's Council, 2000
2000.7.G.Ph.

In *The Doubting of Thomas*, 2000, Vik Muniz presents his ironic version of Caravaggio's famous painting *The Doubting of Thomas*, 1602–03 (Sanssouci Palace, Potsdam, Germany). Creating the image from memory, Muniz worked quickly to render its likeness in Bosco chocolate syrup and then photographed it in color before it dried to capture the slickness and blood-like tone of his unusual medium. Like Caravaggio, Muniz depicts the climactic moment in the New Testament story of the Resurrection when the apostle Thomas is seen placing his finger in Jesus' wound. Chocolate's symbolism—passion, comfort, indulgence, sin—makes it a metaphor for this story.

Chocolate also specifically lends a graphic and fluid treatment to the figures in *The Doubting of Thomas*, making the image look painted, even though it is a photograph. With it, Muniz makes us think not only about our perception of a famous Caravaggio work, but also about the relationship between painting and photography, which in this case reveals a slippage between figuration and abstraction within the two mediums. The graceful flow of the chocolate sauce and the shapes created within it can look entirely abstract, and the flatness of a photograph—as compared to the depth of illusion possible in a painting—adds to this, making the work provocative on numerous levels.

Muniz's less-than-perfect masterwork, made in a nontraditional medium, also speaks to the idea of illusion and how our memories play a role in our perception—we fill in the blanks based on the information given. In this case, we make a connection between what is seen in the photograph and what we remember of Caravaggio's famous painting. Even if one has never seen the original in person, looking at a photographic reproduction seemingly provides some sort of understanding of it. Muniz, however, has tried to remove his image from its source by a process of copying from memory, painting with chocolate, and then photographing the painting. But his efforts to disconnect actually paradoxically reconnect to Caravaggio in several ways, especially in that both artists break conventions.

Caravaggio was a revolutionary in his day, accused of using realism to such an extreme that he sacrificed ideal beauty. He was considered impious for having hired impoverished people to model for his religious paintings, and he worked directly on the canvas without first making drawings or studies, which went against academic precedents. Muniz's version can be considered rebellious and irreverent in today's world, but it is not necessarily scandalous. Rather, it is wry and witty.

For much of his work, Muniz has found inspiration by looking to twentieth-century artists. From Pablo Picasso to Jasper Johns and Robert Rauschenberg, many of his forerunners have used found objects and unconventional materials to convert the ordinary into artistic statements. There is a clear, and perhaps odd and amusing, connection between Muniz's chocolate pictures and Andy Warhol's familiar images of Campbell's Soup cans. Warhol claimed to have eaten Campbell's Soup (a liquid food like Muniz's Bosco syrup) daily as a child and frequently as an adult. Likewise, Muniz loves Bosco chocolate and relates it to his own childhood memories, even joking that after he paints his surfaces with chocolate and photographs them, he licks them clean.

In certain ways, however, Muniz extends or even subverts the ideas of the Pop artists, who often started with an ordinary consumer good and turned it into art. He too starts with a common household good, but then combines it with an already established masterwork. Along with chocolate, Muniz has used sugar, cotton, wire, and refuse (such as cigarette ashes) in his compositions, and has re-created works by numerous artists, including his contemporaries, such as Chuck Close. By changing the context of renowned artworks, Muniz is perhaps conceptually closer to the French Dada artist Marcel Duchamp, whose famed image *L.H.O.O.Q.* defaced Leonardo da Vinci's *Mona Lisa*.

Like Duchamp's work, humor is key in *The Doubting of Thomas*. In this photograph, the New Testament story is depicted in a seventeenth-century Italian Baroque style, but it was created in 2000. In today's society, computer-enhanced imagery and special-effects technology continuously prod us to believe more-real-than-real visual information, yet Muniz's simple, low-tech illusion of an age-old story is still surprisingly funny and effective.

ANDREA KARNES

Bruce Nauman
American, born 1941

Setting a Good Corner (Allegory & Metaphor), 2000
DVD, edition of 40
Dimensions variable
Museum purchase,
Sid W. Richardson Foundation
Endowment Fund
2001.10.P.V.

Art is something that happens when you find a structure of some kind in which something can happen. Sometimes it's just a matter of doing something from beginning to end. The decisions you make between those points— some conscious, some unconscious—can be the art.[1]

Over Bruce Nauman's forty-year career, his work has often explored the most basic aspects of the artmaking process and their relation to common experiences. Acknowledging the influence of John Cage's "found" music, Merce Cunningham's elegantly pedestrian dance movements, and the lengthy, documentary-style films of Andy Warhol, Nauman has structured many of his works around simple activities in which time and process are exposed and are often central elements in his art. Nauman's approach also led him to Ludwig Wittgenstein's *Philosophical Investigations* (posthumously published in 1953), which he read as a student at the University of California, Davis. Nauman interpreted the German philosopher's basic methodology in the following way: "Wittgenstein would follow an idea until he could say either that it worked or that life doesn't work this way and we have to start over. He would not throw away the failed argument, but would include it in his book."[2]

It is this philosophy that led to one of the artist's earliest works, *Fishing for Asian Carp,* 1966. This two-minute, forty-four-second film consists of Nauman filming his friend and fellow artist William Allen putting on wading boots, entering a river, and eventually catching a fish. The structure of the work was based on the process and goal of catching a fish, an event that could not be precisely predicted. When the fish was caught the film was over. Part tongue-in-cheek instructional film, *Fishing for Asian Carp* is also an allegory for the unpredictable nature of artmaking.

Nauman's early performance pieces also emphasized process as final result, manipulating various materials, including his own body, based on a list of actions the artist had written down: standing, leaning, bending, etc. Again, the outcome of each of these actions was unpredictable, but all were essential in establishing the parameters of the work. In describing the rationale for these performance/actions, Nauman cites as another early inspiration the plays of Samuel Beckett, using a story about a repetitive task: "I knew this guy in California, an anthropologist, who had a hearing problem in one ear, and so his balance was off. Once he helped one of his sons put a roof on his house, but the son got upset because his shingles would be lined up properly, while his father's were not only laid out in a zigzag, but also the nails were bent and shingles split. When his son got upset about the mess his father had made, the anthropologist replied: 'Well, it's just evidence of human activity.' And that's what Beckett's stories partly deal with—for example, Molloy transferring stones from pocket to pocket....They're all human activities; no matter how limited, strange, and pointless, they're worthy of being examined carefully."[3]

Setting a Good Corner, 2000 essentially restates this story in the context of the artist's ranch in Galisteo, New Mexico. In this case, the artist records himself setting a corner post from which to stretch a wire fence and hang a gate. In recent years Nauman's studio activity has been balanced with the numerous ranch chores that revolve around the raising of cattle and cutting horses on his 1,600-acre property. *Setting a Good Corner* intertwines the often mundane and repetitive activities of ranch life with his necessity to make art. The almost one-hour film records the artist in the solitary process of digging, sawing, and assessing his own progress. The subtitle, *Allegory & Metaphor*, points out the artist's contention that a simple activity can resonate with connected meaning. The layout and physical construction of a fence is an allegory for the often tedious process of making an object of art, which is frequently made through a similar process of tasking and assessing. A corner, which suggests the beginning of containment and the creation of space, is an apt metaphor for a sculpture. As Nauman said recently, "If you are an artist and you just keep making things and are conscious of the conditions of that making, you may find yourself making a sculpture, whether you like it or not."[4]

MICHAEL AUPING

1 The artist in conversation with the author, 19 December 2001.
2 Quoted in Coosje van Bruggen, "Entrance Entrapment Exlt," in *Bruce Nauman* (New York: Rizzoli International Publications, Inc., 1988): 9.
3 Ibid., 18.
4 Conversation with the author, 19 December 2001.

Nic Nicosia

American, born 1951

Untitled #6, 1992
Oil on black-and-white photograph,
edition of 10
36 × 36 inches (91.4 × 91.4 cm)
Museum purchase made possible by
a grant from The Burnett Foundation
1995.40. P. Ph.

Untitled #9, 1992
Oil on black-and-white photograph
36 × 36 inches (91.4 × 91.4 cm)
Museum purchase made possible by
a grant from The Burnett Foundation
1995.41. P. Ph.

Untitled #7, 1992
Oil on black-and-white photograph
36 × 36 inches (91.4 × 91.4 cm)
Museum purchase made possible by
a grant from The Burnett Foundation
1995.43. P. Ph.

Untitled #10, 1992
Oil on black-and-white photograph,
edition of 10
36 × 36 inches (91.4 × 91.4 cm)
Museum purchase made possible by
a grant from The Burnett Foundation
1995.42. P. Ph.

I can talk very easily about all my other series of works when I give a slide talk, but I always get dumb or at least very quiet when I try to talk about the *Untitled* series. I did them at a very strange time in my life. I was very busy doing a lot of portrait commissions. I was also feeling very distant from the art world, partly because I was doing commercial work, and partly because I was living in Dallas, which seemed very far away from New York at the time. In a way, that situation, or that feeling I had, was freeing, in that I felt like I could be free to do anything I wanted. I didn't have to think about "making art." That's the situation these *Untitled* works come from. Maybe they're more about people than they are about art.[1]

Nic Nicosia's photographs explore the suburban family experience. A native of Dallas, Texas, Nicosia attended the University of North Texas in Denton and the University of Houston before returning to Dallas, where he has lived and worked in a suburban neighborhood for much of his career. Critics have variously described his *Untitled* series, of which the Modern Art Museum owns four works, as "documentaries," "family portraits," and "fictional narratives." In fact, they are a combination of all three. Trained as a documentary and portrait photographer as well as an artist, Nicosia captures the unconscious and often revealing gesture, pose, or moment performed by his subjects in response to the artist's subtle directorial skills and staging.

In the *Untitled* series, Nicosia demonstrates a particular talent for turning light, humorous moments into psychological dramas. In *Untitled #6*, 1992, the artist asked a friend and his family to pose in his kitchen. "I like to move with the energy of the subject," Nicosia has said. "They may suggest something that I would never think of." In this case, the young daughter took center stage. Using dramatic lighting effects, the artist captures the girl in a tutu dancing on top of a kitchen table while her mother watches in the darkened background. Is the woman's expression one of admiration or envy? Perhaps seeing a shadow of her former self, she watches as her daughter takes full advantage of her moment under the lights. While the adults, particularly the men, often remain hidden in the shadows of the *Untitled* photographs, children often play a pivotal role, the locus of repressed emotions hidden behind the veneer of upper middle-class living. In *Untitled #9*, 1992, a little girl confronts a faceless man in white shirt and tie at night by shining a flashlight on his chest as if it were a death ray. In *Untitled #7*, 1992, a young girl lies awake at night, a monstrous shadow looming on the wall behind her bed. A closer inspection of the photograph reveals that the artist has dramatically backlit a Barbie doll, creating the grotesquely exaggerated shadow.

In an interview with the author, Nicosia discusses the psychological implications of the *Untitled* series:

MA: The obvious question about the *Untitled* series is where did these scenes come from and what is being projected in terms of content by these scenes?

NN: That's what I have tried to figure out. It's true that I have very carefully staged these scenes, yet I've never been exactly sure what they mean. They are about families, and I've noticed that the man or father is usually in the background, just hanging around and not a central part of the action. Beyond that…

MA: Are they images that relate to your family, things that you have imagined or seen in your home?

NN: Possibly, but more generally I think you have to remember that I was very busy doing these portrait commissions that often involved portraits of a whole family, and I was going into these people's homes and seeing how they interacted—how the parents related to the children and vice versa. That had to feed into it. My fantasies and fears about my children and my own role as a father are probably also in there.

MA: The recent work has a dark, film noir quality.

NN: That is part of the drama I'm trying to set up with these seemingly everyday scenes. Ironically, when I think of this series I think of Edward Hopper, whose work is all about a special light. Not that I think these images look like a Hopper, but there is something in common or that I would like to think we have in common.

MICHAEL AUPING

1 Quotes from the artist are from
a conversation with the author,
23 August 1995.

Claes Oldenburg
American, born Sweden 1929

Tube and Contents—Prop from the performance "Massage," 1966
Canvas, sewn fabric, cardboard, and broom handles; dimensions variable
Tube: 150 × 50 inches (381 × 127 cm)
Contents: 204 × 12 inches (518.2 × 30.5 cm)
Purchased with funds from the National Endowment for the Arts Museum Purchase Plan; donations from Mr. and Mrs. Julian Ard, Mr. and Mrs. Perry Bass, Mr. and Mrs. Sid Bass, Mr. and Mrs. Marshall Brachman, Mr. Roy Browning and Ms. Jaye Skaggs, Mr. Whitfield Collins, Mrs. Fred Elliston, Dr. and Mrs. Robert Fenton, Mr. and Mrs. William Fuller, Mr. and Mrs. James Garvey, Mr. and Mrs. Edward R. Hudson, Jr., Mr. and Mrs. Albert Komatsu, Mr. and Mrs. Richard Moncrief, Mr. and Mrs. E. M. Rosenthal, Dr. and Mrs. William Runyon, Mr. and Mrs. Robert A. White, Mr. and Mrs. C. Dickie Williamson, Mr. and Mrs. S. P. Woodson III, Mr. and Mrs. George M. Young; and funds from The Benjamin J. Tillar Memorial Trust 1981.3.P.S.

Tube and Contents, 1966 epitomizes Claes Oldenburg's 1961 declaration "I am for an art that grows up not knowing it is art at all, an art given the chance of having a starting point of zero."[1] Now exhibited as a work of art, the "starting point of zero" for *Tube and Contents* was its appearance as a prop, or, as Oldenburg prefers, "a player," in a 1966 Happening.[2]

The Swedish-born artist conceived *Massage*, a thirty-five minute "Komposition" in six parts, in connection with an exhibition of his work at Stockholm's Moderna Museet.[3] *Massage* was the last of nineteen Happenings the artist presented in the 1960s. The others had occurred in New York, Chicago, Dallas, and Los Angeles, in venues ranging from art gallery to parking lot to health club to university auditorium to Oldenburg's own Ray Gun Theater.[4] Only two took place in art museums: *Injun* at the Dallas Museum for Contemporary Arts and *Massage* at the Moderna Museet (originally, Oldenburg had wanted it to take place aboard a ship). Happenings allowed Oldenburg, whose sculptures were associated with Pop art, the opportunity to set "objects in motion."[5]

A number of artists, including Allan Kaprow, Red Grooms, Jim Dine, Robert Whitman, Ken Dewey, and Oldenburg, began creating Happenings in the late 1950s. Kaprow's 1958 event at George Segal's New Jersey farm is usually regarded as the first, and his *18 Happenings in 6 Parts*, performed at New York's Reuben Gallery the following year, led to the adoption of the term. Oldenburg participated in Kaprow's *The Big Laugh* in January 1960, and presented his own Happening, *Snapshots from the City*, a month and a half later. A Happening was, for Oldenburg, "a theater of actions or things" whose "cast tends to feature objects."[6] Unlike traditional theater, however, Happenings avoided plot, narrative, and climax. They mixed media and were loosely scripted (though seldom extensively improvised), disjointed, and open-ended. Indebted to the anarchic spirit of Dada, the dreamlike metamorphoses of Surrealism, and the all-over "action" of Abstract Expressionism, Happenings offered viewers the experience of a significant new art form. Oldenburg regarded a Happening as "a breaking down of the barrier between the arts, and something close to an actual experience. It should be a very free form…filled with unexplored and primitive possibilities."[7] As part of the widespread pursuit in the late 1950s and early 1960s to redefine art, the Happening offered a lively, intermedia alternative.

Massage was presented on October 3–4 and 6–7, 1966. Titles, according to Oldenburg, were decisions "of great importance. In searching for a title (it can keep me up several nights) I discover what I have on my mind, and this sets the general pattern of thought for the performance."[8] He chose the title because "massage is associated with Sweden—'Swedish Massage.' The word is spelled the same and means the same in English. In both languages it carries sexual suggestions. It seemed to mean both what one ought to wish to do with my work (my body) and what I ought to wish to do with my audience's body. Communication by touch."[9] In *Massage*, some of the performers (as "demonstrators") played hands touching surrogates for objects the museum had labeled as not to be touched. In his notes, Oldenburg freely associated "massage" with other words, including message, mass age, mass, masturbate, masses, massa, massacre, and modern masseum. This wordplay attests to the artist's fascination with transformation, a constituent element of his art.

Oldenburg regarded a Happening as a process, with each performance inevitably generating its own particular sensibility. Through "erasures and additions and adjustments, including false steps" *Massage* found its "most complete solution" by the last performance.[10] The audience contributed to the performance's metamorphosis, with the spectators of the first three presentations helping to define the final performance. Oldenburg stressed that a Happening was not presented "for" the audience; rather, the audience became "part of the landscape—to be looked at or to be used."[11] Audience members participated in *Massage* by being wrapped in blankets, blindfolded, and tucked in while Hawaiian music played.[12] Oldenburg and seven others acted as a postman, a nurse, a masseur, a sleeper, a plug, a mushroom, and bears. Performers in his Happenings did not play roles, but followed instructions, executed actions, and functioned as agents or "machines."[13] Each had a number of props, with *Tube and Contents* belonging to the masseur (Olle Granath).[14] During the performance, the masseur could be seen massaging the tube, shifting it around, beating it, sweating with it, taking out its contents, and rolling it up and lying down next to it. No

doubt all who experienced *Massage* deemed Oldenburg successful in his goal of making the actions "visually clear but ambiguous in meaning."[15]

The artist has been clear, however, in his notion of the tube as a symbol for the artist, who "takes off his cap and oozes out his content."[16] Oldenburg made his first tube in 1963, and it was considered a self-portrait, especially because it took his place in his bed during the day.[17] Because the artist has characterized the tube as his double in object form, *Tube and Contents*, with its extruded red paint, can be regarded as an emblematic self-portrait.

Tube and Contents relates to the soft sculpture format Oldenburg innovated in the early 1960s. These works typically transformed a commonplace object into a much larger and softer version of itself. Humor, absurdity, and cleverness informed the soft sculptures. Vinyl and canvas were stuffed with kapok to present objects that appeared to have melted or to have had the life sucked out of them. Unlike traditional sculpture, which rises up in defiance of gravity, Oldenburg's radical work is overwhelmed and pulled down by the force of nature. *Tube and Contents* belongs to this body of work, yet originally it was less a soft sculpture and more a collapsible one. As a prop carried, rolled up, spread out on a table, and hoisted in the air during performances of *Massage*, it had to possess even greater malleability than soft sculpture. The collapsibility of *Tube and Contents* meant that its form was not fixed and that potentially it could be arranged and displayed in a variety of ways. However, when the Museum acquired the work, the artist sent installation instructions. Oldenburg wished the rolled tube hung from the ceiling, with the red paint oozing from its mouth, which was to be about six feet above the floor. Seen in this manner, *Tube and Contents* aligns with a number of other Oldenburg works.

As a hanging piece flowing down, *Tube and Contents* resembles such soft sculptures as *Shoestring Potatoes Spilling*, 1966; *Soft Manhattan II—Subway Map*, 1966; *Giant Soft Fan*, 1966–67; *Giant Soft Ketchup Bottle with Ketchup*, 1966–67; and *Soft Drainpipe—Red Hot Version*, 1967.

The overall configuration of *Tube and Contents* anticipates Oldenburg's drawings *Tongue Cloud over St. Louis (with Arch and Colossal Raisin Bread)*, 1975 and the Museum's *Typewriter Eraser as Tornado*, 1972. In keeping with Oldenburg's concerns, *Tube and Contents* displays metamorphosis and allows a reading opposite to its immediate one. Instead of seeing paint flowing out of the tube and onto the floor, it is possible to read the red paint as a column supporting the tube. In this interpretation, the artist has not "ooze[d] out his content" (spilled his guts), but has been lifted to new heights by his medium. Oldenburg materialized this possibility with his fifteen-foot-high painted bronze and steel sculpture *Tube Supported by Its Contents*, 1985.

Tube and Contents is both a modern relic—or, in Oldenburg's words, "a souvenir" from the age of Happenings—and a work of art rich in associations and exemplary of Claes Oldenburg's belief in the importance of art staying "constantly elusive . . . always on its way between one point and another."[18]

MARK THISTLETHWAITE

1 Claes Oldenburg and Emmett Williams, *Store Days* (New York: Something Else Press, 1967): 39.

2 The artist in an e-mail message to the author, 5 June 2001.

3 Claes Oldenburg, *Raw Notes* (Halifax: Press of the Nova Scotia College of Art and Design, 1973): 114.

4 The others were *Snapshots from the City*, 1960; *Blackouts*, 1960; *Circus (Fotodeath/Ironworks)*, 1961; *Store Days I*, 1962; *Store Days II*, 1962; *Nekropolis I*, 1962; *Nekropolis II*, 1962; *Injun I*, 1962; *Injun II*, 1962; *Voyages I*, 1962; *Voyages II*, 1962; *World's Fair I*, 1962; *World's Fair II*, 1962; *Injun*, 1962; *Gayety*, 1963; *Autobodys*, 1963; *Washes*, 1965; and *Moveyhouse [Moviehouse]*, 1965. Oldenburg also prepared a Happening in script form, *The Typewriter*, 1968, for *Esquire* magazine.

5 Oldenburg quoted in Michael Kirby, *Happenings: An Illustrated Anthology* (New York: E. P. Dutton & Company, 1965): 200.

6 Oldenburg and Williams, 80; Oldenburg e-mail message, 5 June 2001.

7 Oldenburg from 1963, quoted in Barbara Rose, *Claes Oldenburg* (New York: The Museum of Modern Art, 1970): 183.

8 Oldenburg, *Raw Notes*, 151.

9 Ibid., 151.

10 Ibid., 145.

11 Ibid., 147.

12 Ibid., 129.

13 Ibid., 146.

14 For his account of the performance, see Olle Granath, "Hur jag lärde mig älska tuben: Reflexioner kring ett stockholmsbesök [How I Learned to Love the Tube: Reflections Surrounding a Stockholm Visitor]," *Konstrevy* 42 (November–December 1966): 221-224. Marianne Bobich kindly provided a translation of the article for the purposes of this essay.

15 Oldenburg, *Raw Notes*, 145.

16 Barbara Haskell, *Claes Oldenburg: Object into Monument* (Pasadena: Pasadena Art Museum, 1971): 83.

17 Ibid.

18 Oldenberg from 1961, quoted in Rose, *Claes Oldenburg*, 189; Oldenburg e-mail message, 5 June 2001.

Tony Oursler
American, born 1957

The Sum of Its Parts, 1997
Fiberglass sphere, Sony CPJ200,
VCR, videotape, and tripod
18 inches (45.7 cm) diameter
(sphere) plus equipment
Gift of the Director's Council, 1999
1999.43.G.V.

The Sum of Its Parts, 1997 is a mesmerizing sound and video sculpture that was created for Tony Oursler's 1997 one-person show entitled *A Field of Eyes* held at the New York City gallery Metro Pictures. The piece consists of a large fiberglass sphere that hangs from the ceiling at eye-level; a magnified, blinking eye is projected onto the sphere from a tripod with a video camera and player attached. Visible in the iris of the eye is a television, which airs the original black-and-white motion picture *Frankenstein* from 1931, adapted from the Mary Shelley novel of 1818. The dramatic dialogue begins, "Doctor, I think the heart is beating…," and the suspenseful script and soundtrack continue throughout the duration of the piece, which plays in an endless loop.

For the novel, Mary Shelley merged the literary Gothic tradition of the haunted and macabre with a supernatural atmosphere that might be seen as a precursor to science fiction. In the movie, the brilliant medical student Henry Frankenstein, assisted by the hunchback Fritz, creates a makeshift laboratory in an abandoned castle surrounded by a picturesque landscape. Driven by his ambition, Frankenstein challenges nature, creating a man using parts from excavated corpses. Animated with electricity from great bolts of lightening, Frankenstein's man comes to life. Fritz, however, botched the experiment by unknowingly choosing a "criminal" brain, creating a monster with brute strength and no power of reasoning. Frankenstein's monster accidentally kills a young girl, and angry villagers eventually kill him. As the story unfolds, ambition turns to disappointment and then to fright. The latter emotion is the strongest throughout the novel and film versions of the story.

Oursler's use of this film and the appearance of the piece itself create intriguing connections with the story of Frankenstein. The title, *The Sum of Its Parts*, is surely a direct reference to *Frankenstein*, and like the monster in the story, this work was created by mixing incongruent parts and then animating them with electricity. Wire, a large fiberglass ball, a video camera, electricity, a human eye, and the film become a form of rudimentary science fiction, and *Frankenstein*, a metaphor for the work.

Oursler's close-up view of the glistening eye makes the skin around it appear exaggerated and grotesque. Reacting to events in the movie, the eyeball darts, stares, and opens wide, and the lashes blink—the human eye becomes completely otherworldly. The eye also creates an unusual form of portraiture, and Oursler, who uses friends and acquaintances as subjects for such works, capitalizes on its diverse symbolism: the "evil eye," a window into the soul, even God (who is "all-seeing"). But perhaps the most obvious reference is to the Cyclopes—a mythological race of savage one-eyed giants.

To film an eye, Oursler seats his model at a piece of plywood so that his or her face fits into a hole that has been cut out and padded for comfort. He describes his process:

> Each piece was created by first videotaping a person's eye and then projecting it onto a sphere. The video image wraps around half of the sphere as though it were a rounded movie screen, allowing us to see the eyeball in great detail. And, reflected on the surface of the iris, one can see a very small image from a television or movie screen. The pupil expands and contracts with the light from the media that is reflected in it, almost as if it were reflexively feeding on the light, opening for the dark parts, closing from the bright ones. The eye as an object is a model for a number of systems and, of course, machines.[1]

In *The Sum of Its Parts* Oursler uses disparate parts and electricity to create a work that, like Frankenstein's monster, feeds our individual fears and fantasies.

ANDREA KARNES

1 Quoted in Elizabeth Janus, "Talking Back: A Conversation with Tony Oursler," in *Tony Oursler Introjection: Mid-Career Survey, 1976–1999* (Massachusetts: Williams College Museum of Art, 1999): 78.

Pablo Picasso
Spanish, 1881–1973

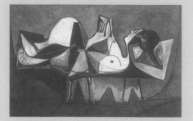

Femme couchée lisant (Reclining Woman Reading), 1960
Oil on canvas
51 1/4 × 77 1/4 inches
(130.2 × 196.2 cm)
Museum purchase, The Benjamin
J. Tillar Memorial Trust
1967.1.P.P.

During the 1960s the Modern Art Museum of Fort Worth acquired three significant works by Pablo Picasso.[1] In 1962 *Head of a Woman (Fernande)*, 1909, a cast bronze and one of Picasso's most famous sculptures, came into the collection. Five years later the Museum purchased the *Vollard Suite*, one hundred etchings created by Picasso between 1927 and 1937. Shortly after that acquisition, the Museum successfully bid at auction for *Femme couchée lisant (Reclining Woman Reading)*, 1960. While not as widely known as *Head of a Woman* and the *Vollard Suite*, *Femme couchée lisant* is undoubtedly the most spectacularly acquired work in the Museum's collection. On 5 February 1967, as millions of viewers watched the first internationally televised auction, the Modern Art Museum's director, Donald Burrows, secured the painting by outbidding potential buyers in London, Los Angeles, and New York. (Paris was also part of the satellite hookup, but did not participate in the auction.) Several unusual occurrences led to this thrilling event.

In November 1966, Italy suffered tremendous flooding. Florence was particularly devastated, with water and mud seriously damaging more than one thousand of the city's works of art. To assist in efforts to conserve and restore art objects, the Committee for the Rescue of Italian Art (CRIA) was formed. With Mrs. John F. Kennedy as its honorary chair, the New York–based CRIA encouraged and engaged in a variety of fundraising activities. Pablo Picasso agreed to donate one of his

paintings to be auctioned, with its proceeds benefiting CRIA. That painting was *Femme couchée lisant*.

The large painting shows a reclining nude female figure reading a book. She holds the book with both hands as she stretches out on what appears to be a chaise longue. Painted lines in the lower portion of the composition and on the far right, as well as what may be a shadow on the left side, suggest that the figure is set within a room. However, space is ambiguous and the setting may be either an interior or exterior one. The figure and her environment are rendered in tones of grays, blacks, and whites. Picasso distorts and fragments the woman in the cubistic manner typical of his late style, though less aggressively so. He does not emphasize her pubic region as he does in other numerous female nudes of the period, although the space between the woman's legs carries a vaginal connotation. By centering the figure, delineating its forms in a relatively clear manner, leaving breathing space around the figure, and limiting color, Picasso achieves an almost classical serenity in *Femme couchée lisant*.

As a depiction of a reclining nude woman, the painting is deeply embedded in the traditions of Western art. For all his inventiveness and modernity, Picasso was always aware of art of the past. Indeed, much of his art from the mid-1950s on is a dialogue between himself and past masters, such as Diego Velázquez, Nicolas Poussin, Rembrandt van Rijn, Eugène Delacroix, Jean-Dominique Ingres, and Edouard Manet. No specific artist or historical image can, however, be cited as the source for *Femme couchée lisant*. Nor can the figure be identified as a specific woman, although there is good reason to assume she is based on Picasso's companion Jacqueline Roque. Picasso's biographer John Richardson, believing that Roque's image permeates the artist's work from 1954 until his death, designates the last two decades of Picasso's career "*l'époque Jacqueline*."[2]

Picasso finished the Museum's painting on 5 December 1960, dating it precisely, as was his habit. The untitled painting remained in his villa La Californie, near Cannes, until he donated it to CRIA in 1967. At that

time he gave the composition its title.[3] Before being auctioned off by Parke-Bernet Galleries in New York on February 5, the painting was exhibited briefly in Los Angeles, then in Fort Worth and Dallas. On the day of the auction, *The New York Times* ran a full-page advertisement that featured a reproduction of *Femme couchée lisant* and the teaser headline "How Much Is This Painting Worth?" The advertisement's copy read:

It's called "Femme couchée lisant," and we'll know exactly how much it's worth when it's auctioned off tonight on the NBC News special "Bravo, Picasso!"

The auction—with bidders assembled in television studios in New York, London, Los Angeles and Fort Worth—is but one of many highlights on this live two-continent tribute via satellite to the grand old master of modern art. Of course, it's all in color.

Prior to the auction, viewers will see an interplay between two Picasso exhibitions: one in Paris (a show that has already been called "the exhibition of the century") and the other a two-city showing in Dallas–Fort Worth, culled from the best of Picasso in America.

Actor Yves Montand, a longtime friend of the artist, will serve as host for tonight's special, which offers the largest display of Picasso works (oils, drawings, graphic, sculptures, ceramics) ever seen at one time.

All you have to do is watch.

How many actually watched the program is uncertain, but one Fort Worth source claimed, perhaps over-enthusiastically, between 20 and 40 million people saw the show.[4] What is certain, however, is that this event was possible only because of communications satellite technology and Picasso's reputation as "the grand old master of modern art."

With the launching of the Early Bird commercial satellite (later renamed Intelsat 1) on 6 April 1965, a new era in the age of mass communication began. It was this satellite that linked the five cities participating in "Bravo, Picasso!" As the *New York Times* advertisement indicated, the NBC special focused on two major exhibitions of Picasso's art. The Paris show had opened in

November 1966 at the Grand Palais and Petit Palais, and featured more than seven hundred works of art. The exhibitions at the Modern Art Museum of Fort Worth and the Dallas Museum of Art were conceived as a joint presentation. The Dallas segment included 137 objects (paintings, prints, sculpture, and books) and that in Fort Worth consisted of seventy-two gouaches, watercolors, and prints. Also to be seen in Fort Worth were the one hundred etchings of the *Vollard Suite* and, after the auction, *Femme couchée lisant*. Commenting on Picasso's works for the television audience were Yves Montand and critic Aline Saarinen in Paris, and in Fort Worth, Picasso expert Douglas Cooper. The latter had been instrumental in the organization of the Dallas–Fort Worth exhibitions and in the production of their catalogues. Focusing on the French and American shows, the hour-long television broadcast was intended as a grand celebration of the artist's work and further confirmation of his status as "artist of the century." The NBC program concluded with the auction of a single Picasso painting, *Femme couchée lisant*.

During the auction, no bidders from London came forward, and those in Los Angeles dropped out fairly early; it "could have been a lot more exciting if London and Los Angeles hadn't chickened out," offered a Fort Worth newspaper columnist.[5] The bidding came down to the Museum (with support from several donors) and some New York collectors.[6] The Museum's bid of $105,000 proved successful ("Art Center Scores," exclaimed an editorial in the following day's *Fort Worth Star-Telegram*). This became the highest price that the Museum had ever paid for a work of art, substantially eclipsing the previous record of $30,000, which had only recently been set with the purchase of the *Vollard Suite*.

Director Burrows stated that the Museum had decided to enter the bidding when the plans for the auction were first announced, as it "was an opportunity to purchase a major work of modern painting and to help save Italian objects."[7] The Museum's participation and successful bid also served to bolster civic pride. The *Fort Worth Star-*

Telegram editorialized that the Museum had effectively "advertised [itself] to the world."[8] A local bank ran a newspaper advertisement that included photographs of Burrows bidding on the painting and a group of citizens looking at the newly installed painting. Under the headline "Why Picasso's 'Femme couchée lisant' was a bargain at $105,000," the advertisement declared that the city had profited by the international exposure: "The eyes of the world were on Fort Worth at a memorable moment of high drama."[9]

This major purchase of a painting by *the* modernist artist signified the Museum's ambition and its desire to transform itself from an art center into a museum of modern art. *Femme couchée lisant* played, therefore, a crucial and highly public role in the Museum's process of maturation.

MARK THISTLETHWAITE

1 The institution was then known as the Fort Worth Art Center. To avoid confusion, its current name—the Modern Art Museum of Fort Worth—will be used throughout.

2 Tate Gallery, *Late Picasso: Paintings, Sculpture, Drawings, Prints 1953–1972* (London: Tate Gallery, 1988): 47. Picasso and Roque married in 1961.

3 Undated typescript, Registrar's Files, Modern Art Museum of Fort Worth.

4 Fort Worth National [bank] advertisement, *Fort Worth Star-Telegram* (18 February 1967): 7B.

5 Jerry Coffey, "Tube Limits/ Smothers," *Fort Worth Star-Telegram* (7 February 1967): 8A.

6 The collectors were identified as Mr. and Mrs. Paul Caudell. Jack Gould, "TV: 'Bravo, Picasso!' Spans Atlantic in Living Color," *The New York Times* (6 February 1967): 59.

7 Robert Simpson, "Art Center Here Buys Picasso Work," *Fort Worth Star-Telegram* (6 February 1967): 1.

8 "Art Center Scores," *Fort Worth Star-Telegram* (7 February 1967): 6C.

9 Fort Worth National [bank] advertisement (see note 4).

Michelangelo Pistoletto
Italian, born 1933

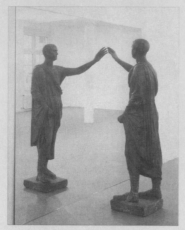

The Etruscan (L'etrusco), 1976
Bronze, mirror
120 × 84 × 47 inches
(304.8 × 213.4 × 119.4 cm)
Museum purchase,
The Friends of Art Endowment Fund
2001.11.P.S.

The Etruscan, who comes from a faraway past, touches with his hand the point in the mirror where the future originates. He connects to a future that does not move directionally, but that has transformed itself through the mirror into an expanded flow, a fluid that opens up concentrically toward what is unknown. MICHELANGELO PISTOLETTO

Michelangelo Pistoletto's work has been loosely related to the Arte Povera movement in Italy of the late 1960s and 1970s. Generally coincident with post-Minimalism in the United States of the same period, Arte Povera encouraged the use of a wide range and mix of common (or "poor") materials. While many of the artists associated with the movement—Jannis Kounellis, Alighiero Boetti, Pistoletto, Pino Pascali, Mario Merz, Luciano Fabro, and Giuseppe Penone, among others—have utilized many different materials—including earth, fire, water, glass, rags, stone, photography, and electric light—to create physical symbols for broad philosophical concepts, each of them tended to locate a signature material that clearly identifies their work. In the case of Pistoletto, that material is the mirror.

Pistoletto's interest in mirrors and their reflective possibilities began in the mid-1950s, when he was painting a self-portrait. The artist's process involved painting his own image from a mirror: "On one side I faced the mirror, on the other side the canvas. I painted many self-portraits during that period, as I was constantly seeking an answer to the problem of recognizing myself through art, of bringing to the surface the various strata of my inner self and transferring these reflections to the canvas."[1]

For the backgrounds of his self-portraits, the artist often used gold, silver, or black. One day while applying lacquer to a black ground, he noticed his image reflected in the painting. "The canvas itself became the mirror, and I realized that—instead of a painted background—the living world appeared in the painting. Behind my own image in the painting, I noticed the wall of the room I was working in, and any other person could have seen his or her reflection in this area of the painting." From that point on, Pistoletto decided that his art needed to reflect the larger ambient world or "whole," of which he and his art were only parts. The goal was not to isolate the painting as a privileged experience from the world, but to include the world in his paintings.

By 1963 the artist was applying collaged photographic reproductions of everyday people onto polished stainless steel surfaces mounted to the wall like paintings. Viewers of these "paintings" immediately saw their own reflection integrated with that of the photographic reproduction, becoming a part of Pistoletto's unique form of illusionistic space. Pistoletto's technique of integrating photography into the arena of painting coincided with a similar development during the emergence of Pop art in the United States and England around the same time. Pistoletto's images, however, diverge from most works associated with Pop art and its embrace of postwar affluence and advertising. For Pistoletto, the anonymous figure was only a foil to ignite the larger philosophical possibilities of the mirror, which for the artist has come to represent a doorway into concepts of space and time. "If one wants to walk into the mirror, actually walk further into it, one must step back, turn around and walk in the opposite direction. Looking into the mirror one can see one's own image walking into the mirror. For me this was the only possible way to reach the other side."

For Pistoletto, steeped in the history of Western culture and questioning his role in it, "the other side" is a place where the past, present, and future come together in an imaginative synthesis. In this regard, the Modern Art Museum's *The Etruscan (L'etrusco)*, 1976 is one of his most memorable and emblematic works. Expanding the artist's typical procedure of collaging a figure on top of a reflective surface, it consists of a free-standing, life-size bronze cast of an original Etruscan figure, whose raised arm and hand touch the surface of a large mirror mounted on the wall. The mirror reflects not only the bronze sculpture, but also the spectator and much of the room he or she is standing in. Pistoletto conceives the point where the Etruscan's hand touches the surface of the mirror as representing the present, while the illusionistic reflection in the mirror suggests the past and "the role of perspective in painting, which in its time was a new way of perceiving time and space." Finally, the space that is reflected in the mirror, the space in which the viewer finds himself, and that extends behind and around him infinitely, represents the future. Writing about his intentions for *The Etruscan*, the artist notes, "The Etruscan, who comes from a faraway past, touches with his hand the point in the mirror where the future originates. He connects to a future that does not move directionally, but that has transformed itself through the mirror into an expanded flow, a fluid that opens up concentrically toward what is unknown."

The value of any work is partly a function of a viewer's ability to find himself within it. In Pistoletto's work, not only is an invitation offered, but a door is opened and we become an integral part of the image we are contemplating. Through this reflection, it is the artist's hope that we will attempt to locate ourselves in what he calls "an expanded flow" of time.

MICHAEL AUPING

1 Quotes from the artist are from an undated letter to the author, 2001.

Sylvia Plimack Mangold
American, born 1938

Winter Writing, 1984
Oil on linen
60 × 80 inches (152.4 × 203.2 cm)
Gift of Anne and John Marion
2002.18.G.P.

> *My work is not about fooling the eye, but about questioning the nature of painting and thereby the nature of levels of reality....The only element which is true to itself is the paint when it is applied as a covering on a flat field.*
>
> SYLVIA PLIMACK MANGOLD

The paintings of Sylvia Plimack Mangold represent a rare braiding together of traditional realism and Minimalism. The artist's early paintings took the form of meticulously rendered depictions of the floor of her studio/apartment in which she utilized rulers, graph paper, and masking tape to faithfully depict in acrylic paint the scale and grid pattern of her parquet wooden floors. These images had an edgy, reductive quality not common among contemporary realist painters. In fact, her realism would eventually develop into an acute analysis of the nature of depiction itself.

Born in New York in 1938, Plimack Mangold attended Yale University School of Art, where she encountered a unique cross-section of realists (William Bailey, Rackstraw Downes, Janet Fish, and Chuck Close) working alongside artists exploring reductive abstraction (Robert Mangold, Richard Serra, and Brice Marden). In her search to discover her identity within this milieu, she forged a pictorial strategy that played various descriptive mechanisms—realism/illusion, abstraction/representation—against each other.

In an essay for *Direct Representation*, a 1969 exhibition at the Fischbach Gallery in New York that included her work, the Minimalist sculptor Scott Burton qualified Plimack Mangold's approach in relation to other forms of realism, sensing its hybrid nature:

Here the motivation seems more one of conceptual reappraisal of the relation between a picture and an image. These views of nothing but floor and ground planes also convey an alienation ...but are more clearly related to recent ideas in abstract art. The subject of floor boards is as normally non-relational as any gridded configuration in Minimal art—or would be were it not for the simple experience of perspectiveThe exclusion of objects ...and the strange light coming from behind the paint instead of from a depicted, internal source are additional devices which relate this artist especially to recent abstraction; but it must be remembered that they are devices subsumed within a legitimately figurative intention.[1]

Primarily a sculptural movement, Minimalism was rooted not only in reductive form, but also in an awareness of the context and space in which a work is made or placed. Because no figures or even furniture exist in Plimack Mangold's images, surface and space become the content of the work, acknowledging the Minimalists' interest in spatial context. In the early 1970s the artist complicated her compositions by depicting mirrors on the floor, creating the illusion of expanding the space of the room while seeing it from different viewpoints. Such images were followed by walls and floors that incorporated full-scale rulers, which simultaneously measured the surface/space of the depicted room and, ironically, the canvas upon which it is depicted.

However, by depicting something inherently flat—the floor—the artist also used an image that mimicked the planar surface of her canvas, creating one that conflated modernism's insistence on flatness and "truth to materials" with representational painting's penchant for illusionism. The artist further emphasized the surface of the painting with the subsequent portrayal of masking tape, along with rulers, deliberately engaging what the artist calls "a deception of appearances." In other words, "All the elements in the new work are constructed from paint: 1. The masking tape is paint looking like tape. 2. The rulers are paint looking like rulers....My work is not about fooling the eye, but about questioning the nature of painting and thereby the nature of levels of reality....The only element which is true to itself is the paint when it is applied as a covering on a flat field."[2]

Plimack Mangold's illusionistic use of masking tape has come to be her symbol of the layered illusions and realities of the painting process. The irony that the masking tape, which was once a means to an illusion, now becomes the illusion, and that the artist is now revealing illusionistically the reality of her process of painting, is a key part of the experience of Plimack Mangold's paintings.

Over the last two decades Plimack Mangold's work has evolved from renderings of floors, mirrors, and rooms to depictions of landscapes around her Hudson River Valley studio. In these recent works, the changing appearance of nature meets the everyday practice of painting, just as the seemingly limitless space of landscape confronts the practical limitations of painting. Painting the landscape of the Hudson River Valley through different seasons, the artist uses color to evoke elements of atmosphere and time. The Modern Art Museum's *Winter Writing*, 1984 is a poignant example. The upper quarter of the canvas is a gentle, non-representational blue zone. This flat, eye-pleasing field of color comes to an abrupt end as it meets a ridge of *trompe l'oeil* masking tape, which also runs along the side and bottom of the canvas, and frames a winter landscape of bare, leafless trees. The artist's attention to the "personality" of each tree as it lifts above the rolling hills is acute, rendering them not just as backdrop but as haunting calligraphic forms, nature's equivalent of expressionist line. The sky within the taped boundaries is a hazy, winter white. The suggestion is that summer has been pictorially covered over, literally taped over, by the onset of winter, as if it were a page from a seasonal journal in which each sheet represents a layer of the artist's immediate realities.

At the same time she engages the moody sublimity of the natural world outside her studio, the artist acknowledges her Minimalist roots, the bare trees echoing Piet Mondrian's reductive images of trees that were important precursors of Minimalism. The masking tape framing the image and the occasional paint drips that are the inevitable part of the painting process and that she chooses not to paint over bring us back to the immediate subject: painting. By pointing out the elusive distinctions between illusion and reality, Plimack Mangold reinvests the genre of *trompe l'oeil* painting with a new quality of immediacy.

MICHAEL AUPING

1 Scott Burton in *Direct Representation: Robert Bechtle, Bruno Civitico, Yvonne Jacquette, Sylvia Mangold, John Moore: Five Younger Realists Selected by Scott Burton* (New York: Fischbach Gallery, 1969).
2 The artist quoted in the exhibition brochure for *Sylvia Plimack Mangold: MATRIX 62*, Wadsworth Atheneum, Hartford, Conn.: 26 November 1980 to 25 January 1981.

P

Jackson Pollock
American, 1912–1956

Masqued Image, 1938
Oil on canvas
40 × 24 inches (101.6 × 61 cm)
Museum purchase made possible by
a grant from The Burnett Foundation
1985.29.P.P.

Untitled (Animal Figures), *c.* 1939–42
Blue ink on paper
13 × 10³/₈ inches (33 × 26.4 cm)
Museum purchase made possible by
a grant from The Burnett Foundation
1985.13.P.Dr.

Untitled (Collage I), *c.* 1951
Enamel, silver paint, and pebbles
on illustration board
21³/₄ × 30 inches (55.2 × 76.2 cm)
Museum purchase made possible by
a grant from The Burnett Foundation
1985.30.P.P.

Untitled (34 Bird), *c.* 1942
Pen and ink and gouache on deep
pink paper
10⁵/₈ × 3³/₄ inches (27 × 9.5 cm)
Museum purchase made possible by
a grant from The Burnett Foundation
1985.15.P.Dr.

Number 5, 1952, 1952
Enamel on canvas
56¹/₄ × 31³/₄ inches (142.9 × 80.6 cm)
Museum purchase made possible by
a grant from The Burnett Foundation
1985.31.P.P.

Commentary on page 133

Richard Prince
American, born 1949

Untitled (Cowboy), 1995
Ektacolor print, edition of 1
48 × 72 inches (121.9 × 182.9 cm)
Museum purchase made possible by
a grant from The Burnett Foundation
1995.46.P.Ph.

Richard Prince's photograph of a cowboy in action possesses an aura of overwhelming familiarity. This is because the composition taps into primary American myths—the frontier and rugged individualism—and recalls countless images—paintings, photographs, movies, and advertisements—that have helped sustain those myths. Prince's depiction does more, however, than merely resemble such imagery; it actually reproduces an advertisement from the Philip Morris company's long-running and ubiquitous advertising campaign for its Marlboro brand of cigarettes.[1] As both a representation and a "re-presentation," *Untitled (Cowboy)*, 1995 raises provocative questions about the nature of art in a postmodern age.

A notoriously slippery term, "postmodern" nonetheless has been the prevailing designation used to characterize and theorize society and culture since the early 1970s. Postmodernist art, which Richard Prince's work exemplifies, has been especially concerned with critiquing artistic originality and invention, as well as exploring the ability of mass-media images to often seem more real than the reality they represent. In addressing these interests, postmodernist artists have frequently turned to photography, not only because it is a mode integral to the mass media's production and distribution of images, but also because photography is inherently problematic in terms of originality: Which print of a photograph is the original? Is the negative the original? Like others of his generation, Prince turned to photography after beginning his career working with

another technique, in his case, painting. By 1975 he had produced photo collages, and in 1977 he commenced "rephotographing" magazine advertisements. Although his utilization of pre-existing images followed the earlier examples of Pablo Picasso's collages, Marcel Duchamp's Readymades, and Andy Warhol's silkscreen portraits (such as the Museum's *Twenty-Five Colored Marilyns*), Richard Prince has been widely recognized as the first to engage in the postmodernist practice known as appropriation.[2]

In the postmodern context, *to appropriate* is to take (or, as Prince bluntly states, "to steal"[3]) another's composition and re-present it, with little or no artistic change or intervention, as your own. Photography is a particularly apt medium to be associated with appropriation because we have come to regard as natural the notion of "taking" a picture. Prince's work is radical because his appropriation appears absolute. More so, for example, than Ed Blackburn's in *Hoppy Serves a Writ*, also in the Museum's collection, which translates a photographic source (itself taken from a movie) into an expressionistic painting. *Untitled (Cowboy)* reproduces its magazine source directly, with selection taking priority over creation.[4] As a total appropriation, the work provokes questions: How is it a work of art, while its source is considered merely an advertisement? What is original about it? Where is its artistic innovation? Does it imply that there is no need to invent new images in an image-saturated society?[5] These questions, whose answers might be endlessly debated, form part of the postmodern project of investigating and analyzing the socially construct-ed character of art and its myths of artistic originality and genius.

Despite its apparently complete appropriation of a Marlboro advertisement, *Untitled (Cowboy)* discloses artistic intervention. For example, Prince eliminated all text (known, appropriately in this case, as "copy") from the advertisement—no "Come to Marlboro Country" or Surgeon General's Warning occurs.[6] The artist substantially enlarged the image, changing its scale from that of the magazine to that of the museum. With the increase in size,

the half-tone dots that make up the ad become clearly evident in sections of the composition. Their presence not only adds an abstract visual interest to *Untitled (Cowboy)*, but reminds viewers that the rephotograph's source was itself a published reproduction of a photograph. The obvious presence of the Benday dots used in the printing process also parodies Pop artist Roy Lichtenstein's signature motif (as seen in the Museum's *Mr. Bellamy*). Prince's artistic presence is also manifest in his choice of image. Beyond being a type of image that the artist "happen[ed] to like" and probably saw daily while employed in the mid-1970s clipping articles for *Time-Life* staff writers, *Untitled (Cowboy)* seems calculated to elicit mixed responses and readings. By appropriating an advertisement from the highly visible "Marlboro Country" campaign, Prince knowingly employed an image fraught with multiple associations and charged with a variety of meanings.

As a contemporary portrayal of a cowboy rounding up wild horses, *Untitled (Cowboy)* extends and updates the tradition of action-packed, heroic depictions of the American West. The subject has been undertaken by scores of artists, none better known than Frederic Remington. Paintings by this artist likely served as touchstones for the Marlboro photographer and Richard Prince in their efforts to produce a composition both dramatic and believable. And aptly so, since much of the realism in Remington's paintings—convincingly rendered galloping horses, for example—was based on his use of photographs. For Remington, however, the photograph was a means to an end, while for Prince the photograph is both means and end. Even though Remington was more artist than cowboy, he did bring a certain authenticity to his works because of his direct experience of the frontier. Prince, on the other hand, by quoting an advertisement, underscores how such imagery mediates our view of the world. He puts authenticity under suspicion. *Untitled (Cowboy)* glorifies the deeply embedded American belief in and admiration for rugged individualism, personified by the cowboy-hero who tames the West, but it does so with an image in

the service of selling a product. The beautiful, soft-focus presentation of a great American myth plays nostalgically upon nationalistic sentiments, while serving commercial interests.[7] Prince's appropriation of a Marlboro advertisement astutely acknowledges that no company has been more successful than Philip Morris, through its Marlboro Man, in conflating marketing and nationalism.

In April 1999 the journal *Advertising Age* named the top ten advertising icons of the twentieth century. Criteria for the selection included effectiveness, longevity, recognizability, and cultural impact. Topping the list was the cowboy appropriated by Richard Prince: the Marlboro Man.[8] This symbol of rugged individualism had been developed in 1955 by the Leo Burnett advertising agency to bolster the weak sales of Marlboro cigarettes, which for decades had been marketed primarily to women. The Marlboro Man (actually "men," including sailors, cowboys, pilots, and hunters, all marked by a tattoo on one hand) was an immediate and tremendous success. In 1962 the "Marlboro Country" cowboy became *the* Marlboro Man. Within ten years, the cigarette was the number-one-selling brand in the world and "Marlboro Man" was secure in the lexicon of popular culture as a term to describe a tough, no-nonsense individual. An article published in 1999 on Senator John McCain typifies the ongoing use of the phrase: Entitled "The Media's Favorite Marlboro Man," the article concerned neither smoking nor advertising, but focused on the media's perception of McCain as being "genuine, not manufactured."[9] Of course, the Marlboro Man is not genuine, but wholly manufactured. Its power as an icon is such that its aura of being real and natural overwhelms its actual artifice. This slippage between image and reality is a phenomenon that fascinates postmodernists such as Richard Prince.

Untitled (Cowboy) is a photograph of a magazine illustration that reproduced a photograph of a scene staged by Marlboro. Which image, Prince might be asking, is the real one? Is an image, by its nature, not only a fabrication, but also the manifestation of an agenda?

Untitled (Cowboy) reinforces a deep-seated view of the American cowboy and the frontier, yet it is an image originally constructed to sell a product that bears a health warning from the country's chief medical officer. By appropriating an advertisement, is the artist critiquing the role advertisements play in visualizing and perpetuating cultural and societal values, or is he celebrating their persuasiveness and artfulness? Is he suggesting that mass-media imagery is essentially no different than the art of the museums? Richard Prince's rephotograph *Untitled (Cowboy)* challenges us to rethink and review the complexity and power of the image.

MARK THISTLETHWAITE

1 The Museum's collection also includes two related photographs by Richard Prince: *Untitled (Cowboys) #8*, 1980–84 and *Untitled (Cowboys)*, 1992.

2 Sherry Levine also adopted rephotographing as a technique in 1977, apparently after seeing Prince's work.

3 Prince quoted in Judith Russi Kirshner, "Redefining Conceptualism," in Neal Benezra, ed., *Affinities and Intuitions: The Gerald S. Elliott Collection of Contemporary Art* (New York and Chicago: Thames & Hudson in association with The Art Institute of Chicago, 1990): 240.

4 Andy Grundberg, "Richard Prince, Rephotographer," in *Crisis of the Real: Writings on Photography, 1974–1989* (New York: Aperture, 1990): 133.

5 At the time Prince produced *Untitled (Cowboy)*, it was estimated that Americans were exposed to 3,000 advertisements a day. James Twitchell, *Adcult USA: The Triumph of Advertising in American Culture* (New York: Columbia University Press, 1996): 2.

6 In a survey of *Esquire, Life, Newsweek,* and *Time* magazines from 1977–1995, only one instance was found in which a Marlboro advertisement appeared without text: the inside front cover of the February 1991

issue of *Esquire*. This appears due, at least in part, to a printing error, for a few letters from the government's warning about cigarettes are visible at the far edge of the two-page spread.

7 It may be more than coincidental that Prince began producing his cowboy rephotographs during the first years of Ronald Reagan's presidency. Reagan was often pictured in the guise of a cowboy, working and riding around his California ranch, and America was called "Reagan Country."

8 The others, in descending order, were Ronald McDonald, The Green Giant, Betty Crocker, The Energizer Bunny, The Pillsbury Doughboy, Aunt Jemima, The Michelin Man, Tony the Tiger, and Elsie. *Advertising Age* also ranked the top 100 advertising campaigns; Marlboro placed third, behind Volkswagen and Coca-Cola.

9 Michael W. Lynch, "The Media's Favorite Marlboro Man," *Reason* 30 (January 1999): 40.

P

Martin Puryear
American, born 1941

Red, Yellow, Blue, 1982
Painted pine
50 × 62 × 8 inches
(127 × 157.5 × 20.3 cm)
Museum purchase, The Benjamin
J. Tillar Memorial Trust
1991.1.P.S.

During Minimalism, I felt like a holdover from the craft tradition.... When I first saw Donald Judd's work, it cleared the air for me to do whatever I wanted. And I wanted purity and simplicity. But I couldn't be as distant as Judd—the working process is essential to me.

MARTIN PURYEAR

Red, Yellow, Blue, 1982 comes from Martin Puryear's wall-mounted *Ring* series created during the 1970s and 1980s. It is a harmonious circle composed of thin strips of laminated pine painted in the primary colors. While many of the rings in the series are open, *Red, Yellow, Blue* is one of the few that is unbroken. Its red section lies flat against the wall, and the lower blue portion subtly protrudes outward into the viewer's space. Yellow is used only in two small "joints" that connect the larger red and blue areas. Puryear, a master woodworker, leaves human touch evident in this smooth, round form, seen especially in the paint and texture of the wood's surface.

Significantly, in the year *Red, Yellow, Blue* was made, Puryear began the first of several outdoor projects, *Bodark Arc*, 1982 (Nathan Manilow Sculpture Garden, Chicago), which comprises a monumental semicircle carved from grass that incorporates a wooden bridge and other elements to form an arc.[1] *Bodark Arc* is a precursor to Puryear's indoor, human-scale rings. For both outdoor and smaller-scale works like *Red, Yellow, Blue*, Puryear incorporates wood, his preferred medium

(although he also frequently uses wire). Besides rings and arcs, other characteristic shapes in his sculpture include large cones, cocoon-like solid wood forms, woven baskets, and sleek funnel and ovoid structures, many of which are anthropomorphic and/or imply human shelter.

Puryear was largely influenced by his studies of craft and carpentry in Sierra Leone as a participant with the Peace Corps from 1963 to 1965, and later by his interaction with Swedish woodworkers during his enrollment at the Swedish Royal Academy of Art. He received his master's degree in Fine Art at Yale University in 1971, where he studied with sculptors Al Held and James Rosati. Richard Serra and Robert Morris were visiting artists at Yale while Puryear was there, and their artistic concerns for making three-dimensional forms, like Puryear's, involved using aspects of Minimalism and post-Minimalism. His work aligns more closely with that of the post-Minimalists, however, who used a pared-down Minimalist vocabulary to make objects that often looked handmade. Comparing his sculpture to that of the Minimalists, who worked toward an industrial or machine-made aesthetic, Puryear has said, "During Minimalism, I felt like a holdover from the craft tradition When I first saw Donald Judd's work, it cleared the air for me to do whatever I wanted. And I wanted purity and simplicity. But I couldn't be as distant as Judd—the working process is essential to me."[2]

Embracing certain aspects of Minimalism, Puryear reconnected its austerity to nature and handmade processes. His sensibility is anomalous to the prevailing art movements of the 1980s, when he matured as an artist. Many sculptors—such as Robert Gober, Kiki Smith, and Jeff Koons—and artists working in painting and photography—Cindy Sherman, Sherry Levine, and Richard Prince— at the time focused on issues of identity (i.e., race, gender, and culture) and on other aspects of postmodernism. Rather than working within that movement's political or aesthetic principles, however, Puryear's work remained beautifully constructed, introspective, and meditative. *Red, Yellow, Blue* is expressive of this, with its

humble focus on human touch and the craft tradition in woodwork and sculpture.

ANDREA KARNES

1 For a thorough discussion of Puryear's career see Neal Benezra, with essays by Robert Storr, *Martin Puryear* (New York and Chicago: Thames & Hudson in association with the Art Institute of Chicago, 1991).
2 Quoted in Steven Henry Madoff, "Sculpture Unbound," *ARTnews* 85 (November 1986): 104–105.

Robert Rauschenberg

American, born 1925

Whistle Stop (Spread), 1977
Combine painting, mixed media on
five panels, overall approximately
84 × 180 × 8 inches
(213.4 × 457.2 × 20.3 cm)
Museum purchase and commission,
The Benjamin J. Tillar Memorial Trust
1977.13.P.P.

Robert Rauschenberg is typically
described as a "protean" artist, and
for good reason. Diversity, versatility,
and inventiveness have defined his
art; "Rauschenberg has created in a
range of mediums, materials, and
techniques probably wider and more
varied than any other artist of this
century."[1] This breadth is embodied
in *Whistle Stop (Spread)*, 1977, with
its inclusion of fabric, painting,
drawing, transfer-prints, and real
objects. In its juxtaposition and
fusion of various forms, *Whistle Stop*
relates to the "Combines" that
Rauschenberg developed in 1954.
These works combined painting and
sculpture, abstraction and repre-
sentation, in order to bridge art and
life so that the artist could, as he
famously said, "act in the gap
between the two."[2] The array of
images and objects that make up a
Combine often suggest, but rarely
support, a sustained narrative
reading. Instead, the elements in
Rauschenberg's art trigger associa-
tional meanings for each viewer. Still,
the will to uncover and decipher an
underlying and unifying story is
powerful. This is true of *Whistle Stop*,
especially because the artist
dedicated the piece to his father.

Whistle Stop contains approxi-
mately fifty reproductions of photo-
graphs and illustrations clipped from
books, magazines, and newspapers.
The images range from Abraham
Lincoln to a lunar landscape.
Arrowheads, birds, comic strips,
diagrams of a house and a car, and
a Neoclassical painting of a young
woman drawing are among the
reproductions that have been affixed

to three of the five panels by a solvent
transfer-printing technique. The
process involves laying the images
on a flat-bed press, spraying them
with solvent, and pressing them onto
fabric, which is then laminated to the
panels.[3] The technique reverses the
images and gives them a uniform
smoothness and blurriness. Besides
numerous images, *Whistle Stop*
includes a blinking red light and two
doors (normally, the left door
remains closed, while the right one is
wide open). The doors give the piece
an architectural quality, although the
work is installed like a painting and
hung at least eight inches off the
floor.[4] Rauschenberg found the doors
near his home in Captiva, Florida,
and replaced the wire screens with
white silk, which elegantly veils the
images. But even with a door open,
the transfer-printed images display a
muted, hazy appearance. The images
behind the doors are contained within
boxes, lightly delineated in graphite,
which parallel the spaces created by
the slats and frame of each door.
Lacking such a structuring device,
the images on the far right panel
float, collide, and overlap more freely.
Rauschenberg, however, plays with
all his images not only by reversing
them but also by placing some on
their sides and inverting others. This
leads to a dynamic slippage between
representation and abstraction.

Whistle Stop was the second of two
pieces the Museum commissioned
from Rauschenberg in 1975–76. For
the Museum's *Great American Rodeo*
exhibition, Rauschenberg created
Rodeo Palace, 1976. This eleven-by-
sixteen-foot work, with its mixed
media and three doors, embodied
what the artist characterized as "rural
opulence."[5] The multitude of images
and forms that make up *Rodeo Palace*
marked a departure from the more
austere works Rauschenberg had
been producing since 1970, and
initiated a series called *Spreads*.
Over the next five years, the artist
produced fifty-two *Spreads*. The
series' name carries several connota-
tions for the artist: "'Spread' means
as far as I can make it stretch, and
land (like a farmer's 'spread'), and
also the stuff you put on toast."[6]
The range of diverse meanings
Rauschenberg attached to the term
is evident in *Whistle Stop*, an early
Spread.

Even more than *Rodeo Palace*,

Whistle Stop relates to the artist's
having grown up in Texas. Milton
Ernest Rauschenberg (he changed
his name to Bob in 1947, then to
Robert) was born in Port Arthur, an
oil-refinery town on the Gulf of
Mexico. He lived there until the age
of eighteen, when he moved to
Austin to attend the University of
Texas. Rauschenberg left school after
a short time, in part because he
refused to dissect a live frog in a
biology class. He was drafted into the
United States Navy in 1944, and
honorably discharged the following
year. Rauschenberg returned to Port
Arthur only to discover that his
family, without telling him, had
moved to Lafayette, Louisiana. This
incident underscores his conflicted
relationship with his family, in
particular his father, and with Port
Arthur. However, *Whistle Stop* initially
offers little hint of this, because its
architectural character, hazy images,
and dedication to the artist's father
evoke an appealing sense of home
and the past.[7]

The two screen doors set a
nostalgic mood of rural domesticity.
The old-fashioned forms recall a time
of screened-in porches and houses
without air conditioning, when screen
doors allowed sights, sounds, and
smells to flow freely between outside
and inside. The indistinctness of the
images, due to veiling and the
transfer-print technique, suggest the
passage of time, while the doors
provoke a yearning to step back into
the past. Several of the reproductions
relate to Rauschenberg's Port Arthur
years: a *Gulf* oil tanker, a diagram of a
"shotgun" house (the kind in which
his father grew up, and he himself
lived), the sea, a lobster, and birds
and fishes. Some—a bicycle,
arrowheads, a drawing of a baby,
comic strips—can be perceived as
generally relating to his childhood.
But other images have little to do
with the Gulf Coast environment,
except in offering a contrast to it, and
perhaps an escape from it:
mountains with snow, a downhill
skier, more mountains, more skiers,
a map of Africa, Native American
ruins, and the lunar landscape. These
images suggest that underlying the
benign facade of *Whistle Stop* is a
complex and contradictory attitude
toward the past.

The very title of the work is open-
ended. A "whistle-stop" (a word that,

coincidentally, first appeared around
1925, the year of Rauschenberg's
birth) signifies a small station at
which trains only stop on signal. It
can also refer to a small community,
or a brief personal appearance, as by
a politician on tour.[8] The flashing red
light attached to the right panel
suggests the railroad, affirming the
small station and town of a "whistle-
stop." It might further imply that the
Rauschenberg family, which was
poor, lived on "the wrong side of the
tracks." The artist may also be linking
the word's meaning of "brief
appearance" to his feelings toward
his hometown, an isolated place that
he could not wait to leave (and, then,
did not return to for forty years).
"There's a lot of sadness about Port
Arthur. And I had a terrible time in
school. I didn't have a particularly
celebrated childhood there."[9] These
early years were fundamentally
marked by his adverse relationship
with his father.

Ernest Rauschenberg worked as a
lineman with Gulf States Utilities.
Whistle Stop's blinking light, which
more closely resembles a warning
signal set out by a lineman than the
lantern traditionally employed in
railroading, can be understood to
represent the artist's father. A light
signaling caution and danger is
additionally appropriate to symbolize
his father because he had a "fantastic
temper" and could become
physically violent.[10] The elder
Rauschenberg was an avid sports-
man and well-known breeder of bird
dogs. Several images in *Whistle Stop*
relate to his father's avocation, with
reproductions of birds appearing just
below and to the left of the flashing
light. Partially because of nearsight-
edness, and a fondness for animals,
Robert Rauschenberg was neither
accom-plished nor interested in the
hunting pursuits enjoyed by his
father. In this and other ways, the son
felt he continually disappointed his
father, who told him on his deathbed,
"I never did like you, you son of a
bitch."[11]

Of all the images in *Whistle Stop*,
the most intriguing in regard to the
father-son relationship is the portrait
of Abraham Lincoln that appears
behind the left door. A heroic and
tragic figure, Lincoln was "father" to
a house divided against itself. Art
historically, the Lincoln portrait
recalls the American painter John

P

Peto's wistful *trompe l'oeil* compositions of the late nineteenth and early twentieth centuries, which, with their multiple, random images and references to doors, anticipate *Whistle Stop*.[12] The Lincoln portrait also conjures up the biblical Abraham, who was called upon, and was prepared, to sacrifice his son. The story of this patriarch was certainly known to the artist, who as a teenager had decided to become a minister. Despite its prevailing sense of domestic tranquility, *Whistle Stop* subtly yet insistently refers to a strained relationship between father and son.

Ernest Rauschenberg suffered a fatal heart attack in October 1963, and the artist felt that he had "died before I could make him proud of me."[13] In 1976, when he began work on *Whistle Stop*, Robert Rauschenberg was honored by the National Collection of American Art (now the Smithsonian Museum of American Art) as *the* artist of the American Bicentennial. The same year, he appeared on a self-designed cover of *Time* magazine as "The Most Living Artist." In dedicating *Whistle Stop* to his father, the artist was perhaps seeking to secure a measure of paternal approval by opening, and closing, doors to his past.

MARK THISTLETHWAITE

1 Walter Hopps, "Introduction: Rauschenberg's Art of Fusion," in Walter Hopps and Susan Davidson, *Robert Rauschenberg: A Retrospective* (New York: Solomon R. Guggenheim Museum, 1997): 20.
2 Quoted in Dorothy C. Miller, ed., *Sixteen Americans* (New York: The Museum of Modern Art, 1959): 58.
3 Mary Lynn Kotz, *Rauschenberg/Art and Life* (New York: Harry N. Abrams, Inc., 1990): 214.
4 Undated typescript, "Installation Instructions for *Whistle Stop* by Robert Rauschenberg," Registrar's Files, Modern Art Museum of Fort Worth.
5 Jay Belloli, "American Realism and 'The Great American Rodeo,'" in *The Great American Rodeo* (Fort Worth: Fort Worth Art Museum and Texas Christian University Press, 1976): 23.
6 Quoted in Thomas B. Hess, "Replenishing Rauschenberg," *New York* (16 May 1977): 79.
7 An early Combine, *Untitled*, 1955 (in the collection of The Museum of Contemporary Art, Los Angeles), included more direct autobiographical references (photographs, for instance) to his family and home in Port Arthur than are evident in *Whistle Stop*.
8 *Merriam-Webster's Collegiate Dictionary*, 10th ed.
9 Quoted in "The Boy from Port Arthur," *Art and Antiques* (January 1986): 60. The artist suffered in school because of dyslexia, which was undiagnosed at the time.
10 Quoted in Jill Johnston, "The World Outside His Window," *Art in America* 80 (April 1992): 118.
11 Ibid.
12 See, for example, *Rack Painting with Jack of Hearts*, 1902, in the collection of the Des Moines Art Center.
13 Quoted in Johnston, 118.

Ad Reinhardt
American, 1913–1967

No. 6, 1946
Oil on masonite
32 × 48 inches (81.3 × 121.9 cm)
Museum purchase,
The Friends of Art Endowment Fund
2000.4.P.P.

Like his Abstract Expressionist peer Barnett Newman, Ad Reinhardt eventually rejected the gestural spontaneity of Jackson Pollock, Willem de Kooning, and Franz Kline, establishing a uniquely geometric and purist side of Abstract Expressionism. At the time of his death in 1967, Reinhardt embraced a challengingly austere image: his so-called Black paintings, consisting of subtle, almost indiscernible variations of black painted in symmetrical geometric blocks. The artist's own description of his final pictorial statements as "shapeless," "colorless," "textureless," and "transcendent"[1] indicate the radical nature of his vision.

These paintings were the culmination of a considered evolution that began in the late 1930s. Reinhardt's statements and the development of his art indicate a profound understanding and appreciation of the achievements of the great pioneer of geometric abstraction, Piet Mondrian. The evolution of Mondrian's art involved a gradual paring down of various landscape images to fundamental and ultimately abstract forms. By the time he moved to New York in 1940, Mondrian had reduced his compositions to the exclusive use of primary colors in strict vertical and horizontal geometric forms, and his philosophy of Neo-Plasticism was well known. The evolution of Reinhardt's art demonstrates a similarly considered path, albeit one filtered through the gestural surrealism of early Abstract Expressionism.

Reinhardt essentially began as an abstract painter, evolving an ever more radical form of abstraction in his ambition to go "beyond Mondrian."[2] His work of the late 1930s and early 1940s contained abstract forms, organic as well as geometric, flattened and set off against a background of contrasting color. It was in the 1940s, however, that Reinhardt began to dissolve his shapes, exploring the boundaries between color, tone, and form, an area of investigation that would occupy him throughout his career. Paintings such as *No. 6*, 1946 constitute what might be called the first phase in Reinhardt's mature evolution. In *No. 6*, the artist's earlier shapes have been dematerialized into veils of small, gestural brushstrokes that merge with their background to form a tapestry effect. Rather than reading a shape against a background, the artist presents us with an overall abstract field, the type that would distinguish Abstract Expressionism from early modern abstraction and its part-to-whole compositional strategies. Reinhardt's personal calligraphic symbols—part gesture, and vaguely pictographic—owe a debt to Surrealist automatism, as well as the artist's passionate interest in Chinese calligraphy. Rendered in rich greens, butter yellows, and pale pinks, *No. 6* also reflects Reinhardt's interest in exploring how much pictorial load color can carry without relying on the focused quality of contained forms. *No. 6* is a classic example of what would be subsequently called Color Field painting.

MICHAEL AUPING

1 Margit Rowell, "Ad Reinhardt: Style as Recurrence," in *Ad Reinhardt and Color* (New York: Solomon R. Guggenheim Museum, 1980): 22.
2 Ibid., 9.

Gerhard Richter

German, born 1932

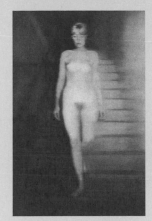

Ferrari, 1964
Oil on canvas
57 × 78 ½ inches (144.8 × 199.4 cm)
Museum purchase,
Sid W. Richardson Foundation
Endowment Fund
1997.4.P.P.

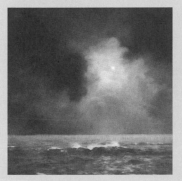

*Seestücke—Welle
(Sea Piece—Wave)*, 1969
Oil on canvas
79 × 79 inches (200.7 × 200.7 cm)
Gift of Anne and John Marion
in honor of Marla Price
2002.20.G.P.

*Ema (Nude Descending a
Staircase)*, 1992
Cibachrome, edition 9/12
76 ³/₈ × 49 ½ inches (194 × 125.7 cm)
Museum purchase,
Sid W. Richardson Foundation
Endowment Fund
1996.20.P.Ph.

*Photography had to be more relevant to me
than art history: it was an image of my, our,
present-day reality. And I did not take it as a
substitute for reality but as a crutch to help
me to get to reality.* GERHARD RICHTER

Commentary on page 142

R

Linda Ridgway
American, born 1947

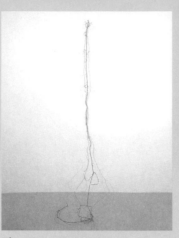

Three Squares, 2001
Bronze
108 × 26 × 26 inches
(274.3 × 66 × 66 cm)
Dimensions variable
Gift of Anne and John Marion
2002.21.G.S.

You don't really see the squares at first. I wanted them to look as if nature had made them, as if they were a rarity formed by the root, perhaps in its search for water. The part of the piece that I love the most is that the squares don't really seem like a human imposition. LINDA RIDGWAY

Linda Ridgway's *Three Squares*, 2001 is a cast bronze sculpture of a grapevine root that the artist dug out of the ground. She has always been intrigued with the idea of using parts of nature that are not normally visible, like roots, something she describes as "beauty overlooked."[1] In *Three Squares*, the root forms a single, delicate line that hangs against the gallery wall, coiling at the base. The line is broken by three bronze squares at its top, middle, and bottom, carefully infused to create a subtle interruption. This piece is the first of Ridgway's sculptures to combine an organic form with geometric ones. Her intent was to create something that nature would not, but put it all together as if it had occurred naturally. Of *Three Squares*, Ridgway has said, "You don't really see the squares at first. I wanted them to look as if nature had made them, as if they were a rarity formed by the root, perhaps in its search for water. The part of the

piece that I love the most is that the squares don't really seem like a human imposition." The idea of geometric shapes coalescing with a natural form is a metaphor for the cycle of life, especially the balance between man and nature, which is an ongoing theme in Ridgway's work.

Three Squares, like much of the artist's work, is cast directly from a grapevine root, rather than a mold, making it a unique bronze. In fact, Ridgway casts some of the thinnest and most fragile materials available—natural and man-made, from spools of yarn to twigs— making her work technically challenging. To create *Three Squares*, Ridgway completely obliterated the vine; high temperatures reduced it to ashes. Yet bronze is eternal, thus she immortalizes what she destroys. In *Three Squares*, Ridgway's artistic method and sensibilities come together to create one fragile-looking, sublime line.

Her use of basic form and its minimal presentation make the work kindred in spirit to that of Agnes Martin, whose work she has often cited as an inspiration, especially because of its meditative quality and symbolic content. Martin, like Ridgway, uses line as a central motif to make metaphoric connections to nature. Instead of casting her lines in bronze, however, Martin creates grids, either drawn with graphite or painted in restricted color palettes. In 1976, shortly after Ridgway moved to Dallas, she visited the Modern Art Museum (then called the Fort Worth Art Center), where she saw Martin's work for the first time, in a group exhibition called *American Artists: A New Decade*. "I had just moved to town and it was my first time to visit the Museum. I had never seen Martin's art before, and the show featured her paintings and prints. I thought it was the most beautiful work I'd ever seen."

Ridgway's sculpture also shares a kinship with the work of Richard Tuttle, who creates simple sculptural forms using man-made and natural materials. Tuttle frequently takes risks in his art by using understated materials and motifs that are often physically small in comparison to the large gallery walls they hang on, but his subtlety is successful. The impact of Ridgway's sculpture works in a similar way. She describes *Three*

Squares and much of her work as "three-dimensional drawings," because the light and shadow that fall on the wall and the piece become an integral part of its form. Like Tuttle's work, *Three Squares* requires "breathing space," and, despite its size and scale, it easily commands an entire wall. "The piece determined its own space in a way. I had actually gathered the grapevine root for another piece that I never made. I hung the root aside in my studio and realized after looking at it there for a while that it was a wonderful thing on its own. Writers often say, 'the piece wrote itself,' and to me, this is an apt explanation of how *Three Squares* came about."

Titles are important to Ridgway, who believes that they convey essential information, not only for a specific piece, but also within a particular body of work. In the case of *Three Squares*, elegance of form is combined with humor and personal history: "My dad used to repeat the old adage, 'Everything is all right as long as you have three squares.' He meant meals, of course. But for me, just having three squares means everything is really okay."

ANDREA KARNES

1 Quotes from the artist are from a conversation with the author, 21 August 2001.

Susan Rothenberg
American, born 1945

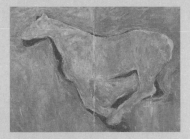

Cabin Fever, 1976
Acrylic and tempera on canvas
67 × 84 ¹/₈ inches (170.2 × 213.7 cm)
Museum purchase,
Sid W. Richardson Foundation
Endowment Fund
and an anonymous donor
1991.10.P.P.

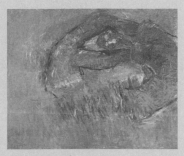

Orange Break, 1989–90
Oil on canvas
79⁵/₈ × 95¹/₈ inches
(202.2 × 241.6 cm)
Museum purchase
1997.1.P.P.

Commentary on page 149

Mark Rothko
American, born Latvia. 1903–1970

Light Cloud, Dark Cloud, 1957
Oil on canvas
66 × 61³/₄ inches (167.6 × 156.8 cm)
Museum purchase, The Benjamin
J. Tillar Memorial Trust
1970.28.P.P.

I realize that historically the function of painting large pictures is painting something very grandiose and pompous. The reason I paint them, however…is precisely because I want to be very intimate and human.

MARK ROTHKO

With its floating, feathery rectangles of color, *Light Cloud, Dark Cloud*, 1957 exemplifies Mark Rothko's mature Abstract Expressionist style of the 1950s. Russian-born Marcus Rothkowitz had come to the United States in 1913, became a United States citizen in 1938, and adopted the name "Mark Rothko" in 1940 (legalizing it in 1959). Between 1924 and 1926 he took classes at the Art Students League, where he studied primarily with the modernist Max Weber. In the late 1920s Rothkowitz met Milton Avery, whose coloristic art was to profoundly affect him. He also became friends with Adolph Gottlieb, who like him would become a leading member of the New York School. During the 1940s Rothko's art evolved from an expressionistic realism to a myth-oriented Surrealist manner to the beginnings of his chromatic Abstract Expressionism. *Light Cloud, Dark Cloud* is a "classic" Rothko composition, although it is also unusual because of its referential title.

The painting shows three soft-edged rectangles of color—dark pink, deep red, and bright white—one on top of the other. The forms float next to one another and over

R

the composition's very thinly painted burgundy ground. The red and white shapes are flatly painted, while the pinkish form displays color modulations and evidence of brushwork. As in many Abstract Expressionist paintings, space fluctuates between being perceived as infinite and shallow. With their diffused edges, the color forms suggest a transitional state, as though they are in the process of expanding or contracting. However, their symmetrical arrangement, their being set within the margins of the canvas, and the central placement of the large red-saturated rectangle all serve to counter any tension generated by the forms' indefinite boundaries and spatial relationships, and imbue the composition with serenity.

In 1949 and 1950 Rothko developed the technique and style evident in *Light Cloud, Dark Cloud*. The artist would begin by coating raw canvas with a glue size mixed with powdered pigment. This would be covered by an oil ground, followed by washes of paint so thin that they created the extraordinary translucency for which Rothko's paintings are admired. Conservator Dana Cranmer has explained that as a result of his dilution of the paint, "light penetrate[s] the attenuated paint film, striking the individual pigment particles and bouncing back to suffuse the surface and engulf the viewer in an aura of color."[1] For many viewers, this effect promotes the religious or spiritual feeling often associated with Rothko's works. In *Light Cloud, Dark Cloud* the ground is so thin that the canvas shows through to such an extent that the surface appears almost speckled, which strikingly contrasts with the denser rectangles of white and red. The large size of the canvas enhances the power and beauty of the colors, and makes the spectator's experience more immediate and engaging. The artist stated, "I realize that historically the function of painting large pictures is painting something very grandiose and pompous. The reason I paint them, however…is precisely because I want to be very intimate and human. To paint a small picture is to place yourself outside your experience… [with] the larger picture, you are in it. It isn't something you command."[2] The large format and Rothko's

technique assured the dominance of color, yet the artist did not intend the experience of color in *Light Cloud, Dark Cloud* and his other pictures to be an end in itself.

Like other Abstract Expressionists, Rothko shunned the concept of art for art's sake. Rather, he believed that "there is no such thing as good painting about nothing….the subject is crucial and only that subject matter is valid which is tragic and timeless."[3] By tragic, the artist meant a sublime acceptance of the inevitability of death; "tragic art, romantic art deals with the fact that a man is born to die."[4] Rothko regarded color as "merely an instrument" that allowed him to achieve "poignancy of mood" and express "basic human emotions—tragedy, ecstasy, doom….The people who weep before my pictures are having the same religious experience I had when I painted them. And if you … are moved only by their color relationships, then you miss the point."[5] As art deeply *felt*, Rothko's paintings are infused with the spirit of Romanticism.[6]

The priority given to feeling, mood, and emotion accounts for most of Rothko's mature pictures, being untitled or designated by a number or colors. By not assigning associative titles, Rothko chose to leave open a viewer's experience and reading of a work. With its referential title, *Light Cloud, Dark Cloud* differs from most of his pictures; only three other paintings from the 1950s have similar titles: *Blue Cloud*, 1956 (Ho-Am Art Museum, Seoul); *White Cloud*, 1956 (Private collection); and *White Cloud over Purple*, 1957 (Private collection). References to his compositional forms as "cloudlike" and "clouds of color" do occur regularly in the literature on Rothko's art, and, on one occasion, even the artist used a cloud metaphor to describe his work. Nevertheless, while it is tempting to read Rothko's forms as symbolizing natural phenomena, such as clouds and horizons, the artist clearly opposed such interpretations—"There is no landscape in my work."[7]

Rothko rarely offered an interpretation of his work, because "a painting is not a picture of an experience; it is an experience."[8] However, Rothko did say of *Green and Tangerine on Red*, 1956

(The Phillips Collection, Washington, D.C.) that the red form "could symbolize the normal, happier side of living; and in proportion the dark, blue-green rectangle measure above it could stand for the black clouds or worries that always hang over us."[9] His unusually specific reading suggests one way of approaching *Light Cloud, Dark Cloud*. Perceiving the pinkish form at top as "dark cloud" and the white shape at bottom as "light cloud," the viewer may feel them to be opposing elements (perhaps signifying such universal polarities as negative/positive, death/life) held in check by the "normal" red rectangle in the center. The painting presents life's spectrum and communicates the fleeting, tenuous resolution of its extremes. Any interpretation of a Rothko painting, however, ultimately fails to capture fully the experience of the picture's power, subtlety, presence, and color.

After 1957 Rothko increasingly adopted a more somber palette and gave harder edges to his forms. An untitled work from 1969 in the Modern Art Museum's collection exemplifies the artist's late "dark paintings." The stark and dramatic contrast between darks and lights in such a work is often linked to the artist's uncertainty about the direction and reception of his art as he became famous, and, with its brooding sensibility, is seen as foreshadowing his suicide in 1970. In fact, his last compositions were not limited to black, browns, and grays. Rothko explored the possibilities of predominately white paintings, and he continued to work with a range of colors. Red—"the most divine of ancient colors in the West"[10] and the color dominating his Abstract Expressionist paintings of the 1950s, such as *Light Cloud, Dark Cloud*—was the color of his final composition.

MARK THISTLETHWAITE

1 Dana Cranmer, "Painting Materials and Techniques of Mark Rothko: Consequences of an Unorthodox Approach," in *Mark Rothko 1903–1970* (New York: Stewart, Tabori & Chang, 1997): 192.

2 Rothko quoted in Diane Waldman, *Mark Rothko, 1903–1970: A Retrospective* (New York: Harry N. Abrams, Inc. in association with the Solomon R. Guggenheim Museum, 1978): 62.

3 Ibid., 39. This quotation is taken from the 7 June 1943 letter that Rothko, Adolph Gottlieb, and Barnett Newman (unacknowledged at the time) sent to the *New York Times* art critic Edward Alden Jewell in response to his review of the third annual Federation of Modern Painters and Sculptors exhibition.

4 Rothko quoted in Anna C. Chave, *Mark Rothko: Subjects in Abstraction* (New Haven and London: Yale University Press, 1989): 191.

5 Rothko quoted in Chave, 173 and Waldman, 58.

6 The fundamental writing on Rothko, Abstract Expressionism, and Romanticism is Robert Rosenblum, "The Abstract Sublime," *ARTnews* 59 (February 1961): 38–42, 56, 58.

7 Chave, 128–129.

8 Ibid., 172.

9 Marjorie Phillips's recollection quoted in Chave, 180.

10 John Gage, "Rothko: Color as Subject," in Jeffrey Weiss, *Mark Rothko* (Washington, D.C.: National Gallery of Art, 1998): 258.

Thomas Ruff
German, born 1958

Portrait (P. Lappat), 1987
Ektacolor print, edition of 4
83 × 65 inches (210.8 × 165.1 cm)
Museum purchase made possible by
a grant from The Burnett Foundation
1995.47.P.Ph.

Like the innovative German photographer August Sander, who in 1912 began a sociological study of German people by depicting them with the tools of their trade, Thomas Ruff documents the Western European culture of his generation. Sander, with his systematic approach, attempted to make class distinctions clear, but Ruff's portraits, which are also very methodical, collapse the hierarchy of class status, making race, age range, and gender the only obvious assumptions we can make about the people depicted in his work.

Portrait (P. Lappat), 1987 is part of Ruff's ongoing series that he began in 1984 and has been refining over time to reflect his evolving conceptual concern: making pictures that *seem* piercingly real, but in fact do not strictly represent real life. His early portraits captured sitters in various poses, but usually in profile and in front of a backdrop color of their choice. As Ruff went along, however, he decided to photograph all of his subjects (usually friends and acquaintances) in exactly the same way: all are evenly lit and in color, in a frontal pose, unadorned and before a white backdrop. Ruff shows the same ratio of head to body in each frame, and he enlarges the print so that it is three times bigger than life. Of this established formula, which evolved through experimentation with the medium, Ruff has said:

For a while, as I kept enlarging, I was printing them [the photographs] life-size, but that comes too close to reality, literally competes with reality, and since a picture is but a two-dimensional portrayal of three-dimensional reality, this does not make sense. I finally reached this dimension [three times life-size] in 1986, and I have been blowing them up this way ever since. At first I feared they would look even harder, more stark, but to my surprise the enlargement softened the facial surface, perhaps because the photographic elements of the paper became more apparent, thus conveying that it is just a picture.[1]

Ruff approaches all of his projects—documenting buildings, photographing stars in the night sky, and rephotographing newspaper pictures—with a strict technique, one that focuses on the subject in an unglamorous way absent of nostalgia and sentiment. Like Sander, and Bernd Becher—Ruff's teacher at the Kunstakademie in Düsseldorf and a photographer who has collaborated with his wife Hilla on a long-term project documenting industrial sites—Ruff is dispassionate toward his sitters.[2] Surprisingly, the ever-present matter-of-fact quality in his pictures is precisely what pushes them into the realm of fine art. They are ordinary, yet when looked at long enough, they become disturbing. Autonomous and detached, they explore the narrow gaps between objectivity and subjectivity, individuality and universality, and representation and abstraction.

Through Ruff's process of standardization and seriality, his subjects seem scientific—as if they are prototypes of the human race. But what do the images tell us about real people? In *Portrait (P. Lappat)*, the female sitter gazes directly out toward us with a deadpan stare. She wears no jewelry, minimal makeup, and a neat black turtleneck sweater. Her auburn hair is pushed back, shiny and styled, and her freckled skin glows. Her healthy and tidy appearance might lead us to assume that she is middle- or upper-class, but how do we really know? What does she do for a living? Is she a mother? Is she happy? What language does she speak? What is her personality like? These are the types of questions prompted by Ruff's portraits—and the answers depend on the connections we make when looking at his sitters, rather than what the photographs actually tell us about them.

ANDREA KARNES

1 Quoted in John Dornberg, "Thomas Ruff," *ARTnews* 88 (April 1989). 165.
2 Thomas Ruff, Thomas Struth, and Andreas Gursky, all represented in the collection, studied with Bernd Becher in Düsseldorf. Ruff, Struth, and Gursky began to receive notoriety during the 1980s for their use of photography to express their ideas with a strange and banal sensibility—something they had learned from Bernd and Hilla Becher.

R

Edward Ruscha
American, born 1937

Jar of Olives Falling, 1969
Oil on canvas
60 × 54 inches (152.4 × 137.2 cm)
Purchased from James J. Meeker,
Fort Worth
1975.49.P.P.

Paradox and absurdity have just always been really delicious to me. EDWARD RUSCHA

From out of nowhere and in the middle of nowhere, a falling jar with olives flying out of it—like a plunging meteor breaking apart—is about to make impact and will either bounce, crack, or shatter. Dramatic, perhaps; odd, certainly; Ruscha, definitely. *Jar of Olives Falling*, 1969 affirms Edward Ruscha's assertion that "paradox and absurdity have just always been really delicious to me."[1]

An aspect of the painting's "absurdity" is its taking of objects that might appear in a *still*-life painting and rendering them, not resting on a table, but hurtling through space. "Space" seems to be the term that best approximates the light-to-dark olive green expanse surrounding the glass jar and its tumbling and spilling contents. The viewer receives no orientation, except the color values, which gradually darken from bottom to top, suggesting gradations in the sky seen when looking at the horizon at sunset. Yet the perception of celestial infinity abruptly collapses because of the shadow cast by the jar. Suddenly, infinite space becomes finite and flat, but—paradoxically, absurdly, and deliciously—only in this portion of the composition. The rest of the work maintains spatial indeterminacy.... in contrast to the life-size realism of the falling jar of olives.

By 1969, the painting's date, Ruscha had gained wide recognition

as an artist whose compositions merged elements of Dada, Surrealism, Pop, and Conceptual art. Like many artists, Ruscha dislikes labels; for instance, being associated with Pop art made him "nervous."[2] He has acknowledged his kinship to the Surrealists and Dadaists, whose "nonsense was synonymous with seriousness, and I've always been dead serious about being nonsensical."[3] More than anything else, however, Ruscha's art was shaped by what he called the "atomic bomb" in his training: seeing a reproduction of Jasper Johns's *Target with Four Faces*, 1955 (The Museum of Modern Art, New York).[4] Ruscha, who had driven from Oklahoma City to Los Angeles in 1956 intending to become a commercial artist, came across a small black-and-white image of Johns's composition in *Print*, a graphic design journal. Appropriately, this work, which Ruscha declared disarmed and puzzled him, but also gave him great strength, appeared in a special 1957 issue devoted to "Sources of Inspiration." Although he was to work for a time as a graphic designer after graduating from the Chouinard Art Institute in 1960, Ruscha's encounter with *Target with Four Faces* had inspired him to become an artist.

As Ruscha's artistic career developed during the 1960s, Los Angeles was establishing itself as a vital art center. The Ferus Gallery, founded by Ed Kienholz with Walter Hopps and Irving Blum in 1957, showed important works by established and emerging artists. Andy Warhol's *Campbell's Soup Cans* were first exhibited there, in 1962. The Pasadena Art Museum hosted retrospectives of two artists admired by Ruscha: Kurt Schwitters in 1962, and Marcel Duchamp the following year. Ruscha participated in a significant 1962 Pasadena Art Museum exhibition, *New Paintings of Common Objects*, which also included work by Jim Dine, Roy Lichtenstein, Wayne Thiebaud, and Andy Warhol, among others. In 1965 the Los Angeles County Museum of Art opened its new building, and from 1965 to 1967 the influential magazine *Artforum* was based in L.A. Ruscha, under the *nom de commerce* Eddie Russia, produced layouts and covers for the magazine.[5] Particularly striking is his cover design for the

September 1966 issue on Surrealism: the word "Surrealism" shown soaped and scrubbed. With John Altoon, Larry Bell, Billy Al Bengston, Joe Goode, Robert Irwin, and Craig Kauffman, Ruscha helped shape the extraordinarily vital Los Angeles art scene of the mid- to late 1960s and define the cool, polished L.A. Look.

Today Ruscha is regarded as one of the most significant and influential of American artists. He has produced a large and impressive body of work that includes paintings, prints, drawings, books, movies, and graphic designs. The Modern Art Museum of Fort Worth holds an extensive collection of Ruscha's art, which, in addition to *Jar of Olives Falling*, includes another large painting (*Ice Princess*, 1990), a drawing (*Chop*, 1967), sixty-two individual prints (1962–1989), a portfolio of seventy-six organic and nonorganic images (*Stains*, 1969), a portfolio of six serigraphs (*Insects*, 1972), and a suite of twelve lithographs (*That Is Right*, 1989). Most of these compositions feature Ruscha's signature motif: words as visual objects. Because his art is closely identified with the representation of words, *Jar of Olives Falling*—a painting without a word—may seem unusual; however, the composition fits easily into his seminal work of the 1960s.

Jar of Olives Falling shares with other Ruscha compositions a fascination with visualizing noise. In *Honk*, 1962; *Noise*, 1963; and *Smash*, 1963, painted words convey and provoke aural sensation; while in *Large Trademark with Eight Spotlights*, 1962; *Noise, Pencil, Broken Pencil, Cheap Western*, 1963; and *Standard Station 10¢ Western Being Torn in Half*, 1964, words and images work together to suggest sound. *Marble Shatters Drinking Glass*, 1968 eliminates words and lets the image speak for itself. In *Jar of Olives Falling*, noise is anticipated: the glass jar is about to hit with a thud or crash; the olives and their juice are about to splatter. The splattering sensation relates to Ruscha's series of "liquid word" paintings (1966–1969), while the painting's instant-before-the-sound depiction links it to his *Bouncing Marbles, Bouncing Apple, Bouncing Olive*, 1969. The artist has remarked that he was "into freezing things" in his paintings, and likens

such imagery to that of Harold Edgerton's ultra-high-speed, stop-motion photographs.[6]

In regard to Ruscha's work, 1969 might be dubbed the Year of the Olive. Besides *Jar of Olives Falling* and *Bouncing Marbles, Bouncing Apple, Bouncing Olive,* the artist also rendered the fruit in *Eye* and *Painkillers, Tranquilizers, Olive.* It appears in his pastel *Adios with Olive,* three lithographs (*Sin; Marble, Olive;* and *Olive, Screw*), and a silkscreen, *Cheese Mold Standard with Olive.* Depicting olives convincingly at actual size brings a sense of realism to these otherwise often unreal compositions. But why olives? "Well, I don't really know. They confused me so I stopped using them." Ruscha further explains, "You know what they call pure research? *What you're doing when you don't know what you're doing.* That's what pure art is, too Well, with the olives I never *did* find out what I was doing."[7] The artist's comments should not, however, be considered a sign of frustration or failure, for he enjoys the belief that "disorientation is one of the best things about making art."[8]

Jar of Olives Falling is disorienting, but it is also intriguing, provocative, and humorous. The painting illustrates the artist's fondness for rendering "the raw power of things that make no sense."[9] Ruscha once spoke admiringly of Marcel Duchamp's painting *Chocolate Grinder,* 1914 (Philadelphia Museum of Art): "It was like a mystery that did not need explaining to me. I'll never need to take an intellectual delving into that subject—not because I'm afraid to, but because I don't think there would be that much to offer over something that just has its own power. The real oddity of the *Chocolate Grinder* is that it has a dedication to certain classic truths about the making of a picture and the illustrating of an object and then it also has this *inane*-ness to it."[10] Perhaps these words also offer the best account of *Jar of Olives Falling.*

MARK THISTLETHWAITE

1 Quoted in Ralph Rugoff, "The Last Word," *ARTnews* 88 (December 1989): 123.
2 Quoted in Neal Benezra and Kerry Brougher, *Ed Ruscha* (Washington, D.C. and Oxford: Hirshhorn Museum and Sculpture Garden, Smithsonian Institution, Washington, D.C. and the Museum of Modern Art, Oxford in association with Scalo, 2000): 150.
3 Patricia Failing, "Ed Ruscha, Young Artist: Dead Serious about Being Nonsensical," *ARTnews* 81 (April 1982): 77.
4 Ibid.
5 The phrase "*nom de commerce*" is from Dave Hickey, "Wacky Molière Line: A Listener's Guide to Ed-werd Rew-Shay," *Parkett* 18 (December 1988): 29.
6 The artist in conversation with the author, 23 March 2001.
7 Quoted in Dave Hickey, "Available Light," in Anne Livet, *The Works of Edward Ruscha* (New York: Hudson Hills Press in association with the San Francisco Museum of Modern Art, 1982): 26, 27. Recently Ruscha reiterated that the olives carried no symbolic meaning and that they were shapes he liked (conversation with author, 23 March 2001).
8 Quoted in Yves-Alain Bois, *Edward Ruscha: Romance with Liquids, Paintings 1966–1969* (New York: Gagosian Gallery and Rizzoli International Publications, Inc., 1993): 19.
9 Ibid.
10 Failing, 77.

Lucas Samaras
American, born Greece 1936

Stiff Box #10, 1971
Cor-ten steel
$21^3/_4 \times 22 \times 15^7/_8$ inches
($55.2 \times 55.9 \times 40.3$ cm)
Museum purchase, The Benjamin J. Tillar Memorial Trust
1971.56.P.S.

Lucas Samaras works in a broad range of media, including painting, sculpture, photography, and film, and he also participated in Performance art and Happenings in the late 1960s and 1970s. Boxes, such as *Stiff Box #10,* 1971, however, have been a central and consistent motif throughout the artist's career. Samaras began making them in the early 1960s, and in 1971 he created a sub-category, the *Stiff Box* series. He varied the size, format, and content, but for all of the *Stiff Box* pieces, he used cor-ten steel as a medium to create inflexible structures that explore balanced and geometric form. The stiff boxes also have in common that they remain open, and are in fact impossible to close.

The cor-ten steel used to fashion *Stiff Box #10* has a lush, rust-brown surface that looks like suede, which gives it a skinlike, tactile, and seductive appeal. The box is divided into four distinct parts. The left top quarter takes the shape of a staggered ziggurat, an ancient Mesopotamian temple usually at the center of a sprawling citadel. The top right quarter is the shape of another ancient construct, a pyramid with four triangular sides curving inward and upward toward its sharp central point. With its title and temple references, *Stiff Box #10* suggests the idea of death; "stiff box" is a vernacular term for a coffin.

In 1965 Samaras created his first "environment," entitled *Room #1,* a re-creation of his own bedroom and an important precursor to his boxes.[1] In the room, Samaras's personal belongings and artwork line the walls around the bed. Although the room is empty, the blanket on the bed is wrinkled and indented, as if someone has just been there. This idea of presence/absence, a strong current in his boxes, reveals itself even in this early work, which is incidentally a big box. *Room #1* contains a direct connection to the Modern Art Museum's work: the side panel of an open wood veneer cabinet by the bed echoes the distinctive ziggurat shape used in *Stiff Box #10.* From 1966 to 1970 Samaras elaborated on the idea of the box in yet another way, creating mirrored corridors on a human scale. The act of walking through the corridors, with the obvious focus on the self, provokes a range of emotional states, from introspection to narcissism.

Samaras has made two other significant box types: colorful mixed-media assemblages and chicken-wire boxes. The assemblages often incorporate pins, razors, knives, and other potentially violent materials that invoke a rich visual and visceral response. They are dazzling fetish-like objects, yet they are also repellent and threatening. His chicken-wire boxes, often painted, focus on beauty and simplicity of form and reflect openness, which is inherent to the wire medium. With *Stiff Box #10,* Samaras created a visual puzzle: the bottom quarters of the box comprise corresponding negative spaces for the top quarters' geometric shapes, yet because the box cannot close, these matching sections will never fit together. The box form itself implies the idea of containment, and Samaras further constructs a work with a number of other provocative binary opposites, such as male/female, positive/negative, sensual/resistant, full/empty, in/out, and perhaps most significantly, presence/absence.

ANDREA KARNES

1 Information about Samaras's *Room #1* and a photograph of the actual environment was obtained from Thomas McEvilley's essay "Intimate But Lethal Things: The Art of Lucas Samaras," in *Lucas Samaras Objects and Subjects: 1969–1986* (New York: Abbeville Press, 1988): 14–15.

R

Kurt Schwitters
British, born Germany. 1887–1948

Egg, Half Moon, Birchwood, Opening Blossom, and *Flint Pebble,* 1937–47
Painted plaster, dimensions variable
Museum purchase, The Benjamin J. Tillar Memorial Trust
1971.48.1–5.P.S.

Kurt Schwitters's *Egg,* 1937–38, *Half Moon,* 1938–39, *Birchwood,* 1940, *Opening Blossom,* 1943–44, and *Flint Pebble,* 1945–47 are individual pieces, although historically the Modern Art Museum has shown them as a group. These intimately scaled sculptures were made at a time when Schwitters had left Germany, for Norway and then England, to escape the Nazi regime.[1] Schwitters began his career as an expressionistic painter who also created realistic portraits, but as he matured as an artist, he began to work in a broader range of media. He also wrote poetry and articles, worked as a graphic designer, and created advertisements. He is perhaps best known for his collages and assemblages, often made from trash, such as discarded train tickets and newspaper clippings. However, the Modern Art Museum's five small sculptural works, each made of plaster and hand-painted by the artist, reflect some of the main aesthetic concerns of his later career—creating harmonious forms that are personal and universal, and that connect art to nature.

Schwitters is most often associated with the German Dada artists, partially because he used unconventional materials to make his art. In comparison with theirs, though, his work is less severe and less political. His artistic production is perhaps best understood not only in relation to Dada and the climate of post-World War I Weimar Germany, from which the movement took shape, but also in terms of 1920s avant-garde art. Schwitters's style of creating linear and carefully arranged compositions, often built up from found objects, was influenced by the Constructivist movement that began in Russia and the Dutch movement known as De Stijl (the style). Both movements linked advertising and architecture to fine art, and celebrated the idea of modernity.

In the period between the two World Wars, Germany was on the verge of civil war and its people experienced upheaval, in part due to Fascist dogma and the false optimism and propaganda of the Weimar Republic. During these years, approximately 1919 to 1939, the country was traumatized, as was much of Europe, and tried to recover its morale, in part through the campaign promises of the Weimar government. Many German Dada artists made art in response to their political disillusionment. Their artistic output was largely divergent from that of France's Dadaists—such as Francis Picabia and Marcel Duchamp—whose creations were often political, but were also mocking, ironic, and humorous. The German Dadaists were generally more aggressive and revolutionary, often directly reflecting the country's volatile atmosphere.

Although affected by the war, some new German movements were less political, and Schwitters's work is an example of this. Certain groups of the time, such as Walter Gropius and his faculty at the Bauhaus (founded in 1919)—which included such artists as Wassily Kandinsky, Paul Klee, and Lyonel Feininger—were using the formal and design aspects of artmaking to form an influential, international, modern style. Other popular artistic offshoots of Cubism were forming, such as Purism in France and Precisionism in America. In 1919 Schwitters coined *Merz,* a nonsense word that he used to describe his personal aesthetic vision, which involved using refuse to make art. He looked to the collages of Pablo Picasso, Georges Braque, and others for inspiration and as a point of departure. *Merz* focused on the formal aspects of artmaking and was most often non-objective and apolitical. He also created *Merzbau* (Merz Buildings), an addition to *Merz* that involved making large architectural environments out of discarded materials.

In 1924 Schwitters founded his own advertising agency, *Merz Wrebezentrale,* in Hanover. He stayed in the Weimar Republic until 1933, at which time, with the mounting political problems and the rise of the National Socialist party, he left his homeland. Leaving his wife in Hanover, Schwitters began traveling throughout Europe with his teenage son, Ernst. In 1937 he immigrated to Norway and by 1940, he had settled in England, where he lived until his death in 1948. Although he is often described as actively anti-Fascist, Schwitters's insistence on keeping art and politics separate is well documented. He believed art could be personal and at the same time speak to broader public issues that connected art to nature, more than to political and cultural ideologies of the day.

The five small-scale works in the Modern Art Museum's collection mirror his philosophy. Each simple shape, although not made from objects found in nature, is organic, biomorphic, and seemingly interdependent; every shape complements the next. In the works' titles, Schwitters reveals what these abstract forms represent to him—*Egg, Half Moon, Birchwood, Opening Blossom,* and *Flint Pebble.* The works are subtle, and as beautiful and sincere as the objects in nature they suggest.

ANDREA KARNES

1 For detailed information about Schwitters's career see John Elderfield, *Kurt Schwitters* (New York: Thames & Hudson, 1985) and Stephanie Barron with Sabine Eckmann, *Exiles + Emigrés: The Flight of European Artists from Hitler* (New York and Los Angeles: Harry N. Abrams, Inc. in association with the Los Angeles County Museum of Art, 1997).

Sean Scully
American, born Ireland 1945

Wall of Light Desert Night, 1999
Oil on linen, two panels
Overall 108 × 132 inches
(274.3 × 335.3 cm)
Museum purchase
2000.24.P.P.

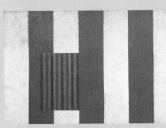

Pale Fire, 1988
Oil on canvas
96 × 146 ½ inches (243.8 × 372.1 cm)
Museum purchase,
Sid W. Richardson Foundation
Endowment Fund
1989.3.P.P.

Catherine, 1979
Oil on canvas
84 × 84 inches (213.4 × 213.4 cm)
Museum purchase made possible by
a grant from Anne and John Marion
2002.22.P.P.

Catherine, 1982
Oil on canvas
114 × 97 ³/₄ inches
(289.6 × 248.3 cm)
Museum purchase made possible by
a grant from Anne and John Marion
2002.25.P.P.

Catherine, 1983
Oil on canvas, two panels
Overall 115 × 96 inches
(292.1 × 243.8 cm)
Museum purchase made possible by
a grant from Anne and John Marion
2002.26.P.P.

Catherine, 1986
Oil on canvas, three panels
Overall 96 × 130 inches
(243.8 × 330.2 cm)
Museum purchase made possible by
a grant from Anne and John Marion
2002.29.P.P.

Commentary on page 157

George Segal
American, 1924–2000

Chance Meeting, 1989
Three life-size bronze figures with
dark patina, aluminum post,
and metal sign
125 × 74 × 58 inches
(317.5 × 188 × 147.3 cm)
Museum purchase,
Sid W. Richardson Foundation
Endowment Fund
1989.20.P.S.

George Segal created his first plaster
figure, *Man at a Table*, in 1961. Of
the piece, Segal said, "I was my own
first model. I wrapped myself in the
bandages and my wife put on the
plaster. I had a hell of a time getting
the pieces off and reassembled. But
it eventually became *Man at a Table*.
I had found my medium."[1] Previously
a painter, Segal switched to sculpture
during this period and continued
throughout his career to elaborate
on figures within environments that
include props from real life—
benches, movie marquees, lunch
counters, or in the case of the
Museum's piece, a street sign. In the
mid-1970s he began casting in
bronze, as he did for *Chance Meeting*,
1989. The bronze works, like the
ghostly plaster figures, focus on
contemporary daily life, often
conveying a kind of existential
loneliness.

Chance Meeting depicts a street
corner with three life-size figures,
finished with a dark green patina
and dressed in modern clothes.
Apparently having unexpectedly run
into each other at the intersection of
two city streets, the figures' postures
and attentive expressions indicate
that they are engaged in a serious
conversation. The two women have
their hands in their coat pockets and
the man stands with his hands

clutched together behind his back.
While they are seemingly relaxed in
one another's company, the piece
also portrays a classic example of
being alone in a crowd.

Segal created works such as
Chance Meeting by casting several
sections of his models (often family
members and friends) and then
assembling their parts to complete
the piece. His artistic technique
involved making molds of their body
parts and faces by wrapping the
sections in the same material
doctors use to make casts for broken
bones. Segal often described this
creative process as magical, explain-
ing that the model's personality and
emotional state came through when
the plaster or bronze anatomy was
completely assembled. But while the
figures are in many ways distinct and
naturalistic, the artist only partially
described certain features. For
example, he usually left their eyes
and mouths closed, just as the
models actually were while he
created the molds. The effect of this,
combined with their being all one
color (whether it is white plaster or a
dark patina), strips down the figures
to essentials, reinforcing that they
are objects meant to make us think
about real people.

Like Segal, Edward Hopper used
the figure in his work to depict
routine events in daily American life.
Acknowledging Hopper as a major
artistic influence, Segal said, "He
[Hopper] had to make some kind of
marriage between what he could see
outside with his eyes, touch with his
hands, and the feelings that were
going on inside. Now, I think that's
as simply as I can say what I think
about art."[2] His assessment of
Hopper emphasizes sight, touch,
and emotion, which are clearly key
aspects of his own artistic concerns.
While Segal's play on typical urban
scenarios, such as the one seen in
Chance Meeting, broadly addresses
human interaction, it also reveals
basic and individual psychological
states that we undergo in an ordinary
day, but are not always acutely
aware of.

ANDREA KARNES

1 Quoted in Phyllis Tuchman,
 George Segal (New York:
 Abbeville Press, 1983): 23.
2 Ibid., 111.

Richard Serra
American, born 1939

*Right Angle Corner Prop
with Pole*, 1969
Antimony lead
51 3/16 × 76 3/4 × 76 3/4 inches
(130 × 194.9 × 194.9 cm)
Museum purchase,
Sid W. Richardson Foundation
Endowment Fund
1999.32.P.S.

The evolution of twentieth-century
sculpture and its embrace of metal,
from Pablo Picasso and Julio
González in the early part of the
century to David Smith in the 1950s
and 1960s, involved a crucial stage of
development from figuration and
metaphor to abstraction. In his *Cubi*
works of the 1960s Smith explored
the deconstructive possibilities of
sculpture by creating simple geo-
metric forms that appeared to be
coming together and falling apart
simultaneously. The implication was
one of an ambiguous state between
balance and instability. In Smith's
work, however, gravity was illusionis-
tically suspended by the forms' being
welded together, linking it with past
forms of gravity-defying sculpture.

Richard Serra's sculpture of the
1960s and 1970s once again
reconceived the general orientation
of sculpture, from that of three-
dimensional illusion to an aesthetic
of direct physical experience. Serra's
early experiments focused on matter
itself and the various procedures
suggested by different materials and
their properties. The artist made a
series of *Belt Pieces* in 1966 after
coming upon discarded rubber in the
Canal Street area of New York City.
These works were composed of
lengths of rubber that were wired
together to form large, curving
bands. The wall reliefs were defined
by gravity, the lyrical beauty of the
line created by the looping belts,
which hung according to the weight
of the rubber material.

The development of Serra's art
reached a critical point in 1969. At

that time he created *Casting*, 1969,
which was made when the artist
threw molten lead at a cast made by
the angle between the wall and floor
of a large warehouse. As the molten
lead cooled, it took the form of the
corner it had been thrown into.
In making such works, the artist
employed large lead plates as corner
props. That same year, he began
balancing the props into free-
standing works. The result was the
Modern Art Museum's *Right Angle
Corner Prop with Pole*, 1969. A rolled
lead pole and heavy lead plates lean
against each other in the manner of a
house of cards. Because the con-
stituent parts are not welded or arti-
ficially connected, the viewer needs
to inspect the configuration, moving
carefully around it, to reassure them-
selves of what Serra already knows:
"You can build a structure under
compression that implies collapse
and impermanence and yet in its
mere existence denies this. What I
find interesting…is that as its forces
tend toward equilibrium, weight is
negated."[1] By relying on gravity and
inertia rather than a welding torch,
Serra stripped assembled sculpture
of its characteristic stasis and
architectonic illusionism, at the
same time creating a sculptural
experience of profound balance.

Experiencing vividly the interplay
of weight and balance, the viewer is
drawn into the behavioral space of
the work, a space that is actual and
potentially dangerous. Serra has
stated flatly that the idea of a
detached spectator, in a perceptual
space somehow separate from that
of the sculpture, is a fiction,[2] and
much of his work of the past three
decades has been designed to
underscore that contention.

MICHAEL AUPING

1 Quoted in "Interview: Richard
 Serra and Peter Eisenman,"
 Skyline (April 1983): 14
2 Quoted in "St. John's Rotary
 Arc," *Artforum* 19 (September
 1980): 52.

Andres Serrano
American, born 1950

Klansman (Imperial Wizard III), 1990
Cibachrome print, edition of 4
60 × 49¹/₂ inches (152.4 × 125.7 cm)
Museum purchase made possible by
a grant from The Burnett Foundation
1995.14. P. Ph.

Nomads (Bertha), 1990
Cibachrome print, edition of 4
60 × 49¹/₂ inches (152.4 × 125.7 cm)
Museum purchase made possible by
a grant from The Burnett Foundation
1995.13. P. Ph.

*When I was photographing the Imperial
Wizard and saw him put on his green robe,
I said to his secretary that it looked like a
religious robe. And she said, "To some Klan
members they are."* ANDRES SERRANO

Klansman (Imperial Wizard III), 1990
simultaneously attracts and offends.
With its dramatic play of lights and
darks, incredible capturing of detail,
electric lime-green color, and
technical perfection, *Klansman
(Imperial Wizard III)* is beautiful to
behold. That this exquisite
composition monumentalizes a
member of the white-supremacist Ku
Klux Klan is profoundly disturbing.
Neither satirically nor ironically
presented, the hooded figure gazes
squarely—but with hidden eyes—at
the viewer. Repellent and seductive,
Klansman (Imperial Wizard III)
embodies the powerful, unsettling
ambiguity that characterizes Andres
Serrano's art.[1]

Serrano created *Klansman
(Imperial Wizard III)* in the aftermath
of the intense controversy surround-
ing his inflammatory image *Piss
Christ*, 1987 (Collection of the artist).
This five-foot-high photograph of a
cheap plaster crucifix immersed in
urine was a primary target for
right-wing conservative attacks on
government funding of the arts. The
"culture wars" began in the United
States Senate Chamber on 19 May
1989, when Senator Alfonse D'Amato
ripped up the catalogue for an
exhibition funded by the National
Endowment for the Arts that
included Serrano's photograph.[2]
The artist, a former Catholic who had
been drawn to the church for
aesthetic rather than spiritual
reasons, asserted that he was not
a heretic nor intent on destroying an
icon, but rather was concerned
with making a new, provocative one.
In this regard, Serrano clearly
succeeded. Unfortunately, the
striking beauty of the image, the
issues it raises, and the several
possible meanings it suggests
were all overlooked in the
impassioned rancor caused by its
perceived blasphemous title and
sacrilegious content.

As a result of the controversy,
Serrano realized that he could "no
longer function as a human being in
a vacuum....I began to allow people
to enter my life and work."[3] To this
end, he produced and exhibited
together two series in 1990: *Nomads*
and *Klan*. The romantically titled
Nomads consists of portraits of New
York City homeless people taken late
at night using a portable studio in
Tompkins Square Park and several
subway stops. Serrano drew
inspiration from the turn-of-the-
century photographs of Native
Americans made by Edward Curtis,
who saw himself as recording a
vanishing race. Serrano conceived
Nomads as representing "a class of
people who are on the verge of
extinction as individuals."[4] He aimed

to give a heroic face to an often willfully ignored group of people. The Museum's own photograph from the series, *Nomads (Bertha)*, 1990, exemplifies the dignity and individualism that Serrano brought to these usually "faceless and nameless people."[5] One writer found the "genially beaming" Bertha reminiscent of "one of Tolstoy's hardy, salt-of-the-earth peasants."[6] After completing *Nomads*, Serrano wanted to continue making portraits, but felt his sitters "had to be unusual subjects for me to be interested in them. I thought that masked portraits would be very unusual and immediately thought that the Klan would be natural."[7] Selecting the Klan as a subject was a daring, perhaps defiant, act by an artist who considers himself Hispanic.

Photographing the Klan represented a cultural and racial challenge for Serrano, the son of an African-Cuban mother and Honduran father. The artist acknowledged that it was also a challenge for the Klan to work with him. He realized, too, that his images would open him to charges of supporting and glorifying the Klan. Indeed, the riveting, monumental *Klansman (Imperial Wizard III)* and other images in the series possess such nobility, and the glossiness of fashion photography, that a friend told Serrano, "they almost look like recruitment posters for the Klan."[8] Serrano found that possibility repugnant, but knew he "had to grapple with the idea that for some, these hooded figures would appear as heroic knights rather than symbols of hatred and oppression. So much as I dislike what the Klan stands for, I had to put aside my personal feelings and photograph in the spirit of tolerance and compassion."[9] Nevertheless, the artist has stressed the role his personal feelings play in his work: "It is also important that I identify with my subjects. The Klan people and the homeless are outcasts. I have always felt like an underdog, I root for the underdog."[10] Serrano also felt that just as the *Piss Christ* controversy had turned him into a symbol, Klan members were more powerful as symbols than as people: "I saw them as human beings first and then they put on their robes and become symbols."[11] The Imperial Wizard was

a modest air-conditioning repairman, and Serrano found other members of the Atlanta chapter of the Klan whom he photographed to be "quite nice to me, yet they represent this organization dedicated to the hatred of people not like themselves."[12] Describing his intentions in *Klan* and *Nomads*, Serrano stated, "I am trying to connect with my own feelings. I am somewhat ambivalent about most things and sometimes even confused."[13] More than "tolerance and compassion," *Klansman (Imperial Wizard III)* expresses ambiguity and presents open-ended readings.

The photograph intrigues and frightens. Most museum viewers likely associate violence, hatred, fear, and militancy with the Ku Klux Klan, and few probably have encountered a Klan member close up. Serrano offers a safe opportunity to satisfy our curiosity. Virtually filling the composition from top to bottom, the heroic, centered, half-illuminated green-hooded man projects a powerful, assertive presence. At the same time, the contrasting darkness that engulfs the rest of the body (including the eyes), and which silences the surrounding space, renders the figure as mysterious and spooky. The one prominent eye opening in the hood—essentially a black hole—conceals the individual within and suggests the emptiness of a hollow man. The composition's realism, monumentality, and theatrical effects of lights and darks recall religious paintings by Caravaggio, while the photograph's sense of enigma and menace bring to mind Francisco de Goya's images of monks and flagellants. Serrano has acknowledged the influence of earlier art on his own, and has expressed an interest in showing how Klan members regard themselves as religious figures: "When I was photographing the Imperial Wizard and saw him put on his green robe, I said to his secretary that it looked like a religious robe. And she said, 'To some Klan members they are.'"[14]

In examining the costume in *Klansman (Imperial Wizard III)*, what stands out, even more than the robe's saturated green fabric, is the amateurish stitching around the eyeholes. The everyday reality of this unskilled handiwork jumps out at the viewer, and offers a human dimension to the otherwise

diabolical symbol of evil. It puts a face to the shrouded man. By focusing on the awkward sewing, Serrano counters the threatening presence of the figure, the beauty evoked by the richness of the Cibachrome process, and the feeling of mystery generated by the strong contrast of light and dark. Serrano's skill in artistically incorporating these competing elements and holding them in tension allows *Klansman (Imperial Wizard III)* to be a commanding and arresting image that eludes a single or comforting interpretation.

MARK THISTLETHWAITE

1 The Museum's collection includes three other Serrano photographs: *Nomads (Bertha)*, 1990; *The Church (Soeur Yvette II)*, 1991; and *The Morgue (Infectious Pneumonia)*, 1992.

2 Bruce Ferguson, "Andres Serrano: Invisible Power," in Brian Wallis, ed., *Andres Serrano: Body and Soul* (New York: Takarajima Books, 1995).

3 Quoted in Coco Fusco, "Andres Serrano Shoots the Klan," *High Performance* 14 (Fall 1991): 44.

4 Ibid., 45.

5 Ibid.

6 Ken Johnson, "Andres Serrano at Stux," *Art in America* 79 (March 1991): 134.

7 Quoted in Fusco, 44.

8 Quoted in Anna Blume, "Andres Serrano," in Betsy Sussler, *Speak Art!* (New York: New Art Publications, 1997): 208.

9 Ibid.

10 Quoted in Fusco, 44. Seeing himself as an outcast relates partly to his being a high school dropout taking art classes at the Brooklyn Museum, then being a drug addict and dealer.

11 Ibid., 45.

12 Robert Hobbs, "Andres Serrano: The Body Politic," in Robert Hobbs, Wendy Steiner, and Marcia Tucker, *Andres Serrano: Works 1983–1993* (Philadelphia: Institute of Contemporary Art, University of Pennsylvania, 1994): 38; Celia McGee, "A Personal Vision of the Sacred and Profane," *The New York Times*, 22 January 1995: H35.

13 Quoted in Fusco, 45.

14 Ibid.

Ben Shahn

American, born Lithuania. 1898–1969

Allegory, 1948
Tempera on panel
36 ⅛ × 48 ⅛ inches (91.8 × 122.2 cm)
Gift of W. P. Bomar, Jr.
in memory of Mrs. Jewel Bomar
and Mr. A. C. Phillips
1969.30.G.P.

Through his many paintings, prints, photographs, and illustrations, Ben Shahn became one of the best known and most widely collected American artists of the middle decades of the twentieth century. The year *Allegory*, 1948 was painted, he was named one of America's ten best painters by *Look* magazine. Shahn's high reputation was apparent in his being selected, with Willem de Kooning, to represent the United States at the Venice Biennale in 1954, and his serving as Charles Eliot Norton Professor of Poetry at Harvard University (1956–1957). The latter resulted in the publication of Shahn's influential book *The Shape of Content*. Primarily known as a practitioner of Social Realism, Shahn established himself as a leader of that movement with his 1931–32 series *The Passion of Sacco and Vanzetti*. Shahn and other Social Realists, including Philip Evergood, William Gropper, Jack Levine, and the Soyer brothers, rendered potent images of social, economic, and political events and injustices. The topicality of such works began to give way for Shahn during World War II, and he moved to an art that was more universal and also more personal. *Allegory* is the most significant example of this change.

Allegory's importance to the artist is clear, because the painting serves as the focus of his essay "The Biography of a Painting," which appeared in *The Shape of Content*. A colorplate of the painting is the book's frontispiece. In his essay, Shahn offers an insightful and thought-provoking analysis of the origins of *Allegory*. His discussion was triggered by the comments of a friend, the art critic Henry McBride, who singled *Allegory* out in his *New York Sun* review of the Whitney Museum's 1948 Annual Exhibition of Contemporary American Painting. McBride perceived in the red coloring of the painting's central form "a subtle tribute to our quondam friend but present enemy, the Soviet Republic."[1] Shahn found McBride's suggestion disconcerting, which is not surprising given the Cold War climate. It led him to review the painting and "try to assess just for my own enlightenment what really was in it, what sort of things go to make up a painting."[2]

Shahn succinctly describes *Allegory* as featuring "a huge Chimera-like beast, its head wreathed in flames, its body arched across the figures of four recumbent children. These latter were dressed in very commonplace clothes, perhaps not entirely contemporary, but rather as I could draw them and their details from my own memory."[3] The artist does not mention the stand of trees that appears (almost like a collage element) at the far left of the composition, nor the expressionistic touches of varied colors that activate the indefinable space the figures inhabit.

The direct source for the painting was a series of drawings that Shahn had produced for a *Harper's* magazine article about a Chicago fire in which four African American children had died.[4] Their father, John Hickman, was to shoot and kill their landlord, whom he held responsible for the fire. Shahn felt that "the implications of this event transcended the immediate story; there was a universality about man's dread of fire, and his suffering from fire. There was a universality in the pity which such a disaster invokes. Even racial injustice, which had played its part in this event, had its overtones. And the relentless poverty which had pursued this man, and which dominated the story, had its own kind of universality."[5] The artist began to develop some symbolic drawings of an abstract nature, but ultimately rejected them. He did retain, however, one symbolic element in the *Harper's* illustrations: "a highly formalized wreath of flames with which I crowned the plain shape of the house which had burned."[6] This motif was to appear around the head of the beast in *Allegory*.

After finishing the magazine commission, Shahn found that he could not dismiss the symbolic direction his drawings had initially taken, nor the event of the fire. He believed that he had not fully treated the potential of either. Among his discarded drawings were several of beasts and semiclassical shapes and figures. Of these, one showing a lionlike head caught his eye, and he began drawing variations of it in order to approach "some inner figure of primitive terror which I was seeking to capture."[7] The fire aroused in him memories of two fires he had experienced in childhood: one in his grandfather's Russian village of Vilkomir, and the other in Brooklyn, when his father saved Shahn and his siblings from their burning building. Perhaps the trees in *Allegory* relate to the conflagration in Vilkomir, while the beast's wreath of flames (taken from the *Harper's* illustration of a burning apartment building) refer as much to the Hickman fire as to that at Shahn's Brooklyn tenement.[8]

The fiery red beast that dominates *Allegory* recalls the image of the she-wolf who suckled Romulus and Remus, the founders of Rome. Shahn acknowledged this, but asserted that he abhorred the motif and found it immensely irritating.[9] The reason for this centered on his lifelong fear of wolves, "the most paralyzingly dreadful of beasts, whether symbolic or real."[10] He could easily imagine the great Roman wolf destroying, not nourishing, the children. These recumbent figures also carried personal meaning for Shahn: they are neither Roman nor the Hickman children, but "resemble much more closely my own brothers and sisters."[11] Yet, the pile of children—asleep or dead—derives from a United States Office of War Information (OWI) photograph of Holocaust victims.[12]

During World War II, Shahn worked in the OWI and encountered a barrage of photographs and other forms of evidence documenting the devastation and decimation abroad. This included "the secret confidential horrible facts of the cartloads of dead."[13] Shahn's appropriation of the photograph of war corpses and his own Jewishness do open a reading of *Allegory* as relating to the Holocaust. The artist never made such a claim, however. Instead, Shahn described his efforts to create a painting that was not about a specific occurrence, but one resonant with "the emotional tone that surrounds disaster; you might call it the 'inner disaster.'"[14] In *Allegory*, that sensibility centers on disaster and evil overwhelming the helpless and innocent. To convey the universality of his theme, Shahn drew upon his personal memories and current events, and synthesized them into a provocative symbolic painting, colorfully expressive in form and profoundly humanistic in content.

MARK THISTLETHWAITE

1 Francis K. Pohl, "Allegory in the Work of Ben Shahn," in Susan Chevlowe, *Common Man Mythic Vision: The Paintings of Ben Shahn* (New York: Jewish Museum, 1999): 114.
2 Ben Shahn, *The Shape of Content* (Cambridge, Mass.: Harvard University Press, 1957): 26.
3 Ibid., 25.
4 John Bartlow Martin, "The Hickman Story," *Harper's* 197 (August 1948): 39–52.
5 Shahn, 28.
6 Ibid.
7 Ibid., 31.
8 Pohl, 117.
9 Shahn, 32.
10 Ibid.
11 Ibid.
12 Ziva Amishai-Maisels, *Depictions and Interpretations: The Influence of the Holocaust on the Visual Arts* (Oxford: Pergamon Press, 1993): 78.
13 Shahn, 41.
14 Ibid., 32.

Cindy Sherman
American, born 1954

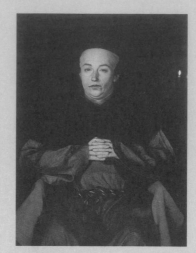

Untitled Film Still #65, 1980
Gelatin silver print
40 × 30 inches (101.6 × 76.2 cm)
Museum purchase made possible by
a grant from The Burnett Foundation
1995.10.P.Ph.

Untitled #207, 1989
Cibachrome print
65 $^{11}/_{32}$ × 49 $^{13}/_{16}$ inches
(166 × 126.5 cm)
Museum purchase made possible by
a grant from The Burnett Foundation
1995.12.P.Ph.

Untitled Film Still #55, 1980
Gelatin silver print
30 × 40 inches (76.2 × 101.6 cm)
Museum purchase made possible by
a grant from The Burnett Foundation
1995.9.P.Ph.

Untitled, 1981
Cibachrome print
24 × 48 inches (61 × 121.9 cm)
Museum purchase made possible by
a grant from The Burnett Foundation
1995.11.P.Ph.

Commentary on page 168

Michael Singer
American, born 1946

First Gate Ritual Series 10/78, 1978
White pine, stones, and marsh reeds
108 × 168 × 238 inches
(274.3 × 426.7 × 604.5 cm)
Purchased with funds from Mr. and
Mrs. Lewis Kornfeld and Nancy
O'Boyle and a matching grant from
the National Endowment for
the Arts Museum Purchase Plan
1981.18.P.S.

Using abstract and semiabstract configurations, Michael Singer's work mirrors the energies and forms he finds in remote natural landscapes. His vision of landscape is one of subtlety and transience, emphasizing it as a phenomenon that reveals itself in a series of events or moments. Singer has spent more than three decades studying various landscape environments in the United States and Europe, carrying out different types of "research" (a term he often uses to describe his temporary outdoor constructions). The metaphors he creates in his indoor sculptures and drawings are derived from his direct contact with the landscape while working outdoors.

Born in Brooklyn, New York in 1946, Singer studied art at Cornell and Rutgers Universities. In the late 1960s he rented a studio on the lower East Side of New York City, where he began making large-scale sculptures of steel and milled wood. One of these works consisted of four steel beams that went completely around the outer walls of a room, defining its space and emphasizing its geometrical strictness. Singer has remarked, "In retrospect, that piece related very much to what the city was about for me."[1] A number of works from that period were constructed with pivot points, which allowed them to be moved into different configurations. "Again, I think it might have been a psychological response to the city.

There was tremendous tension implied in the balance because you had these very, very heavy weights, and unless they were absolutely centered, correctly centered at an exact point, they would collapse."

In 1971 Singer opted for isolation from the art world of Manhattan, relocating to Wilmington, a small town in the wooded hills of Vermont. Singer's new environment spawned a number of adjustments in the way he approached his art. Part of Singer's adjustment to living in Vermont involved taking long walks in the woods, which led to his first outdoor constructions. These early outdoor works, entitled *Situation Balances*, were initiated by his interest in natural sculpture made by windfalls. Singer's first response to the woods was to collaborate with nature by emphasizing what was already there. He balanced large fallen trees across each other, using stumps as fulcrums or pivots, echoing an aspect of the early works. In some instances he would cut down dead trees, painting and chipping their ends to disguise the man-made saw cuts so the tree would appear to have fallen naturally. The largest of these works, constructed in a beaver bog, was three years in the making. It didn't bother Singer that few people (in some cases no one other than himself) actually saw these early works.

Eventually Singer began exploring other types of outdoor environments. In 1972 and 1973 he worked in the saltwater marshes on Long Island, New York, acquainting himself with a different set of natural materials. In Vermont he had manipulated the large hemlocks indigenous to that area; in the New York marshes he began using lighter, more mutable materials—mainly bamboo and reed—which he has continued to use since. The Long Island works, however, displayed the same qualities the Vermont *Situation Balance* series had; their form reflected the visual pattern of their surroundings to the extent that they began to blend into their context.

In 1975, again using bamboo and marsh reeds, Singer created his first work in the Florida Everglades, *Glade Ritual Series*, 1975. It was one of the first works to include the term "ritual" in the title—a word that encapsulates the artist's slow,

methodical process of working. For Singer, one of the most important aspects of making a work is the time he spends tuning in to a place: getting acquainted with the terrain, foliage patterns, sounds, and particularly the quality of light. For almost two months he lived in an isolated section of Everglades National Park, creating a work that consisted of fourteen separate constructions of marsh reeds and bamboo, stretching across 700 feet of a vast open glade. Relatively delicate in feeling, the constructions tended to draw more attention to the sense of light and space that filled the glade than to themselves as objects. *Glade Ritual Series* was precisely placed so that the blonde surfaces of the bamboo reflected the different moods of the sky (sunny, cloudy, overcast, etc.).

First Gate Ritual Series 5/76, 1976 in Roslyn, New York, also took place on a marsh. Long, thin slats of oak, held on the surface of the water by submerged stones, were bowed into forms that simulated the contour of nearby hills. Because the materials were bent into an elaborate vocabulary of curves based on the rhythms of the landscape and woven through each other, it was often difficult to tell if a particular line was moving toward the viewer, away, or diagonally. Depending on viewpoint, the work may appear to expand or contract, "as though," Singer has remarked, "it was a living, breathing form."

These same qualities are apparent to different degrees in Singer's indoor works, such as the Museum's *First Gate Ritual Series* 10/78, 1978. Singer's vision of nature as a continually changing form rather than a static scene or artifact is clearly reflected in this intricately balanced structure of wood and stone. The complex patterns he weaves together using stones and thin sections of wood appear to shift with the viewer's position, as transient natural phenomena—wind-blown limbs, rushing water, light, and shadow—are evoked. These are not outdoor sculptures brought indoors. They are a symbolic distillation of forms Singer perceived while spending extended periods working outdoors.

The First Gate referred to in the title and the elegantly bowed strips of

wood spanning thick sections of tree branches that make up the main body of the sculpture refer to the Japanese Tori gate, a ceremonial gateway that marks the entrance to the sacred precinct of a Shinto temple. The Tori, which has numerous variations, generally consists of two cylindrical vertical posts topped by a slightly bowed crosswise beam that extends just beyond the posts. The cross beam gently slopes downward from the horizontal as a gesture to the earth and its importance to the life force. Singer's *First Gate Ritual Series* is made of many bowed elements that counterbalance the vertical thrust of the twisting reeds. "For me," Singer has said, "it's all about nature, bringing the sculpture back down to earth. I don't see my sculptures as nature. They are just a gateway to nature."

MICHAEL AUPING

1 Quotes from the artist are from a conversation with the author, November 1981.

S

Leon Polk Smith
American, 1906–1996

Homage to Victory Boogie Woogie No. 2, 1946–47
Oil on wood
29½ inches (74.9 cm) diameter
Gift of Dr. and Mrs. Arthur Lejwa
1971.22.G.P.

For more than fifty years Leon Polk Smith explored the possibilities of geometric abstraction. His compositions display a myriad of configurations and colors, but his work is forever tied to the art of Piet Mondrian, in large part because of *Homage to Victory Boogie Woogie No. 2*, 1946–47. Smith always acknowledged the impact the Dutch painter's work had on him, although in later years he expressed resentment at "too much" having been made of the Mondrian connection.[1] To emphasize his artistic independence, the Brooklyn Museum of Art pointedly titled its 1996 retrospective of the artist *Leon Polk Smith: American Painter*.

Leon Polk Smith's origins could not have been more American. His parents were of mixed Cherokee and European ancestry, and he was born in 1906 in what was called Indian Territory (the following year it became the state of Oklahoma). Smith accidentally discovered art and a passion for it in his last year of college at what is now East Central University. He left Oklahoma for New York in 1936 to pursue graduate study in fine arts and art education at Teachers College, Columbia University. He received his master's degree in 1938. It was during his first year in New York that he encountered abstract art.

Smith's introduction to modernism took place at A. E. Gallatin's Gallery of Living Art. This influential collection of contemporary art, amassed by Albert Eugene

Gallatin, was housed at New York University from 1927 to 1943. Artists frequented the gallery (renamed the Museum of Living Art in 1936) to see works by Pablo Picasso, Fernand Léger, Joan Miró, Constantin Brancusi, Hans Arp, Piet Mondrian, and other modernists. Smith described the impact and importance of his visits to this gallery: "The Gallatin Collection opened my vision to uncharted territory. In particular, my eye was trained for spatial relationships and the ability to measure by looking at Mondrian."[2] Smith was not alone in his attraction to Mondrian's art.

Interest in the Dutch painter's work and geometric abstraction was strong among American artists in the 1930s and 1940s. Not only could examples of such art be seen in the Gallatin collection, but also variations of it were produced by artists who formed the American Abstract Artists group in 1937. These artists aimed to promote the cause of abstract art in the United States. Although Smith declined membership in their organization, his work was to have much in common with AAA painters, such as Ilya Bolotowsky, Burgoyne Diller, Fritz Glarner, and Charmion von Wiegand. This American commitment to geometric abstraction was reinforced by the presence of Mondrian himself in New York City from 1940 until his death in 1944. Mondrian and Smith never met, however, because Smith had left New York in 1939 and was not to return until early 1945.

The year following his return, Smith executed *Homage to Victory Boogie Woogie No. 1*, 1946 (Dallas Museum of Art, Dallas, Texas) and began work on the Modern Art Museum's painting, which was completed in 1947. What led him to undertake these two paintings at this time is not precisely known, but Smith would have heard of, and most likely visited, the Mondrian memorial retrospective held at The Museum of Modern Art in New York during the spring of 1945. There he would have viewed the last painting Mondrian worked on, the unfinished *Victory Boogie Woogie*, 1942–44 (Gemeentemuseum, The Hague). In speaking about what did inspire his *Homages*, Smith only said, "There have been times I've wanted to do a painting inspired by a particular

painting of Mondrian's. I wanted to make them as much my own as possible, but I wanted to show that they were inspired by *Victory Boogie Woogie*."[3] What drew the artist to this particular Mondrian painting?

We can only speculate on why Smith focused on *Victory Boogie Woogie*. Perhaps Smith, like later art historians, recognized in the work-in-progress a new stage for Mondrian: "A liveliness, a receptivity to new impressions, a suppleness in dealing with his own approach—all sharply in contradiction to the reputation of dogmatism that surrounded him."[4] Smith never cared for Mondrian's theoretical writings about art. He read them, but he found them "tedious" and "a waste of time."[5] The empirical American may have seen in *Victory Boogie Woogie* less theory at work and more intuition and experience. Undoubtedly, he admired the unresolved painting as an embodiment of Mondrian's continual commitment to push his art further.

Each of Smith's two *Homages* exhibits an open, airy arrangement of color forms that differs from the density of the more numerous blocks of color that make up *Victory Boogie Woogie*. Smith painted thin lines to link—explicitly and implicitly—color squares and rectangles, rather than duplicate the multicolored bars found in the Mondrian picture. More strikingly, Smith decided not to replicate the diamond shape of *Victory Boogie Woogie*.[6] His initial *Homage* takes the vertically rectangular format commonly associated with Mondrian works, while *Homage to Victory Boogie Woogie No. 2* more radically employs a circular support, or tondo, which the Dutch artist never employed.[7] The first *Homage* pays tribute by emulating the essence of Mondrian's art. *Homage to Victory Boogie Woogie No. 2*, however, honors Mondrian's creative spirit by using his art as inspiration to move in a new direction. Not surprisingly, Leon Polk Smith never made such claims about his work.

When asked why he made *Homage to Victory Boogie Woogie No. 2* a circular work, the artist laconically replied, "I likely found a circular piece of wood."[8] He went on to state that he found nothing challenging or special about working on a circle.

Yet Smith did explain that what drew him to Mondrian's art was the belief that "it would be wonderful to use his great discovery of the interchange of elements of form and space, or background/foreground ... [and] find a way of using that in curvilinear form—and that's what I was looking for, all through the forties."[9] It was not until 1954 that the artist felt he truly realized this goal. Nevertheless, *Homage to Victory Boogie Woogie No. 2* was an important first step in this realization, as well as a fitting tribute to an artist who had inspired Smith to begin his own intense exploration of geometric abstraction.

MARK THISTLETHWAITE

1 Brooke Kamin Rapaport, "Interview with Leon Polk Smith," in *Leon Polk Smith: American Painter* (Brooklyn: Brooklyn Museum of Art, 1996): 16. Smith also expressed admiration for the work of Hans Arp and especially that of Constantin Brancusi.
2 Leon Polk Smith in an interview with Robert T. Buck, in *Leon Polk Smith, Selected Works 1943–1992, Promised Gifts to the Brooklyn Museum* (Brooklyn: Brooklyn Museum, 1993): n.p.
3 Rapaport, 16.
4 Hans C. Jaffé, *Piet Mondrian* (New York: Harry N. Abrams, Inc., 1970): 158.
5 Carter Ratcliff, "Leon Polk Smith: The Geometry of Optimism," in *Leon Polk Smith: American Painter* (Brooklyn: Brooklyn Museum, 1996): 11. Also in Rapaport, 15.
6 A 1947 painting by Smith, *Black-Blue-White Squares*, does utilize the diamond format. The work is in the Sheldon Memorial Art Gallery and Sculpture Garden, University of Nebraska, Lincoln.
7 Mondrian did experiment with an oval format in the 1910s.
8 Rapaport, 16.
9 Exhibition brochure for *Leon Polk Smith*, Washburn Gallery, New York: 22 September–30 October 1982.

Nicolas de Staël
French, born Russia. 1914–1955

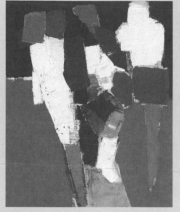

The Football Players, 1952
Oil on canvas
32 × 26³/₄ inches
(81.3 × 67.9 cm)
Gift of Mr. and Mrs. William M. Fuller
1975.39.G.P.

In April 1951 Nicolas de Staël attended an evening football match between France and Sweden at the Parc des Princes in Paris, and for the next year, he painted a series inspired by the game. *The Football Players*, 1952 belongs to this important series, which marked his return to figuration from his completely abstracted paintings of the late 1940s and 1950. In this work, de Staël transforms the flashes of color, light, and movement from the floodlit game onto his canvas with quickly executed large blocks of deep red, blue, gray, yellow ochre, black, and white. He balanced the composition with two horizontal bands—black at the top to indicate the night sky and convey the artificial lights of the stadium, and red for the grass at the bottom, making the light colors of the figures advance and appear energized with movement. De Staël's paint application—impasto patches of pigment applied with a palette knife—produced even, heavy, pure color that corresponded to the physicality, immediacy, and aggression of the game. Of this body of work, de Staël wrote to his friend the poet René Char, "On grass that is either red or blue, there whirls a ton of muscle in complete disregard for self with, against all sensibilities, a great sense of presence. What Joy!"[1]

Although de Staël was born in St. Petersburg to a family of Baltic nobility, the Bolshevik Revolution resulted in his immigration first to Poland, and then, as an orphan at the age of eight, to Belgium. From 1933 to 1936 de Staël attended the Académie Royale des Beaux-Arts in Brussels and was trained as a painter in the classical tradition. He eventually moved to France, where he was influenced by the great French avant-garde painters who came before him. His influences can be traced to Paul Cézanne, Henri Matisse, Chaim Soutine, Pablo Picasso, and Georges Braque. The influence of Cézanne's landscapes, especially the ways in which his passages of paint evoke the stirring of foliage and tree branches in the breeze, is apparent in de Staël's ability to invigorate static blocks of color with small slurred frissons of motion. Matisse's early flat patterning, use of bright colors like red and blue, and late paper cutouts also certainly inspired de Staël's painting. *The Football Players* is collage-like; each plane of color is an individual shape that adds to the unified whole, and indeed de Staël often used cutout arrangements as preliminary exercises for his paintings.

Cubism, however, especially that of Georges Braque, is perhaps de Staël's greatest influence. The two artists were neighbors in Paris at the end of World War II and Braque became de Staël's mentor, not only critiquing his works, but also introducing him to important artists, dealers, and collectors. Like Braque's Cubist works, *The Football Players* is characterized by complex dynamics between space and form, and limited but essential geometric shapes that represent three-dimensionality on the two-dimensional surface of a canvas. Braque's late work—landscapes with predominantly pure colors taken straight from the tube, and black skies—closely relates to *The Football Players*. De Staël's series, however, is more emotional and painterly than are many Cubist works, and in this way he connects to the work of the German Expressionists and other European modernists. He blurs figuration and abstraction to create fluidity, expressing action and excitement. De Staël also knew the work of Robert Delaunay, and had shown with Wassily Kandinsky in Paris in 1944. The focuses of these artists—rhythmic patterns, form, and color—were also concerns of his.

By 1950 de Staël had achieved success as an artist in Europe and America, where, with Braque's help, his works were purchased by important collectors such as Duncan Phillips and Albert Barnes. Although Abstract Expressionism was gaining momentum for its focus on non-representational works, de Staël was seen as the inheritor of French modernism, creating imagery that was set apart from the American work, but was recognized for its important place within European art of the time.

In 1955 de Staël, who had long suffered from depression, isolation, and insomnia, cut short his life, leaping from his studio terrace in Antibes, France. It is impossible to know how his career might have progressed and how he would have matured artistically, but de Staël was prolific during his brief career, creating approximately one thousand paintings and drawings in which he grappled with his primary artistic concerns. In *The Football Players*, de Staël illuminated space and played on lights and darks with the sequential handling of white and black paint, which he juxtaposed with bright and muted colors to animate and enliven the figures on the field. The patterned surges of color and the direct and physical quality of the artist's involvement with paint add to the overall spirit and movement, creating an essence of the subject that we understand immediately. The strength in movement found in the series that includes *The Football Players* is unparalleled within de Staël's oeuvre. It marked his return to figuration, and was his last major series before his premature death at the age of forty-one.

ANDREA KARNES

1 Quoted in Robert Hughes, "A Lyrical Colorist Rediscovered: De Staël painted by 'the Rule that Corrects the Emotion,'" *Time* (23 July 1990): 76.

s

Ann Stautberg
American, born 1949

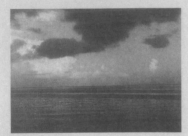

8.28.00, A.M., Texas Coast #4, 2000
Oil on black-and-white
photograph, edition 1/3
68 × 90 inches (172.7 × 228.6 cm)
Gift of the Director's Council, 2001
2001.16.G.Ph.

6-10-94 Texas Coast, 1994
Oil on black-and-white
photograph, edition 3/3
57 1/2 × 51 1/2 inches (146.1 × 130.8 cm)
Museum purchase made possible by
a grant from The Burnett Foundation
1998.16.P.Ph.

The Modern Art Museum's photograph by Ann Stautberg entitled 8.28.00, A.M., Texas Coast #4, 2000 is part of the artist's ongoing series that documents the Gulf Coast of Texas. She began making these works in 1991, when she moved from Dallas to Galveston Island. After this black-and-white image was printed, Stautberg painted over its surface with colors that coincide with her personal memory of the place at the moment it was photographed. In 8.28.00, the darkened thunderclouds that are juxtaposed with brilliant white clouds and the gray-blue sky that meets the green Gulf water are all hand-colored, boosting the electric atmosphere of the approaching storm and making the scene seem hyper-real. For Stautberg, this picture of sky, horizon, and water is an important one within the series because it represents what she sees as a "natural progression toward abstraction that deals with the elements in nature."[1]

Stautberg studied painting and printmaking as an undergraduate at Texas Christian University and as a graduate student at the University of Dallas. She switched to photography after completing her master's degree, incorporating her formal training by applying thin layers of translucent oil paints to the surfaces of her images. Each photograph is titled by its location and the date and time of day that it was taken. Stautberg's use of literal titles to label and organize her photographs indicates that they are produced in a documentary mode, but her hand-coloring technique works to offset this idea of straight documentation.

Although photography is a detached process, Stautberg uses the medium in a way that is almost paradoxical. She softens its innate impersonal quality by adding elements of fantasy. She also overturns photography's mass-reproducibility (a point used in the past to argue against its being considered fine art) by uniquely hand-tinting each photograph. No matter how many times she reprints a negative, she can never exactly duplicate the print's overlaid pigments. Although the process of hand-treating each print is significant, it does not eliminate Stautberg's responsibility of finding the perfect moment through her camera lens. Of her working process for 8.28.00, she has said, "I tried to present the full image as something pure, not manipulated. I just waited and watched, looking for the right light and reflections in the water. For 8.28.00, A.M., Texas Coast #4, the moment came together without my controlling it. It was just an instance when the sunshine and storm were almost happening at the same time."

Stautberg's 6-10-94, Texas Coast, 1994 is also in the Museum's collection. Again, the atmosphere verges on turbulent as the ocean and low storm clouds appear to converge in the distance. In the foreground is a beach umbrella attached to a wooden rail. The area is completely deserted, like all of Stautberg's coastal imagery, but there are visible signs of civilization that conjure up nostalgia. By painting the umbrella bright red, yellow, and blue, Stautberg echoes the colors of a beach ball, evoking for many people memories of childhood vacations to the beach. As with all of her photographs, the image works in collaboration with her hand-tinting to create meaning.

Galveston's beaches are particularly unsightly and fraught with problems such as pollution, red algae, and jellyfish, and Stautberg resists as much as possible glamorizing its shores in her work. In the Museum's two Stautberg photographs, the artist's color choices create dreamlike pictures that portray Galveston's beaches as darkened and tinged with melancholy. The images exist somewhere between reality and romanticized memory, as many photographs ultimately do.

ANDREA KARNES

1 Quotes from the artist are from
a conversation with the author,
8 August 2001.

Frank Stella
American, born 1936

Gur I, 1968
Polymer and fluorescent polymer
paint on canvas
120 1/8 × 181 inches
(305.1 × 459.7 cm)
Museum purchase, The Benjamin
J. Tillar Memorial Trust
1987.6.P.P.

The December 1967 cover of ARTnews magazine featured two working drawings for a new series of paintings that Frank Stella had on view at the Leo Castelli Gallery in New York. Surprisingly, these watercolor drawings on graphic paper did not illustrate, as one would expect, the magazine's "cover story." Instead, a blurb on the contents page informed readers that Stella's paintings would be the subject of an article in the following month's issue. The drawings served to announce and to fuel interest in what appeared to be a remarkable shift in the artist's work: the Protractor series. One of the drawings on the ARTnews cover heralding this new body of work was a study for the Museum's painting Gur I, 1968.

The exuberant Day-Glo colors, curving forms, and architectural character of the Protractor paintings completely opposed the minimal black stripe compositions that had established Stella's reputation only eight years earlier. As the most provocative works in the 1959 exhibition 16 Americans, held at New York's Museum of Modern Art, the Black Paintings were considered difficult, shocking, "unspeakably boring,"[1] and an affront to and rejection of Abstract Expressionism, then at its apogee. Although Stella soon introduced color in his works and produced a variety of shaped canvases over the intervening years, the impact of the Black Paintings was such that they were the standard against which the Protractor works were compared. The two series could hardly be more different: the severely reductive earlier compositions are

like black holes that suck light and energy into them, while the colorful complexities of the *Protractor* paintings burst upon the viewer. The *Black Paintings* are quiet, the *Protractors* loud; the *Black Paintings* focus a viewer's response, the *Protractors* project a myriad of associations.

More than any of Stella's previous works, a painting such as *Gur I* evokes a wide range of contemporary visual connections, from the dynamics of Op art (including M. C. Escher's popular works) to the emerging fascination with Art Deco to the eye-catching psychedelic colors of rock music posters to the anticipation of the Pattern and Decoration movement of the 1970s. Like the latter, *Gur I* and the other *Protractor* pictures were profoundly influenced by Islamic art and architecture. A 1963 trip to Iran proved to be, according to the artist, "a very big experience for me. It was an alien world, but not that alien, and the architecture is so terrific. I'd been involved with my life in New York and just seeing something so different yet so familiar was fascinating. There's all that interlacing, or interweaving, in barbarian decoration—I'd touched upon it in my dissertation at Princeton. Things double back on themselves, like snakes swallowing their tails. This came out in the *Protractor* series."[2] Stella's "dissertation" was his senior thesis at Princeton University about Hiberno-Saxon illuminated manuscripts (which he linked to Jackson Pollock's paintings). The artist's visit to Iran confirmed and expanded this early interest in decorative abstract forms.

When Stella began the *Protractor* series in 1967, he was also intrigued by the art of Henri Matisse and aimed "to combine the abandon and indulgence of Matisse's *Dance* with the overall strength and sheer formal inspiration of a picture like his *Moroccans*."[3] Pictorial problems and concerns, not the expression of ideas, beliefs, or stories, took priority for Stella, who famously declared, "What you see is what you see."[4] He stressed that his aim in the *Protractor* series was not to produce "conventionally decorative" paintings, but ones "truly viable in unequivocal abstract terms.

Decorative, that is, in a good sense, in the sense that it is applied to Matisse."[5] Stella's concern for qualifying his sense of "decorative" acknowledges the pejorative nature the term has held for many modernists. To be decorative has often been regarded as to lack seriousness, and intellectual or spiritual content. Stella's success in achieving a "truly viable" decorative art in *Gur I* and other *Protractors* has been aptly captured by the *Los Angeles Times* art critic William Wilson: "At best, Stella's paintings take us flatfooted. Their aggressive self-assurance hits us like careless matadors. They are visually solid, as organized as a computer, entertaining as a baroque ceiling."[6]

Stella's first *Protractors* were produced in the summer of 1967, and the last in 1971. *Gur I* dates from January or February of 1968.[7] For the series, the artist established thirty-one formats (twenty-seven, plus four variants) based on the semicircular shape of the protractor. Each format took one of three designs: interlace, fan, or rainbow. Ninety-three different images make up the series. Each picture's title signifies the specific format, which takes its name from an ancient circularly planned city in Asia Minor, with the Roman numeral identifying one of the three designs.[8] *Gur I*, then, indicates the Gur format of four protractors (three on their ends, with two back-to-back) and the interlace layout. Gur was a third-century-B.C. circular Sassanian city in Persia, near the present-day Iranian town of Firuzabad. For his titles, the artist looked to K. A. C. Creswell's *A Short Account of Early Muslim Architecture* (Harmondsworth, England: Penguin Books, 1958).[9] E. A. Carmean, Jr., former director of the Museum, has noted that the forms within *Gur I* relate not only to the idea of a circular city, but also to specific Sassanian decorative patterns that show vertical elements interwoven with curving forms.[10]

The source of *Gur I*'s title, the reference to a tool associated with engineering and mechanical drawing, and its monumental shape all imbue the painting with a feeling of the architectural. Its thick stretcher bars move the picture away from the wall, giving it a physical presence and objectness almost three-dimensional in character. The huge curved form

resembles exotic architecture more than it does a typical rectilinear painting. The wide bands of solid color of which the painting is constructed function almost like structurally supporting elements of a building. Yet countering the architectural sense is the insistent flatness of the composition. Despite the painting's having overlapping and intertwining sections, the relentlessly flat consistency of the fluorescent colors denies a sustained reading of depth and always returns the viewer to the surface of the canvas.

Gur I not only plays off the pictorial and architectural, and the two-dimensional and three-dimensional; it also holds in creative tension color and linearity, logic and intuition, and order and exuberance. That Stella is able to resolve, without muting, these oppositions, is a mark of the painting's success and its power to enthrall the viewer. During the early stages of the *Protractor* series, the artist responded to the charge that his work was merely decorative. His words are particularly applicable to *Gur I*: "My eyes and my emotions tell me something different. They tell me it's very beautiful, complicated, moving, disturbing, and challenging. There are forces at work to think about here."[11] What you see is, in fact, complex, exciting, decorative, and stately.

Gur I and the other *Protractor* pictures did mark a significant shift in Frank Stella's art. The series brought to an end his Minimalist phase and initiated an ongoing and expansive exploration of the spatial dynamics of abstraction in which he has increasingly blurred the boundaries between painting and sculpture, and painting and architecture. The pictorial complexities and intricacies of a work like *Gur I* opened the way and provided the foundation for Stella's later art.

MARK THISTLETHWAITE

1 Emily Grenauer, *Herald Tribune* art critic, quoted in "Art—Painting—Minimal Cartwheels," *Time* 90 (24 November 1967): 64.

2 Quoted in Robert Saltonstall Mattison, *Masterworks in the Robert and Jane Meyerhoff Collection* (New York: Hudson Hills Press, 1995): 173.

3 William S. Rubin, *Frank Stella* (New York: The Museum of Modern Art, 1970): 149.

4 Quoted in Hilton Kramer, "Frank Stella: 'What You See Is What You See,'" *The New York Times* (10 December 1967): 39.

5 Ibid.

6 William Wilson, "Pasadena Show Surveys Decade of Stella," *Los Angeles Times* (31 January 1971): 50.

7 E. A. Carmean, Jr., *Modern Art Museum of Fort Worth Calendar* (January/February 1988): 3.

8 For renderings of the formats, see Rubin, 136–37.

9 Richard H. Axsom, *The Prints of Frank Stella: A Catalogue Raisonné 1967–1982* (New York: Hudson Hills Press, 1983): 134.

10 Carmean, 3.

11 Quoted in "Art—Painting—Minimal Cartwheels," 64.

S

Clyfford Still
American, 1904–1980

1956-J No. 1, Untitled, 1956
Oil on canvas
115 × 104³/₄ inches (292.1 × 266.1 cm)
Museum purchase, The Benjamin
J. Tillar Memorial Trust
1968.15.P.P.

When I die, people will say—they
are saying it already—that I acted
ruthlessly and amorally, with
ingratitude to those toward whom
I should be grateful. And they will
be correct. At the same time, I can
think of no other way for a serious
artist to achieve his ends than by
doing what I did—show that this
instrument, the limited means of
paint on canvas, had a more
important role than to glorify
popes and kings or decorate the
walls of rich men.[1]

Among the small and elite group of
American artists referred to by *Time*
magazine as The Irascibles, and who
made up the groundbreaking
movement known as Abstract
Expressionism in the 1940s and
1950s, Clyfford Still was arguably the
most irascible and vociferous.
Among a generation of American
artists who were attuned and
sensitive to the potential commercial
and political exploitation of their art,
Still was undoubtedly the most
suspicious of institutional culture.
He had little need for "middle men"
to present his art and ideas. As a
result, critics, curators, and private
collectors were often the object of his
scorn. Moreover, Still sought to
maintain complete control over the
exhibition and distribution of his
paintings. In this regard, he was
unwilling in most circumstances to
allow his paintings to be represented
in group shows, or to be sold to
private collectors who did not exhibit
a commitment to the work. Because

of this control, the number of Stills
in private and public collections is
remarkably small compared to
those of other artists of similar
stature and achievement. Still's strict
control over the presentation and
exhibition of his work also extended
to the content of the exhibition
catalogues that documented his few
one-person shows.

Still's writings are variously adroit,
effusive, militant, and even
threatening. The artist's infamous
warning to those who might think of
exploiting his paintings encouraged
the description of the artist as a
"Black Angel": "Therefore, let no
man undervalue the implications of
this work or its power for life—or
death, if it is misused."[2]

An essentially self-taught artist,
Still was born in Grandin, North
Dakota, subsequently moving as a
young child to Washington, and
finally to a homestead on the harsh
prairies of Alberta, Canada. The
artist's earliest works take the form
of dark, haunting variants of
American Regionalist landscapes—
melancholic variants of Thomas Hart
Benton's popular and optimistic
images of the values of heartland
America. *Row of Grain Elevators*, c.
1928 (National Museum of American
Art, Smithsonian Institution)
has a dark, brooding presence and
evidences an appreciation for
aggressive surface texture, light and
dark contrasts, and the fascination
with an ascending vertical image that
would be some of the hallmarks
of Still's art throughout his career.

These spirelike elevators would
be replaced by strange figures in
desolate landscapes. In 1934 Still
painted the image of a tall, naked
figure walking through a dark, rocky
landscape. The primitive figure with
Neanderthal-like features and large,
pawlike hands covers nearly the
entire surface of the landscape
background. At the same time that
it dominates the land it inhabits,
its rich red coloration suggests a
blending into the earthen back-
ground. Like Alberto Giacometti's
emaciated figures, which stand in
space while barely distinguishing
themselves from it, Still's image
evokes a fragile yet powerful
existential presence. The painting,
eventually designated as *PH–323*,
1934 (San Francisco Museum of
Modern Art), bears an uncanny

allegorical relationship to the veiled spiritual quest contained in the artist's statement for a retrospective at the Albright-Knox Art Gallery in Buffalo, New York:

It was as a journey that one must make, walking straight and alone. No respite or shortcuts were permitted. And one's will had to hold against every challenge of triumph, or failure, or the praise of *Vanity Fair*. Until one had crossed the darkened and wasted valleys and come at last into clear air and could stand on a high and limitless plain. Imagination, no longer fettered by the laws of fear, became as one with Vision. And the Act, intrinsic and absolute, was its meaning and the bearer of its passion.[3]

By the late 1930s Still was beginning to abandon the literalness of the human form as a symbol of self, replacing it with a cluster of totemic, rocklike presences erupting flamelike from an earthen base. In a painting like *1937–8–A*, 1937, (Albright-Knox Art Gallery) the "figure" has dissipated into, and become part of, a turbulent, raw surface, creating a hybrid between figuration and landscape. In a review in *ARTnews* in May 1947, Still is indirectly quoted as stating that he was "preoccupied with the figure in landscape, with overtones of man's struggle and fusion with nature."[4]

The surfaces of Still's paintings are unique among the Abstract Expressionists, referring on the one hand to an earthen texture, while also facilitating a particular kind of light. Constructed from a combination of palette knife and brushwork, Still's surfaces are complex and multi-layered, owing much more to the tradition of built-up surface painting, as represented by Albert Pinkham Ryder or Joseph Mallord William Turner. The empathy between the work of Still and Ryder, in particular, consists in their rich organic and moody surfaces. In both cases, the technique of applying paint is as critical to the emotional effect of the work as the abstract image or landscape being portrayed.

John Ruskin, who described Turner's work from numerous viewpoints, commented on the importance of unifying color and texture to create light: "Give me some mud off a city crossing, some ochre out of a gravel-pit, a little whitening, and some coal dust, and I will paint you a luminous picture, if you give me time to graduate my mud, and subdue my dust."[5] Ruskin's analogy reads like a description of Still's colors and surfaces. By using large quantities of linseed oil, Still created a remarkable range of glossy and matte colors that both reflect and absorb light. Still mixed his own paints because "particles of paint would catch the light whereas commercial pigments were ground too fine."[6] This may account for Still's comment regarding the 1959 Buffalo exhibition: "One problem we had was the tendency of the museum people to over-light all of my paints … my last instruction to Mr. Smith was, 'you can turn the lights out. The paintings will carry their own fire.'"[7]

Many of Still's most complex paintings were made during the 1950s, a period when darkness and light found a tempered balance in his imagery. It is during this decade that the artist achieves his goal of having "space and the figure…resolved into a total psychic entity."[8] In the Modern Art Museum's *1956–J No. 1, Untitled*, 1956 a black, craggy gesture is combined with attenuated areas of yellow, ochre, red, orange, and white, creating a Gothic spaciousness unique in twentieth-century abstraction. One reviewer aptly described a new quality of liberation developing in Still's imagery: "We feel as if we had suddenly been catapulted from somewhere deep inside the earth to somewhere out in the void. A geological space has given way to a galactic one."[9] In a diary note of 1956, Still seems transformed from a painter of "the damned" to one of "the recreated":

Quiet. Broken by the stretching of four canvases. A great free joy surges through me when I work. Only, the conceptions are born too quickly. And with tense slashes and a few thrusts the beautiful white fields receive their color and work is finished in a few minutes. Like Belmonte weaving the pattern of his being by twisting the powerful bulls around him, I seem to achieve a comparable ecstasy in bringing forth the flaming life through these large responsive areas of canvas. And as the blues or reds or blacks leap and quiver in their tenuous ambience or rise in austere thrusts to carry their power infinitely beyond the bound of the limiting field, I move with them and find a resurrection from the moribund oppressions that held me only hours ago. Only they are complete too soon, and I must quickly move on to another to keep the spirit alive and unburdened by the labor my Puritan reflexes tell me must be the cost of my joy.[10]

Cutting through the right center of *1956–J No. 1, Untitled* is a "black wing" that would seem to act as a coda to Hubert Crehan's designation "Black Angel in Buffalo." The dark feathery form tears open its surrounding field to reveal a rich, dark core, relating it to the later *1963–A*, 1963 (Albright-Knox Art Gallery). Commenting on the work, Still noted, "Maybe he [Crehan] was right. There is his 'black angel.'"[11] In *1956–J No. 1, Untitled*, Still isolates the two sides of his aesthetic—his sense of the power of extreme light and extreme dark—as well as the radical psychological extremes they evoke. Perhaps more than any other Abstract Expressionist, including Mark Rothko, who is often discussed in these terms, Still throughout his career seemed preoccupied with using darkness. As Still put it, these are "not paintings in the usual sense; they are life and death merging in fearful union."[12]

MICHAEL AUPING

1 The artist quoted in Thomas Albright, "The Painted Flame," *Horizon* (November 1979): 33.

2 Clyfford Still, "Letter to Gordon Smith, 1 January 1959," in *Paintings by Clyfford Still* (Buffalo: Albright Art Gallery, 1959): 5.

3 Ibid., 4.

4 "Clifford [sic] Still: Parsons Gallery," *ARTnews* (May 1947): 50.

5 Kenneth Clark, *The Romantic Rebellion: Romantic versus Classic Art* (New York: Harper & Row, 1973): 251, 253.

6 Robert Lodge, Interview with Mrs. Still, 26 May 1985. Document files, Albright-Knox Art Gallery (unpublished).

7 Letter to Mrs. [Betty] Freeman, 14 December 1960. Betty Freeman Papers, Smithsonian Institution, Archives of American Art, Midwest Regional Center, Detroit, Michigan, microfilm no. 4060.

8 Quoted in *Clyfford Still* (Philadelphia: Institute of Contemporary Art, University of Pennsylvania, 1963): 5.

9 Colin L. Westerbeck, Jr., "Still Life: Clyfford Still—The Metropolitan Museum of Art," *Artforum* 18 (February 1980): 93.

10 From diary notes, 11 February 1956 in *Clyfford Still* (San Francisco: San Francisco Museum of Modern Art, 1976): 122–23.

11 Seymour H. Knox, in Michael Auping, Interviews with Seymour H. Knox, 27 September 1987, 12 October 1987, and 6 November 1987 (unpublished).

12 Letter to Betty Parsons, 26 September 1949. Betty Parsons Papers, Smithsonian Institution, Archives of American Art, Midwest Regional Center, Detroit, Michigan, microfilm no. N68/72.

Thomas Struth
German, born 1954

Uffizi I, Florence, 1989
C-print
70 × 66½ inches (177.8 × 168.9 cm)
Museum purchase made possible by
a grant from The Burnett Foundation
1995.8.P.Ph.

Uffizi I, Florence, 1989 is one of
the early works from German
photographer Thomas Struth's
Museum Photographs series, for
which he is best known.[1] In it, two
elderly tourists are standing before
Giotto's early Renaissance altarpiece
Ognissanti Madonna, *c*. 1310 at the
Uffizi Gallery in Florence. Struth
records this banal moment in a
straightforward manner, yet his
photograph is not strictly objective
in nature. His image points to the
changing roles of painting and
photography as it addresses both
disciplines—Giotto's work is seminal
to the history of painting, and Struth's
picture is part of modern art history,
which is now open to photography.

In size, scale, and color, Struth's
photograph is analogous to a
traditional painting, and as is often
the case with paintings, the imme-
diate eye-catchers in *Uffizi I* are the
people, who bring an authentic
human element into the work. The
two women in this picture seem
more real than Giotto's painted
Madonna and Child, and this points
to photography's ability to ostensibly
capture fixed reality, which distin-
guishes it from painting. From the
format and contents of *Uffizi I*, we
might assess the roles of painting
and photography and how the
museum setting influences our obser-
vations and understanding of art.

Struth's *Museum Photographs* are
informed by a German photographic
tradition in which artists take their
cue from physiognomy, the
encyclopedic approach to docu-
menting a particular class of people
within society. This type of
photographic classification was first
used in the 1920s by August Sander,
whose book *Face of Our Time* (1929)

was part of an ongoing series in
which he recorded German working-
class citizens in a frank manner.
In the 1950s the German photo-
graphers Bernd and Hilla Becher
continued Sander's legacy, but they
elaborated on and varied the idea of
classification by changing the focus
to typology, the collecting of a
common class or type of thing, rather
than of people. The Bechers often
document industrial architecture in
order to draw attention to cultural
differences and similarities that are
associated with architectural styles.

Struth and his contemporaries
Thomas Ruff and Andreas Gursky
were all students of Bernd Becher
during the 1970s and 1980s at the
Kunstakademie in Düsseldorf. The
three younger artists were influenced
by the Bechers' serial and detached
approach to their subject matter, and
used it to investigate their own
artistic concerns. Struth's early
pictures, like much of the Bechers'
work, were small-scale black-and-
white images of human-altered
landscapes that omitted human
presence, but suggested it. *Uffizi I*
and the entire museum series also
takes a systematic approach, and
reverts back to August Sander's
physiognomic concerns by creating a
kind of sociological study based on
the different ways and places people
look at art.

In Düsseldorf, Struth also studied
with Gerhard Richter, one of the most
influential German artists of our
time, who has focused much of his
conceptual investigation on the
relationship between painting and
photography, using both mediums to
express his ideas. Richter's impact
on Struth is clear—the younger artist
also explores our perception of
painting and photography by making
photographs of paintings; but
moreover, both artists investigate
how reality is conveyed, perceived,
and questioned through visual
information.

In *Uffizi I*, the conceptual element
of the work is as monumental as the
photograph itself. Struth critiques
the museum and the ways in which
art is shaped and understood within
its setting. The photograph has an
ironic ring when we realize that we
are viewing art that depicts other
people viewing art.

ANDREA KARNES

1 For a detailed discussion of
Struth's *Museum Photographs*
series see Hans Belting, *Thomas
Struth: Museum Photographs*
(Munich: Schirmer/Mosel,
1998).

Hiroshi Sugimoto
Japanese, born 1948
Lives and works in America

Earliest Human Relative, 1994
Black-and-white silver gelatin print,
edition of 25
20 × 24 inches (50.8 × 61 cm)
Museum purchase made possible by
a grant from The Burnett Foundation
1995.18.P.Ph.

Manatee, 1994
Black-and-white silver gelatin print
20 × 24 inches (50.8 × 61 cm)
Museum purchase made possible by
a grant from The Burnett Foundation
1995.17.P.Ph.

Queen Victoria, 1994
Black-and-white silver gelatin print,
edition of 25
20 × 24 inches (50.8 × 61 cm)
Museum purchase made possible by
a grant from The Burnett Foundation
1995.22.P.Ph.

Alhambra, San Francisco, California, 1992
Black-and-white silver gelatin print, edition of 25
20 × 24 inches (50.8 × 61 cm)
Museum purchase made possible by a grant from The Burnett Foundation
1995.20.P.Ph.

Since the 1970s Hiroshi Sugimoto has used photography to investigate contemporary society's methods of conveying history. His work reveals that art, education, and entertainment often unite to inform our perceptions of the past in a way that is broadly accepted as neutral and truthful, even though it is inherently biased.[1] Sugimoto's motivation, however, is not to revise history and make it more honest. Instead, he adds yet another layer of subjectivity by presenting his version of the past through photography, a medium that, like history, is created by someone and records a bygone moment with a sense of authority.

In Sugimoto's black-and-white photograph *Earliest Human Relative*, 1994, two life-like primates—a male and a female—walk arm-in-arm in the sand in front of an obviously painted backdrop. The figures are a part of a natural history museum diorama; in that environment, they are meant to teach us about ourselves—our evolution—by presenting a freeze frame of a historical moment. But Sugimoto further blurs the "truth" of the diorama by completely removing it from its context—he leaves out the museum labels, glass cases, frames, and barriers. By omitting the museum's didactic information, his work is as deceptive as the dioramas themselves. Sugimoto's *Earliest Human Relative*, like all of his art, is a fake of a fake.

His imagery, however, can also have the opposite effect, seeming to legitimize the contrived scene that he records. Framing and cropping

decisions in *Manatee*, 1994, for example, give the diorama's panoramic backdrop and three-dimensional props a heightened look of reality. By documenting the scene in the realist vocabulary of a black-and-white photograph, the artist strengthens the appearance of authenticity. *Manatee* depicts an elaborate underwater scene that at first glance passes for a photograph of live animals. A mother manatee and her calf swim over rocks that have settled on the ocean floor. Overhead, sunlight shines into the water and waves ripple, completing this tranquil view of marine life. But Sugimoto's deceptions become recognizable if we look at the work long enough. Slowly, we can access the "truths" in his imagery. The manatees are in fact made of steel, the water is painted, and the light that beams down from an unseen point, fanning out across the span of the backdrop, is artificial.

Sugimoto's interest in dioramas and wax figures began in the early 1970s, when he moved to Los Angeles to attend the Art Center College of Design. He initially planned to learn to make wax portraits, but became more focused on their history and how they are used to convey the past. He began to photograph them. Many Conceptual artists at this time were exploring aspects of identity, often using photography to express their ideas. Sugimoto's work, such as his images of wax figures and museum dioramas, contributes to this discourse by exposing how history is interwoven with cultural myths to shape our individual and collective identities.

Sugimoto began seriously photographing dioramas and wax portraits in 1976, after moving from Los Angeles to New York, where he continues to live and work. He travels throughout the United States, Europe, and Japan to add to his series. He has photographed wax figures at Madame Tussaud's in London, Amsterdam, and New York. *Queen Victoria*, 1994 is part of his *Wax Museum* series. By isolating the figure in a photograph, this wax portrait becomes as "real" as the steel manatees. Wax museum portraits, however, generally offer idealized composites of the people they portray, and are often depicted in inaccurate settings and costumes.

These exhibits can be perplexing. What is their purpose? Are wax portraits meant to be educational tools or entertainment? Is presenting an idealized semblance of Queen Victoria in a wax museum any different than seeing a painted portrait of her, or a Hollywood production about her life? For Sugimoto, the answer is no. In his art, photography replaces the wax museum portraits, but the idea is the same: "Madame Tussaud played an important role as a recorder of history. In a way, the portrait in wax served as photography does now. More than fifty years before the invention of photography, a wax portrait had the same function: to preserve what a person looked like and to record history."[2] Like Madame Tussaud, Sugimoto is a recorder of history, fully realizing that his medium is no more accurate than wax portraits or museum dioramas.

The Museum's collection also includes three photographs from Sugimoto's *Theater* series, in which he investigates how Hollywood and the movie industry have influenced our perception of history and identity. For this body of work, the artist photographed movies running in empty movie theaters from the 1920s and 1930s, and 1950s-era drive-ins. The resulting photographs, such as *Alhambra, San Francisco, California*, 1992, depict scenes that are illuminated by a brilliant blaze of white light emanating from the movie screen. To achieve this effect, Sugimoto set up his 4 × 5 view camera in the back of a darkened theater, or under a night sky, and slowly exposed the film while the entire movie ran. No image is visible on the screen; only light. Sugimoto's process erases the movie's imagery and contents, draining nostalgia while alluding to the past by recording the passage of time, literally, as the movie plays. Only the bright rectangle of light recorded in the photograph is left to indicate its existence.

Since their creation, movie theaters and drive-ins have influenced the way we see and experience imagery. Dioramas and wax portraits have functioned similarly, by fooling our eyes. Photography also plays tricks with perception, and Sugimoto understands its inherent ability to

make illusions seem real. He uses photography to show how our perceptions of the past are formed, and because his images are not straightforward, they make us conscious of how identity is created. In an interview about his work, Sugimoto acknowledges his own degree of truthfulness: "How can I be an honest person and a good artist at the same time? It's a contradiction in terms."[3]

ANDREA KARNES

1 For an insightful essay on Sugimoto's interest in investigating art, science, and religion in his work see Nancy Spector, "Reinventing Realism," in Tracey Bashkoff and Nancy Spector, *Sugimoto: Portraits* (New York: Solomon R. Guggenheim Museum, 2000): 10–23.
2 The artist quoted in Tracey Bashkoff, "The Exactness of the World: A Conversation with Hiroshi Sugimoto," in Bashkoff and Spector, 28.
3 Ibid., 35.

Donald Sultan
American, born 1951

Dead Plant November 1, 1988, 1988
Tar and latex paint on canvas
108 1/8 × 144 1/4 inches
(274.6 × 366.4 cm)
Museum purchase made possible by
a grant from The Burnett Foundation
1989.5.P.P.

*Stacked Pomegranates
Oct. 10, 1994*, 1994
Tar, oil, and spackle over masonite
49 3/4 × 49 3/4 inches
(126.4 × 126.4 cm)
Gift of the Director's Council, 1995
1995.54.G.P.

In 1975 Donald Sultan received his
MFA from the Art Institute of
Chicago, where he first made poured
paintings in the style of Jackson
Pollock. Sultan's signature style
began to evolve, however, with his
innovative technique of using tar
along with more traditional materials
to depict his most famous motifs of
obsolete industrial plants, flowers,
and fruit. The Museum's *Dead Plant
November 1, 1988*, 1988 is an
important work from the artist's
industrial landscape series. The
large-scale canvas depicts a steel
plant and its surrounding
environment rendered primarily in
tar. Sultan's reductive process
involves covering the surface of a
canvas with molten tar and then
scratching and cutting into it with
a knife, even burning it with a
blowtorch. After he completes the
tar image, he fills in damaged spots

with plaster, building up the surface
so that he can add pigment, usually
applying color—in this case yellow—
with a saturated rag.

In *Dead Plant*, Sultan juxtaposes
the matte, tactile tar, an industrial
material with sculptural qualities,
with the bright yellow, glossy sections
that convey an eerie electric glow.
Combining these elements with
abstract and representational shapes
produces a visually dynamic image.
Powerful diagonal lines form a
utilitarian bridge by cutting across
the upper left to the mid-right edge of
the canvas to draw our eyes across
the picture plane. Dark patches in the
foreground and light patterns of
scratches in the background create
a balanced rhythm. A blackened
cluster of smokestacks sits lifeless
and abandoned in the background,
further emphasizing this wasteland
environment.

The artist has discussed this
painting in relation to his
fundamental artistic theme: "Most
of my work deals with the idea of
passing. *Dead Plant* is part of a series
in which the image is meant to
convey a kind of systemic passing by
recognizing the impermanence of
seemingly permanent structures. The
plant symbolizes the changing of
ostensibly unchanging aspects of life.
It also points to the unseen impact of
emotional and economic distress."[1]
Given that Sultan matured as an
artist in the 1980s, it is also possible
to view *Dead Plant* as a broader
reflection of the time. The decade
provided ample source material for
an artist interested in conveying
"the impact of…distress." Consider
some of the events of the 1980s:
identification of the AIDS virus; the
crack epidemic; the Chernobyl
nuclear power plant disaster
(following the accident at Three-Mile
Island in 1979); the Union Carbide
gas leak in Bhopal, India, which killed
6,400 people; scientists discovering
a hole in the ozone layer over
Antarctica; and the first warnings
being issued about the effects of
global warming and greenhouse
gases.

Like many institutions, the Modern
Art Museum strives whenever
possible to collect multiple objects
by important artists, and Sultan falls
into that category. In 1995 the
Director's Council bought Sultan's
Stacked Pomegranates Oct. 10, 1994,

1994 for their annual gift to the
Museum's collection. Like *Dead
Plant*, *Stacked Pomegranates* is
symbolic of change and transition.
Sultan explains, "With the still lifes,
I was showing other aspects of
passage. *Stacked Pomegranates*
recalls the history of the still-life
genre, but it displays the still life in
a different manner to show the
systemic way in which we transport
images and their meanings." Also in
the Museum's collection are two
prints by Sultan—*Red Peppers*, 1989,
and *Morning Glories Nov. 1991*,
1991—and a lush charcoal drawing,
Black Lemons May 20, 1985, 1985.
The latter depicts one of the artist's
most recognizable images, in which
the voluptuous fruit suggests the
female form.

ANDREA KARNES

1 Quotes from the artist are from
 a conversation with the author,
 28 August 2001.

James Surls
American, born 1943

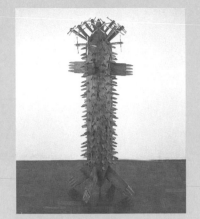

High Flying Man, 1974
Pine, hog hair, and oak
79 1/2 × 34 × 33 inches
(201.9 × 86.4 × 83.8 cm)
Museum purchase, The Benjamin
J. Tillar Memorial Trust
1975.8.P.S.

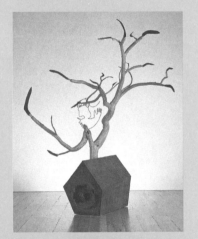

On Being in the Wind, 1984
Cypress, pine, oak, and steel rod
148 × 132 × 100 inches
(375.9 × 335.3 × 254 cm)
Gift of Emily Fisher Landau,
New York
1998.2.G.S.

The Museum's permanent collection includes several works by native Texan James Surls, including two key sculptures created a decade apart, *High Flying Man*, 1974 and *On Being in the Wind*, 1984. Both are made primarily of wood, Surls's preferred material, and both typify his style and address his major artistic concerns. Like all of his works, they are autobiographical.

Surls made *High Flying Man*, a rustic, anthropomorphic sculpture, in New Mexico in 1974, which was a decisive year in his life. The work is human-scale, made of one central log placed vertically and carved to a point at both ends, supported at the base with four two-by-fours that are angled toward the ground, resembling feet. The same two-by-four shapes are placed perpendicular to the core at the piece's upper midsection, suggesting extended arms. The central core form is interspersed with scaled-down versions of its own shape, which look like small spikes that point outward. The top of *High Flying Man* is covered with crude propellers made of wood and hog-hair bristles. In describing the work, Surls has said:

High Flying Man is a direct representative of a particular point in my career that is very important to me. In 1968 I finished graduate school [at the Cranbrook Academy of Art, Bloomfield Hills, Michigan] and though I was teaching at Southern Methodist University, I was really just floating for a few years. 1971, 1972, and 1973 were like 'sleeping years,' but 1974 was the year that consciousness struck me. During that year, I spent three months in Kit Carson National Park in New Mexico, a massive terrain, and I had a huge psychological change there. I made a rudimentary studio from four pieces of cast concrete and I had no accoutrements. *High Flying Man* was fabricated from the simplest approach—I used a hatchet and knife to carve, whittle, and chop—but there was an incredible freedom in using such a basic method. The world became a bigger picture. This work and the three others I made in New Mexico are about my time on the mountain and the psychological revelations I experienced. *High Flying Man* is a rocket man, flying through the air, taking off, jettisoning into a new and different space.[1]

On Being in the Wind also represents an essential stage in Surls's life. In 1977 he and his family settled in Splendora, Texas, forty miles outside of Houston, where they lived for two decades until relocating to Colorado in the mid-1990s. This work was made in Splendora, in Surls's studio on his thirty-two-acre parcel of land. *On Being in the Wind* is a massive piece made from cypress, pine, oak, and steel wire. In Surls's words the sculpture is "symbolic of house, home, place, and the whole idea of belonging, but it is not about a specific thing; rather, it marks a psychological place." He further explains, "My art is about psychological phenomena. It is not the polished object that is important to me, but rather, it is the idea and its shape and form as symbolic of something else. In this case, it is the house, the tree, the wind, and me." Although the piece's symbolism is personal to Surls, the elements he works with—wind and shelter—are things everyone can potentially experience, literally and metaphorically. Of this idea, Surls says, "Wind and house have a certain universality. The wind can carry us, and we can come and go mentally and physically from the home base. We have an immense capacity for mental travel, and mental travel is what it takes to enter the creative zone."

The weighty house in *On Being in the Wind* is the base shape, and it is made from an old cypress tree. As Surls remembers, "The house was literally cut from a cypress tree and the variations in its rings, from thick or thin to loose or tight, were governed by the wind—prevailing wind moved the tree around to form its rings, before it was cut down." From the roof of the house, large branches extend upward, forming a tree. Thin, flat, leaf-like forms made from carved wood represent its foliage. The branches above the house balance its solidity and motionless quality, because they produce a sense of rhythmic movement. Hanging from one of the tree's central branches is a black, steel-wire self-portrait of the artist in profile, and it fittingly reinforces his statement "All of my sculpture operates from myself in the center outward to the world." The house, tree, leaves, and wire profile of Surls are all motifs commonly used in his work.

On Being in the Wind, even with its great physical presence, is also precarious and vulnerable. The title and the idea of wind suggest unpredictability and lack of control. Surls describes the work as "a kind of paradox for the human condition. Two different things occur: the house is stable and the tree shows signs of wind. Wind is a nebulous given; it drifts. When you're drifting in the wind you can be blown from place to place, and we, too, fluctuate between stability and the unknown."

Surls considers *High Flying Man* and *On Being in the Wind* to be connected: "In a strange way, *On Being in the Wind* is the end result of *High Flying Man*." He sees each of these works as marking major points in his life. The earlier piece represents a vital self-awareness and coming of age, whereas the latter work signifies family and the importance of a home base. But perhaps the key relationship between *High Flying Man* and *On Being in the Wind* is that both illustrate the forces at play in Surls's own creative process, which link to his personal experience on one level and are universally understood on another.

ANDREA KARNES

1 Quotes from the artist are from
a conversation with the author,
4 September 2001.

S

Erick Swenson
American, born 1972

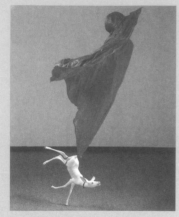

Untitled, 2000
Mixed media
91 × 40 × 40 inches
(231.1 × 101.6 × 101.6 cm)
Gift of Anne and John Marion
2002.59.G.S.

Erick Swenson's *Untitled*, 2000 depicts a dramatic scene in which a seamlessly crafted, meticulously hand-painted figure resembling a dog or fawn is being swept upward from the ground by a billowing red and black cape hooked to its tail. The small, pale animal bares its teeth, adding tension to the moment, yet the story behind this strange event is undisclosed. Swenson's scenes are the result of a hybrid of influences, including animation, movie and stage sets, and natural history dioramas. The connection to dioramas is an intriguing one, because as is frequently the case with them, Swenson's work is made to look remarkably realistic and is viewed in the round in a museum setting. Swenson mimics the naturalistic execution of dioramas, but he does so in order to create fantastic scenes.

Swenson's main formal device—how he distributes the weight of his forms, which are created with rubber and polyurethane—is an important aspect of the surreal quality of his objects. He has connected the cape and the animal to create a fluid and rudimentary S curve, a traditional compositional device used by artists to move the viewer's eye through a work of art. The heaviness of the cape, as it moves up toward the ceiling, is visually much stronger than that of the frail animal beneath it, which looks like an oversized porcelain figurine. Yet the entire piece comes to rest on the

animal's small hoof, making its overall feeling and appearance precarious.

In *Untitled* the illusion of movement and physicality is seen in the cape, but the source of its power—whether it be the wind, a person, an apparition—is absent from the scene. Unlike a natural history diorama, there is no set storyline to explain the action taking place in the work. Instead, a number of dichotomies exist: the scene is in an art museum, rather than a natural history museum; the figure is fantastical and animal-like, but exhibits human qualities; the piece is frozen, but it conveys dramatic movement; it is made of plastic, but its textures and details look naturalistic.

Untitled leaves us to piece together a narrative based on a few visual clues that conjure up various associations. The three thin leather straps, for example, that are attached to the animal's neck and hind legs accentuate its delicacy, but they could also be read as a designer accessory, dog collar, or symbol of bondage. The animal could be perceived as wild, but the straps might also suggest domestication. The cape is another part of the piece that carries wide-ranging connotations. It is commonly associated with magic, but its implications extend to such opposite poles as Dracula and Little Red Riding Hood. In Swenson's stripped-down but impeccable illusionism, the story is unresolved, but strangely familiar.

ANDREA KARNES

Mark Tansey
American, born 1949

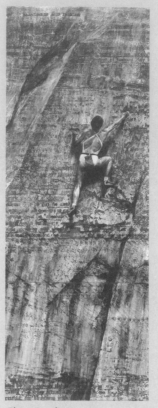

Close Reading, 1990
Oil on canvas
121 1/2 × 46 1/8 inches
(308.6 × 117.2 cm)
Museum purchase,
Sid W. Richardson Foundation
Endowment Fund
1990.2.P.P.

Since the end of the 1970s Mark Tansey's art has explored the nature of representation, history, and interpretation. His large, ambitious paintings have displayed the influences of illustration, art history, literary theory, philosophy, fractal geometry, and chaos theory. Reflecting and expressing an era in which meaning has often been perceived as being unstable, negotiable, and pluralistic, Tansey regards the "metaphor for the function of painted pictures . . . as *inquiry*. The picture as question. Picture making as questioning."[1] *Close Reading*, 1990 demonstrates the visual and intellectual richness of his inquiries, especially in terms of his concern for "how different realities interact and abrade."[2]

Initially *Close Reading* appears to offer a straightforward, almost photographic image of a rock climber

performing an action called *stemming* as she strains to make her way up the face of a precipice.[3] The painting's unusually narrow vertical format accentuates her ascent and the sheerness of the rock face. Tansey counters the realism of the scene by making it obvious that the composition consists of two canvases butted together. This underlines the fictional quality of the painting—any painting—and inserts a controlled straight line in a composition filled with seemingly random natural forms.[4] Following the lead of the painting's title, a closer look reveals that the climber grasps and traverses a surface embedded with letterforms and words; the phrase "blindness and insight" looms at the top, left of center. In presenting one reality and then offering others, *Close Reading* fulfills the artist's desire that his compositions "can, at first reading, be viewed within a range of conventional plausibility. But there is usually a moment, at the edge of expectations, where one may notice that something is not quite right. That's where the picture really begins."[5]

Tansey's career began when he moved to New York City in 1974 after graduating from the Art Center College of Design in Los Angeles. He pursued graduate study at Hunter College while working as an art handler at the Whitney Museum of American Art. From 1978 to 1979 he served as studio assistant to Helen Frankenthaler. He also supported himself as an illustrator. His conception of illustration as "embedding the idea in an image" reinforced his belief that painting should be about subject and content.[6] In the early 1980s Tansey found himself part of a renewed interest in representational painting and its possibilities and problematics in a postmodern age. Since then his work has appeared in major exhibitions and has been widely reproduced.[7] Typical of his work, *Close Reading* features a monochromatic, appropriated image (from the artist's inventory of clippings from magazines, journals, and books), which opens itself to a variety of interpretations.

The painting's title suggests at least three meanings. It refers to the athletic woman's need to read the

surface closely in order to know where to pinch grip, finger lock, and edge her feet as she grapples her way up the rock. Her success, and indeed her survival, depends on her ability to read the surface closely. The title also relates to the viewer's role as a "reader," who, in order to engage fully the work's different realities, must read the picture closely. The viewer mimics the climber by facing the rocky surface and intently studying and deciphering its intricacies. Both viewer and climber confront a surface whose insistent planarity also suggests a reference to the modernist emphasis on pictorial flatness. A third meaning carried by the title pertains to literary criticism and theory. "Close reading" is the methodology associated with American New Criticism, which emerged in the 1920s and dominated critical commentary through the 1950s. This approach focused on "the words on the page" and "the text in itself," not on historical, biographical, or intellectual context. New Critics believed in the fundamental unity of a work of art and the stability of language as "something capable of *grasping* reality."[8] Tansey's climber personifies the critic in the grip of the close reading technique, as she strives for the "absolute," a word barely discernible in the rock high above her outstretched arm. The quest for a correct textual close reading is, however, challenged by the inclusion (or intrusion) of "blindness and insight," inscribed even higher in the composition.

The phrase repeats the title of a 1971 book by Paul de Man; his *Blindness and Insight* is one of the seminal texts of deconstruction, a critical theory and movement inaugurated by Jacques Derrida in the 1960s. De Man promulgated the self-contradictory nature of texts, the imprecision of language, and "the blindness of critics with regard to their own insights, of the discrepancy, hidden to them, between their stated method and their perceptions."[9] Tansey knew de Man's book well, and included text from it not only in *Close Reading*, but also in at least four other 1990 paintings: "*a*," *Bridge over the Cartesian Gap*, *Incursion*, and *Reader*.[10] The same year, the artist portrayed de Man in two pictures,

Constructing the Grand Canyon and *Derrida Queries de Man*. Although it is not possible to identify specific excerpts from the book in the painting, passages found throughout *Blindness and Insight* resonate with Tansey's *Close Reading*. For example, de Man charges that New Criticism's rejection of authorial intentionality results in "a hardening of the text into a sheer surface."[11] Writers are characterized as adventurers, and author, critic, and reader are seen as participants in a "perilous enterprise."[12] Particularly resonant is de Man's account of how poetic transcendence has been linked to anxieties associated with mountain climbing and the sensation of height.[13] More than illustrating *Blindness and Insight*, Tansey's *Close Reading* is deeply embedded with the book's ideas, implications, and text.

Tansey incorporates text into the rocky surface by silkscreening collaged sentence fragments onto the canvas. He purposely keeps most of the words illegible in order to emphasize the difficulty of interpretation (a task de Man describes, with a rock-related metaphor, as Sisyphean). The elusive and allusive character of the text reinforces the deconstructionist conception of meaning as being fluid and evasive. By including text, Tansey prompts consideration of the multifaceted relationship between words and images: Images generate words, words inspire images, and both can carry several meanings or be indeterminate. The artist aimed to break down what he saw as the oversimplified dichotomy traditionally constructed between picture and text.[14] For Tansey, text also helps shape texture, an integral element in *Close Reading*'s surface appeal and visual intrigue.

The artist begins a work such as *Close Reading* with a gessoed canvas, which he coats with a layer of oil paint. Using his fingers and what he calls the "extended brush"—wood, string, crumpled paper, anything to remove paint—he creates the figure and surrounding forms by manipulating the paint and exposing the white ground underneath. As the paint dries, Tansey scratches, scrapes, abrades, and smudges the surface. This convincingly conveys the variety of formations encountered by the climber and the

nuances of touch she must employ in scaling the rock. Texture takes compositional and aesthetic precedence over color, although the all-over dark terra-cotta palette contributes to pictorial unity. In contrast to color's immediate opticality, Tansey finds that "texture involves interactions of time, memory, touch, and sight. There is also a built-in narrative element, in that texture, in a sense, is the fossilized record of action, both natural and cultural."[15]

Close Reading's climber grapples with the "natural and cultural," which are inseparably bound together in the composition. The figure simultaneously negotiates the natural (rocks) and the cultural (words). By reading each closely, she determines which bits of information will facilitate the quest to reach the summit and, metaphorically, to attain knowledge. Blind to her larger context, the figure can only grasp what is in sight. As she inches her way up, her interpretations of what will support her and keep her from plunging into the abyss must necessarily be both cautious and confident. Alone—her fate in her own hands—will she succeed in her efforts? What will be gained? What will be overlooked? The picture remains a question, while it offers an allegory of human striving.

MARK THISTLETHWAITE

1 From unpublished notes of 1984, quoted in Judi Freeman, *Mark Tansey* (Los Angeles and San Francisco: Los Angeles County Museum of Art in association with Chronicle Books, 1993): 27.
2 Quoted in Arthur C. Danto, *Mark Tansey: Visions and Revisions* (New York: Harry N. Abrams, Inc., 1992): 132.
3 While aware that the figure can initially be read as male or female, Tansey perceived the climber as representing "strength and female," "capability and sensuality," and "strength and beauty." The artist in conversation with the author, 10 April 2001.
4 Tansey speaks of his decision to use two canvases as a practical one that occurred while working on the painting. With just one

canvas he found the figure too centered and the proportions of the composition did not emphasize climbing. Conversation with the author, 10 April 2001.
5 Quoted in Judith Bell, "Deconstructing Mark Tansey: An Artist Combines Words and Pictures to Often Startling Effect," *Omni* 15 (August 1993): 18.
6 Quoted in Danto, 132.
7 Reproductions of his work have appeared, for example, in major college art history textbooks, including *Gardner's Art Through the Ages*, which for many years was authored by his father, art historian Richard Tansey.
8 Raman Selden and Peter Widdowson, *A Reader's Guide to Contemporary Literary Theory*, 3rd ed. (Lexington: University of Kentucky Press, 1993): 121.
9 Paul de Man, *Blindness and Insight: Essays in the Rhetoric of Contemporary Criticism* (New York: Oxford University Press, 1971): 111.
10 "*a*" is cited in Mark Taylor, *The Picture in Question: Mark Tansey and the Ends of Representation* (Chicago and London: University of Chicago Press, 1999): 79. The other three are listed in Freeman, 53.
11 De Man, 27.
12 Ibid., 44. De Man is discussing Oskar Becker's "Of the Fragility of the Beautiful and the Adventurous Nature of the Artist" (1929).
13 Ibid., 46. De Man focuses on the writing of Ludwig Binswanger.
14 Conversation with the author, 10 April 2001.
15 Quoted in Danto, 128.

Cy Twombly
American, born 1928

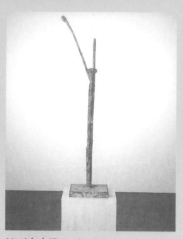

Untitled (Rome), 1997
Bronze
65³/₄ × 13³/₄ × 13³/₄ inches
(167 × 34.9 × 34.9 cm)
Museum purchase,
Sid W. Richardson Foundation
Endowment Fund
1999.42.P.S.

Cy Twombly is well known for his oeuvre of paintings, which, along with those of his longtime friends and peers Robert Rauschenberg and Jasper Johns, established important avenues of transition from the Abstract Expressionism of the 1940s and 1950s to Pop art and Minimalism in the 1960s and beyond. At the urging of Rauschenberg, Twombly attended Black Mountain College in North Carolina in 1951. The experimental curriculum at the school as well as its distinguished faculty, among them the poet Charles Olsen and the painter Josef Albers, made it one of the most advanced for the education of writers and artists. At Black Mountain, Twombly studied briefly with Robert Motherwell, who helped him obtain his first one-person exhibition, at the Samuel Kootz Gallery in New York in 1951, and wrote an introductory note on his work for an exhibition at the Seven Stairs Gallery in Chicago in the same year. Twombly also studied with Franz Kline, whose classic expressionistic paintings of large calligraphic gestures became a signature of the Abstract Expressionist movement.

Twombly drew a number of elements of his art from the Abstract Expressionists, most notably Motherwell's mixing of words and gestures; Kline's bold, free-form brushstroke; and Jackson Pollock's impulse to combine drawing and painting. Twombly's sensibility, however, synthesized these influences into a form of markmaking that created a thin line between writing, drawing, and painting. As the philosopher Roland Barthes has written about the unique gestural personality of Twombly's paintings, "With Twombly, the letter is the very opposite of an ornamental or printed letter; it is drawn, it seems, without care; and yet it is not really childlike, for the child tries diligently, presses hard on the paper, rounds off the corners, puts out his tongue in his efforts. He works hard in order to catch up with the code of adults, whereas Twombly gets away from it. He spaces things out, he lets them trail behind; it looks as if his hand were levitating, the word looks as if it had been written with the fingertips, not out of disgust or boredom, but in virtue of a fancy which disappoints what is expected from the 'fine hand' of a painter."[1]

The elevated awkwardness that has become the signature of Twombly's paintings is also evident in his sculptures, which the artist has been making since the 1950s. Consisting of humble, found materials, they maintain a striking balance between the seemingly casual and the elegantly formal. *Untitled (Rome)*, 1997, in the Modern Art Museum's collection, is a bronze version of an earlier work by Twombly, *Untitled (Gaeta)*, 1990 (Collection of the artist). The latter consists of three long wooden stems or sticks lashed together with wire and further cemented together with discreet applications of clay. Three-quarters of the way up this vertical structure, the petals of a plastic tulip sprout from the shortest stem. At about this same juncture, a longer stem arcs off the vertical axis, rising above the others and also sprouting the bud of a plastic tulip.

The entire surface of *Untitled (Gaeta)* has been painted a creamy white. Twombly's white creates a particular effect in his paintings and sculptures. In the paintings, it establishes a pristine ground against which his gently nervous gestures are set off. In the sculptures, it lightens the already delicate form at the same time that it seems to cleanse and idealize his pedestrian materials. As one writer suggests, the "pervasive white translates it from the sensual into the realm of pure feeling."[2]

Atypically, the Modern Art Museum's bronze version has been left unpainted; its patina is a range of green, brown, and muddy gold. Rather than lightness, the effect is that of a more natural, weighted, and earthy condition. Here, the artist's appreciation and observation of nature—its sensual curves, buds, and sprouts—seems particularly apparent. Along with its earthen hues, the scale of *Untitled (Rome)* also projects an unusual presence. Without the whiteness to lighten the form, its presence seems larger than its slightly more than five-foot height. Placed on a modest pedestal as the artist has suggested,[3] its scale seems ambiguously targeted between a plant and a tree.

Unlike many of Twombly's earlier, more delicate constructions, *Untitled (Rome)* has a powerful sculptural quality that transcends a specific reference to nature. Its emphatically vertical character implies a human form with an arm raised to the sky, and may relate obliquely to the artist's longtime appreciation of Alberto Giacometti's attenuated figures. While Giacometti's figures project a sober, existential quality, however, Twombly's "figure" is erotic by comparison. For Twombly, the flower, or nature in general, is an acknowledgment of growth and death cycles; at the same time, it is a symbol of the sensuous enjoyment of life.

MICHAEL AUPING

1 Roland Barthes, "Discussions of Cy Twombly," in *Cy Twombly: Paintings—Works on Paper—Sculpture* (Munich: Prestel-Verlag, 1987): 26.
2 Katharina Schmidt, "Looking at Cy Twombly's Sculpture," in *Cy Twombly: The Sculpture* (Ostfildern, Basel, and Houston: Hatje Cantz Verlag in association with Kunstmuseum Basel and The Menil Collection, 2000): 113.
3 A letter to the author from Anthony d'Offay Gallery, 6 March 1999, relayed the artist's request that the sculpture be placed on a "modestly sized" pedestal.

Jacques Villeglé

French, born 1926

Rue de Tolbiac, c'est normal, c'est normand, 1962
Ripped posters mounted on canvas
52³/₁₆ × 76¹/₄ inches
(132.6 × 193.7 cm)
Museum purchase,
Sid W. Richardson Foundation
Endowment Fund
2001.12.P.C.

The lacerations, traces of the gesture in its wild state, come out of anonymity. I would have liked to see them remain there.[1]

When Jacques Villeglé was a student at the Ecole des Beaux-Arts in Rennes, France, just after World War II, his artistic activity consisted primarily of collecting discarded objects, including pamphlets and various fragments of printed matter, as material for making assemblages and collages. His close friend and fellow student Raymond Hains was taking photographs of posters and advertisements pasted to walls around the school and city. Villeglé and Hains would later be instrumental in founding the Nouveaux Réalistes, a group of French artists whose works reflect the influence of Surrealist automatism and the gestural dynamics of Abstract Expressionism, while prefiguring the development of American and British Pop art.

In the late 1940s Villeglé helped pioneer the development of *décollage*, a technique that reversed the additive technique of collage. Rather than adding or pasting down disparate elements to a flat surface to create an overall composition, as the Cubists and Surrealists had done, the method of décollage involved taking parts away from an existing image by tearing, ripping, or erasing. Engaged by the "found" beauty of the often torn and ripped posters that his friend Hains had been photographing for a number of years, Villeglé began searching the streets for posters, removing selected

sections of each poster and mounting them on canvas. He would also take entire posters and spontaneously tear sections away. These "lacerated" surfaces became a form of deconstructive gestural painting, while the fragments of the original poster or advertisement engaged the new popular imagery being reflected in a postwar advertising boom. Neither an anti-painter nor a gestural mannerist, Villeglé took a decidedly neutral stance as to the nature of invention and beauty:

The ensemble of lacerators, ravishers, and collectors will therefore be called "Lacéré Anonyme," and would it be to establish the facts of activity whose author would seem to be elusive that my goal would be restricted, or rather, would it be in reconstituting the work of a collective unconscious in personalising the "Lacéré Anonyme"? Giambattista Vico did not act differently when he proved that Homer was not one single person but a collective being, a symbol of the Greek people, telling of its own history in national songs.[2]

In a modern tradition that extends from Marcel Duchamp's Readymades to the vernacular images of Pop art, Villeglé's shredded posters, such as *Rue de Tolbiac, c'est normal, c'est normand*, 1962, constitute a unique contribution to our appreciation of the beauty of the everyday.

MICHAEL AUPING

1 The artist quoted in Joann Cerrito, ed., *Contemporary Artists*, 4th ed. (Detroit: St. James Press, 1996): 1242.
2 Ibid.

Bill Viola
American, born 1951

The Greeting, 1995
Video and sound installation:
Color video projection on large
vertical screen mounted on wall
in darkened space, amplified
stereo sound
168 × 258 × 306 inches
(426.7 × 655.3 × 777.2 cm)
Museum purchase
1995.30.P.V.

There is a certain exclusionary aspect to conversations that take place in paintings, particularly when you're viewing them hundreds of years later. BILL VIOLA

Bill Viola is a pioneer of the video installation, which combines elements of sculpture, theater, and performance. He has been particularly effective in transforming a medium that for many years has been used as a tool of documentation into one of introspection. Viola's sophisticated, digitally edited image environments explore the edges of perception, addressing subjects that are deeply unconscious, often buried in details of public activity that are so fleeting they go unnoticed.

The Greeting, 1995 is a classic example of Viola's video metaphysics. The installation debuted at the 1995 Venice Biennale, where Viola represented the United States, and is a translation—physically and psychologically—of a 16th-century painting, *The Visitation*, 1528–29 (San Michele, Carmignano, Florence), by the Florentine Mannerist Jacopo Carucci, named Pontormo after his birthplace. Pontormo's *Visitation* depicts the New Testament story of the visit by Mary to her older cousin Elizabeth shortly after both women

miraculously become pregnant, Mary with Jesus and Elizabeth with John the Baptist.

Inspired by Pontormo's original image, Viola has created a secular but psychologically gripping translation. *The Greeting* consists of a large color video image projected onto a screen mounted on the wall of a dark room. The video begins with two women engaged in conversation at a street corner. They are soon joined by a third woman in a dress of brilliant orange, who appears to be pregnant. She greets and embraces one of the women, whispering something to her.

A simple performance that took all of forty-five seconds to complete has been slowed down to unfold over the course of ten minutes. The result is that many subtle aspects of the choreography become apparent and significant. Facial features that reveal intimacy, jealousy, suspicion, and empathy on the part of the three different women become almost glaring. The baroque billowing of the women's dresses is as mesmerizing as the body language is revealing of subtle tensions within the momentary triangular relationship. Nonetheless, the precise meaning of the event remains ambiguous and open to interpretation.

The following is an excerpt from an interview with Viola conducted by the author in London, October 1995.

MA: What attracted you to this image by Pontormo?

BV: I guess it was the moment of mystery that is contained in that event of *The Visitation* when Mary speaks to Elizabeth. I'm fascinated by the whole tradition of sacred conversation in painting. There is a certain exclusionary aspect to conversations that take place in paintings, particularly when you're viewing them hundreds of years later....Anyway, I looked at the image and these women, and I just became entranced. I remember I photocopied it and put it up on my wall, and I don't do that a lot. I'd look at it from time to time, notice the colors, and the strange figures. They're elongated in a funny way. I began to break it down optically. Eventually I got interested in it as social observation. I saw it simply as a social situation; something that happens on street corners all the time, where two people are talking

and someone else comes into the meeting. I'm fascinated by the subsurface or subtextual machinations that go on when you're in those situations. There's the polite hellos, how do you dos, and everybody's trying to figure out where everybody stands in this group.

MA: In the original Pontormo painting there are four individuals. Would it be correct to say that the fourth person in your *Greeting* is in fact the person watching the tape?

BV: Yes, absolutely. You are part of a series of stages of psychological engagement within the whole group. You could be a bystander on the street corner nearby. They know your presence is there but because of their involvement with each other, they can't acknowledge you into their social sphere. Except at that one point when the woman in the middle looks out in your direction. At that point, you're halfway in and still halfway out of their social triad. A piece of her psychological energy reaches out. It's like coming out this way. That's a key point. In a funny way, you've been tagged. You're no longer just a voyeur.

MA: They're intruding on my space in the same way I'm intruding on theirs.

BV: Right. She was most important for me, the woman in the back who stares out. In a way, she's the point of the whole piece. I worked on her the longest. She is the quiet outsider, engaged with everyone, but on the edge of everyone's circle. I put myself in her position. The way I structured the piece was that I imagined I was waiting with a friend (the woman on the viewer's right) and someone else comes up. They know each other; in fact, better than I know the one I'm waiting with. The irony is that the one in the middle eventually becomes peripheral, and therein lies the tension. She begins by being very cheerful and outgoing, and then when this other woman comes in she subtly pulls away—her energy is pulled back—she becomes more withdrawn. She looks down at one point like she doesn't know what to do. The other two women seem to share a secret, as if they have been meaning to talk for some time. It's just a simple chance meeting, but under a magnifying glass.

MA: The magnifier being the element of time.

BV: Yes. By slowing everything down, every breath, gesture, or eye movement has the effect of an earthquake. They were out just talking and by chance she happened to come by.

MA: The woman who arrives whispers something to the woman on the right, but the audio is not distinct. What is she saying? What is the secret?

BV: What do you think it is? One of the reasons I don't like to get too specific with a narrative is that I want the image to cycle through the viewer and let the viewer take the narrative where they will. Unlike Pontormo's Christian image—we know what they said—I want a fluid meaning. It's important that the secret is never really clear.

MA: The figures in this video seem way too big for the space they inhabit. They're giants.

BV: Yeah, they are. We worked hard for that effect. It took a very elaborate setup.

MA: What was the reasoning?

BV: It takes it out of the domain of the document. Video is a documentary medium. That's its power. It's the power of the "objective eye." But it can be so much more than that—a subjective, speculative medium. Leave the "truth" to CNN. Magnification and subtle distortions allow me to get at a more subjective truth.

MA: Was this filmed on a stage set?

BV: Yes. Completely constructed from scratch. What I'm trying to do is integrate the two worlds of painting and video installation, and if I pull it off, and I think I have here, it will open up a whole new area in my work. At the same time, I think it's consistent with my other work in terms of its coming out of interests and developments over a number of years—almost ten years. The other thing is that I think it also can be misinterpreted in the sense that it, in fact, *is* an installation. It may not be as total and involving physically as others, but it is a room, and there are restrictions on how it can be installed. It's a strange and slightly odd space between video and painting, which theoretically is not supposed to work. But I think it can. It's a physical screen on the wall, it's not a projection on the wall. It has a profile. It's coming off the wall maybe four inches.

MA: Like a painting, and it's framed.

BV: Yes. But the room is dark, so you're not so much confronted by a thing on the wall as you are by life-size, moving people. What brings the experience into the room and puts the viewer in the piece is the sound. It would be a very different work without the sound.

MA: What are the other sounds we hear? They're difficult to make out.

BV: The sound is a combination of recordings of traffic on the freeway, wind noise in the desert, people at lunch break in a large lobby of a downtown office building recorded from a distance, and a recording of a woman whispering.

MA: I'm curious about the two men in the extreme background. What is going on there?

BV: That's the male complement to what's going on with the women. It's another kind of "greeting," recapitulating the whole thing of what's happening in the foreground.

MA: I couldn't tell whether they were male or female.

BV: No, you can't. Also, you can't read their actions as well as the women in the foreground because they're slowed down so much and they're so small. Basically, what happens is, there's a guy who's crouching when the piece starts; he stands up and is standing there, then turns and lights a match, and there's a little flare, and you see the waft of smoke coming up. Then another man comes in, and they exchange greetings. Then the visitor leaves to get something for the other one and he comes back in with something, which is a book, and he hands it to him. You can barely see it as it catches a little bit of light when he hands it over. And then that other guy receives it, and they just sort of stand there. It's a little more complicated than that, but that's the basic action.

MA: Why did you feel you needed those? Were they part of the idea the whole time?

BV: Yes. There has to be another element drawn out, not just compositionally, but psychologically. There had to be a counterpoint to the massive intensity of the three women. It adds mystery while reinforcing the theme of a secret.

MICHAEL AUPING

Andy Warhol
American, 1928–1987

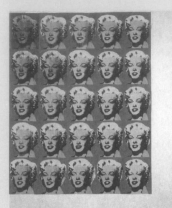

Twenty-Five Colored Marilyns, 1962
Acrylic on canvas
82 × 66¼ inches (208.3 × 168.3 cm)
The Benjamin J. Tillar Memorial
Trust, acquired from the collection
of Vernon Nikkel, Clovis, New
Mexico, 1983
1983.2.P.P.

Gun, 1982
Synthetic polymer paint and
silkscreen ink on canvas
72 × 92 inches (182.9 × 233.7 cm)
Museum purchase,
Sid W. Richardson Foundation
Endowment Fund
1998.11.P.P.

*...when Marilyn Monroe happened to die
that month, I got the idea to make screens
of her beautiful face....* ANDY WARHOL

Commentary on page 188

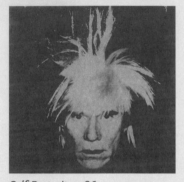

Self-Portrait, 1986
Synthetic polymer paint and
silkscreen ink on canvas
108 × 108 inches
(274.3 × 274.3 cm)
Museum purchase,
The Friends of Art Endowment Fund
1998.10.P.P.

Carrie Mae Weems
American, born 1953

Untitled (Kitchen Table Series), 1990
Three gelatin silver prints with text
panels, edition of 5
Each 27¼ × 27 inches
(69.2 × 68.6 cm)
Museum purchase made possible by
a grant from The Burnett Foundation
1995.25.1–3.P.Ph.

Commentary on page 195

William Wegman
American, born 1943

Man Ray Contemplating the Bust of Man Ray, 1978/1991
Gelatin silver print, edition of 20
11 × 14 inches (27.9 × 35.6 cm)
Museum purchase made possible by a grant from The Burnett Foundation
1995.48.P.Ph.

Purina Red, 1982
Two unique Polaroid Polacolor ER photographs
Overall 24 × 20 inches
(61 × 50.8 cm)
Museum purchase made possible by a grant from The Burnett Foundation
1995.49.P.Ph.

One of the best known, and arguably most beloved, of contemporary art subjects are William Wegman's weimaraners. Man Ray, the first of his dogs, was even named 1983's "Man of the Year" by *The Village Voice*! Photographs and videotapes featuring the animals are found in museum collections throughout the world, and have been frequently featured on television (including "The Tonight Show," "Late Night with David Letterman," "Saturday Night Live," and "Sesame Street"). The canines appear in nearly a dozen children's books, and on calendars, cards, magnets, mousepads, posters, screensavers, and T-shirts. The *Wegman World* Web site provides answers to frequently asked questions about the dogs, and includes a family tree with biographies. Like the art of Red Grooms (see *Ruckus Rodeo*), Wegman's work remarkably bridges the often-opposed worlds of high art and popular culture.

Wegman, a self-described "'60s minimalist-conceptualist,"[1] initially included a dog in his work in 1970, more out of necessity than artistic intention. A newly acquired puppy demanded constant attention and the artist discovered that as long as he "was pointing a camera at the dog, he would be quiet and happy."[2] The animal became an integral element in the deadpan humor of Wegman's calculatedly informal, seemingly artless photographs and videotapes. The artist and the dog performed droll comedy sketches in which, for instance, Wegman tries teaching the canine how to smoke, or corrects his spelling. In *New & Used Car Salesman*, Wegman holds the squirming eighty-pound animal on his lap "even though pain from the weight of the dog is almost unbearable" in order to convince potential customers he is a kind person: "Just as this dog trusts me, I would like you out there to trust me and come down to our new and used car lot and buy some of our quality cars."[3] In all the works, the dog maintains an amazing presence and possesses the ability to suggest a startling range of emotions. Recognizing the dog's star quality, Wegman ceased including himself in the works and gave the stage over to the dog.

Wegman had wanted to call the dog Bauhaus, but instead decided on Man Ray. The name is that of the then-living pioneer American Dadaist and Surrealist, who specialized in photography. However, to give the dog his own mythology (and to enhance his art's off-centeredness), Wegman has related several versions of the name's origin. He has claimed that it struck him "like a ray of light" and that the dog "looked like a little old man. Then a shaft of light like a ray blasted down on him in this ordinary little duplex house and blew away the Bauhaus."[4] At other times the artist has stated that Man Ray sounded "kind of magical" and came "to me like a light bulb" and "in a ray of inspiration."[5] The various accounts of the dog's name add to his mystique, while affirming Wegman's place as "one of the art world's most affable subversives."[6]

Man Ray Contemplating the Bust of Man Ray, 1978/1991 was created in 1978 (the Museum's photograph is a 1991 reprint from the original negative), and it is one of three versions of the subject. The version most often reproduced is of the same title, size, and year as the Museum's photograph, but shows the full-length dog seated on a box mirroring the profile of the clay bust on the modeling stand.[7] In the Modern Art Museum's print Wegman has positioned the dog closer to the small sculpture, shows him at half- rather than full-length, and has him twisting his head to convey more convincingly the sense of contemplation. Where the other photograph essentially depicts two forms (one a sculpture, the other sculpture-like) facing each other, the Museum's image presents Man Ray as being deeply engaged in meditating his own effigy. The photograph plays off profundity—the contemplation of one's self—and absurdity—it's a dog![8]

Wegman's composition both spoofs and embraces the human traits and feelings that people attach to dogs. The artist, and the dog, would have us believe that Man Ray is not only gazing upon—and recognizing—his portrait, but is also pondering its—and his—existential meaning. The irony of the photograph as a profound absurdity, or absurd profundity, is reinforced by its title, which waggishly parodies Rembrandt's famous painting

W

Aristotle Contemplating the Bust of Homer, 1653 (Metropolitan Museum of Art). Further, the circularity of the photograph's title and composition reminds us of the anti-art art produced by the dog's Dadaist namesake.

Although the artist Man Ray (1890–1976) is not known to have been pictured contemplating his own bust, a sculptural portrait of him based on a lifemask appears in two photographs he took in 1932 and 1934. The latter, which serves as the cover for an album of his photographs, features the name "Man Ray" to the left of his plaster bust. The placement may have inspired Wegman to arrange his Man Ray near and to the left of his likeness. Wegman more directly conflated artist and dog in his video *Man Ray Man Ray*, 1978. In this slightly over five-minute-long mock documentary, with its authoritatively voiced narration, Wegman intertwines the lives and images of the two Man Rays: School of Paris meets obedience school. A final linkage between the Dadaist and dog occurs in the twin dedication given them in Wegman's book *Man's Best Friend*, 1982.

In 1979 Wegman began photographing Man Ray in color. This resulted from Wegman's receiving an invitation from the Polaroid Corporation to make images using its special camera that generates twenty-by-twenty-four-inch color prints. The intricacies of the camera require technicians to operate it, which caused Wegman to function more as producer and director than photographer. The Polaroid works the artist created over the next three years, with their large formats, lush colors, and often striking sets, incidents, and costumes, became extraordinarily well known. The Museum owns one of the last in the series, *Purina Red*, 1982. In this diptych (a format long favored by Wegman), Man Ray is observed eating out of a dog food bag. When he pulls his head out of the bag and realizes he has been caught, he is literally red-faced. The success of this image, and of all Wegman's images of Man Ray, derives not only from the artist's ability to set up a situation and manipulate the dog to capture the decisive moment, but also

from the animal's uncanny ability to assume an appropriate attitude and express a humanlike emotion. More than one critic has likened Man Ray's understated, evocative, and at times forlorn demeanor to the comedic genius of Buster Keaton.

The canine Man Ray died in 1982. Wegman continued to photograph (no dogs, however), and he produced drawings, as he had always done. In 1985 he returned to painting for the first time since his student days in the mid-1960s, when he had dismissed painting as dead, a nineteenth-century activity. The same year, much to his surprise, he acquired another weimaraner, named her Fay Ray, and commenced a new body of photographs, video, and films.[9] Using Fay Ray, then her offspring and their offspring, Wegman has created an increasingly complex and ever-delightful world peopled by these most extraordinary dogs. Like Man Ray contemplating his bust, our attention remains captivated by and riveted on their images.

MARK THISTLETHWAITE

1 "Photographs," *Wegman World* Web site (www.wegmanworld.com). Accessed 2 May 2001.
2 Quoted in Lisa Lyons and Kim Levin, *Wegman's World* (Minneapolis: Walker Art Center, 1982): 15.
3 Ibid., 72.
4 Brooks Adams, "Wegman Unleashed," *ARTnews* 89 (January 1990): 152; Michael Gross, "Pup Art," *New York* 25 (30 March 1992): 48.
5 William Severini Kowinski, "Is Wegman an artistic comic or a comic artist?" *Smithsonian* 22 (September 1991): 44; Laurance Weider, introduction to *Man's Best Friend* (New York: Harry N. Abrams, Inc., 1982): 7; "The Dogs/Do You Know?" *Wegman World* Web site.
6 Lyons and Levin, 7.
7 The third version is a cropped variation of the seated dog print in which the portrait bust is altered by the addition of a woman's body. It is entitled *Man Ray with Sculpture*, 1978.
8 Wegman's photograph brings to mind Nam June Paik's *T.V. Buddha*, 1974, in which a small Buddha statue faces its own live image on a television monitor.
9 The Museum's collection also includes *Horned Snout*, 1991 and *Zig Zag Zig*, 1992, both unique twenty-four-by-twenty-inch Polaroid Polacolor ER photographs.

William T. Wiley
American, born 1937

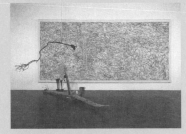

Quivering on the Path, 1974
Acrylic on canvas with attendant
construction of mixed media
Canvas: 84 1/2 × 177 3/4 inches
(214.6 × 451.5 cm)
Construction: 68 × 32 × 118 inches
(172.7 × 81.3 × 299.7 cm)
Museum purchase, The Benjamin
J. Tillar Memorial Trust
1975.18.P.P.

William T. Wiley is an influential
northern California–based artist
known for his loosely represen-
tational, autobiographical, and
humorous artwork in a variety of
media. Although Wiley does not
easily fit into a style or category, he
has said that "in some ways…I'm
just a landscape painter. I look out
the window and I see what's going
on, and I paint it."[1] Certainly the
Museum's fantastic landscape
Quivering on the Path, 1974 is a
testament to that description; but
what Wiley sees, and subsequently
what he paints, is informed by his
own unique artistic vision.

In *Quivering on the Path*, as with
many of his works, the landscape is
represented by a frenetic and allover
linear composition. The piece
requires a significant amount of
installation space for its
monumentally scaled canvas, its
wooden element that hangs by a rope
from the gallery ceiling, and the
planks and stakes that lie on the
floor, jutting out from the canvas
toward the center of the room. With
this work, Wiley investigates spatial
relationships: the way objects affect
the space around them, and are in
turn affected by the space. His
imaginary landscapes are made with
personal and recurrent symbols that
potentially evoke emotion on a
universal level. Wiley's "pound" sign,
for example, seen at the lower right
corner of the canvas, is his mark for
family; it represents the artist,
his wife, and their two sons. It could
also represent the widely known

tic-tac-toe game, however, and it is
also an editor's mark that indicates
more space is needed between
sentences or lines of text.[2] This idea
extends to Wiley's piece and his
concern for its space.

In the canvas component of
Quivering on the Path, Wiley's chaotic
painted lines form a sort of abstract
topographical map. But when you
step back from the work, represen-
tational elements begin to advance
from its craggy terrain: the tic-tac-toe
sign, the white outlines of quartz
crystals in various sizes, and the
words "quivering" and "path" are
scribbled into the rough landscape.
While the canvas alone offers
abundant visual material, the three-
dimensional elements of the work
also enhance its dynamic presence.
A tree root that hangs from the
ceiling and moves slightly as viewers
walk by has something of a
serpentine appearance. On one end
of the root's curved, lean line is a
gnarled, skull-like form; on the other
end, frayed roots. On the floor are
warped two-by-fours and large
wooden stakes, three painted black
trumpets, jagged Plexiglas, and
various other materials. What does
this sprawling imaginary landscape
mean?

In a letter from the late 1970s the
artist explains the work:

I was working up in Mendocino
County [in northern California]—
working on a cabin—went out for
a walk one evening and came upon
a big rattlesnake. It was heading
toward the barn and I kept trying to
dissuade it with rocks and sticks
but it kept aiming for the barn and
it was getting dark—the kids
had been riding along this path.
Finally decided I will kill it. Did so.
Felt bad about it—buried it under
some rocks. Decided that was
a warning—early summer—
snakes abound—hadn't been
thinking about them.

Next day went out to walk this
pipeline—waterline to the spring
box—was clogged—going through
rocks and weeds shaking it.
Cautiously had a walking stick
poking ahead for snakes. But at
some point forgot (again). Laid
down my stick, went on thrashing
and shaking the line—blundering
suddenly in one of those frozen

action memory shots, stepped into
a pocket, head and hand down
close to the pipe. Eye catches slight
flicker on the right. Body like a
puppet on invisible strings, some-
how gets jerked up back and out of
range. Almost falling down the hill.
Manage to land o.k. Wake up and
from a safer distance I see another
large rattler coiled and buzzing. I
just stood there quivering on the
path—trumpets blaring. Amazed
at life—luck and hurry! Thanked
the snake for not striking—and
proceeded slowly on my way.[3]

Wiley's writing style reflects his
artistic style: descriptive, funny, and
open to interpretation. Like his
landscapes, he sees narrative as a
path with many potential discoveries
and offshoots.

ANDREA KARNES

1 William T. Wiley, "Oral History
Interview," interview by Paul
J. Karlstrom, 8 October 1997,
Archives of American Art Web site
(http://artarchives.si.edu/
oralhist/wiley97.htm). Accessed
28 August 2001.
2 Graham W. J. Beal, "The
Beginner's Mind," in Graham W.
J. Beal and John Pevreault, *Wiley
Territory* (Minneapolis: Walker
Art Center, 1979): 26.
3 Undated letter from William
Wiley to the Curator of
Education, Modern Art Museum
of Fort Worth, Museum
Archives.

W

Jackie Winsor
American, born Canada 1941

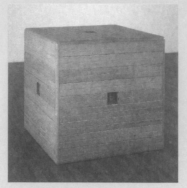

Green Piece, 1976–77
Painted wood, wire,
and cement
32 1/2 × 32 1/2 × 32 1/2 inches
(82.6 × 82.6 × 82.6 cm)
Museum purchase
1992.4.P.S.

… the mass disappears. All you have is this little negative, delicate little bit of space inside. All those layers of this huge thick wall silenced that space, it protected it and it silenced it. JACKIE WINSOR

At first glance, Jackie Winsor's *Green Piece*, 1976–77 appears to typify Minimalism, an art movement that began around 1963 and involved such artists as Carl Andre, Larry Bell, Donald Judd, Dan Flavin, Sol LeWitt, and Robert Morris. *Green Piece* displays the simplicity, geometry, and directness characteristic of Minimalism, and like Minimalist sculpture, Winsor's cubic form sits on the floor, not on a base or pedestal. Despite these superficial connections to Minimalism, her sculpture is not part of the movement and instead belongs to a body of work generally labeled post-Minimalism.

Winsor is one of several artists, including Lynda Benglis, Jackie Ferrara, Eva Hesse, Barry Le Va, Bruce Nauman, and Richard Tuttle, who reacted to the mid-1960s dominance of Minimalism by embracing some of its traits and concerns while rejecting others. Although their works varied significantly, these artists were nevertheless grouped under the headings Process art, antiform, and most often, post-Minimalism. None of the designations (like most art labels) is entirely satisfactory, but post-Minimalism does indicate that

the art refers to, and moves away from, Minimalism.

The most striking distinction between *Green Piece* and Minimalist sculpture is the evocativeness of Winsor's work. The impersonal, factory-fabricated surfaces and nonreferential forms associated with Minimalism run counter to the handmade character of *Green Piece*. The natural wear and tear of age evident in its wooden sides evokes a sense of history and "personality" (a quality the artist has sought out in her materials).[1] Winsor has compared *Green Piece*'s surface to "the bark of a tree which comes with its own natural variations,"[2] while the square openings—the artist calls them windows—and the space within suggest architecture. The windows puncture the solidity of the cube and invite a close and intimate examination of the sculpture. More than is the case with Minimalist work, *Green Piece* engages the viewer in a compellingly intimate way. Peering through the tunnel-like windows, the viewer can gauge the thickness and weightiness of the piece as well as imagine the tremendous time and effort involved in its construction. Winsor notes that as you gaze through a window and the center pulls you in, "the mass disappears. All you have is this little negative, delicate little bit of space inside. All those layers of this huge thick wall silenced that space, it protected it and it silenced it."[3]

Green Piece is one from a series of cubes that the artist produced between 1974 and 1985. Prior to this body of work, Winsor had gained recognition for her rope and wood-and-hemp pieces. She participated in the early efforts of the women's movement, and her work appeared in the groundbreaking gender-focused exhibition *26 Contemporary American Women Artists* at the Aldrich Museum of Contemporary Art, Ridgefield, Connecticut in 1971. The rope and wood-and-hemp sculptures took their shapes from the specific materials she used. They exhibited a powerful physical presence and revealed the repetitive and immensely time-consuming movements and efforts that had been required for their completion. Around 1974 Winsor decided her forms should be more neutral. She turned to cubes, and "wanted the

focus to be on what went on within them."[4] Her inclusion of windows on each side of a cube (beginning with *Sheetrock Piece*, 1976), centered attention on the form's interior core of space, where "nothing becomes something."[5]

That "something" offers silence, stillness, reflection, and "perhaps, also, finding new recesses within yourself."[6] Speaking about how the hollow cubes might reflect her own life, Winsor said, "It's all about where you want to put your attention. If you place value on the silence, the space in yourself, then you have the capacity for silence in your work. All the cube pieces did was contain space. All the body contains is space."[7] In articulating her desire to make the abstract physical, Winsor frequently employs the body as a metaphor. "I like to make an empty little place the focus of the piece, while at the same time making the piece very solid. It reminds me of the body: you drag it around with you, then you close your eyes and it seems to disappear, to go floating away."[8] Early in her career, Winsor was captivated and inspired by the choreography of Yvonne Rainer, in particular her dance *The Mind is a Muscle* (1966/68). Rainer's work, which the dancer and others have linked to Minimalism, stressed the corporeality of dance: "I love the body—its actual weight, mass, and unenhanced physicality"—and its factuality—"the demands made on the body's (actual) energy resources appear to be commensurate with the task—be it getting up from the floor, raising an arm, tilting the pelvis, etc."[9] Rainer's concept of "task-like dance" resonates with Winsor's belief that the time, energy, and attention she gives to constructing a piece is bound up in the viewer's perception of the work. Winsor may have also envisioned the viewer performing a "task-like dance" when engaging with a work like *Green Piece*, by standing on toes to peek into the window on top, moving from side to side, and kneeling down and lowering and twisting the head to look into the side openings. In the process, the viewer's body becomes an active element in the perception of the work.

Besides connecting to the body, Winsor's cubes also allude to architecture, especially because of

their windows and containment of space. Of all of the cubes, *Green Piece* makes the architectural relationship most obvious and personal. The wood that makes up *Green Piece*'s exterior is wainscoting the artist salvaged during renovations undertaken when she moved into an old building in New York's SoHo area in 1976. Over the years, this nineteenth-century building had been damaged by fire and rebuilt, and had housed various commercial enterprises, including a freak museum and a sweatshop. Using the wainscoting, with its timeworn green paint, allowed her to produce a work that already "had its own history."[10] Winsor literally reinforced this historicity by constructing the form with Structolite, a coarse concrete and plaster mixture that had been employed in the creation of the building's walls.

Green Piece's evocation of the past also includes a personal dimension. As a stable form with windows, sheltered interior space, and wood construction, *Green Piece* brings to mind domestic architecture. The connection is direct, in that the work was built of materials found in Winsor's new home (in a building oriented around an open interior core not unlike her cube). Her studio was not only the site of the work's creation, but also its literal source. Metaphorically, *Green Piece* represents an intimate place of privacy and quietness for Winsor, who had moved from a very noisy nearby area.[11] Further, as a recycling of materials to produce something new, *Green Piece* recalls Winsor's Newfoundland childhood, throughout which her parents continually built and rebuilt houses (her mother had constructed the first home Winsor lived in).[12] The relationship to domestic architecture is also implicit in the artist's description of *Green Piece* as "physically really there, but comfortably there."[13]

Although reductive in form, *Green Piece* is nevertheless an extraordinarily evocative work of art. An awareness of history, architecture, and the body are all called forth in the presence of the work. It simultaneously suggests energy and stillness, heaviness and emptiness, obviousness and wonder.

MARK THISTLETHWAITE

1 John Gruen, "Jackie Winsor: Eloquence of a Yankee Pioneer," *ARTnews* 78 (March 1979): 60.

2 Janet Kutner, "Simplistic Sculpture Reaches Back to Basic Design Concept," *Dallas Morning News* (27 September 1979): K21.

3 Although Winsor was speaking specifically about *Sheetrock Piece*, 1976, her words are also appropriate to *Green Piece*. Quoted in Beryl Smith, Joan Arbeiter, and Sally Shearer Swenson, *Lives and Works: Talks with Women Artists 2* (Lanham, Maryland and London: Scarecrow Press, 1996): 250–51.

4 Dean Sobel, "Jackie Winsor's Sculpture: Mediation, Revelation, and Aesthetic Democracy," in *Jackie Winsor* (Milwaukee: Milwaukee Art Museum, 1991): 33.

5 Ibid.

6 Eleanor Munro, *Originals: American Women Artists* (New York: Simon and Schuster, 1979): 437.

7 John Bentley Mays, "The Winsor Posture," *Canadian Art* (Fall 1994): 117.

8 Quoted in Sobel, 33. Although at the time she constructed *Green Piece* she was not influenced by Eastern philosophies, practices, and ideals, Winsor now recognizes affinities with them. The artist in conversation with the author, 22 February 2001.

9 See Yvonne Rainer, *Work 1961–73* (Halifax and New York: Press of the Nova Scotia College of Art and Design in association with New York University Press, 1974): 63–106 and Carrie Lambert, "Moving Still: Mediating Yvonne Rainer's *Trio A*," *October 89* (Summer 1999): 87–112.

10 Quoted in Sobel, 38.

11 Conversation with the author, 22 February 2001.

12 Munro, 432.

13 Conversation with the author, 22 February 2001.

Presidents of the Fort Worth Art Association

Year	President	Chairman
1910	Mrs. M. P. Bewley	
1933	Miss Olive Peak	
1938	E. E. Bewley	Mrs. Charles S. Scheuber (Emeritus)
1941	Harry Weeks	
1942	Sam B. Cantey III	
1944	O. P. Newberry	
1948	Robert F. Windfohr	
1954	Sam B. Cantey III	
1959–1960	Garland Ellis	
1960–1964	Whitfield J. Collins	
1964–1965	Robert F. Windfohr	
1965	Earl Baldridge	
1965–1973	Edward R. Hudson, Jr.	
1973–1975	Charles Tandy	Edward R. Hudson, Jr.
1975–1977	Sid R. Bass	Charles Tandy
1977–1979	Richard Tucker	Sid R. Bass
1979–1981	S. Patrick Woodson III	Richard Tucker
1981–1983	William F. Runyon	S. Patrick Woodson III
1983–1986	George M. Young	William F. Runyon
1986–1988	Anne W. Marion	George M. Young
1988–1990	Lee M. Bass	Anne W. Marion
1990–1996	Marsland Moncrief	Lee M. Bass
1996–2000	Cornelia Blake	Marsland Moncrief
2000–present	William P. Hallman, Jr.	Cornelia Blake

Directors of the Museum

	
1950–1955	Daniel Defenbacher
1955–1960	Henry B. Caldwell
1960–1966	Raymond Entenmann
1966–1968	Donald A. Burrows
1968–1973	Henry T. Hopkins
1974–1976	Richard Koshalek
1976–1978	Jay Belloli
1978–1979	Marge Goldwater, Acting Director
1979–1984	David Ryan
1984–1991	E. A. Carmean, Jr.
1991	Marla Price, Acting Director
1992–present	Marla Price

Founding Members of the Fort Worth Public Library and Art Gallery Association

Mrs. E. E. Chase
Mrs. F. S. Boulware
Mrs. C. D. Brown
Mrs. V. D. Eaton
Mrs. B. C. Evans
Mrs. J. R. Hoxie
Carrie Huffman
Mrs. J. J. Melton
Mrs. G. M. Otten
Mrs. B. B. Paddock
Lillie Peak
Olive Peak
Mrs. Charles S. Scheuber
Mrs. J. P. Smith
Mrs. John Sway
Mrs. J. C. Terrell
Mrs. Ida L. Turner
Mrs. N. M. Washer
Mrs. P. M. White
Mrs. R. M. Wynne

The Evolution of a Name

1892 Fort Worth Public Library and Art Gallery, Founding Charter
1901 Carnegie Public Library Art Gallery
1910 The Fort Worth Museum of Art
1954 Fort Worth Art Center
1971 The Fort Worth Art Museum-Center
1974 The Fort Worth Art Museum
1987 Modern Art Museum of Fort Worth

Photograph Credits

Michael Bodycomb: 19, 183.

Tom Jenkins: Cover, 11, 21, 22, 23, 24, 26, 27, 30, 34, 35, 36, 37, 39, 40, 44, 45, 46, 47, 51, 52, 53, 58, 59, 60, 61, 62, 65, 68, 69, 70, 71, 72, 74, 75, 76, 77, 78, 79, 80, 82, 83, 84, 85, 87, 88, 89, 91, 93, 98, 100, 101, 103, 104, 105, 106, 107, 109, 110, 116, 117, 122, 124, 128, 130,134, 135, 136 (right), 139, 141, 143, 145, 146, 148, 149, 150, 152, 154, 155, 157, 159, 160, 161, 162, 166, 168, 169, 174, 175, 176, 177, 178, 180, 184, 185, 186, 189, 196, 197, 198, 199, 211, 220, 293, 304, 307.

David Wharton: 66, 67.

11 © 2002 Andy Warhol Foundation for the Visual Arts/ARS, New York
19 © 2002 The Josef and Anni Albers Foundation/ Artists Rights Society (ARS) New York
20 © Carl Andre/Licensed by VAGA, New York, NY
21 © 2002 Milton Avery Trust/Artists Rights Society (ARS) New York
22 © 2002 Stephan Balkenhol/Artists Rights Society (ARS) New York/ VG Bild-Kunst, Bonn
23 © 1976 Georg Baselitz
24 © 1986 David Bates
25 © 1952 William Baziotes, Courtesy Joseph Helman and the Estate of William Baziotes
26 © 1972, 1980, 1965 Bernd & Hilla Becher
27 © 1984, 1982 Bernd & Hilla Becher
28 © 1973 Robert Bechtle
29 © 1968 Larry Bell
30 © Lynda Benglis/Licensed by VAGA, New York, NY
31 © 1982 Ed Blackburn
32 © 1997 Dennis Blagg
33 © 1980 Jonathan Borofsky
34 © 2000 Julie Bozzi
35 © 1986 Sophie Calle
36 © 1987 Anthony Caro
37 © 1966 Vija Celmins
39 © 1970 Vija Celmins
40 © 2000 Vija Celmins
41 © 2002 John Chamberlain/Artists Rights Society (ARS) New York
42 © 1989 Chuck Close
43 © 1988 Clyde Connell
44 © 1995 Thomas Joshua Cooper
45 © 1996 Thomas Joshua Cooper
46 © 1996 Thomas Joshua Cooper
47 © 1994 Thomas Joshua Cooper
48 © The Joseph and Robert Cornell Memorial Foundation/ Licensed by VAGA, New York, NY
49 © 1990 Tony Cragg
51 © 1953 Estate of Richard Diebenkorn
52 © 1962 Estate of Richard Diebenkorn
53 © 1978 Estate of Richard Diebenkorn
54–55 © 1972 Jim Dine
56 © 1989 Barbara Ess
57 © 2002 Lyonel Feininger/Artists Rights Society (ARS) New York/ VG Bild-Kunst, Bonn
58 © 1974 Vernon Fisher
59 © 1979 Vernon Fisher
60 © 1995 Vernon Fisher
61 © 1999 Vernon Fisher
62 © 2002 Estate of Dan Flavin/Artists Rights Society (ARS) New York
63 © Bill Bomar
64 © 1950 Cynthia Brants
65 © Dickson Reeder
66 © Bror Utter
67 © 1945 Kelly Fearing
68 © 2002 The Estate of Sam Francis/Artists Rights Society (ARS) New York
69 © 1976 Hamish Fulton
70 © 1976 Gilbert & George
71 © Adolph and Esther Gottlieb Foundation/Licensed by VAGA, New York, NY
72 Art © Nancy Graves Foundation/Licensed by VAGA, New York, NY